Thomas Eakins

HIS LIFE AND ART

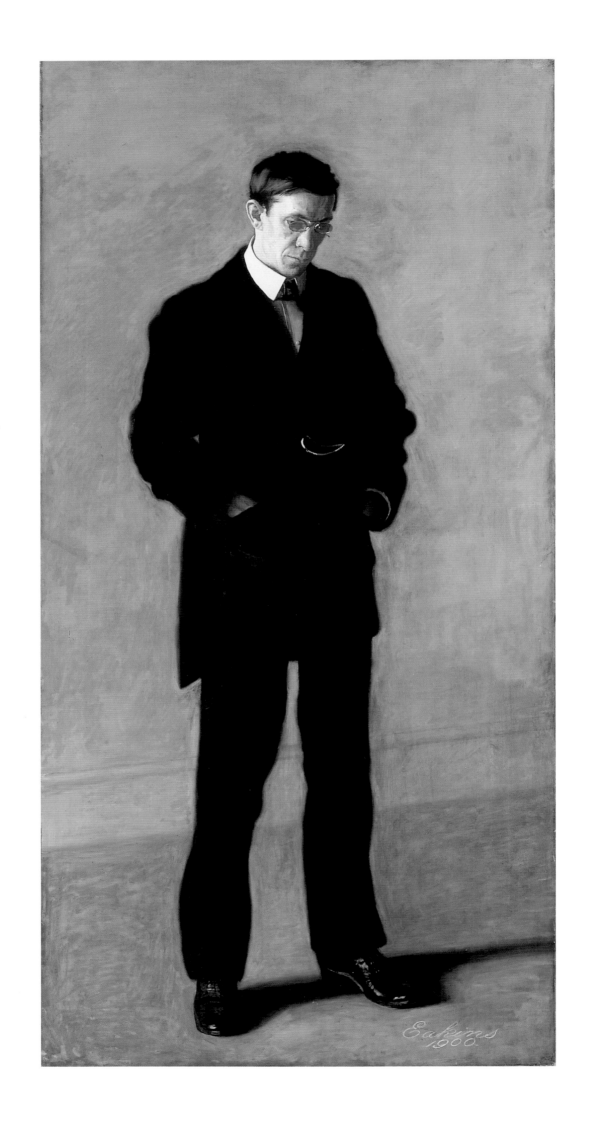

WILLIAM INNES HOMER

•

THOMAS EAKINS

HIS LIFE AND ART

•

ABBEVILLE PRESS PUBLISHERS

NEW YORK LONDON PARIS

For Christine, with love

FRONT COVER: Detail of *Maud Cook*, 1895. See plate 189.
BACK COVER: *Starting Out after Rail*, c. 1874. See plate 52.
FRONTISPIECE: *The Thinker: Portrait of Louis N. Kenton*,
 1900. Oil on canvas, 82 x 42 in.
 The Metropolitan Museum of Art,
 New York; Kennedy Fund, 1917

A NOTE ABOUT THE CAPTIONS

Works not otherwise attributed in the captions are all by Thomas Eakins. The references to catalog numbers in the captions for plates 10, 12, 17, 39, 98, 101, and 130 are keyed to Kathleen A. Foster, *Thomas Eakins Rediscovered*, forthcoming.

EDITOR: Nancy Grubb
DESIGNER: Nai Chang
PRODUCTION EDITOR: Cristine Mesch
PICTURE EDITOR: Anne Manning
PRODUCTION SUPERVISOR: Hope Koturo

First edition, second printing

Library of Congress Cataloging-in-Publication Data

Homer, William Innes.
 Thomas Eakins: his life and art/William Innes Homer.
 p. cm.
 Includes bibliographical references and index.
 ISBN 1-55859-281-4
 1. Eakins, Thomas, 1844–1916. 2. Artists—United States—Biography. I. Title.
N6537.EH65 1992
709'.2—dc20 92-10163
[B]

CONTENTS

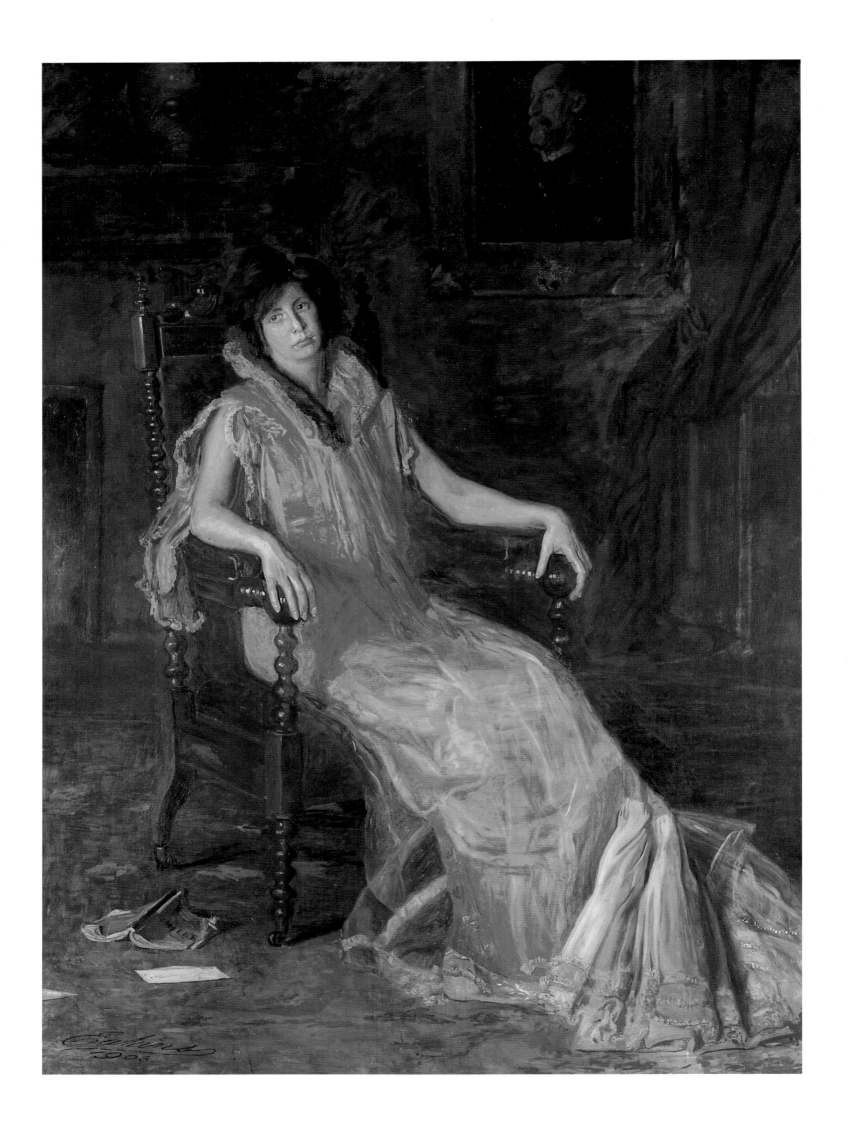

Introduction

Defiant, inflexible, and self-righteous are words not commonly used to describe Thomas Eakins. They do, however, accurately define aspects of the personality of this great American artist, whose ambitious drive toward his own vision of perfection left him disillusioned and alienated. Although time has idealized the man, his paintings remain a constant truth, portraying the American people and their world with remarkable fidelity and sympathy.

When functioning at his highest level Eakins was a superb artist, ranking with the best American painters of his time, painters such as Winslow Homer and John Singer Sargent. He shared their immense ability to capture the human image, to place it within a convincing space and make it seem tangible in its reality, while avoiding mere painterly pyrotechnics. His profound knowledge of the human head and body provided a foundation for his unusual skill in penetrating surface appearances to reveal the psychological traits of the subjects who posed for him. His best portraits are extraordinary not only because he mastered the conceptual and technical skills needed to make inert paint and canvas come alive but also because he discovered the personal traits most worthy of recording.

In his devotion to American subjects, Eakins seems to have responded to Walt Whitman's challenge to portray life in the United States rather than worn-out European myths and allegories. His genre paintings—especially of hunting, sailing, and rowing scenes—reflect his pleasure in these commonplace sports while also elevating them to a higher, more universal plane. The pictorial language he used was not particularly original, yet it differed from what he had been taught at the Ecole des Beaux-Arts; it was also allied to but separate from the American genre tradition of George Caleb Bingham, Homer, Eastman Johnson, William Sidney Mount, and others. His work resembles theirs in subject as well, but more than any of them he derived his visual information directly from nature, just as the realists had done in France.

Eakins pursued his goals in art and life with unswerving determination. Not only did he work diligently to become an accomplished painter himself, but he also forcefully imposed his credo on his students in an effort to make them good artists. For some of them this was the right approach, but for others his

1. *The Actress (Portrait of Suzanne Santje)*, 1903
Oil on canvas, 79¾ x 59⅞ in.
Philadelphia Museum of Art; Given by Mrs. Thomas Eakins and Miss Mary Adeline Williams

teaching seemed far too limited, confined to the appearance and mechanics of the nude human body and little else.

For Eakins the nude was a crossroad where all of his ideas intersected. His passion for the unclothed human body can be traced to Whitman, who hailed the joys of unembarrassed nakedness. For Eakins, as for Whitman, the undressed figure was a talisman of freedom, a symbol of intellectual and sexual liberty and of resistance to narrow-minded prudery. Eakins's experiences in Paris reinforced this view, for the French, especially within the high-spirited art community, were far less puritanical than the Americans back home. It was in Paris that he absorbed the ideas of the sixteenth-century monk turned physician and satirist, François Rabelais, whose motto Do What You Want guided the American painter for the rest of his life.[1]

Eakins's approach to the nude encapsulated the various tenets of modernity as it was understood in the 1860s and 1870s. The nude was not a transcendent image, nor was it symbolic in the traditional sense: it was a marvel of nature, the superb end product of centuries of evolution. To see and study the body in this way, Eakins had to invoke all the authority of science, drawing endless analogies between medicine and art. Yet he seems also to have seen the human form as a carrier of vital energy, an organism whose biological force excited him and carried sexual implications as well.

Caring far less about his public reputation than about his freedom to paint as he pleased, Eakins tenaciously upheld his principles, no matter what the cost. His candor regarding the nude led to his expulsion from his teaching position at the Pennsylvania Academy of the Fine Arts, prevented him from continuing his beneficial influence in art education, tarnished his personal reputation, and exiled him from the social and art-political circles in Philadelphia where he could have exerted considerable leadership. His uninhibited, often vulgar speech made him seem a boor, and his stubborn, self-righteous behavior made him an outcast. (Of course, it is not necessary to be a pleasant person to be an effective artist.) It is as though he thoroughly enjoyed offending the commercial aristocracy and the philistines who appreciated neither his ideas nor his art.

Eakins himself placed little importance on his own biography, saying, "For the public I believe my life is all in my work."[2] But in order to evaluate the contribution of this complex and rewarding artist, one must scrutinize both his life and his art. To that end, I have used the latest available information—published and unpublished—to write the most comprehensive account possible. I have examined Eakins's family, his personality, his professional and personal relationships; his theories, his prejudices, and his responses to earlier and to contemporary art; and the strengths and weaknesses of his own painting and sculpture. I have tried to view Eakins in the context of his culture (especially the materialistic, scientific ethos of his day), to say something about his attitudes toward women as well as to his male friends, and to probe his psychological makeup.

In the course of my research I was able to examine materials that had never before been accessible. They offered fresh and often startling insights about the role of intellect in Eakins's art and teaching, about his relation to his con-

temporaries, about the dark and obsessive side of his sexuality. The most important new source—sequestered in the home of the widow of Eakins's student Charles Bregler until 1985, when it was purchased by the Pennsylvania Academy—is a collection of paintings, sculptures, drawings, photographs, personal documents, and letters by and to Eakins. Susan Macdowell Eakins (the artist's widow), who had originally owned most of the material, had shown only portions of it to the American art historian Lloyd Goodrich, withholding documents that showed Eakins's behavior—especially toward women—in a bad light. Bregler had shared some of the collection with Eakins's biographer Margaret McHenry, but except for her, Goodrich, and a few others who glimpsed fragments of these materials, it remained an unknown treasure. Besides the letters, the collection includes invaluable ephemera and sketches from the artist's youth; perspective drawings and oil studies for various works; and memorabilia such as his paint boxes, palette, and brushes.

Other new sources have become available within the last few years. The papers of the late Gordon Hendricks, given to the Archives of American Art, Smithsonian Institution, include an enormous amount of biographical and historical data not fully mined even by Hendricks in his own publications on Eakins. There is also the Eakins Archive bequeathed to the Philadelphia Museum of Art by Lloyd Goodrich. It includes, among other things, notes on his interviews with Mrs. Eakins and with many of the artist's students and friends; Goodrich's copies of Eakins's letters, lent to him by Mrs. Eakins (the originals of which, in some cases, are now lost); a copy of Eakins's own cumulative record of his paintings; Goodrich's unfinished draft catalog of the artist's life work; and many photographs of Eakins's paintings, drawings, and sculptures. Goodrich's small pencil sketches made in the early 1930s, when he was going through the many unsold paintings still in Mrs. Eakins's possession, provide the only visual records of certain lost works.

I also learned a great deal from the late Seymour Adelman, a Philadelphia attorney and bibliophile, who befriended Eakins's widow in the 1930s. Adelman, who loved the work of Eakins, absorbed much information about the artist from his chats with Mrs. Eakins. During my visits to the Eakins house on Mount Vernon Street—which Adelman had purchased and donated to the Philadelphia Museum of Art as an Eakins memorial and a community art center—he would walk from room to room, sharing with me his memories of Mrs. Eakins and the house in the 1930s. One other resource, also connected to Adelman, is the collection he sold to Mr. and Mrs. Daniel W. Dietrich II in order to buy the Eakins house. The collection—still to be fully explored—includes paintings and oil sketches, small sculptures, drawings, photographs by and of Eakins, letters, journals, and memorabilia.

The availability of this rich vein of material gave me an opportunity to challenge existing views of Eakins, to abandon the hero worship that has dominated so much of the writing about him. Eakins was not the near-perfect human being portrayed by his admirers: he was domineering, obsessive, egotistical, and filled with sexual conflicts. That he was a great painter cannot be denied, but

2. *Nude (Front View)*, 1908
 Oil on canvas, 24¼ x 14⅛ in.
 Hirshhorn Museum and Sculpture
 Garden, Smithsonian Institution,
 Washington, D.C.; Gift of Joseph
 H. Hirshhorn, 1966

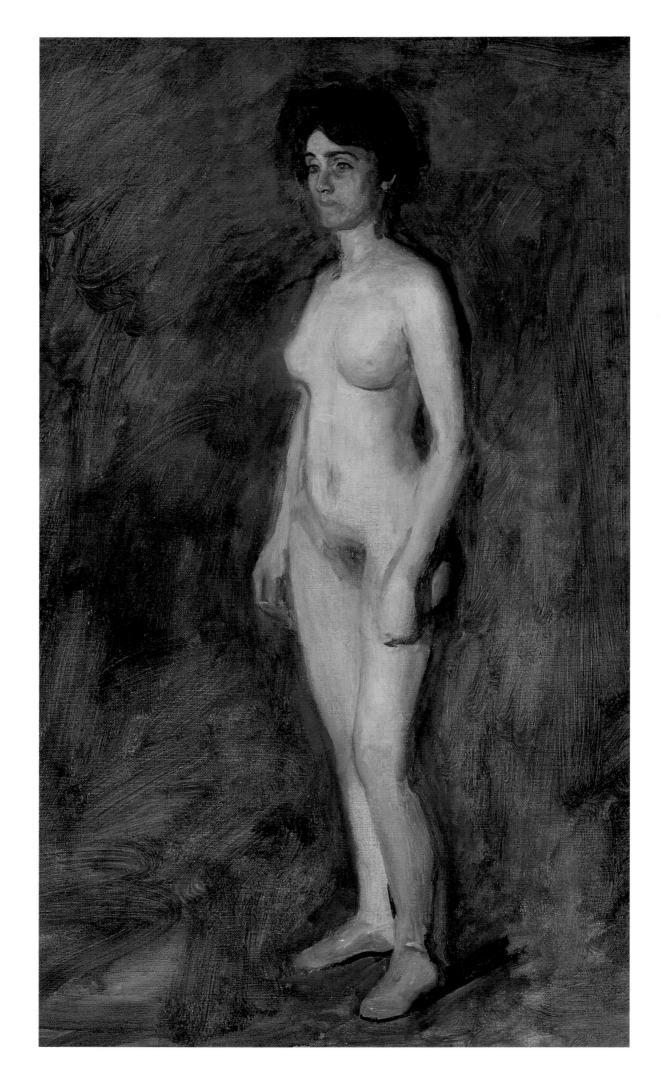

not all of his works are equally good, and they must be evaluated with a critical eye. My intent has been to capture the essence of the man with the same penetrating spirit that he used to portray his own subjects—honestly and without idealization.

3. *Nude Woman*, c. 1882
 Watercolor on paper, 17 x 9 in.
 Philadelphia Museum of Art; Given
 by Louis E. Stern

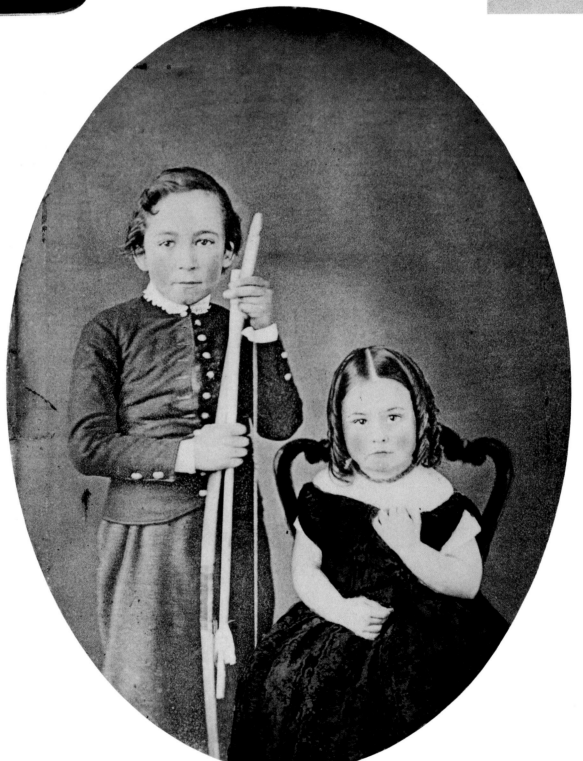

1. Beginnings

Thomas Cowperthwait Eakins was born on July 25, 1844, in a modest row house on Carrollton Square in Philadelphia. His father, Benjamin Eakins, was the third of four children born to a Scotch-Irish weaver named Alexander Eakins, who had emigrated to the United States with his wife, Frances Fife Eakins, about 1812 and settled on a farm in Valley Forge, Pennsylvania. Benjamin became a writing master in Philadelphia, teaching penmanship at Friends Central School, a Quaker institution, between 1845 and 1896. He also inscribed deeds, diplomas, and other documents for a fee in a precise Spencerian script. "Master Benjamin" was known as "courtly and affable," a serious, hard-working gentleman "who held himself with great dignity."[1] Although not a Quaker, he seems to have adopted the traits of sobriety, diligence, and thrift associated with that sect. Benjamin's astute investments in securities and real estate allowed his family to live comfortably, if not luxuriously.

Little is known about the background of Benjamin's wife, Caroline, whom he married in 1843. Her father, Mark Cowperthwait, was a Quaker of English and Dutch stock. He married Margaret Jones, moved from southern New Jersey to Philadelphia, and established himself as a shoemaker before turning to building and real estate. Caroline was born in Philadelphia in 1820, the youngest of ten children. A photograph of her at about age thirty (plate 5) shows a severe countenance softened by soulful, expressive eyes.

Benjamin and Caroline Eakins had five children. Thomas was the oldest. The second child, Benjamin, Jr., died at the age of four months; three daughters—Frances (Fanny), Margaret (Maggie), and Caroline (Caddy)—grew to maturity. The family was quite close, with aunts and uncles frequently joining this tightly knit, mutually respectful group. Mrs. Eakins's unmarried sister Eliza lived with the family until her death in 1899. Little is known of her other than her interest in needlework and her stern manner, but it is likely that she perpetuated the Cowperthwaits' strict Quaker traditions in the Eakins household.

From 1857 onward, the Eakinses lived at 1729 Mount Vernon Street, a spacious four-story brick house that Benjamin had purchased not far from the center of the city. The area is now rather run down and very different from the quiet, middle-class neighborhood it was in Thomas Eakins's time. Then the

Opposite, top left
4. Photographer unknown
Benjamin Eakins, c. 1845
Daguerreotype
Mr. and Mrs. Robert Trostle

Opposite, top right
5. Edward R. Morgan
Caroline Cowperthwait Eakins, c. 1850
Photograph
Mr. and Mrs. Daniel W. Dietrich II

Opposite, bottom
6. O. H. Willard
Thomas Eakins and His Sister Frances, c. 1850
Salt print, hand-colored
The Bryn Mawr College Library, Bryn Mawr, Pennsylvania; The Adelman Collection

Above
7. 1729 Mount Vernon Street, Philadelphia

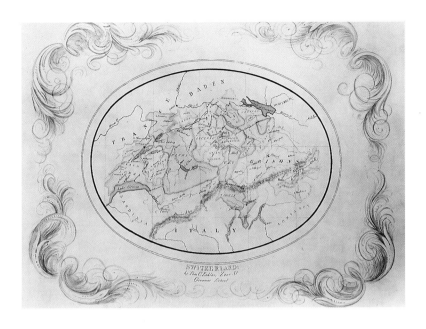

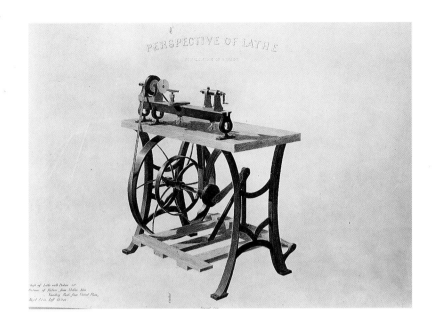

block was populated by merchants, lawyers, clerks, an organ manufacturer, a book publisher, a dentist, and an undertaker, among others.

Being the firstborn and a male child, Thomas was the subject of devoted attention from his parents, his aunts and uncles, and his only living grandparent, Margaret Cowperthwait. Apparently he was tutored at home until he entered Zane Street Grammar School at the age of nine. There his rigorous course of study stressed reading, spelling, history, literature, and arithmetic, as well as moral lessons and readings from the Bible. Later Eakins remembered writing poems "all about sweethearts. I guess they were madrigals."[2] Two maps he copied, of Switzerland (plate 8) and Southern Europe, show his precocious skill in handling ink and watercolor.

Eakins graduated with excellent grades in 1857 and entered Central High School that fall. Formerly a college and still empowered to award a Bachelor of Arts degree, Central High provided a demanding education for the city's best male students. Although a classical curriculum was offered, much emphasis was placed on the natural sciences. As one graduate recalled:

> Natural Science . . . is the basis upon which other studies must be built. Only with the just ideas of cause and effect, and the knowledge of the universal reign of law, gained in the laboratory and the observatory, does the student become prepared to understand the facts of language, history, art and literature, which thus find their natural relations, no longer isolated fragments of knowledge, but the records of the movements of the great tide of human endeavor.[3]

School records show that Eakins's classes would have included physiology, history, algebra, mathematics, geometry, natural philosophy, drawing, and writing.[4] Eakins earned a grade of one hundred in drawing during each of his four years in high school. His surviving drawings are mainly renderings of geometric figures (plate 10) and mechanical devices, presented in a neat, clear, objective manner and carefully inscribed. Their precise perspective reflects instruction

based on Rembrandt Peale's *Graphics* (1834 and later editions), a widely used textbook on drawing and writing. Eakins's drawing of a lathe (plate 9) is typical: painstakingly executed, it reveals his command of his medium and his respect for accuracy.

From time to time Eakins turned to picturesque, romantic images, often of foreign subjects, which he copied in pencil or crayon from popular drawing manuals or prints, making detailed records (plate 11) that are more linear than tonal. Also fundamentally linear are his exacting pencil copies of trees and foliage from James D. Harding's book entitled *Lessons on Trees* (1855). Eakins's tour de force was his copy of a photographic reproduction of Thomas Crawford's *Freedom* on the Capitol dome in Washington, D.C. (plate 12).

Eakins's student drawings offer clues to his later attitudes toward draftsmanship and representation. For Eakins, art was a rational process that depended on measurement and absolute control of the three-dimensional spatial framework of the picture. Drawing, in particular, was a slow, methodical exercise that left no room for guesswork. Moreover, as the art historian Michael Fried has pointed out, drawing and writing were for Eakins fundamentally the same kind of activity: "Not only were [they] considered essential skills but were taught as different aspects of a single *master* skill of eye and hand working in concert."[5] Fried believes that the ties between drawing and writing influenced Eakins's art throughout his life. Many of his paintings and even a few of the frames he made contain clearly defined passages of writing, and Eakins's frequent use of a one-point-perspective grid made his pictorial fields emphatically horizontal rather than an illusionistic vertical "window."

Eakins graduated from Central High on July 11, 1861, just a few days before his seventeenth birthday. He received a Bachelor of Arts degree, ranking

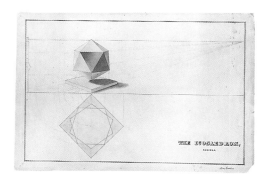

Below, left
11. *Untitled (Spanish Scene)*, 1858
Pencil heightened with white ink on paper, 11½ x 17 in.
Hirshhorn Museum and Sculpture Garden, Smithsonian Institution, Washington, D.C.; Gift of Joseph H. Hirshhorn, 1966

Below, right
12. *Thomas Crawford's "Freedom,"* 1861
Pen, ink, and wash on cream wove paper, 13½ x 10⅛ in., irregular
The Pennsylvania Academy of the Fine Arts, Philadelphia; Charles Bregler's Thomas Eakins Collection. Purchased with the partial support of the Pew Memorial Trust and the John S. Phillips Fund. PAFA-CB cat. 14

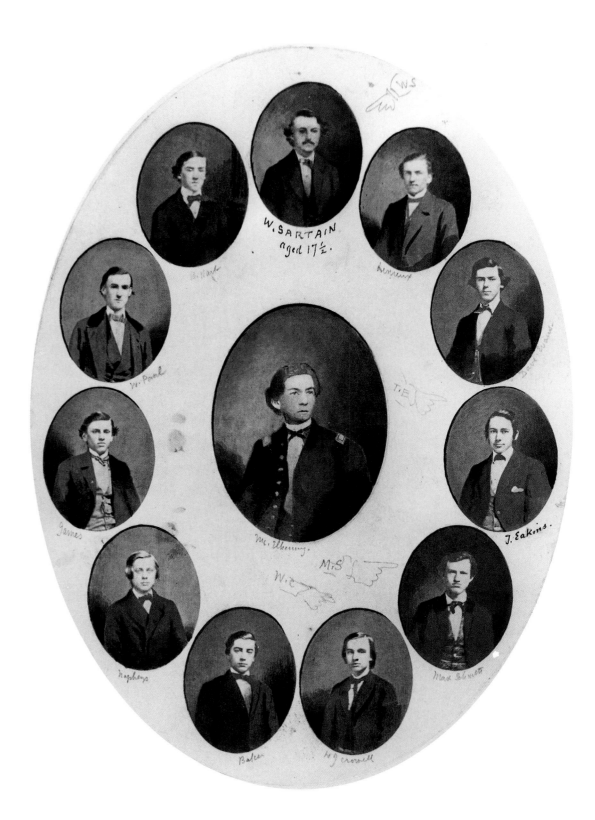

13. O. H. Willard
 *Graduation Photograph, Central High
 School*, 1861
 Composite salt print
 The Pennsylvania Academy of the
 Fine Arts, Philadelphia; William
 Sartain Scrapbooks in the
 Pennsylvania Academy Archives

fifth among fourteen who had qualified for this diploma. He was scheduled to give a "scientific address," the graduation program tells us, but apparently he balked at the last minute, because the definitive newspaper account of the event notes that his speech "was omitted."[6] Years later his widow reported that he gave this explanation: "All I have learned is from books, I have not invented or discovered anything, and have nothing to tell people [but] what I have learned in books, and this same knowledge anyone can get from the books."[7]

Unfortunately, not much is known about Eakins at this point in his life. He never composed an autobiography or any written recollections; nor did his boyhood friends, other than William Sartain, write much about him, then or

later. But all the available evidence suggests that Eakins was a bright young man, with a fine analytical mind. He had earned high grades at Central in mathematics, sciences, and French; had done good or fair work in English and history; and had received high marks in first-year Latin but low grades the following two years.[8] His talent in drawing was so exceptional that at age eighteen he was considered for the position of professor of drawing, writing, and bookkeeping at Central (he did not get the job).

It is said that Eakins contemplated studying medicine after finishing high school, and for a time he helped his father teach penmanship. Finally, in October 1862, he became a student at the Pennsylvania Academy of the Fine Arts in Philadelphia, the nation's oldest art institution. Just why he made this choice is unknown. Perhaps the elder Eakins encouraged him to view painting as a worthy extension of calligraphy. Or perhaps Benjamin and Thomas considered advanced studies to be the best way for the latter to become a professional portraitist or engraver.

The Academy, founded in 1805 and housed in a building resembling a Greek temple, was not an art school in the modern sense; no such institution then existed in the United States. The Board of Directors had assembled a collection of American and European paintings as well as casts of Greek and Roman sculpture, and beginning in 1855 it gave artists and students an opportunity to draw, at no charge, from antique casts and the live model. A physician, Dr. A. R. Thomas, gave lectures on anatomy, but no formal teaching in art was offered. Following the usual practice in art academies of the day, students would start by copying casts of antique sculpture, then move on to life drawing. Older students or established artists who went there to improve their skills would help neophytes like Eakins as best they could.

The Alsatian-born history and genre painter Christian Schussele frequented the Academy while Eakins was there and may have offered him some guidance.[9] There is a possibility, too, that he taught Eakins in private sessions held in his own studio. One of Schussele's students recalled: "Professor Schussele . . . stood as a thoroughly trained exponent of the academic school of France. He taught the importance of truth, of going to nature for all things, even to the accessory data necessary to make a complete expression of an idea, holding that it was only by following these lines that the picture could be made convincing."[10]

Peter F. Rothermel, another accomplished Philadelphia artist, also attended the Academy and helped the students there. No doubt he, too, influenced Eakins. The younger man's studies from this period (plate 17), like those by Schussele and Rothermel (plates 15, 16), typify the academic approach, portraying the antique cast or the nude model with strong contrasts of light and shade, idealizing and simplifying the subject to planes and angles. No attempt at personal expression or interpretation was made: in fact, academic drawings by one artist are virtually interchangeable with those by another. Eakins's are distinguished only by an especially strong tendency to treat the model geometrically and to jumble body fragments together on a sheet without system or order.

Although Eakins had undoubtedly heard Dr. Thomas lecture on anatomy

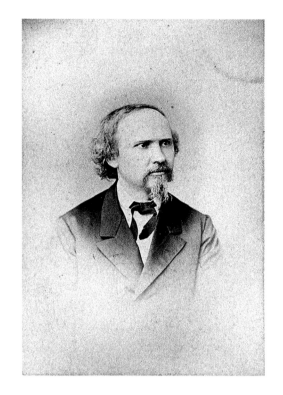

14. Frederick Gutekunst (1831–1917)
Christian Schussele
Photograph
Mr. and Mrs. Daniel W. Dietrich II

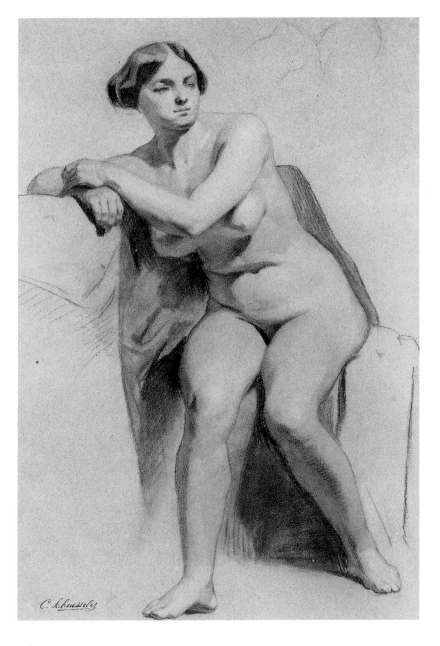

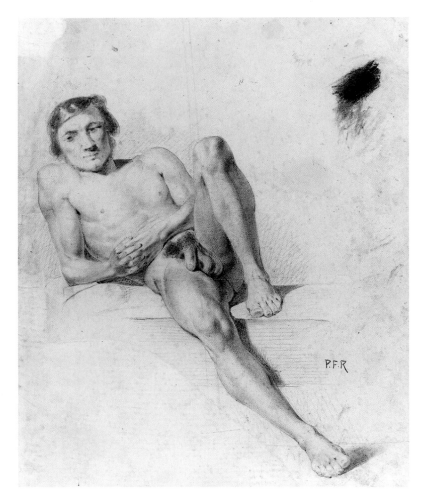

Above

15. Christian Schussele (1824–1879)
 Figure Study: Seated Female Nude Resting on Right Arm, late 1850s–early 1860s
 Black charcoal on blue wove paper, 17⅛ x 11½ in., irregular
 The Pennsylvania Academy of the Fine Arts, Philadelphia; John S. Phillips Collection

Right, top

16. Peter F. Rothermel (1817–1895)
 Male Nude Seated on a Ledge, c. 1860
 Charcoal and pencil on paper, 20 x 13½ in.
 The Schwarz Collection

Right, bottom

17. *Figure Study: Shoulders and Elbow of Seated Man*, c. 1863–66
 Charcoal on buff laid paper, 24 x 18½ in.
 The Pennsylvania Academy of the Fine Arts, Philadelphia; Charles Bregler's Thomas Eakins Collection. Purchased with the partial support of the Pew Memorial Trust and the John S. Phillips Fund. PAFA-CB cat. 22

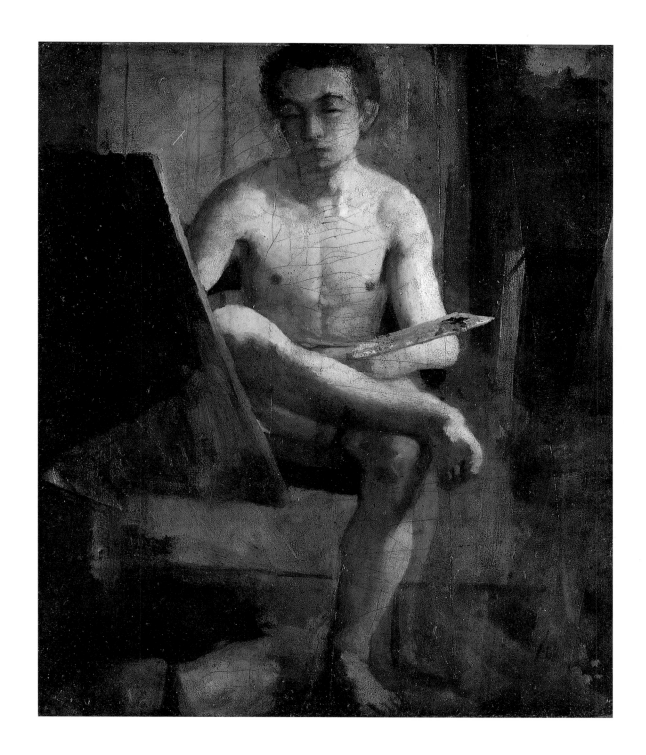

18. Charles L. Fussell (1840–1909)
Young Art Student (Sketch of Thomas Eakins), c. 1865
Oil on paper, 15 x 12¾ in.
Philadelphia Museum of Art; Given by Seymour Adelman

at the Academy, he sought further training at Jefferson Medical College (now part of Thomas Jefferson University). Submitting himself to the same thorough anatomical training received by the medical students of his day, Eakins enrolled in 1864 and 1865 in anatomy courses offered by Dr. Joseph Pancoast, a distinguished surgeon and teacher.

There was no formal instruction in painting in oil at the Academy. For that Eakins turned to Charles L. Fussell, one of his Central High classmates who had left to enroll in the Academy in 1859. Only a few steps ahead of Eakins, Fussell had somehow managed to familiarize himself with the technique of painting in oil and was able to pass his knowledge on to his friend. Fussell painted Eakins seated nude at his easel (plate 18), presumably at the Academy; perhaps Eakins was simultaneously creating an oil study of Fussell (if so, it is now lost). Fussell later became one of Eakins's students at the Academy in 1878 and 1879, and they remained lifelong friends.

19. Frederick Gutekunst (1831–1917)
Thomas Eakins at about Age Twenty,
c. 1864
Albumen carte-de-visite
The Pennsylvania Academy of the
Fine Arts, Philadelphia; Purchased
with funds donated by the
Pennsylvania Academy Women's
Committee

Another painter who influenced Eakins was George W. Holmes, an Irish-born landscape painter who operated an art school in Philadelphia. He was a close friend of Benjamin Eakins, who had acquired at least one of Holmes's paintings, *Study from Nature—Elizabethtown, N.J.,* and hung it in the Mount Vernon Street house. Father and son would often accompany Holmes on sketching trips in the country. On these excursions, or at his studio, Holmes may have offered the aspiring artist instruction in drawing or painting, or both. In any event, the young Eakins seems to have revered Holmes, and in his letters from Paris he often asked about the older man's activities. Their association continued for several decades: Eakins portrayed Holmes in *The Chess Players* (plate 76) and used him as a model, after Holmes had gone blind, for one of the sculptures of prophets he created for the Witherspoon Building in Philadelphia.

A friend of Holmes was the English-born engraver John Sartain, a highly cultured artist whose expert reproductive work had brought him international acclaim. He was a major force in the management of the Pennsylvania Academy, a friend and backer of Schussele, and a power in the city's art organizations. He and his family—especially two of his children, William (a classmate of Thomas's at Central High) and Emily—were close to the Eakinses. A formidable ally to Eakins, John Sartain may have influenced him to attend the Academy, and later his highly favorable letter of introduction helped Eakins get admitted to the Ecole des Beaux-Arts in Paris.

Independence of thought was apparently important in the Eakins household, for Thomas's behavior during his youth and throughout his life reflects it again and again. This may have been fostered by his being the firstborn child. Possibly, too, the Quaker strain in his family, with its emphasis on answering the inner voice of conscience, reinforced his confidence in his own judgment. Whatever the reason or reasons—heredity or upbringing or both—Eakins stubbornly held to his ideals and goals. He was also quite domineering. Sallie Shaw, Benjamin Eakins's grandniece, reported, "He ruled his mother as well as the rest of the family."[11] Nonetheless, he had many friends, both his own age and older, divided about equally between the sexes. He developed particularly close ties with three of his classmates from Central High: William Sartain; Max Schmitt, an oarsman and attorney; and William J. Crowell, a lawyer who became Thomas's brother-in-law.

Eakins was robust, with a solid, athletic frame. He was about five feet nine inches tall, and as Goodrich observed, he had "the build of a runner, swimmer, rower, or skater, more than of a boxer or wrestler."[12] He enjoyed many sports: hiking, followed by picnics along Wissahickon Creek, in the company of William and Emily Sartain; sculling on the Schuylkill River with Max Schmitt, who spoke of Eakins's prowess as a swimmer and diver;[13] hunting rail (a wading waterfowl) with his father in the marshes near Fairton, New Jersey; and ice skating with his sisters. Photographs taken in his early twenties (plate 19) show Eakins as serious and confident, fairly dark in complexion, with a determined mouth and jaw and intense yet slightly sad, searching eyes. His high voice seemed out of tune with the rest of him. According to his friend Weda Cook, it resembled "cold lemon juice."[14]

20. Photographer unknown
Sartain Family Group, 1865
Albumen print
The Pennsylvania Academy of the
Fine Arts, Philadelphia; William
Sartain Scrapbooks, vol. 5, in the
Pennsylvania Academy Archives

Having studied drawing for four years at the Academy, Eakins must have realized the shortcomings of art education in Philadelphia. He remarked many years later, "Naturally one had to seek instruction elsewhere, abroad."[15] Not surprisingly, he chose to go to the renowned Ecole des Beaux-Arts in Paris, which was generally viewed as the leading art academy of its day. There was a movement among Americans during the 1860s to attend the Ecole rather than the academies of Düsseldorf and Rome, which had earlier been in fashion. Several Philadelphia artists associated with the Academy during Eakins's time there had ties with the Ecole, and Schussele and John Sartain, in particular, may have urged him to attend.

21

2.
Paris and Spain

Thomas Eakins would spend almost four years in Paris. There he was destined to receive a rigorous art education and encounter a whole new and unfamiliar culture. Though immeasurably broadened by this experience, he had no desire to spend his whole life abroad (unlike contemporaries such as James McNeill Whistler and John Singer Sargent). Study in Paris was, for him, just a means to an end: to return to Philadelphia and make a name for himself as a painter.

Leaving his family and friends was not easy. Just before his departure Eakins wrote to Emily Sartain, in whom he had developed a romantic interest, about his fears and misgivings. Written in Italian, the letter was stilted and sentimental but nonetheless revealing:

> I received your second letter in Italian, and I read it with pleasure mixed with a great deal of pain; the pleasure derives from a sense of assurance that although I am gone, I shall not be forgotten, and that a dear friend grieves at my departure. But here in my soul, great sadness arises, because Emily is sad; and I think it will never go away. Nevertheless since I have often heard the proverb, that says happiness becomes greater when it is shared and pain becomes lessened by compassion, and because I have a great need for consolation, I pray you, so that I may not die for lack of it, to have pity for my sorrow. I am departing not just from one friend, but from everyone. I am leaving my good father and my sweet mother, and shall go to some strange place, certainly not England, but much stranger still, where there are no relatives, friends, or friends of friends; and I go alone.[1]

This was not his final farewell to Emily. She, her brother William, and Benjamin Eakins went to New York to see Thomas off on September 22, 1866.

The nine-day crossing was hard on Eakins, for he was seasick much of the time. In spite of his discomfort he made friends with several of his fellow passengers, including a Jesuit priest. Once in Paris, he quickly settled in a "respectable and reasonable" hotel near the Louvre and wasted no time in looking up those to whom he had letters of introduction.[2] One was Lucien Crépon, a young French painter who had been befriended by the Sartain and Eakins families while study-

21. Detail of *A Street Scene in Seville*, 1870. See plate 42.

23

22. Frederick Gutekunst (1831–1917)
Frances Eakins, c. 1868
Albumen print
The Pennsylvania Academy of the
Fine Arts, Philadelphia; Archives

ing at the Pennsylvania Academy. He proved to be of great assistance to Eakins, orienting him to the city and helping him find lodgings at 46, rue de Vaugirard, just across from the Palais du Luxembourg and within easy walking distance of the Ecole des Beaux-Arts. Fortunately, the French language did not present an obstacle for Eakins: he had studied it privately in Philadelphia and could write and, presumably, speak French reasonably well.

Eakins was rather naively amazed to discover how different Paris was from Philadelphia. People ate later, seemed happy, and were "easily amused," though children appeared "listless" in the way they played games. Many of the houses, and even the floors, were built of stone; some of the furniture was unlike any he had seen before. The cats were "strange," larger than the ones at home, and the dogs had "neither nobility, dignity, nor intelligence."[3]

A rather curious emotional coldness emerges in Eakins's early letters home to his parents and sisters. Although he often geared his writing to the interests of the recipient—ice skating for his sister Margaret and women's fashions for his aunt Eliza, for example—he wrote objectively and dispassionately; his letters are monologues on events filtered through a strong, self-involved personality, showing little warmth or tenderness. A concern for the happiness and material well-being of the family is usually evident, but he never voiced real affection. His only references to love in the letters relate to his feelings for several young women he had left behind in Philadelphia. Eakins liked to show his superior knowledge, to adopt the role of intellectual authority. He was particularly hard on his sister Frances, four years younger than he. His letters to her from Paris often focused on her main interests, music and foreign languages, but his tone was patronizing.

What of politics and religion? His letters show that Eakins was a Republican in favor of the Union. His widow told Lloyd Goodrich, "He belonged to no church,"[4] and there is no evidence that he practiced Christianity privately. He often mocked organized religion, particularly the rituals of the Catholic church. He also mounted verbal attacks on those he viewed as superficial or aristocratic, stupid or ugly, fat or dirty. He was especially ruthless in lambasting devout Christians, and whole nationalities came under fire when they showed lack of "self respect and morality."[5] The English he found particularly contemptible. Such intolerance is hard to explain. Opinions of this sort appear primarily in his letters to his father; and if we accept the idea that Thomas adjusted his tone to his reader, then it is possible that Benjamin had nurtured his son's attitude of moral superiority. Whatever the cause, young Eakins's stance was unbecomingly arrogant.

The day after his arrival Eakins began his quest for admission to the Ecole des Beaux-Arts.[6] Informed that there were no openings for foreigners, Eakins—with characteristic gusto and determination—sought to find an opening for himself. Albert Lenoir, secretary of the Ecole, told him that he would need a letter from the American minister, John Bigelow, requesting his admission. After a visit from Eakins, Bigelow recommended him *and* four other Philadelphians who had been waiting to get in. Highly pleased with himself, Eakins took the documents to Lenoir and was notified that he also had to have permission from his chosen

professor, Jean-Léon Gérôme.[7] Accordingly he went to call on Gérôme and to his great pleasure gained the artist's written endorsement.

Believing that he had all the necessary papers, Eakins jubilantly wrote to his father that he had been admitted to the Ecole. Then he discovered that he still needed the approval of Count Alfred-Emelien de Nieuwerkerke, superintendent of fine arts. Eakins decided to plead his case in person in the Tuileries, so in his best script he addressed a huge envelope to the count and inserted his "modest little card" in it. Bluffing his way past "rows of soldiers and servants" by feigning ignorance of French, he finally gained entrance to the count's reception room. A secretary took his envelope to the count, who would not see Eakins but asked for a letter stating his business. Returning to his lodgings, Eakins wrote: "I would not have dared address you this supplication, but I feel so much of my success depends on your kindness that I cannot resist. In leaving my home I have made great sacrifices to come here expecting to be able to enter the Imperial School. . . . Would it be too much to ask of you your signature without which I cannot commence my studies."[8]

Eakins then delivered this and his other official letters to the count's office. First he was asked to wait, then to come back the next day. When he returned, he found that the count had turned the matter over to his bureau chief, a Monsieur J. Tournoi, who was equally hard to see. Eakins again pretended not to know French, a ploy so frustrating to the petty officials protecting Tournoi that they finally let him in. The bureau chief turned out to be unexpectedly gracious and, in fact, had already approved Eakins's application. Finally Eakins was in.

Eakins confessed to his father that he did not enjoy "this pushing business": "On looking back at my month's work, I have certainly to regret that to get what I wanted I had sometimes to descend to petty deceptions but the end has justified the means and I cannot feel ashamed of them for they were practiced on a hateful set of little vermin, uneducated except in low cunning, who having all their lives perverted what little minds they had, have not left one manly sentiment."[9] This attitude of self-righteous superiority seems, in Eakins's mind, to have fully justified his less-than-honorable behavior.

In choosing to attend the Ecole des Beaux-Arts, Eakins allied himself to an academic tradition with roots in the seventeenth century. The Ecole had grown out of the Académie Royale de Peinture et de Sculpture, established in 1648. The first head of the Académie, the painter Charles Le Brun, set out rules for the practice and theory of art in the belief that the principles of beauty could be taught. Those principles were exemplified in the art of the seventeenth-century master Nicolas Poussin, whose style, based on antique and Renaissance sources, epitomized restraint, order, and stability. Students began by copying the drawings of esteemed masters; then they drew from casts of ancient statues, then from the live model. Line took precedence over color. History painting reigned supreme; genres such as landscape, portraiture, and still life were deemed inferior.

The Académie Royale was suppressed during the French Revolution, but in 1795 a similar, and similarly prestigious, body was reconstituted under the

aegis of the Institut de France. It was this revived Académie that sponsored the Ecole des Beaux-Arts. There students received instruction from twelve faculty members—seven painters and five sculptors—who took turns criticizing their drawings of plaster casts and of the nude model. Lectures in anatomy and perspective were also given. In 1863 the Ecole's program underwent radical changes, instituted by the Count de Nieuwerkerke, that made the school a preeminent training ground for professional painters, sculptors, and architects from all over the world. Separate ateliers, or studios, for the study of painting, sculpture, and architecture were created within the Ecole. The first painting ateliers were run by Gérôme, Alexandre Cabanel, and Isidore Pils, and admission to their ateliers was obtained by personal application to them. Acceptance did not mean that the applicant automatically became a matriculated student in the Ecole; for that, it was necessary to enter the *concours des places,* a competition that included examinations in anatomy, perspective, and drawing from casts or life. There is no evidence that Eakins ever matriculated.

At the post-1863 Ecole, as the scholar Albert Boime has observed, "Charcoal and stump gradually displaced pencil and hatching procedures, and an underpainting in local colors seemed preferred to the more conventional monochromatic base."[10] Although Gérôme declared that drawing would take priority over color, loosely brushed sketches were allowed, even encouraged, at the Ecole. In the ateliers the model would strike the same pose for a week, and students were expected to spend that period of time on a single drawing or painting. The master would visit on Wednesdays and Saturdays to criticize, and on the latter day he would also offer his comments on compositional sketches in oil (*esquisses peintes*) that the students had made on an assigned subject.

Lectures were offered on a wide variety of topics related to the fine arts. Eakins could have attended lectures on the history of art and aesthetics; history and archaeology; anatomy (there was a dissecting room in the school, and students could also work in local hospitals); mathematics (conic sections, statics, and so on) and geometry; perspective and construction; and elementary physics, chemistry, and geology as related to art.[11] Hippolyte Taine, noted critic and exponent of positivism, expounded on his philosophy of art in weekly lectures between 1864 and 1877.

The academic system of instruction was not limited to the Ecole des Beaux-Arts. The public's desire for art in the academic mode had created such a demand for artists that private schools rose to fill the need. Some teachers operated their own ateliers or offered instruction in separate schools. Adolphe-William Bouguereau, for example, taught at the Académie Julian, and Léon Bonnat operated his own academy, where Eakins studied briefly. Some of these artists offered private classes to individuals, many of whom were women, who were not admitted to the Ecole until 1897.

Fueling the demand for academic art was the extraordinary success of the Salons. These had started as occasional juried exhibitions sponsored by the Académie Royale. As middle-class patrons proliferated in the mid-nineteenth century, so too did the volume of artistic production. Inevitably, the Salons became larger and more influential. Admission to a Salon conveyed immediate

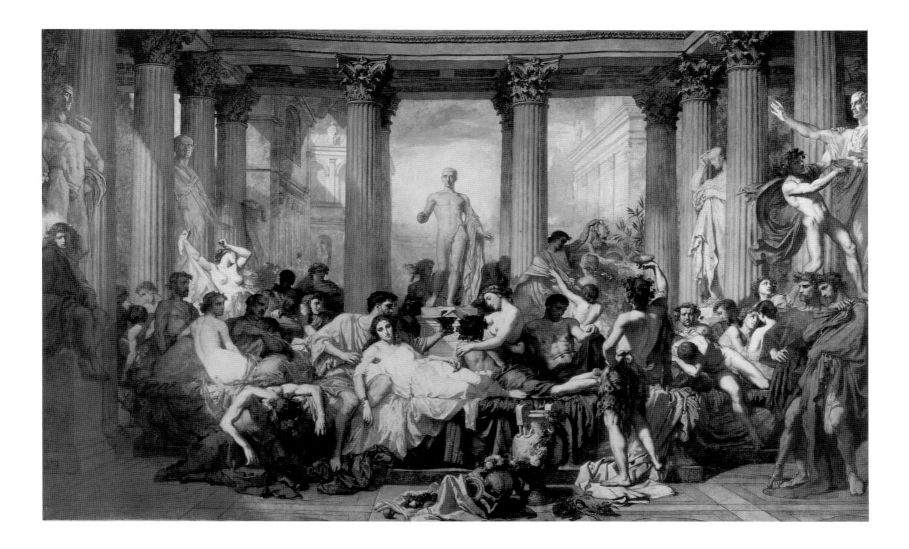

prestige, usually accompanied by sales. Those whose work consistently appeared in the Salons would be generously rewarded by government commissions.

The Salon system united the various elements of the official French art world into a formidable fortress of convention. Teachers at the Ecole and academicians who operated ateliers served as jurors for the Salons and could help gain admission for their students' work. In turn, a prominent artist's public triumph in the Salons could attract students eager to perpetuate his formula for success. Commercial galleries cemented these relationships by avidly following the trends established by the Salon artists. Unfortunately, the result was that mediocrity flourished: many aspiring painters of limited talent sought a quick route to financial gain and personal prestige.

Contrary to much that has been written on the subject, academic art was quite varied, encompassing not only Jean-Louis-Ernest Meissonier's straightforward description but also the classical-linear tradition inherited from Jean-Auguste-Dominique Ingres and styles derived from Renaissance and Baroque Italy. Thomas Couture's *Romans of the Decadence* (plate 23), representing this last approach, is often cited as the epitome of academic painting. The common denominator of all these styles was the belief in correct drawing (including drawing with the brush), especially of the human figure, and a thorough grasp of technique. Even though the academic approach did not produce a uniform style, certain concepts did prevail. Logic had been at the core of French academic training since the seventeenth century, but in the nineteenth this concept was

23. Thomas Couture (1815–1879)
The Romans of the Decadence, 1847
Oil on canvas, 15 ft. 3½ in. x 25 ft. 5 in.
Musée du Louvre, Paris

27

24. Charles Reutlinger
Jean-Léon Gérôme
Photograph
Mr. and Mrs. Daniel W. Dietrich II

affected by recent scientific developments. The abstract logic and order of a Poussin was replaced by a pragmatic new logic that served the desire for a high degree of verisimilitude in the representation of the physical world.

The preferred subject was a morally instructive event, whether contemporary or from the recent or distant past. Sentimentality had also worked its way into the academic tradition, cheapening the elevated approach to noble subject matter found in the art of Poussin and Le Brun. The reason for this growing sentimentality was the infusion of romanticism into all facets of popular culture in the mid-nineteenth century, which could hardly be discounted by even the most idealistic artists. Therefore, much academic art of the era was saccharine story-telling directed to members of the rising commercial middle class. Such patrons were just as happy not to find their lives (and perhaps their humble origins) honestly mirrored in the art of their time; they preferred a more remote, agreeable, and entertaining vision.

Knowing what we do about Eakins's objectivity, his pragmatic cast of mind, and his disdain for the contrived or artificial, it seems a bit odd that he even wanted to attend the Ecole des Beaux-Arts, given the kind of painting its students were producing. But there are two reasons he must have felt that the school would be valuable to him. The first was its disciplined, professional, even scientific method of instruction. The second was the approach taken by Gérôme, which was less grandiose and sentimental than that of other popular academicians, such as Bouguereau. Gérôme was admired for his knowledge of the human body, his precise draftsmanship, and his archaeological exactitude in recreating historical subjects—traits that surely would have appealed to Eakins.

Gérôme was one of the most interesting of all academic painters. By the time Eakins arrived in Paris, Gérôme was the epitome of conventional artistic achievement, but he had been something of a revolutionary as a youth. A student of Paul Delaroche and then Marc-Charles-Gabriel Gleyre, he had joined with several other students in Gleyre's atelier to form a group of artists who called themselves the Néo-Grecs or Pompéistes. Believing that they were at the cutting edge of a new style, Gérôme and his comrades turned their backs on grand figure paintings with heroic classical themes in favor of genre subjects from Greece and Rome portrayed with refinement and sophistication. The highly mannered linear style of Ingres, with its echoes of Raphael's enamellike colors, was one source; the ancient frescoes of Pompeii were another. Gérôme's *Cock Fight* (Musée du Louvre, Paris), painted in the elegant Néo-Grec style in 1846, brought him instant fame when it was shown in the Salon of the following year. But soon he more or less abandoned this stylized approach for a realistic manner that was historically or anthropologically accurate.

Gérôme's subjects, usually tied to everyday life, were almost always set in a distant time—antiquity or the seventeenth century—or a contemporary but exotic setting, such as Egypt or the Near East (plate 25). Like his first teacher, Delaroche, who was a master at staging history paintings, Gérôme exhaustively researched his subjects before starting to paint, and he would travel thousands of miles to study the people and the surroundings he wanted to portray. His research was like that of a film director seeking an authentic effect: he would sketch, take

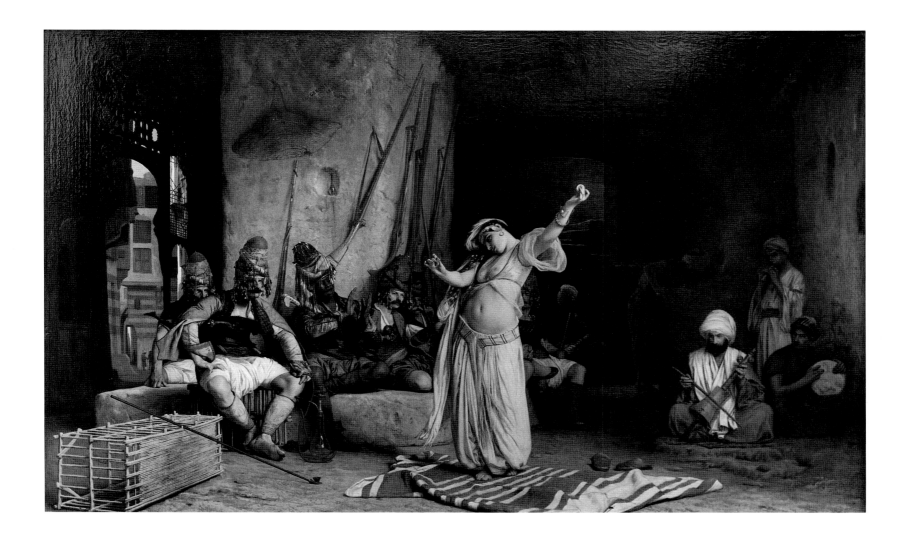

notes, secure or make his own photographs, and even purchase the necessary props. As a result of his careful investigations, he was viewed by many critics as an "ethnographic" painter with an expansive knowledge of a variety of races. For antique subjects, he would often fashion small wax sculptures of the figures that would populate his paintings. (Later in life, he turned to sculpture as a medium in its own right.)

Within the broad spectrum of academic styles, Gérôme was considered a realist. Although he produced paintings that now seem contrived and stagy, he was lavishly praised by his contemporaries not only for portraying his subjects with consummate skill but also for revealing their character. His emphasis on descriptive detail and linear outline, however, left little room for broad effects of tone and color, and his works look all too much like colored drawings. But despite the brittleness of his style, he captured historical events so that the actors and the atmosphere seemed convincing and thus genuinely stirred the emotions of the observer. Eakins, as we shall see, was quite responsive to the expressive qualities of Gérôme's paintings.

Armed with immense technical skill, Gérôme adroitly maneuvered his way through the Parisian art world, earning commissions, winning sales for his ever-popular Salon paintings, and ultimately gaining appointment as a charter member of the faculty of the newly reorganized Ecole. Becoming a favorite at the court of Napoleon III, he reaped the benefits of generous patronage from the ruler and his family.

25. Jean-Léon Gérôme (1824–1904)
Dance of the Almeh, 1863
Oil on panel, 19¾ x 32 in.
The Dayton Art Institute, Dayton, Ohio; Gift of Mr. Robert Badenhop

Gérôme enjoyed phenomenal popularity as a teacher at the Ecole, especially among the Americans. He urged his students to work hard and to progress slowly and gradually from a basic knowledge of how to capture the figure's pose and gesture to full modeling. George de Forest Brush, one of his American students, reported: "He pleads constantly with his pupils to understand that although absolute fidelity to nature must be ever in mind, yet if they do not at last make imitation serve expression, they will end as they began—only children."[12] Gérôme warned his students against mannerisms or working by formula. Although he is said to have advocated no one method and tried to "develop each pupil's peculiarities and temperament,"[13] there was little opportunity for the student to express himself. Many were awed by Gérôme and saw him as an authority figure. As Will Low observed, "His personal presence, alert, erect, and keen, is that of a soldier, and amid his colleagues of L'Ecole des Beaux-Arts, clad in their uniform of dark-green embroidered with silver palms [the formal regalia of those who were members of the Institut de France], he appears a veteran surrounded by conscripts."[14]

Students praised Gérôme's firm but evenhanded response to their efforts. Earl Shinn, who was with Eakins in Gérôme's atelier, compared his method of offering studio criticisms to his approach to constructing a painting:

Beginning at a corner of the studio floor, as if it were the corner of a panel, he progressively and minutely covers it with oversight, as he covers his pictures with drawing—slighting no person, omitting no duty, never failing, never waning. His pupils come seriatim under his criticism, which is able, searching, adaptive—yet unsympathetic—conscientious, implacable and admirable. . . . As his pictures are without atmosphere, so his entertainment of the young intelligences committed to him is without perspective. To say this is, it seems to me, to describe a most excellent professor.[15]

Eakins entered Gérôme's atelier on October 29, 1866. The students greeted him with "a yell which would have lifted the roof up." From the crowd around him he heard: "Oh the pretty child. How gentle. How graceful. Oh he is calling us the fool. Isn't he tall."[16] As a *nouveau*, he was expected to pay a twenty-franc initiation fee and to perform all the menial chores asked of him. Baffled by these demands, he was inclined to refuse, but his friend Lucien Crépon, who had helped in so many other matters, explained that it was the custom and urged him to comply. Eakins finally agreed and took the hazing in a good-natured spirit.

From the start Eakins found Gérôme conscientious as a teacher and physically attractive—"he has a beautiful eye and a splendid head." He wrote to his father: "Gerome comes to each one, and unless there is absolute proof of the scholar's having been idle, he will look carefully and a long time at the model and then at the drawing, and then he will point out every fault. He treats all alike good and bad. What he wants to see is progress. Nothing escapes his attention. Often he draws for us. The oftener I see him the more I like him."[17] Eakins

also praised the school's collection of casts of ancient and modern statues and called it "a palace to work in," with large studios, numerous lecture rooms, a dissecting room, library, and exhibition halls.[18]

Starting with charcoal drawings of casts (plate 26), then progressing to the nude (plate 27), Eakins made slow progress in Gérôme's class. (Unfortunately, few of his figure drawings that can be certainly identified with the Ecole have survived.) To his father Eakins wrote that Gérôme "corrects sharply when one makes a hippopotamus of himself"[19]—presumably a reference to his own shortcomings. Almost two months later, in March 1867, he gave a more specific report: "Only once he told me I was going backwards and that time I had made a poetical sort of an outline."

Recounting the highlights of Gérôme's criticisms, Eakins wrote in that same letter: "The biggest compliment he ever paid me, was to say that he saw a feeling for bigness in my modelling (Il y a un sentiment de grandeur la dedans) and some times he says, 'there now you are on the right track, now push.'" But the letter continued with remarks that were not exactly complimentary: "Last time he made no change in my work, said it was not bad, had some middling good parts in it, but was a little barbarous yet. If barbarous and savage hold the same relation to one another in French that they do in English, I have improved

Above, left
26. *Warrior's Head*
Charcoal on paper, 18 x 14 in.
Alex Hillman Family Foundation,
New York

Above, right
27. *Nude Man Seated*
Charcoal on paper, 24 x 18 in.
Alex Hillman Family Foundation,
New York

28. Pencil sketch by Lloyd Goodrich
after a painting by Eakins
Antique Study, c. 1867
The original, now lost, was in oil on
heavy paper and measured 13½ x
10¾ in.
Philadelphia Museum of Art; The
Lloyd Goodrich and Edith Havens
Goodrich, Whitney Museum of
American Art, Record of Works by
Thomas Eakins

in his estimation and we have the following proportion very savage minus a little Barbarous "Civilized" minus a little Barbarous!!!"[20]

Whatever Eakins's shortcomings might have been in Gérôme's view, the master decided soon after these comments to promote him to the painting class. His first painted studies have not survived. However, when Lloyd Goodrich was conducting research on Eakins in the early 1930s, the artist's widow showed him several oils that he believed had been done during Eakins's earliest student days in Paris. Although Goodrich did not photograph them, he made small pencil sketches that reveal their subjects, including the cast of an antique female head—probably a third century B.C. *Niobe*—leaning on a stack of books (plate 28); a cast of a Roman male head of the Augustan period;[21] and a study of a ram's head on a table. In all probability, these student paintings were either lost or discarded after Mrs. Eakins's death.

Eakins made friends with several Americans—in particular, two students from the Pennsylvania Academy who were also in Gérôme's classes: Earl Shinn, later an influential critic and supporter of Eakins, and Harry Humphrey Moore, an affluent deaf-mute who later became a successful society portraitist. When Moore entered Gérôme's atelier as a *nouveau*, Eakins "explained to all the students his affliction and begged them not to amuse themselves at his expense (and they have respected his infirmity), and introduced him to them."[22]

Reflecting on the friendships he had made with Parisians in the school and out, Eakins proudly announced to Emily Sartain that he was fond of the elderly Dr. Hornor, "a dentist, the best in Paris"; Lucien Crépon, who had already assisted him in innumerable ways; and Albert Lenoir, secretary of the Ecole des Beaux-Arts, who had helped him gain admission to the school and who had done him "a great many practical favors."[23] In Gérôme's classes he had established close ties with Auguste Sauvage and Louis Cure, "his best French friends."[24]

Eakins chose his friends carefully, trying to ally himself with those who exemplified the highest standards of personal conduct. "How comfortable one feels in the company of great men," he wrote to his father. "They are kind, respectful, condescending [i.e., voluntarily descending to someone of lower status]. They listen with attention to any straight forward reasonable demand & grant it immediately when they can." Among those he admired were Gérôme, John Sartain, Dr. Robley Dunglison (a celebrated surgeon at Jefferson Medical College), and Lenoir. These men, he commented, excelled in comparison to inferior types who "have just enough authority to annoy their betters."[25] Like so many other opinions that Eakins expressed during his student years, this illuminates his later attitudes. He would persistently seek out "great men"—intelligent, self-willed individuals who had reached the pinnacle of professional accomplishment or who were well on their way to that goal. He scorned those who did not measure up.

Eakins did manage to relax and enjoy himself in Paris. His letters tell of ice skating, going to Sunday-afternoon concerts, watching the Lenten carnival, and exercising at a gymnasium, of dining with the Moores (Humphrey had brought his mother, sister, and an uncle) and visiting the Jardin des Plantes with them. In the financial accounts he sent to his mother in February 1867, there

was an unusual expense of twelve francs for champagne—the result of losing a bet with his fellow students; he apologized for this extravagance.[26]

On April 1, 1867, the Exposition Universelle opened in a vast building on the Champs de Mars. It was a grand panorama of international achievements in the arts and sciences. Eakins wrote excitedly to his father about what he had seen: the great American locomotive intrigued him and made the English, French, and Belgian examples beside it "look mean." He was attracted to the sewing machines (the American ones were superior) and the French heavy machinery; he wrote, "Some of the engines are the largest I ever saw." He also wrote about the restaurants, the waitresses, the coffee concerts, the Mexican temple, and a Moorish workshop where jewelry and mats were made. At the Romany restaurant he encountered "the most beautiful woman I ever saw or expect to see. . . . I will never forget that long sad face with such clean firm modeling."[27]

Even with his friends and his entertainments, Eakins sometimes became depressed, even homesick. He must have been cheered by the arrival of William Crowell early in June 1867 and, just over a month later, William Sartain, who had come to see the exposition. At the urging of his father, Eakins joined these companions on a walking tour through Switzerland. He did not particularly enjoy it, finding the lake in Geneva, New York, more beautiful than Lake Geneva. Although he liked the residents of Geneva, he was horrified by the people he saw in the remote mountain village of Zermatt:

> The people are all either cretins or only half cretins with the goiter on their necks. They live in the filthiest manner possible the lower apartment being privy & barn combined & they breed by incest altogether. Consequently goiters and cretins only. If I was a military conqueror & they came in my way I would burn every hovel & spare nobody for fear they would contaminate the rest of the world. When you ask them a question they grin & make idiotic motions. . . . They all have big faces and the heads run lower than those of the flat head indians but dont stick out behind like theirs. They are dirty as they can be & so have become contented as they can never become dirtier. They stink their houses stink worse, the water of the valley stinks & the valley itself stinks except in a few places for instance the big French hotel we are now in.[28]

Following this tirade he went on in the same letter to denounce the English he encountered:

> The only bearable ones are those who have lived in Australia a long time or were fetched up at Cape of Good Hope in Africa or the little girls too young to be prudish & English. The latter might be tamed if got away from the disagreeable associations, but it would not be worth the trouble unless to one who could find neither an American French Italian Spanish or Chinese. Now its raining worse than ever & the hotel is full of English. They are great hogs, so different from the French.

29. *Study of a Girl's Head,* c. 1867–69
Oil on canvas, 17¾ x 14½ in.
Philadelphia Museum of Art; Given
by Mrs. Thomas Eakins and Miss
Mary Adeline Williams

It is hard to believe that these intolerant, derogatory remarks came from
one who was later a celebrated advocate of the common man, an admirer of Walt
Whitman—that ebullient and democratic champion of all peoples. Eakins seems
to have felt compelled at this point in his life to criticize those he considered
inferior to himself in order to strengthen and define his own character as an indi-
vidual—and to do the same for his native country.

The three young Philadelphians visited Christian Schussele in the city of
his birth, Strasbourg, France, where he had gone in search of treatment for his
palsy. Concluding their travels, Eakins, Crowell, and William Sartain returned to
Paris at the beginning of September. John Sartain, Eakins's mentor from his
Philadelphia days, had also gone to Paris to see the world's fair. The elder Sartain
spent much time with Eakins in the French capital, going to the Louvre with
him and taking him to dinner and the opera every night. They traveled to

Versailles "to see the pictures and grounds." Eakins "found great pleasure in taking him about." Sartain wanted Eakins to visit England as his guest but the younger man made excuses, explaining in a letter to his father that he would "never want to go to England."[29]

With the departure of the two Sartains and William Crowell in September, Eakins once again settled down to work at the Ecole. Having gained Gérôme's permission to paint in oil, he forged ahead in his studies of the model (plate 29). Eakins also worked on problems of color and composition in the privacy of the new studio he rented at 62–64, rue de l'Ouest, south of his original lodgings on the rue de Vaugirard and further away from the Ecole. There he painted from brightly colored Eastern fabrics that Gérôme had lent him. "The colors are strong," Eakins observed, "& near the ends of my scale of colors, such high & low notes & this has taught me a good many things that I might not have paid attention to."[30]

"I am perfectly comfortable and would be happy if I could make pictures," he wrote his father in November, going on to say that he was "in the dumps" because he anticipated a "good scolding" from Gérôme the next morning. He had made a drawing on his canvas, as Gérôme had told him to do, and then his teacher had said: "Not bad, that will do, now I will mix your colors and you will put them on." But Eakins had trouble making the tints blend and "got a devil of a mess." Still, he had to admit that his teacher had been kind and patient with him. Eakins had refused to continue attending "antique week," wishing that he had "never so much as seen a statue antique or modern till after I had been painting some time."[31] In this exclamation he was beginning to show his independence.

By January 1868 Eakins had become deeply immersed in painting independently. Working from memory and creating his own compositions (none has survived), he confessed to producing "very bad things." Yet he struggled to improve, believing that he was making more progress in his own studio than at the Ecole. Gérôme had painted on one of Eakins's heads, and this had made him feel cheated and insulted. "I would have learned more slathering around," he wrote to his father. Color, in particular, perplexed him: "When it ceases altogether to become a mystery[,] and it must be very simple at bottom, I trust I will soon be making pictures." His avowed purpose was to produce a "selling picture,"[32] thereby proving to his family, especially his father, that he could earn a living and no longer be a financial burden.

Eakins may have been unsure of his technique and handling of color, but he was quite certain about his aesthetic principles. In a long letter to his father written on March 6, 1868, he stated his credo, which seems to have changed little throughout his life. The "big artist," Eakins said, should be committed to nature but not imitate appearances in a slavish way; he is one who "keeps a sharp eye on nature and steals her tools." In other words, he discovers what nature does with light ("the big tool"), color, and form, then "appropriates them to his own use." Drawing an analogy between the artist's formal language and a canoe that was "smaller than Nature's," he said the artist could sail a course parallel to nature, but not try to improve upon it; otherwise, he would capsize or "stick in the mud."[33] He went on to explain what a "big picture" would be:

30. Frederick Gutekunst (1831–1917)
Thomas Eakins, c. 1868
Silver print
Mr. and Mrs. Daniel W. Dietrich II

In a big picture you can see what o'clock it is afternoon or morning if its hot or cold winter or summer & what kind of people are there & what they are doing & why they are doing it. The sentiments run beyond words. If a man makes a hot day he makes it like a hot day he once saw or is seeing if a sweet face a face he once saw or which he imagines from old memories or parts of memories & his knowledge & he combines and combines never creates but at the very first combination no man & less [sic] of all himself could ever disentangle the feelings that animated him just then & refer each one to its right place.

Although Eakins did not cite in his letter any specific artist who painted this way (he would later name those he admired), he was absolutely certain about what he did *not* like. He deplored teachers—obviously men at the Ecole—who "read Greek poetry for inspiration & talk classic & give out classic subjects & make a fellow draw antique not to see how beautiful those simple hearted big men sailed but to observe their mud marks which are easier to see & measure than to understand[.]" Eakins rejected the prospect of ever painting a picture of contemporary Greek life because "my head would be full of classics[,] the nasty besmeared wooden hard gloomy tragic figures of the great French school of the last few centuries & Ingres & the Greek letters I learned at the High School with old Heaverstick [sic, read *Haverstick*] & my mud marks of the antique statues."

Two months later Eakins was even more vehement, this time in his denunciations of French academic art. Referring to a Salon he had just attended, he said there were no more than twenty paintings on view that he would want. The "great painters"—he cited Léon Bonnat, Thomas Couture, Eugène Isabey, and Jean-Louis-Ernest Meissonier—had chosen not to exhibit there. Those who did made "naked women, standing sitting lying down flying dancing doing nothing[,] which they call Phrynes, Venuses, nymphs, hermaphrodites, houris & Greek proper names." (Although he did not cite Bouguereau by name, the work of that artist [plate 31] epitomized everything he disliked.) Eakins avowed that if he had reason to paint a nude woman, he would not "mutilate" her in the process: "She is the most beautiful thing there is [in] the world except a naked man but I never yet saw a study of one exhibited." He went on to say: "It would be a godsend to see a fine man model painted in the studio with the bare walls, alongside of the smiling smirking goddesses of waxy complexion amidst the delicious arsenic green trees and gentle wax flowers & purling streams running melodious up & down the hills[,] especially up. I hate affectation."[34]

Eakins had condemned the whole apparatus of classical training and all but a few artists working in the academic tradition. Although he said nothing in his letters about Gustave Courbet or Edouard Manet, he had aligned himself with comparable, though less controversial, exponents of realism and naturalism within the Académie, such as Gérôme and Meissonier. Eakins's direct and indirect exposure to the popular philosophies of Auguste Comte, Herbert Spencer, and Hippolyte Taine may have reinforced his preference for realism and a scientific approach. The parallels between Eakins's thinking and Comte's positivism were noted as early as 1930 by Francis Henry Taylor, who credited Comte with

31. Adolphe-William Bouguereau
 (1825–1905)
 Nymphs and Satyr, 1873
 Oil on canvas, 102 x 70⅞ in.
 Sterling and Francine Clark Art
 Institute, Williamstown,
 Massachusetts

reviving the "liberal philosophy of the Eighteenth Century to suit the needs of the scientific thinkers of the Second Empire." Taylor defined positivism—a system in which knowledge was gained through the observation of physical data—as a reaction against conventional theology, metaphysics, and sentimentalism.[35]

We cannot prove that Eakins was aware of Comte's teachings, but he did know the closely related ideas of the English philosopher Spencer, either independently or through the critic and historian Taine, who lectured at the Ecole

des Beaux-Arts while Eakins was a student there. The similarities between the thinking of Spencer and Eakins are many.[36] Using the model of a single cell's growth to a fully developed organism, Spencer championed the idea of society's evolution from mass uniformity to a heterogeneous state of individuals. Spencer argued that groups and individuals would survive by exercising their intrinsic abilities and adapting to their environment. Eakins's beliefs, found in his letters and reported later by his friends, echo Spencer's emphasis on the individual who lifts himself above the mass of humanity. Eakins's hatred of mediocrity, his belief in each man's cultivating his special talents to survive in a competitive environment, are very much in the spirit of Spencer.

For Spencer, as for Eakins as a mature artist, science was an essential tool. "Without science there can be neither perfect production nor full appreciation," Spencer wrote. He reminded his readers that "art products are all more or less representative of objective and subjective phenomena; that they can be good only in proportion as they conform to the laws of these phenomena; and that before they can thus conform, the artist must know what these laws are."[37]

Taine carried Spencer's ideas further and declared in his lectures at the Ecole that art was influenced by historical forces rather than being the result of an isolated artist's caprice. Ideas, styles, and images in art were shaped by the period and place in which the artist functioned. Taine believed that just as physical conditions determined the appearance of plants, so there was a "moral temperature"[38] that affected the appearance of art. He praised the period in an artist's life when he looked intently at nature, and he deplored the gradual decline as an artist learned the prevailing formulas. Taine warned, however, that art consisted of more than just the mechanical transcription of a visual impression: there was an intellectual side concerned with logic, structure, and composition. Art thus becomes "intellectual and not mechanical."[39]

In a manner fully in accord with Taine's ideas, Eakins committed himself to representing nature, but not through the copying of every detail. He gave equal attention to organizing his impressions into a rational structure. Furthermore, he agreed with Taine in the matter of consciously reflecting in his art the ideas and values of his own time. Eakins embraced the influence of his milieu and became straightforward in representing the characteristics of his native country and its people.

Toward the end of Eakins's second year at the Ecole—in March 1868—he entered the school's sculpture classes taught by Augustin-Alexandre Dumont. The young American hoped to model in clay from time to time (when he was tired of painting), to "learn faster," to refresh his eye, and to "see more models."[40] His study of sculpture undoubtedly improved his ability to create the illusion of solidity, a trait he increasingly sought in his painting. Dumont, he reported, told his students to work more with their "fingers and brains and less with tools"[41]—a tactile approach that must have been especially appealing to Eakins, given his delight in the tangible and the specific.

Another influence that led Eakins away from Gérôme was the painter Thomas Couture, who was a celebrity in the art world of Paris while Eakins was studying there. An academic painter, he worked both in an overblown official

style (plate 23) and in a more relaxed, painterly mode (plate 32). Eakins linked Couture's name with "some of the greatest men known in Europe and America,"[42] valuing him, as he did other notables, as much for the traits of character that he had read or heard about as for his professional achievements. Eakins never met Couture, but in letters to his family he would occasionally tell stories about him that he had heard secondhand. Late in 1867 or early in 1868 he bought Couture's newly published book, *Méthode et entretiens d'atelier* (Conversations on Art Methods, 1867), which contained chatty essays on the principles of art and inspirational words for the aspiring artist. Eakins said he found it "curious & very interesting" and planned to send a copy to William Sartain in Philadelphia.[43]

Most important was what Eakins learned from Couture's painting—specifically, from his later, more luminous, coloristic manner, inspired by the sixteenth-century Venetians and the seventeenth-century Dutch. This was in sharp contrast to the tight drawing and enamellike surfaces favored by Gérôme. A few surviving student paintings by Eakins clearly reveal a broad, Couture-like treatment of the model in loosely brushed masses of tone (plate 33).

Eakins's father and sister Frances visited him in July 1868, and Frances recorded their activities in her diary: all three walked in the Luxembourg gardens, called on Dr. Hornor, visited Notre-Dame, and saw Couture's decorations in the Chapel of the Virgin at the church of Saint-Eustache. Eakins introduced his father and sister to his friends Auguste Sauvage and Louis Cure; they all

Above, left
32. Thomas Couture (1815–1879)
Petit Gilles (The Little Confectioner), c. 1878
Oil on canvas, 25¾ x 21½ in.
Philadelphia Museum of Art;
William L. Elkins Collection

Above, right
33. *Study of a Girl's Head*, 1868–69
Oil on canvas, 20⅛ x 16⅛ in.
Hirshhorn Museum and Sculpture Garden, Smithsonian Institution, Washington, D.C.; Gift of Joseph H. Hirshhorn, 1966

dined together, then the four men left Frances and went off to "some place of amusement."[44]

After nine days in Paris, Frances and Benjamin departed for Germany, Switzerland, and Italy. Thomas joined them in Genoa on August 1, and they all set sail for Naples, then proceeded northward, stopping in Rome, Florence, Padua, Venice, and Verona. From there they went to Germany again, visiting Munich, Stuttgart, Heidelberg, Mainz, and Düsseldorf. Finally, they stopped in Brussels and Verviers, Belgium, before arriving back in Paris on August 31; Benjamin and Frances sailed home from Le Havre on September 10.

Eakins said little in his letters to his family and friends—or in any other recorded remarks—about the kind of art he viewed on the trip or what he thought about it. Frances recorded only their scrutiny of the Raphaels in the Vatican and the Michelangelo frescoes in the Sistine Chapel; a visit to the art collections in the Pitti Palace, Florence; the picture gallery in Munich "containing Rembrandt, Rubens & Murillo & other fine paintings"; and "the modern pictures" (including ones by "Achenbach, Herzog, etc.") in Düsseldorf.[45]

Having returned to the Ecole feeling more confident than ever before, Eakins planned to spend much more of his time making compositions on his own. Painting both at the school and in his own studio, he was "learning to work clean & bright & to understand some of the niceties of color."[46] His studies of anatomy at the Ecole, probably with Dr. Mathias Duval, and in the Paris hospitals had helped him greatly, as had his work in sculpture.

Eakins was driven to succeed as a painter not only because he was motivated from within but because his father constantly—even compulsively—prodded him on. It must have distressed the young Eakins to accept Benjamin's financial backing without being able to show immediate results, but he also believed in his own need to move ahead slowly. He explained to his father that he had made substantial progress and could

> equal the work of some of the big painters done when they had only been studying as long as I have, & as far as I have gone I see in their works that they have had the same troubles that I have had & the troubles are not few in painting. I have got to understanding much more than I did & though I see plenty of work ahead yet I am not altogether in the dark now but see it plain & sometimes how to catch hold of it.[47]

He wrote to Frances that although their father appeared to be satisfied with his progress, the older man was still not "at ease" and had been entreating him "never to fail." He also reported to her that Benjamin, who lacked a sophisticated knowledge of art, had written to him that Emily and William Sartain were studying with Schussele from the antique, after nature, and so on, implying that such a course might be good enough for him.[48] Someone (probably Emily) seems to have told Benjamin that Schussele was superior to Gérôme as a teacher and that Philadelphia was a better place to study painting than Paris—surely a distressing idea to Eakins, committed as he was to the concept that the French capital offered the best possible education in art. The thought that his father

might call him back to Philadelphia would have unsettled him.

Eakins's love for Emily was waning rapidly, his letters becoming cool and impersonal. When she scolded him for capitulating to bohemian temptations, reading Boccaccio and Rabelais and becoming "ill bodily and mentally," he dashed off a vigorous defense against her "ridiculous" fears.[49] Nonetheless, he was obviously shaken. Sensing that she wanted him to return to Philadelphia, Eakins wrote to his father: "I can't help thinking that Emily has been talking to you about my affairs. Perhaps she would like me to leave Gerome & this naughty Paris & join their sweet little class & come & fetch her & see her home after it & we would drawey wawey after the nice little plaster busty wustys & have such a sweet timey wimey."[50]

Eakins wrote to his sister Frances that there was still some love between himself and Emily, but it never had the intensity of his love "for Mary Pharo or Louise her cousin or Mary Adams or Marty Bowen & is about the same as I have for Johanna [Schmitt] & Amy & Ida" (no family names are known for the last two on his list). Any of these, he confessed, would be a better wife than Emily, and he added, "If I ever marry it will likely be with a girl of Southern feeling good impulses & heart healthy & able to bear strong beautiful children." He promised that he would not pursue a "New England she doctor" but would look favorably upon "an Italian or Jersey farmer's daughter"[51] (whether he meant New Jersey or the island of Jersey is unclear). But later that year he wrote rather mournfully to William Crowell, "I feel my love days long over & they will never come again."[52] Eakins had become friendly with a few women in Paris, but they were mostly married or held no romantic interest for him. His companions at this point were chiefly male, most often fellow art students from the United States: Shinn, Moore, Eugene A. Poole from Baltimore, and William Sartain, who was studying with Léon Bonnat and with whom Eakins shared a studio. Eakins mentioned other art students in his letters home, including Edwin Howland Blashfield, [first name unknown] Lind, Milne Ramsey, Frederic Arthur Bridgman, and Robert Wiley. The French artist Lucien Crépon, Eakins's first and for a time best friend in Paris, fell out of favor because he had passed off another student's work as his own, successfully fooling Eakins. Although he kept up a cordial façade in his dealings with Crépon, he condemned his former friend as "a weak man."[53]

Eakins also became friendly with the French art student Germain Bonheur. His sister was Rosa Bonheur, already a renowned painter, who had been honored by the Salons and was the first woman artist to receive the cross of the Legion of Honor. William Sartain accompanied Eakins on a visit to Germain's parents' home and later reported that Rosa arrived there from her villa at Fontainebleau. She resembled a man in her "upper attire" and was "very bossy and dictatorial." "When Germain differed from her on any point she would tell him to go to bed!" Sartain went on to describe a conversation between Eakins and Rosa: "Tom was speaking of our national mechanical skill and to illustrate his point he pulled out from his pocket his Smith & Wesson revolver—(I know of no other person in Paris who ever carried one!)—Rosa put *her* hand into her pocket and pulled out one of the same make. She acquired the habit of carrying it during her sketching at Fontainebleau."[54]

34. Naudin Studios
Emily Sartain, 1880(?)
Photograph
Moore College of Art and Design, Philadelphia; Library Archives

36. *Study of a Student's Head*, c. 1868
Canvas on cardboard, 7⅛ x 6¼ in.
William E. Stokes, Pine Beach,
New Jersey

Despite bouts of depression and a distracting sojourn in Philadelphia between early December 1868 and March 1869, Eakins was developing power and confidence as an artist. Although he continued to respect Gérôme, his interest in alternative approaches to painting increased. Accordingly, in August 1869 he entered the independent studio of Gérôme's friend Léon Bonnat, where William Sartain was also studying. Sartain may have influenced him to make the change, but it is also likely that Bonnat's taste for seventeenth-century Spanish painting appealed to Eakins. Bonnat's brushwork was softer than Gérôme's and his naturalism more painterly, concerned with mass and weight rather than detail (plate 35). He urged his students to paint broadly and directly, without overworking the surface. Another American student at Bonnat's, Edward Howland Blashfield, recalled that "construction and values, values and construction" were at the heart of his teaching.[55]

As a teacher Bonnat was quite relaxed, an approach that did not please Eakins. He wrote to his father that when Bonnat was asked "the best way to do a thing," he would not respond, nor would he "impose his way of working" on his students.[56] Eakins stayed only a month, but he seems to have gained a sympathy for loose paint application and an increasing admiration for Bonnat's favorite Spanish artists, Diego Velázquez and José Ribera. Little of Eakins's work can be securely dated to his month with Bonnat, but *Study of a Student's Head* (plate 36) is executed in the painterly manner that Eakins favored at this time.

Eakins's letters home during the last half of 1869 reveal a restless desire to get away from Paris and start to work on his own. He wrote to his father on November 5 that he could construct a figure "as well as any of Geromes boys" and that his handling of color was improving. He told his father, too, that he would definitely shift from schoolwork to "making up sketches & compositions."[57] William Sartain, who had spent three weeks in Spain that had been "a great revelation" to him,[58] persuaded Eakins to go there for his final winter

abroad. For an artist to paint in Spain had become a tradition in the French art world: academic masters such as Bonnat and Mariano Fortuny had lived and painted there, as had radicals such as Courbet and Manet.

Eakins had already begun to study Spanish and must have looked forward to the change, for weeks of wet, gray Parisian weather had made him sick and tired. In Spain he would be able to study light and color and, above all, to see work by the seventeenth-century Spanish painters who interested him.

Arriving in Madrid on December 1, he immediately declared that he liked the Spaniards "better than any people I ever saw." (In later years Eakins referred to Spain as one of his two favorite places, Philadelphia being the other.) The intense sun promptly rejuvenated him; after one day he wrote, "I never was so strong & I wonder if I can ever be sick or weak again." He found Madrid the cleanest city he had ever seen and admired the brightly colored costumes of the peasants and muleteers. "The ladies of Madrid are very pretty," he wrote, "about the same or a little better than the Parisians but not so fine as the American girls."[59] While in Madrid, Eakins attended Mass—somewhat surprising, given his opposition to organized religion, especially Catholicism. He made no comment on the experience other than to remark on the strangeness of the organ music and the fact that there were no seats for the worshippers.

Both of his days in Madrid, Eakins went to the Prado, where he found innumerable paintings he liked, especially by Ribera and Velázquez (plates 37, 38). He wrote to his father: "I have seen big painting here. When I had looked at all the paintings by all the masters I had known I could not help saying to myself all the time, it's very pretty but its not all yet. It ought to be better, but now

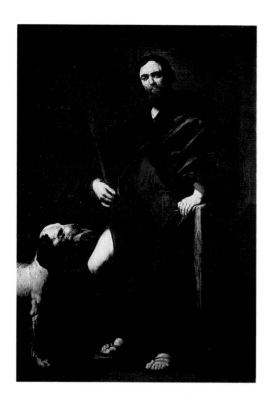

37. Jusepe Ribera (1591–1652)
Saint Roch, 1631
Oil on canvas, 83½ x 56⅜ in.
Museo del Prado, Madrid

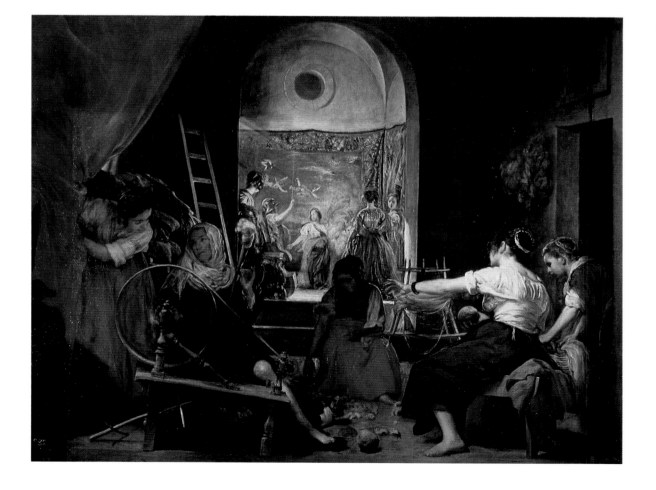

38. Diego Velázquez (1599–1660)
Las Hilanderas, 1645–48
Oil on canvas, 66½ x 98⅜ in.
Museo del Prado, Madrid

I have seen what I always thought ought to have been done & what did not seem to me impossible." He continued: "O what a satisfaction it gave me to see the good Spanish work so good so strong so reasonable so free from every affectation. It stands out like nature itself." He saw Peter Paul Rubens's pictures as well, but hated them: "Rubens is the nastiest most vulgar noisy painter that ever lived. His men are twisted to pieces. His modelling is always crooked & dropsical & no marking is ever in its right place or anything like what he sees in nature his people never have bones, his color is dashy & flashy his people must all be in the most violent action must use the strength of Hercules if a little watch is to be wound up, the wind must be blowing great guns even in a chamber or dining room, everything must be making a noise & tumbling about. There must be monsters too for his men were not monstrous enough for him." Eakins concluded by stating that he would have no regrets if all of Rubens's paintings were burned.[60]

After his brief stay in Madrid, Eakins journeyed south to Seville, where he established himself first in a comfortable hotel, then in a pension. Harry Moore and William Sartain joined him in January, and the three artists remained in Seville for almost six months. Eakins wrote home on January 16, 1870: "Harry Moore, Billy Sartain, & I are all three in fine health & spirits, it is warm & bright. I know ever so many gypsies, men & women & circus people, street dancers, theatre dancers, and bull fighters."[61] (His Spanish was good enough to allow him to communicate, though he was by no means fluent in the language.)

Particularly attracted by the appearance of a seven-year-old gypsy dancer, Carmelita (Eakins spelled it Carmalita) Requeña, he persuaded her to hold still long enough for him to paint a study of her head and shoulders. In its disciplined drawing this work (plate 41) has much in common with his studies of the model at the Ecole, but he heightened the colors—tans and ochers relieved by raspberry red in the headpiece and costume—far beyond anything he might have done in Paris. His conception—with light striking the face from the front and warm transparent shadows and half-lights occupying those portions of the head that are not illuminated directly—is much closer to work by Couture and Bonnat than anything by Gérôme. This picture represents a sincere effort by Eakins to paint on his own, to solve the problems of representing flesh in direct light without help from his teachers. The Ecole, though, had not prepared him to work in natural light: "I cannot make a picture fast yet, I want experience in my calculations," he wrote to his father.[62]

Two months later, having diligently continued to paint, he was still unsettled: "The trouble of making a picture for the first time is something frightful. You are thrown off the track by the most contemptible little things that you never thought of & then there are your calculations all to the devil & your paint is wet & it dries slow, just to spite you, in the spot where you are the most hurried." He did not identify a specific picture on which he was working, but it must have been his first large oil painting, A Street Scene in Seville (plate 42), featuring Carmelita and two other gypsies. His progress, he admitted, was slow: "Picture making is new to me, there is the sun & gay colors & a hundred things you never see in a studio light & ever so many botherations that no one out of the trade could ever guess at."[63]

44

Having gathered information about gypsies by purchasing photographs of them (plate 40), Eakins also made a series of informal drawings in his Spanish sketchbook (plate 39). With Carmelita as the central figure, he constructed a typical scene that he must have observed firsthand: a male musician playing a cornet at the left and at the right a young drummer girl. A few steps closer to the observer appears Carmelita, dancing. The setting is fairly dark, with the sun striking only the dancer from the side, almost with a raking light. Architectural elements at the upper right, seen through an aperture, are also gently touched by warm sunlight.

Eakins used a heavy impasto for the lights in *A Street Scene in Seville*, and much thinner, transparent paint for the shadows. The overall tonality is fairly subdued, depending on neutral tans and warm grays. The painting is brought to life by the introduction of red accents in Carmelita's clothing and that of the drummer girl; these touches give coloristic excitement to what might otherwise have been a monotonous tonal painting. Viewed solely in terms of color and value, the picture is successful. But the composition, drawing, and modeling leave much to be desired. The poses are awkward, and the relationships of the figures to each other and to the surrounding space are not skillfully articulated. Yet as the first large-scale work by an artist fresh out of school, it is a commendable effort.

Eakins, Moore, and Sartain worked strenuously at their painting six days a week. Occasionally, however, they took time off to watch the bullfights, among the best in Spain. Eakins admired the bullfighters, whom he thought were "fine men," and he confessed to liking them "extremely."[64] He even planned a painting of the ring, but there is no record that he ever executed it. Late in their stay in Seville, the three made a horseback trip to see Ronda, a town some sixty miles

Above
39. *Spanish Sketchbook: "Street Scene in Seville: Compositional Sketch, Window at Center,"* 1869–70
Graphite on wove paper bound in cloth-covered cardboard cover, 6⅛ x 3³⁄₁₆ in.
The Pennsylvania Academy of the Fine Arts, Philadelphia; Charles Bregler's Thomas Eakins Collection. Purchased with the partial support of the Pew Memorial Trust and the John S. Phillips Fund. PAFA-CB cat. 145d

Left
40. José Sierra Payba
Gitanas (Group of Gypsies), c. 1869
Photograph
Mr. and Mrs. Daniel W. Dietrich II

southeast of Seville, known for its primitive, dramatic scenery. It took them three days to get there, traveling "over hills & mountainsides, a vast solitary waste," as Sartain put it.[65]

After returning from Ronda they prepared to leave Spain. Moore went to Granada, where he would court and marry "a signorina of that place,"[66] and Eakins and Sartain traveled together to Madrid, where they remained for a few days before proceeding to Paris.

Eakins remained in Paris only a fortnight or so, just long enough to visit the Salon and to put his affairs in order before leaving for Philadelphia. He had been secretive about his plans to return to Philadelphia, asking his father not to mention his pending arrival to Schussele or any of the young artists there. Why Eakins indulged in this secrecy is unknown, but Gordon Hendricks has speculated

Right
41. *Carmelita Requeña*, 1869–70
Oil on canvas, 21 1/16 x 17 1/8 in.
The Metropolitan Museum of Art, New York; Bequest of Mary C. Fosburgh, 1978

Opposite
42. *A Street Scene in Seville*, 1870
Oil on canvas, 62¾ x 42 in.
Rebecca Macdowell Garrett Trust and R. Lee Mastin and J. Randolph Mastin

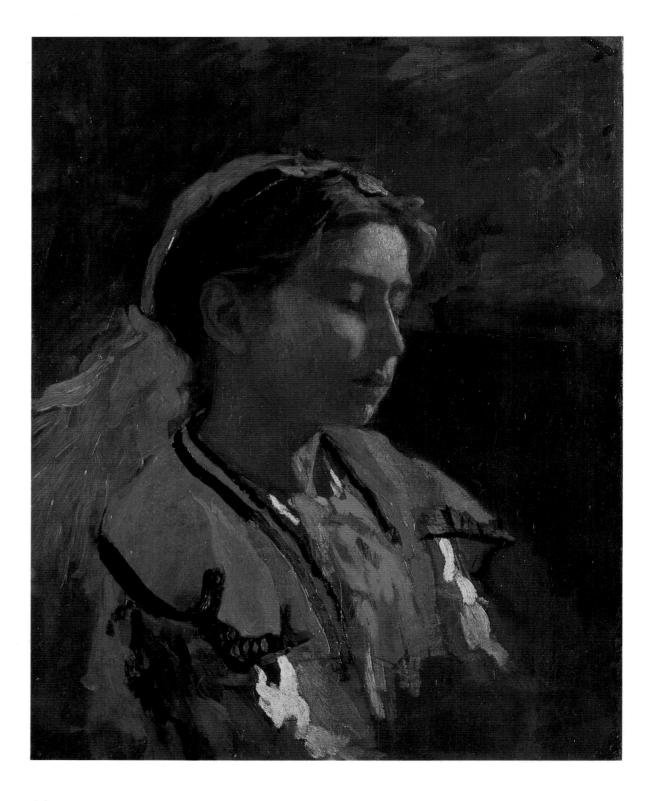

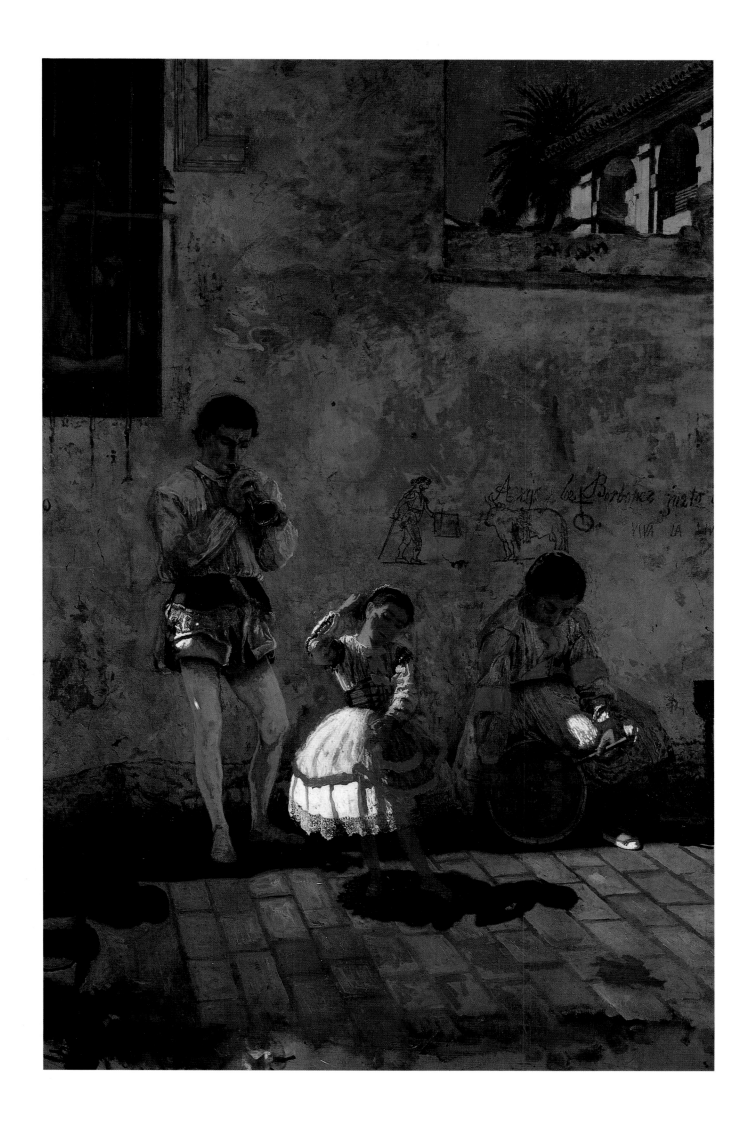

that he was afraid of displeasing Schussele, whose advice about professors in Paris he had ignored and, in Hendricks's words, "did not wish to risk the frustration of having Schussele say 'I told you so.' "[67] Also, he may have wanted to gather his forces, to be certain that he was entirely healthy and fully readjusted to life in Philadelphia before encountering his future colleagues in the world of art.

It was during his second stay in Madrid that Eakins wrote extensively in his notebook about the paintings he saw at the Prado.[68] His remarks, all in French, show a sophisticated awareness of artistic matters, especially technique and execution. In these notes he also reflected about his own painting efforts in the past and engaged in occasional dialogues with himself about what to do in the future.

Velázquez was his favorite among all those he mentioned, and *Las Hilanderas* (plate 38) was "the finest piece of painting I have ever seen." He discovered that the artist initially depicted the tapestry weaver in that painting "without paying any attention to her features," while seeking a harmony of color throughout. Once Velázquez had established that harmony, Eakins thought that he had scumbled over (i.e., toned down, by using loose, rubbed strokes) the surface when it was thoroughly dry. Only then "did he complete his drawing that indicated the features." This method—also shared, in Eakins's view, by Ribera and Rembrandt—was the sole means by which the artist could provide "both delicacy and strength" simultaneously.

Eakins thus became convinced that Velázquez had taken full advantage of a technique commonly used by seventeenth-century European artists. This procedure enabled the artist first to establish the modeling of the subject and the painting's general tonal arrangement in monochrome, then gradually build up color by applying numerous thin, often transparent layers of pigment. Under the influence of Velázquez, Eakins came to admire this indirect technique and to reject the direct painting that had become increasingly common in the nineteenth century. Indeed, Eakins not only thought highly of the indirect technique but was prepared to revive it in his own work. "My own instincts have always led me in that direction," he said.

Eakins also observed that Ribera took pains in his "big painting in Madrid" (unidentified) to "let white show through the light." Eakins's point is not entirely clear, but presumably he meant that he wanted the underpainting to be visible in the lighter areas. That Eakins recognized Ribera's use of the same technique as Velázquez is evident from his remarks that Ribera painted quite smoothly but still made his shadows out of transparent colors. Eakins's prejudice against direct painting is clear in his comments on the paintings by Anthony Van Dyck in Madrid, which seemed to him inferior to the canvases of Velázquez and Ribera because, in Eakins's view, they had been painted directly. (In fact, Van Dyck had used the indirect technique, too, but it is not obvious.)

Eakins's Spanish notebook is filled with observations about paintings that are very different from most of the academic works he had seen in Paris. He was so impressed by the Spanish painters that he felt compelled to remind himself, "I must resolve never to paint in the manner of my master [Gérôme]." The notebook also contains remarks that forecast Eakins's future approach to portraying

the natural world. For example, he said he enjoyed his best progress when he divided his "energies and methods of work"—that is, attacked one problem at a time. Once the preliminary composition was in place on the canvas, he reminded himself to achieve his "broad effect" from the very beginning and to "work solidly right from the start." He found that the rough sketch (which would precede many of his paintings) should be done "very simply" then be developed "to a very close approximation of nature." He allowed himself to paint as heavily as he wished, but "not to leave any roughness." He admired Velázquez because his paintings "are almost made to slide on."

Eakins discovered that in "drawing with color" he was better off using a palette knife, citing Velázquez as his authority for this method. Elsewhere in the notebook he admonished himself not to alter fresh color by placing another tone on top of it. Although the result might be a temporary illusion of luminosity, he found that "the next day it was dull." He also noted that one should "always establish the strong colors before finally painting the delicate colors." Other reminders concerned drawing and anatomy. He counseled himself, for example, always to draw the head in the following order: "The chin, the forehead, and the curve of the eyebrow." (Earlier, he had tried to leave the placement of the chin until later but found that this led to trouble.)

These remarkable early notes and conversations with himself show that Eakins was actively concerned with the grammar and technique of his art. In fact, he seems to have been so involved with the mechanics of making a painting that one wonders whether he thought about such other matters as content, expression, or even composition. If so, he said little about them either in his notebook or in his numerous letters to family and friends between 1866 and 1870. This stage may typify the mentality of the art student who is focused on learning his craft, but for Eakins it continued throughout his career.

Seeing the pictures in Madrid and painting on his own at Seville reinforced convictions that Eakins already held within himself and for which he had found little support within the French academic system. Having produced his first independent paintings, he seems to have enjoyed the prospect of creating pictures that might earn him an income and thus finally satisfy his father's expectations. Eakins felt that many of his French contemporaries had remained in school too long, simply learning to make perfect studies and imitate their masters rather than maturing as original artists. His own resistance to the academic canons of picture making contributed to his ultimate triumph: because he had never fully mastered the artistic conventions imposed on him, he was able to maintain a degree of originality and independence.[69]

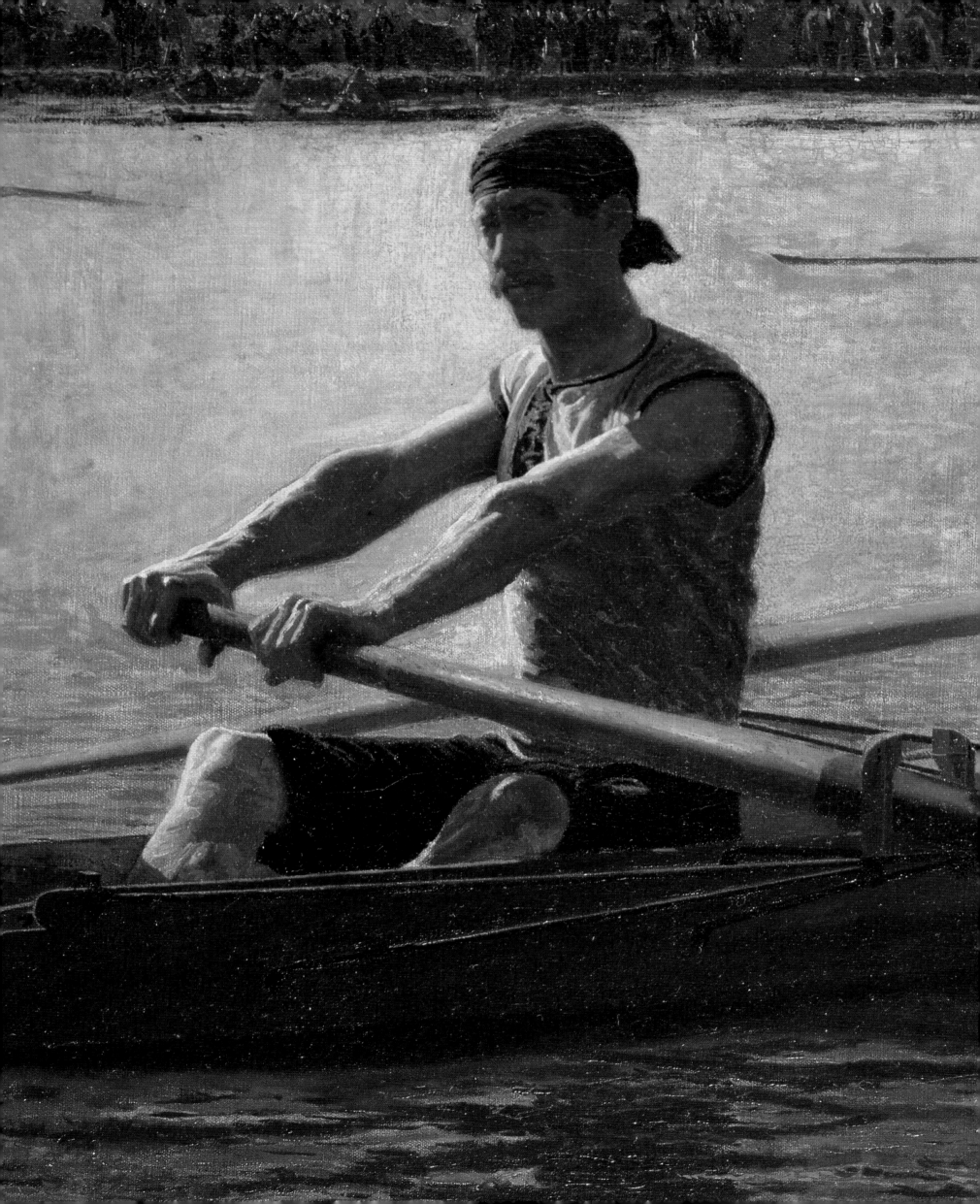

3.
Philadelphia

Eakins arrived in Philadelphia on July 4, 1870—greeted, no doubt, by rejoicing among members of his family, especially those who had not seen him for nearly four years. To facilitate his son's work, Benjamin fitted out a studio for him on the fourth floor of 1729 Mount Vernon Street. Eakins would live in this house, except for a brief residence at the studio he later secured at 1330 Chestnut Street, for the rest of his life. He never traveled to Europe again nor ever expressed any desire to do so.

In Philadelphia, Eakins continued to engage in outdoor activities, often with his father or sisters. He also renewed many of the friendships he had established in high school, especially with the celebrated oarsman Max Schmitt, a frequent rowing and sailing companion. William Sartain had stayed behind in Paris and Emily was no longer a romantic interest, but Eakins remained close to William Crowell and to Crowell's sisters Elizabeth and Kathrin. In 1872 William married Thomas's sister Frances, and the couple moved into the house on Mount Vernon Street. Thomas, in the meantime, became romantically involved with Kathrin.

Excursions with his father and friends often took Thomas to the "fish house," a retreat in the marshes near Fairton, New Jersey, to hunt reed birds. The Williams family, who seem to have been related to the Crowells, lived nearby, and Thomas became close friends with the Williams daughters Abbie and Addie (eventually Addie would live in the Eakins house, and she received one-fourth of Thomas's estate). On hot days the men, along with the dogs and horses, would go swimming in the creek near the house.[1]

Eakins's love of outdoor activities took him to Red Bank, Cape May, and Gloucester as well, also in New Jersey. At Gloucester he sailed and watched others—more skilled than he—do the same. Writing to Kathrin Crowell in 1874, he reported:

> Monday I went off for an all day sail with Max & Freddy. We got up to the boat house about 6 in the morning and soon got started. A little above Red Bank we put in to shore & I went over to Bill Gill's and got him &

43. Detail of *The Biglin Brothers Turning the Stake*, 1873. See plate 51.

then we went down to near Woodbury Creek. We took a swim [,] shot with the pistol & rifle & amused ourselves generally & eat [sic] our lunch and about 2 o'clock or so started up. We dropped Bill Gill a little above his house & then kept on up, and got to the house & everything was put away before 6 o'clock. The wind blew hard all day & we had a very good time.[2]

The thirty-year-old Eakins had developed a romantic interest not only in Crowell but in other young women as well. His father, believing his son was infatuated with too many of them, insisted that he focus on just one.[3] He became engaged to Crowell in 1874, but judging from his letters to her, the relationship seems to have lacked the intensity of his earlier love for Emily Sartain. If one views Eakins's letters as a reflection of the recipient, then Crowell seems not to have challenged his intellect or to have understood his artistic aspirations. His letters to her are as factual and as passionless as a news item: "Em came to dinner yesterday. She came to hunt board which she found finally on Franklin Street opposite the Square. She left Ri in Atlantic City. Ri's wrist is no better nor worse. If Ri writes that she cant pack her trunk Em will go down for her. Otherwise Ri will come up alone. Chippy is well. The cat is well. I am well. Em looks well. Everybody is right well. Sally Lewis is in the country with the Smoedles." He voiced his emotional commitment to her, such as it was, in the occasional comment "I miss you very much."[4] Only once in the surviving letters did he speak of his love for her, and that was in a familial context: "My love to Lizzie [and] to your mother. I will be very glad to see them again. My love to your own self. Wish for all that you can and it is not as much as you always have from me."[5] He signed the letter "Thomas Eakins," hardly a sign of intimacy. Their five-year engagement was abruptly ended by Crowell's death from meningitis at age twenty-seven. Yet had she lived, it is doubtful that the marriage would have proved fulfilling for either individual. Her friend Sallie Shaw remembered her as "just a good decent girl" but "not artistic." Crowell was, moreover, "rather exclusive" and did not easily mix with people—in sharp contrast to the gregarious Eakins.[6]

However interested he might have been in sports and socializing, Eakins's primary goal after returning to the United States was to succeed as a professional painter. He renewed his ties with his old friends and mentors John Sartain and Christian Schussele, but he seems to have had little interest in fraternizing with any other local artists. Self-reliant and proud of his Parisian training, Eakins may have thought that he had no need for political connections with artists of his own generation and that he had little or nothing to learn from them. He did continue his friendship with Earl Shinn, who had been in Paris with him. More talented as a writer than as an artist, Shinn had gravitated to criticism, and he became a kind of father confessor for Eakins as the latter struggled to become an independent artist. He wrote to Shinn about his efforts to paint in a competent and acceptable manner, even positively comparing his treatment of the figure to work by artists in New York. He also told Shinn of his desire to gain recognition among critics and collectors. Perhaps hoping that Shinn would write favorably about him, Eakins bragged about Gérôme's high regard for him and cited his cor-

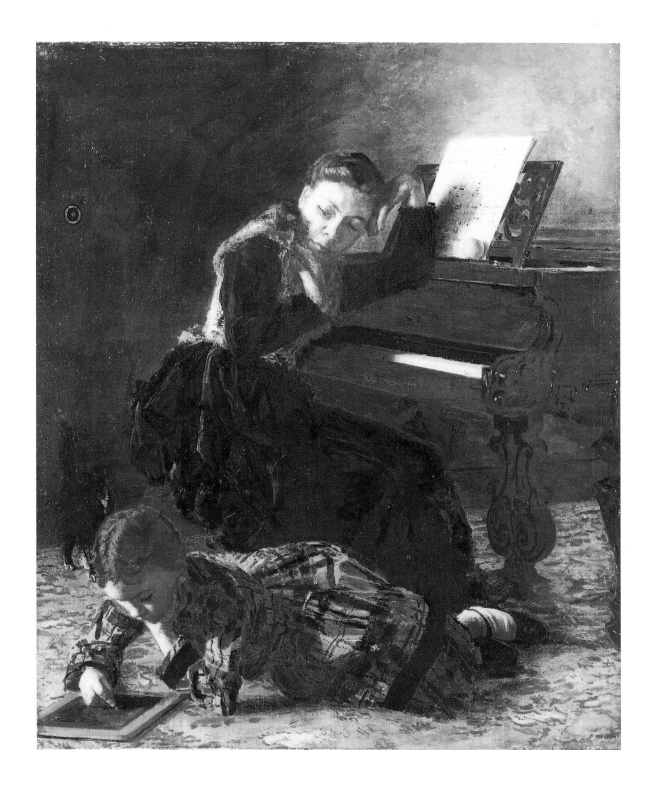

44. *Home Scene*, c. 1870–71
Oil on canvas, 21¹¹⁄₁₆ x 18¹⁄₁₆ in.
The Brooklyn Museum; Gift of
George A. Hearn, Frederick Loeser
Art Fund, Dick S. Ramsay Fund,
Gift of Charles A. Schieren

respondence with the French master concerning pictures he had sent to Paris for
his approval and for exhibition at the Salon.[7]

Eakins spent most of his time in the early 1870s painting his family and
friends. In *Home Scene* (plate 44) he portrayed two of his sisters: Margaret, taking
a break from her piano playing, looks down at Caroline, stretched out on the
floor, studiously writing or drawing on a slate. A strong light from the window at
left picks out salient features: the left side of Margaret's head, a music book on
the piano, an orange on the music rack, the right-hand portion of the keyboard,
and half of Caroline's head and her hands. These are bright accents in a sea of
half-lights and deep, Rembrandtesque shadows. Eakins captures the ambience of
a somber nineteenth-century parlor, no doubt his own, with remarkable fidelity.
An air of stillness pervades this domestic scene. Margaret, gazing reflectively at

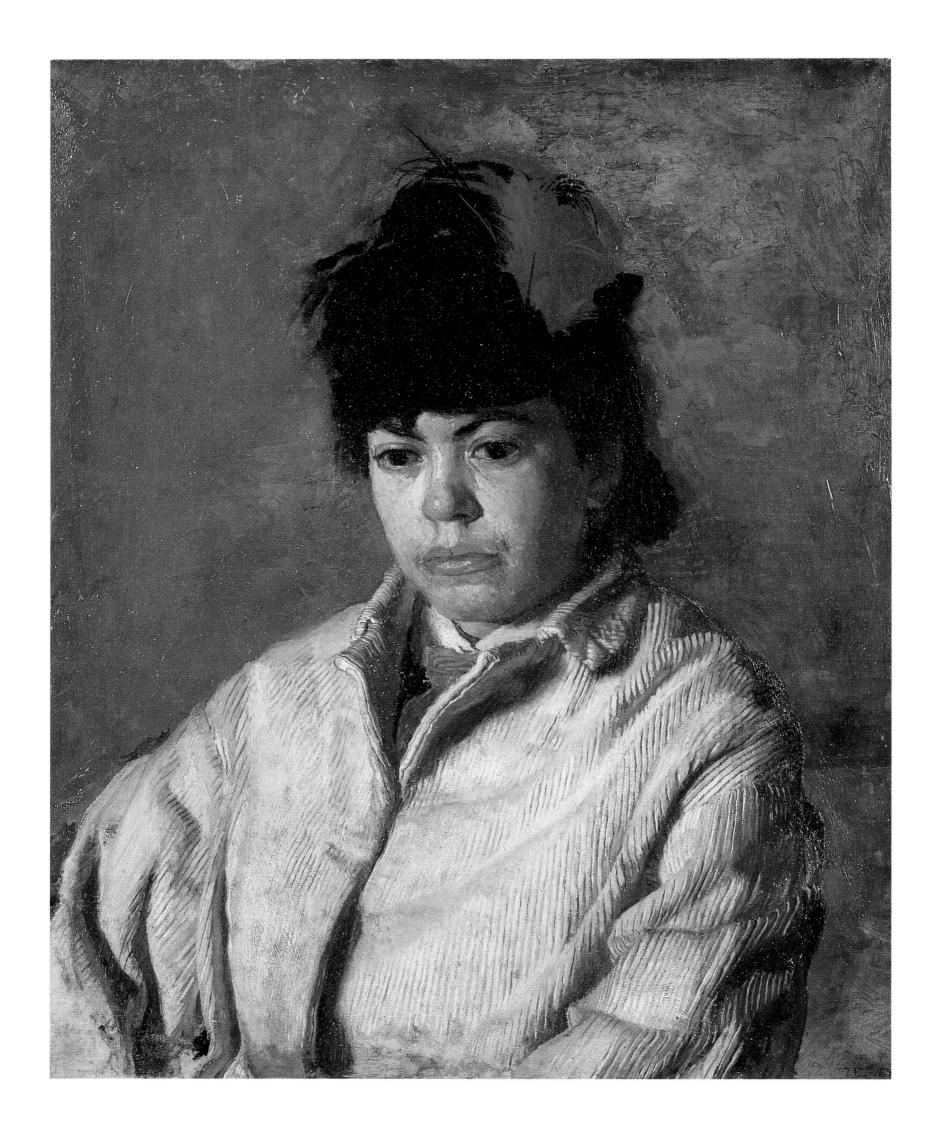

her sister, is deep in thought. Her meditative mood, as portrayed here, may have related to Eakins's own deep reflection on the complicated matter of making a picture. Margaret, in other words, stands in proxy for Eakins in reducing the creative act to a matter of sober, intellectual deliberation.

Notable among Eakins's earliest efforts is *Margaret in Skating Costume* (plate 45), a powerful though still-groping effort. Most striking is his attempt at heavily modeling the face, which is illuminated from the left and shaded rather densely on the right. His sister's clothing is a tour de force of realistic representation on which he has lavished all the care and thought one might give to a still life. As to the portrayal of character, little of Margaret is revealed other than her seriousness and glum expression. Her eyes, dark and lacking transparency, look downward, and not a hint of a smile crosses her lips.

As Eakins developed his skill as a painter of clothed figures indoors, he attempted more complex compositions, such as *Elizabeth Crowell with a Dog*

Opposite
45. *Margaret in Skating Costume*, c. 1871
Oil on canvas, 24⅛ x 20⅛ in.
Philadelphia Museum of Art; Given by Mrs. Thomas Eakins and Miss Mary Adeline Williams

Below
46. *Elizabeth Crowell with a Dog*, c. 1871
Oil on canvas, 13¾ x 17 in.
San Diego Museum of Art

(plate 46). The domestic stage on which this quiet scene is acted out is the richly carpeted floor of a typical Victorian interior, possibly the Eakins house. In the background is visible part of a piano with a rust-red cover; casually draped on top of it is a piece of dark blue fabric, possibly an article of Elizabeth's clothing. A Jacobean-style chair sits against the rear wall, and on it hangs a piece of "Oriental" fabric. These accessories were surely based on actuality, but Eakins no doubt rearranged them in an effort to make a composition with interesting variations in texture, tone, and color. Yet the painting has a rather open, additive, almost primitive quality, with objects widely spaced from one another.

Sharing much of the subdued light and tone of *Elizabeth Crowell with a Dog* is Eakins's first portrait of a sitter outside the family circle: *Professor Benjamin Howard Rand* (plate 47). Rand, who had taken his degree in medicine from Jefferson Medical College in 1848, became a professor of chemistry at the Franklin Institute two years later. He also taught at the Pennsylvania Medical College and at Central High School, where Eakins had studied chemistry with him. Dr. Rand subsequently joined the faculty at Jefferson and was there when Eakins took anatomy courses in 1864 and 1865. Rand served as dean at Jefferson from 1869 through 1873, a year before Eakins painted his portrait, and he remained an honored member of the faculty until 1877.

Eakins showed his admiration for Rand not only by selecting him as a subject, without being paid, but also in his portrayal of him. Rand is shown seated at his desk, leaning slightly forward to scrutinize a passage in the tome that lies open before him. Except for the witty note of the alert black cat on the desk, the atmosphere is completely serious. Rand's furrowed brow tells us his intellect is at work; no outside intrusions disturb his thoughts in this silent Victorian chamber. His microscope and the other scientific instruments on his desk are depicted with precise veracity by Eakins, representing not only part of Rand's scholarly surroundings but also icons of the scientific age, treated with reverence and respect.

The cluttered painting is an almost encyclopedic account of the visual information that confronted the artist. Whereas he had spaced out the objects around the main subject in *Elizabeth Crowell with a Dog,* here he multiplied and compressed the accessories, and as a result the Rand portrait lacks any coherent sense of design. Accessories such as the microscope on the left and the red shawl on the right direct attention away from Rand's head and shoulders. Nor is this the only fault in the work. The doctor's position at the desk is stiff and contrived, the fingers of his left hand too uniform and sausagelike in shape. There is something naive and unskilled in Eakins's presentation, yet he was enormously sincere in his effort to capture the reality of the man and the interior in which he worked. Eakins's patient observation and obvious devotion to his subject are, in the end, curiously appealing.

Once he began painting out of doors, Eakins expanded his range of tones to match the effects of nature. His first painting of this kind, *The Champion Single Sculls,* also known as *Max Schmitt in a Single Scull* (plate 48), portrays his friend Schmitt under a blue-gray sky, his head and body highlighted by the late afternoon sun. Schmitt is shown pausing, while Eakins looks out from another shell at a point farther back on the river. Schmitt dominates the painting, and in a sense

the river and its landscape exist to articulate his role as a champion rower. Indeed, Hendricks insisted that the painting was a portrait, not a genre scene.[8] Elizabeth Johns has gone one step further, writing that the painting commemorates Schmitt's winning a race on the Schuylkill on October 5, 1870.[9] As a member of the Pennsylvania Barge Club, he had triumphed over three other competitors in the category of single sculls (or shells)—hence the title *The Champion Single Sculls* (which, Johns points out, needs a comma after the word *Champion*). Not only did this work acknowledge Schmitt's victory, it also celebrated, in Johns's view, the broader idea of the democratic hero who excels at a demanding sport.[10] Rowing, which had gained popularity in the United States a few decades before this event, not only built health and stamina, it also required mental discipline and control. Moreover, it was a relatively egalitarian sport, accessible to middle-class men like Schmitt and Eakins.

Even though Eakins never quite achieved the authentic effects of sunlight and air that infuse the best of Winslow Homer's work from this period, there is still a persuasive sense of natural illumination in this scene on the broad expanse of the Schuylkill. At the same time, the artist was careful not to let the light dissolve the forms, which he clearly defined even in the far distance. The painting has a curiously dry, airless quality thanks to the carefully drawn detail, from the foreground to the distance. Because the intensity of the hues does not diminish as one moves away from the foreground (in defiance of the principles of aerial perspective), the work has an almost Surrealist sense of the insistent reality of all the objects depicted.

The Champion Single Sculls is an extraordinary work of art to come from the brush of a twenty-seven-year-old painter just back from Paris. It does not look like the paintings by his teachers, nor does it closely resemble the canvases by any other American artists, past or present. Eakins has created his own artistic language, and it recalls his 1868 letter to his father: "The big artist does not sit down monkey like & copy a coal scuttle or an ugly old woman like some Dutch painters have done nor a dung pile, but he keeps a sharp eye on Nature & steals her tools. He learns what she does with light the big tool & then color then form and appropriates them to his own use."[11] In the process of portraying nature, however, Eakins produced an aesthetically satisfying effect: a tightly ordered composition in which tonal values harmonize with each other.

The concept of the rower-as-hero continued to fascinate Eakins until 1874, and he made oarsmen the subject of several other paintings. The celebrated Biglin brothers of New York—Barney and John—posed for most of these, singly or together. The two are featured in *The Pair-Oared Shell* (plate 125), in which Eakins failed noticeably to master the placement of a boat on the river; rather than floating on the water, it seems to hover above it. Perhaps he was thinking too conceptually in this painting, calculating things scientifically and working with a straight edge but not *observing* (two detailed perspective drawings for the painting have survived, plates 126, 127). The two oarsmen are more broadly treated: their bodies and limbs are defined by sunlight striking them from the right, though their faces are not fully modeled. Sitting stiffly in their two-man scull, they look almost as though they were posing for a photographic por-

47. *Professor Benjamin Howard Rand,*
1874
Oil on canvas, 60 x 48 in.
Jefferson Medical College of
Thomas Jefferson University,
Philadelphia

trait. This quality, together with the arid monochromatic colors and the mechanical rigidity of the drawing, reduces this painting to little more than an academic exercise.

Far more successful as a work of art is *The Biglin Brothers Turning the Stake* (plate 51), painted the following year. The composition is more complex, and the rowers and their shell now ride convincingly on the water. The Biglin brothers prepare to pull their oars in anticipation of turning their scull around the stake, the vertical post with a blue flag in the right foreground. The strong light from the left catches only a small part of their muscular bodies, leaving the rest in half-light and shadow. This recalls the use of light in Eakins's interiors, but here the effect seems true to the raking light seen out of doors in early morning or early evening.

48. *Max Schmitt in a Single Scull (The Champion Single Sculls)*, 1871
Oil on canvas, 32¼ x 46¼ in.
The Metropolitan Museum of Art,
New York; Purchase, Alfred N.
Punnett Endowment Fund and Gift
of George D. Pratt, 1934

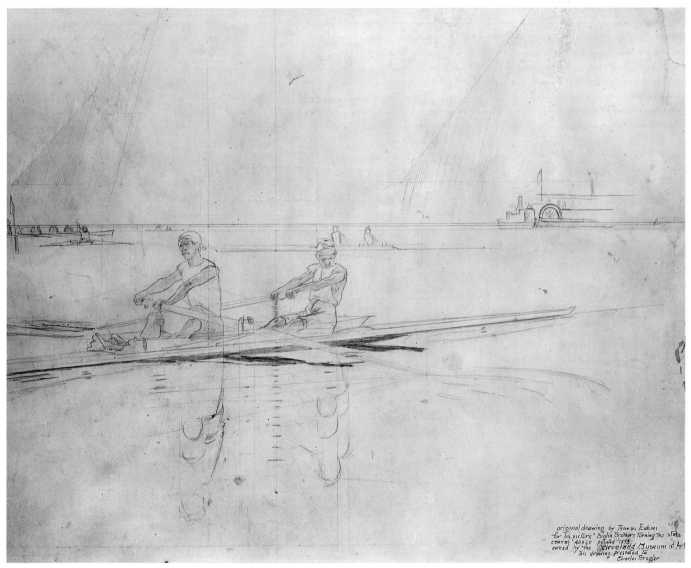

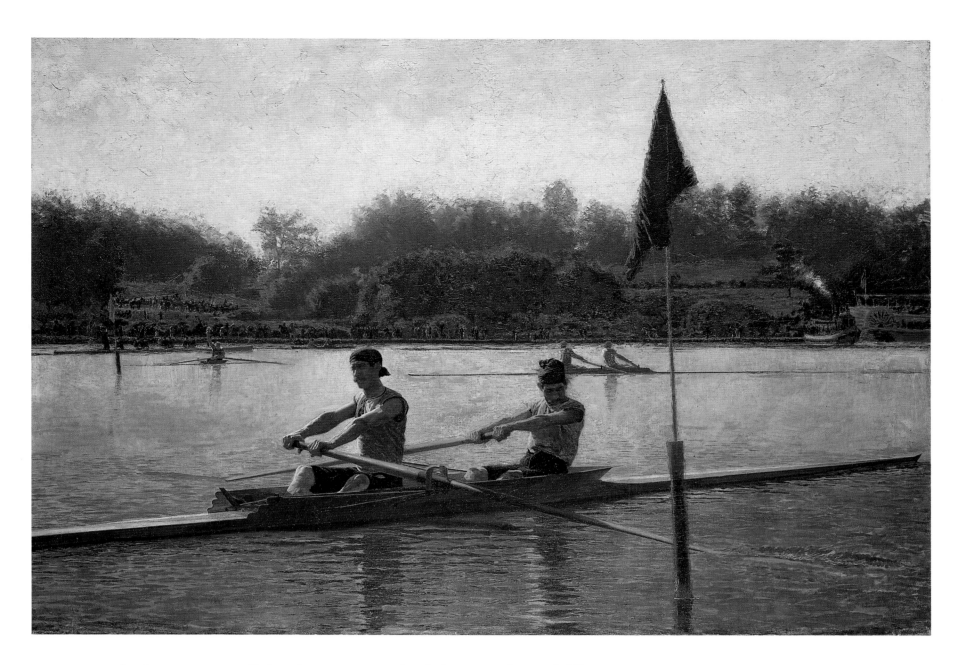

Authentic, too, is Eakins's perspective, both linear and aerial. There are two extant perspective drawings for the work. One (plate 50) is a study for the placement of the rowers and the shell as well as for their reflections; the other (plate 49) is a more detailed analysis of the mechanism and shape of the oars, again fully in accordance with the conventions of perspective. All of this visual information is presented in sharp focus, as in a mechanical drawing, but the painting is treated more broadly than *Champion Single Sculls*. Attention is centered on the two principal figures. The distant oarsmen, though well defined, do not compete with them, nor do the spectators and horses farther away on the bank.

The Biglin Brothers Turning the Stake is an ambitious painting, impressive in size, subject, and style. Yet Eakins was also content at this time to portray outdoor scenes that were more relaxed and casual, probably a reflection of his own genuine enjoyment of sports and therefore a kind of autobiographical testament. Sailing and hunting preoccupied him after his return from Paris, and in the 1870s he frequently turned to these activities, as well as baseball, as subjects for his paintings. Eakins probably adopted these themes not only as expressions of his own interests but also in the hope that such paintings would sell. What subject, after all, could be better for an American audience than sports?

Opposite, top
49. *Perspective Drawing for "The Biglin Brothers Turning the Stake,"* c. 1873 Pen and ink, colored ink, pencil, and ink wash on paper, 31⅞ x 47¹¹⁄₁₆ in. Hirshhorn Museum and Sculpture Garden, Smithsonian Institution, Washington, D.C.; Gift of Joseph H. Hirshhorn, 1966

Opposite, bottom
50. *Perspective Drawing for "The Biglin Brothers Turning the Stake,"* c. 1873 Pencil drawing with sepia wash on paper, 13¹⁵⁄₁₆ x 17 in. The Cleveland Museum of Art; Mr. and Mrs. William H. Marlatt Fund

Above
51. *The Biglin Brothers Turning the Stake,* 1873 Oil on canvas, 40¼ x 60¼ in. The Cleveland Museum of Art; Hinman B. Hurlbut Collection

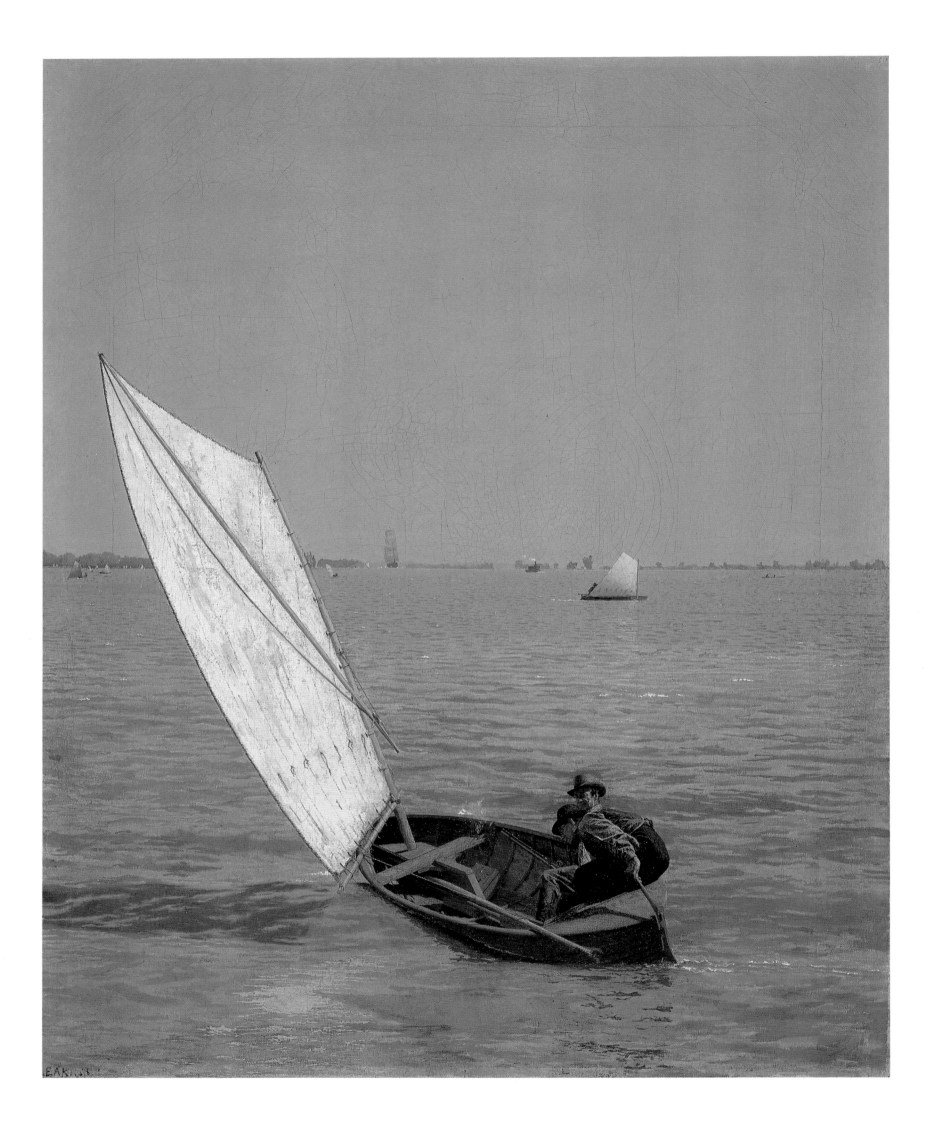

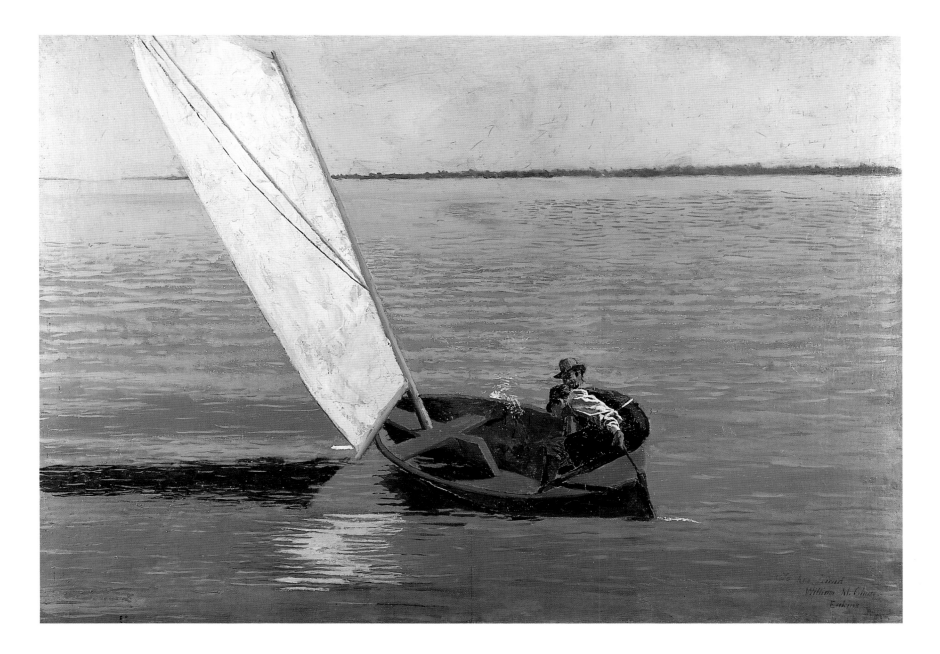

Eakins's marine and sailing pictures, though carefully drawn and based on the artist's direct knowledge of boats and boating, often lack vitality, seeming rather gray and weighty in conception. We know that Eakins studied the placement of the boats and of the reflections quite carefully, and his learned methods are all too evident. He is most guilty of excessively rational control in the pictures of single sailboats, particularly *Starting Out after Rail* (plate 52) and *Sailing* (plate 53). His strength, when he would let himself go, is a looser arrangement of his nautical subjects on the surface of the canvas.

In *Sailboats Racing on the Delaware* (plate 54), his most appealing marine of this group, boats of different shapes and colors relate to each other and to the water in an orderly, but not rigid, way. The sails are painted very broadly in creamy white, and the water, punctuated by gentle waves, is drawn convincingly but not with obvious mathematical precision. Eakins seems to have learned that certain elements must be stressed and others de-emphasized. Thus the main sailboat is made the principal element of the picture, and its shape is repeated with slight variations in the other vessels on the river. The sky, too, is lighter and more luminous than in his other marines of the same time—pale powder blue accentuated by white puffs of clouds. Compared to the work of the French

Opposite
52. *Starting Out after Rail*, c. 1874
Oil on canvas, 24 x 20 in.
Museum of Fine Arts, Boston; The Hayden Collection

Above
53. *Sailing*, c. 1875
Oil on canvas, 31⅞ x 46¼ in.
Philadelphia Museum of Art; Alex Simpson, Jr., Collection

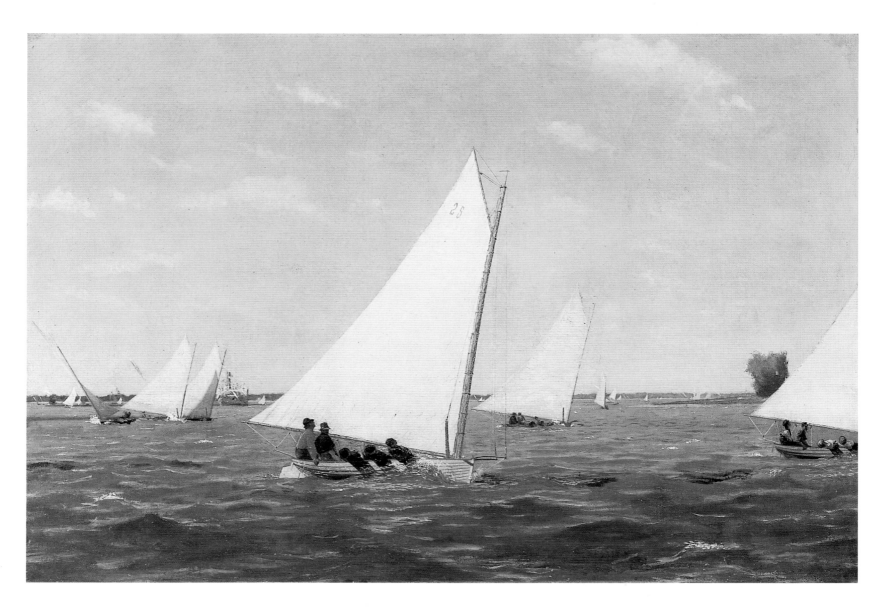

54. *Sailboats Racing on the Delaware*, 1874
Oil on canvas, 24 x 36 in.
Philadelphia Museum of Art; Given
by Mrs. Thomas Eakins and Miss
Mary Adeline Williams

Impressionists, which it resembles in subject and spirit, it remains a tonal paint-ing: the water looks brown or tan, with accents of dark and light blue and white serving as crests of the waves. There is not a true sense of strong light in the pic-ture, though it is more intense than in a typical academic painting.

Rowing and boating subjects inspired Eakins to work not only in oil but also in watercolor, a medium in which he had no formal training.[12] Yet surprising-ly, and without warning, he emerged in the early and mid-1870s as an accom-plished watercolorist. Possibly his unusual procedure of executing complete oil studies for his watercolors gave him the only foundation he needed; there is no other explanation for the impressive results he obtained so quickly with this diffi-cult medium. Eakins did not make many watercolors, fewer than thirty in all, nor did he continue using the medium much beyond 1882. But during the time he was making watercolors, he displayed them frequently in important shows, espe-cially in annual exhibitions of the American Society of Painters in Water Colors. Perhaps he calculated that watercolors would sell more readily than oils, their price generally being lower; or possibly he liked the lighter tone and luminosity that the technique made possible, a relief from his denser oil paintings.

Among his earliest sheets is *John Biglin in a Single Scull* (plate 55). It was executed in response to Gérôme's comments on another work of the same sub-ject, now lost, that Eakins sent to him in the spring of 1873. Gérôme responded:

The individual who is well drawn in his parts lacks a total sense of movement; he is immobile, as if he were fixed on the water; his position I believe is not pushed far enough forward—that is, to the extreme limit of movement in rowing, an infinity of rapid phases, and an infinity of points from his upper body back as far as it will go. There are two moments of action, either when the rower is leaning forward, the oars back, or when he has pushed back, with the oars ahead; you have taken an intermediate point, that is the reason for the immobility in the work.[13]

Eakins took these criticisms to heart and attempted a second version of the subject in which he had Biglin lean forward and cock his oars to the rear, ready to make his next stroke. To better study the position of the rower in a medium that allowed corrections and repainting (watercolor does not) Eakins produced an oil—more tactile and opaque, cropped left and right, but essentially the same image (plate 57). He also made an elaborate perspective drawing (plate 56) showing the figure of Biglin and more of the scull in order to fix the location of the reflections in the water. The final "corrected" sheet that he sent to Gérôme was rediscovered in 1989, after more than a hundred years in obscurity,[14] and shows that he had learned his lesson (though we could also learn this from a copy Eakins made for himself, now in the Metropolitan Museum). "Your watercolor is entirely good," Gérôme wrote in response to the revised version.[15]

Eakins's watercolor technique immediately invites comparison with that of Winslow Homer, one of America's greatest watercolor painters. Whereas Homer boldly applied washes and created vigorous contrasts between large, simplified shapes, Eakins worked in a slow, painstaking manner, polishing every detail. His work is as dry as Homer's is fluid. Eakins must have spent weeks or even months on a single sheet, whereas Homer could produce several in a day. Yet despite Eakins's meticulous technique, there is a bright and airy quality in *John Biglin in a Single Scull*. Like any skilled watercolor painter, he understood how to let enough of the fresh white paper sparkle through so that the sheet has an admirable atmospheric translucency.

Writing to Shinn about *Whistling [for] Plover* (plate 58), Eakins compared it to his oil of an almost identical subject (now lost), saying that it was "not near as far finished" as the oil but had been painted "in a much higher key with all the light possible."[16] The tonality of the sheet is indeed bright, or "blond," and in this respect it is very different from the rich chestnut browns of his oil portraits and interiors of the same time. Although Eakins probably was not yet acquainted with the works of the French Impressionists, his goal in watercolor painting may not have been too different from theirs: the depiction of contemporary outdoor scenes in authentic natural light. Of course, the Impressionists divided their colors more thoroughly than Eakins and also eschewed outlines and earth colors, which the American would not relinquish. But, still, Eakins's watercolors have their own peculiar vibration of color created by juxtaposing a multiplicity of small strokes, many of them slightly different from each other in tone or hue.

65

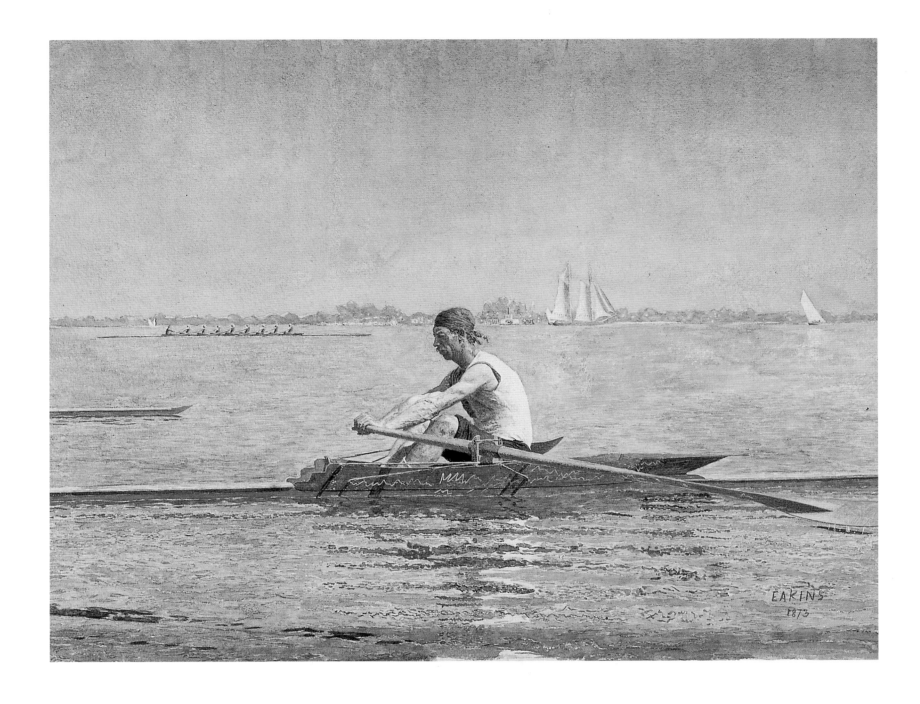

Above

55. *John Biglin in a Single Scull*, 1873/1874
Watercolor on paper, 16⅞ x 24 in.
Collection of Mr. and Mrs. Paul Mellon,
Upperville, Virginia

Right

56. *Perspective Drawing for "John Biglin in a
Single Scull,"* 1873–74
Pencil, pen, and wash on paper, 27⅜ x 45³⁄₁₆ in.
Museum of Fine Arts, Boston; Gift of
Cornelius V. Whitney

Opposite

57. *John Biglin in a Single Scull*, 1874
Oil on canvas on aluminum, 24¹⁄₁₆ x 16 in.
Yale University Art Gallery, New Haven,
Connecticut; Whitney Collection of
Sporting Art, given in memory of Harry
Payne Whitney and Payne Whitney by
Francis P. Garvan

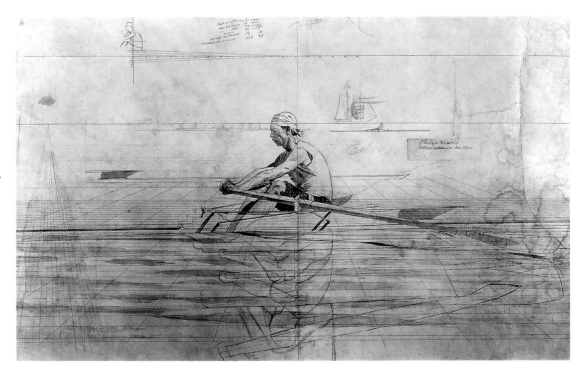

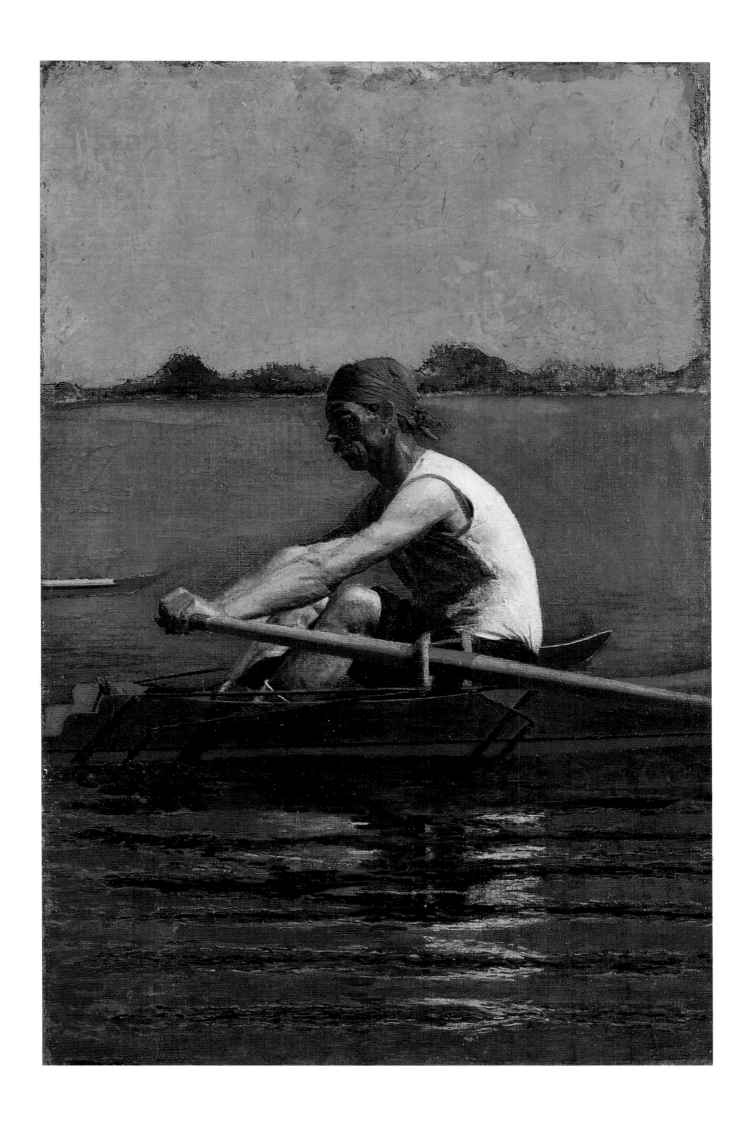

Eakins's landscapes and boating scenes, both watercolors and oils, have been linked with the tradition of Luminism in American painting,[17] and parallels between certain of his works and those by Fitz Hugh Lane, Sanford Gifford, and John Frederick Kensett can easily be found. The common denominator is light, subtle and elusive, that bathes and unifies the scene. This kind of illumination not only expresses what the artist saw in nature, but also enhances the mood or emotion associated with the scene. Few paintings by Eakins belong in this tradition, but those that do, like *Drifting* (plate 59), have a soft atmosphere suggestive of early evening. The sailboats, dotted on the mirrorlike water, are absorbed into the general tone, so that an overall coloristic effect, rather than individual descriptive details, prevails.

Eakins's sporting subjects also included hunting scenes, most often shooters awaiting or firing at rail. These paintings obviously reflect his own experiences in the marshes around Fairton, near the "fish house," and in most cases portray clearly identifiable hunters, including his father and himself. In paintings such as *Pushing for Rail* (plate 60) and *The Artist and His Father Hunting Reed Birds* (plate 61) Eakins represented specific, believable events, encapsulating in the paired figures the activity of the "pusher" handling a long pole and the hunter making ready for the kill. A detailed explanation of rail hunting survives in a draft of a letter by Eakins to Gérôme:

> As soon as the water is high enough for the boat to be floated on the marsh, the men get up and begin to hunt. The pusher gets up on the deck and the hunter takes a position in the middle of the boat (so as not to have his head buried), the left foot forward a little. The pusher pushes the boat among the reeds. The hunter kills the birds which take wing. . . . The pusher always cries out on seeing birds, for during most of the season when

58. *Whistling [for] Plover*, 1874
Watercolor on paper, 11¼ x 16¹¹⁄₁₆ in.
The Brooklyn Museum

59. *Drifting*, 1875
Watercolor on paper, 10¼ x 16½ in.
Private collection

the reeds are still green, it is he who sees first because of the more elevated position of the deck.[18]

Although Eakins was preoccupied with exact detail in this description and in his painted figures, his compositions are remarkably simple. The flat marshes play a dominant role in both works, but especially in *Pushing for Rail*. The sense of openness in that work, in fact, overwhelms the figures, who look almost like mannequins within the long horizontal rectangle. An accent of red, the shirt of the central hunter, gives focus to the composition.

Eakins turned twice to the theme of baseball. His first effort in this genre was a highly detailed watercolor, *Baseball Players Practicing* (plate 62), showing a batter and a teammate; his second, a perspective drawing (plate 63), also shows two players, but their positions are reversed and the batter is accompanied by a catcher. The drawing may have been a trial for *Baseball Players Practicing* (there are also two pencil studies in the Bregler Collection for that work), or it could have been a preparatory effort for another painting, never undertaken. Eakins wrote to Shinn in 1875: "I think I will try [to] make a base ball picture someday in oil. It will admit of fine figure painting."[19]

Baseball had only recently become a recognized team sport, and the National League was not founded until 1876, the year after Eakins painted *Baseball Players Practicing*. Referring to his watercolor, Eakins wrote to Shinn: "The moment is just after the batter has taken his bat, before the ball leaves the pitcher's hand. They are portraits of Athletic boys, a Philadelphia club. I conceive that they are pretty well drawn. Ball players are very fine in their build. They are the same stuff as bull fighters only bull fighters are older and a trifle stronger perhaps."[20] He painted their figures with remarkable precision and fidelity. We can

69

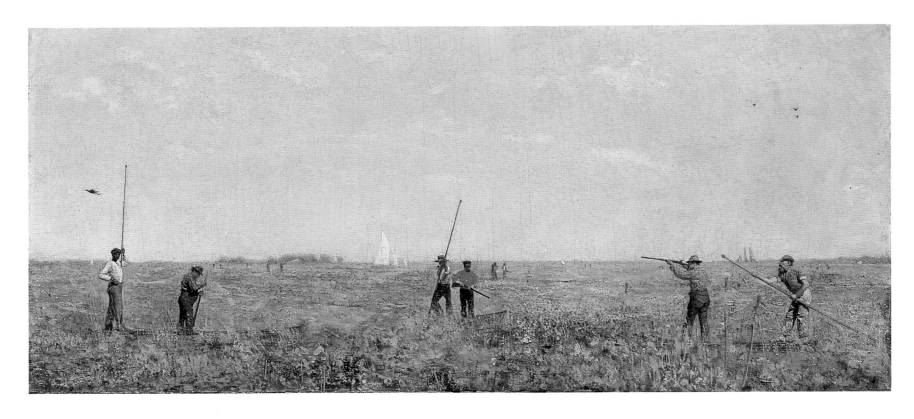

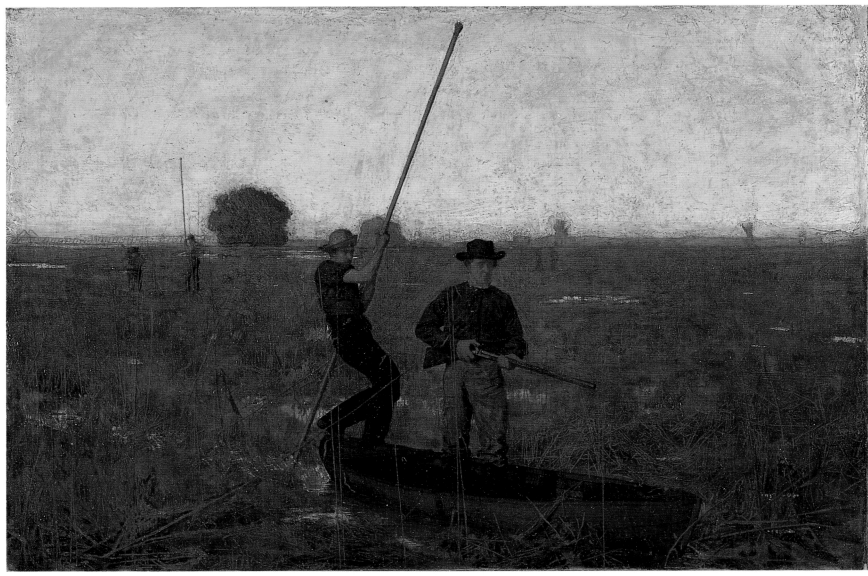

imagine him asking these players to pose in the open air, either in the ballpark or in a field, so that he could capture their rugged forms under the strong flood of sunlight. There is a curiously timeless quality in this image that stems not only from the poses of the figures but also from the plain, architectonic background—the field and the stadium—that supports rather than competes with them.

These two individuals, like Eakins's rowers and hunters, are skilled at what they do. Whether Eakins identified with these men because he played baseball himself, we cannot say. In any event, they assuredly belong to his roster of athletic heroes, and we must credit him with being among the earliest artists of note to celebrate America's national pastime.

Upon his return to Philadelphia, Eakins had clearly made up his mind to paint the themes and subjects he knew best, in sharp contrast to Gérôme's devotion to historical, exotic, and anecdotal subjects. The only apparent exception to Eakins's policy, before 1876, was *Hiawatha* (plate 64), known in an oil and a watercolor (the latter destroyed in the early 1940s). The oil may have served either as a preparatory study or may have existed as a painting in its own right. Goodrich saw the watercolor in the early 1930s, when it belonged to the artist's widow, and he described the subject in these words: "Hiawatha standing in a cornfield, silhouetted against a sunset sky containing clouds in the shapes of a bear, a buffalo, an antelope and a turkey; the cornshocks have the forms of human beings."[21] Goodrich's small pencil sketch, made as a record,[22] shows the theme essentially as it appears in the oil, though in his rendition the figure of Hiawatha seems slightly smaller and a bit farther to the right. Taking his subject from canto V of Henry Wadsworth Longfellow's *Song of Hiawatha* (1855), Eakins portrayed the moment when the Indian prophet conjures up visions during a seven-day fast. On the fourth day Hiawatha was accosted by Mondamin, the Corn-Spirit, and wrestled him to the death. In both of Eakins's paintings Hiawatha is shown victorious but exhausted, standing over his recumbent adversary. Around the pair appear what Eakins referred to as "other angels as cornshocks,"[23] and Hiawatha's fantasies appear as various animals in the sky, some based on the poem and some made up by the artist.

We do not know specifically what inspired Eakins to depict this subject. He was a great admirer of Longfellow, whose poems he thought superior to those of "any Englishman of today even Tennyson."[24] But Eakins's selection of the Indian subject is puzzling. As portrayed by Longfellow, Hiawatha is a strong and fearless opponent of nature's threatening forces, working to cultivate nature for the benefit of his people. Whatever Eakins's original inspiration had been for this choice of subject, he did not continue to paint literary scenes. Perhaps the response of his sister Margaret, in whom he placed great trust, steered him away from such efforts. In a letter to Shinn, Eakins wrote (whether about the oil or the watercolor is not known): "It got so poetic at last that when Maggy would see it she would make as if it turned her stomach. I got so sick of it myself soon that I gave it up. I guess maybe my hair was getting too long for on having it cropped again I could not have been induced to finish it."[25] The nearest he ever came to reiterating a poetic theme would be in his Arcadian paintings and sculptures of the early 1880s, but these were poetic in a general, not a specific, sense.

Above
62. *Baseball Players Practicing,* 1875
Watercolor on paper, 10⅛ x 12⅞ in.
Museum of Art, Rhode Island
School of Design, Providence; Jesse
Metcalf and Walter H. Kimball
Funds

Right
63. *Untitled (Perspective Study of Baseball
Players),* c. 1875
Pencil on paper, 13¹⁵⁄₁₆ x 17¹⁄₁₆ in.
Hirshhorn Museum and Sculpture
Garden, Smithsonian Institution,
Washington, D.C.: Gift of Joseph
H. Hirshhorn, 1966

In the great majority of his paintings Eakins turned to the life of the middle-class Americans he knew in and around Philadelphia. In doing this he answered the challenge posed by the controversial poet Walt Whitman to celebrate ordinary, daily events in the United States. In 1870, the year Eakins returned to his native city, Whitman had published in *Democratic Vistas* lines that could serve as an inspiration to painters as well as poets: "America demands a poetry that is bold, modern, and all-surrounding and cosmical, as she is herself. It must in no respect ignore science or the modern, but inspire itself with science and the modern. It must bend itself toward the future, more than the past. Like America, it must extricate itself from even the greatest models of the past, and, while courteous to them, must have entire faith in itself."[26] Though the beginning of Eakins's interest in Whitman cannot be dated precisely—by the late 1880s he was a confessed admirer—it most likely occurred in the 1870s: Eakins's art and thought of this and later decades clearly reflect Whitman's vigorous naturalism, independence, and freedom from convention.

The America to which Eakins returned in 1870 was far from the ideal democracy populated by free spirits that Whitman had envisioned. The Civil War had wrecked the South's economy and undermined its political system. The North marched toward industrialization. Great fortunes were made, particularly in New York, though Philadelphia had its share of millionaires, too. In the post–Civil War era, successful men often turned to art collecting as a means of demonstrating social status, though some may have genuinely enjoyed works of art for their own sake. The emphasis among American collectors was on European art, not American, which was generally dismissed as inferior and

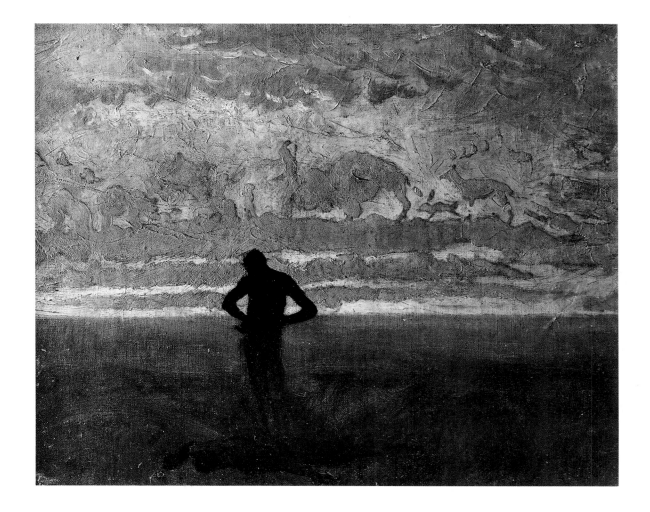

64. *Hiawatha*, c. 1874
Oil on canvas on panel, 14⅛ x 17⅝ in.
Hirshhorn Museum and Sculpture Garden, Smithsonian Institution, Washington, D.C.; Gift of Joseph H. Hirshhorn, 1966

provincial. Those American artists who did succeed were most often close imitators of fashionable European styles, particularly the French academic tradition at its most saccharine and sentimental. Eakins was unprepared for this situation and dismayed by his lack of sales. When he started out as an independent artist, he portrayed real persons, real scenes, and real objects that he could observe directly. He rarely painted historical subjects, he eschewed the popular French academic style, and he favored a broad, tonal method based on work by Velázquez, Ribera, and Rembrandt. None of this endeared him to American collectors.

Eakins's first monumental effort, *The Gross Clinic* (plate 65), has proved to be his most successful from our vantage point, but it was a critical failure in his own time. The negative opinion of this extraordinary painting deeply hurt Eakins and thwarted some of his greatest ambitions. As he started to work on it, Eakins was full of confidence, writing to Shinn in April 1875: "I have just got a new picture blocked in and it is far better than anything I have ever done. As I spoil things less and less in finishing I have the greatest hopes for this one."[27]

Undertaken as a personal challenge, not a commission, this painting was ambitious in scope and size—eight by almost seven feet. It portrays the eminent Philadelphia surgeon Dr. Samuel D. Gross, four doctors assisting him, a fifth almost hidden behind him, a male patient lying on his side, the patient's mother, a recorder, and a sizeable group of onlookers—including Eakins at the right. The event takes place in the amphitheater of Jefferson Medical College. Gross is shown pausing in the midst of removing a piece of dead bone from the thigh of a patient suffering from osteomyelitis. By 1875 this fairly common ailment could be treated in the routine operation that Gross is performing, but in earlier years amputation would have been the only solution. Thus Gross is pictured not only as a healer but also as one who preserves the wholeness of the human body.

There are several reasons, personal and cultural, why Eakins was attracted to this subject. He admired Gross as a master of his profession who performed his duties with skill and dedication. When Eakins painted *The Gross Clinic*, the doctor was nationally and internationally celebrated for his writings and for his achievements as a surgeon. He had come a long way from the farm in Pennsylvania Dutch country near Easton, Pennsylvania, where he was born in 1805.[28] For Gross, the act of surgery was to be "proceeded with, slowly, deliberately, and in the most orderly, quiet, and dignified manner. All display, as such, is to be studiously avoided. . . . Every important operation should be looked upon as a solemn undertaking."[29]

Through his skill in operating and his definitive writings, Gross became an important force in the nineteenth-century movement that elevated surgery to a professional level. From the beginnings of medicine the surgeon had been regarded as vastly inferior to the physician: the former was associated with painful amputations that were seen as no more than a mechanical craft, whereas the latter was involved with healing internal ailments and dignified by his engagement with intellectual theories. By Gross's time the surgeon had earned greater recognition and approval, thanks in part to Gross's own efforts. It is this achievement that Eakins commemorated in *The Gross Clinic*.

Eakins must also have envisioned his portrayal of Gross as a symbol of Philadelphia's high standing in the realm of surgery, a source of pride to the artist, who continued to praise the city of his birth. In particular, Jefferson Medical College had distinguished itself by adopting a clinical method from France that encouraged large numbers of students to observe a wide variety of treatments and operations in a hospital setting. Because of this approach Jefferson found itself at the forefront of medical education in the United States.

Eakins always applauded any evidence of America's superiority over Europe. In his letters from Paris he had proudly hailed his compatriots' technical and mechanical achievements on display at the 1867 Exposition Universelle. At the Centennial Exposition in Philadelphia, planned for 1876, the United States would have its first major opportunity to flaunt its accomplishments side by side with exhibits from all over the world. The fair promised to showcase virtually every form of human activity, including the fine arts. As a result, Eakins planned *The Gross Clinic* not only as a tribute to a surgeon who was esteemed in Philadelphia and honored in Europe, but also as "the finest thing he could possibly do for so great an event."[30]

Eakins approached his project with the same deliberate seriousness that Gross displayed in the act of surgery. He already had repeatedly observed the great surgeon in the amphitheater on the top floor of the templelike building that housed Jefferson Medical College. Indeed, Eakins may have made a small oil sketch (plate 66) in the course of the actual operation or from memory soon after, painting quickly with summary strokes, including work with a palette knife. Eakins took photographs of Gross,[31] and presumably the other doctors as well (now lost), and in his studio made a penetrating oil study of Gross's head and shoulders (plate 67). Not only are the doctors in the operating theater specific individuals—from left to right, Dr. Charles S. Briggs, Dr. William Joseph Hearn, Dr. James M. Barton, Dr. Daniel M. Appel—but the spectators are each identifiable as well. Oil studies were made for many of these, but only one has survived: that of Robert C. V. Meyers, seated in the back row, third from the right (plate 68). All of this visual information was organized within the regulating framework of a perspective drawing, now lost.[32]

For his composition Eakins had no known prototypes in American painting and only a few in European art, none of which possessed the complexity or dramatic power of *The Gross Clinic*. Of course, Rembrandt's celebrated *Anatomy Lesson of Dr. Tulp* (plate 69) must have been known and respected by Eakins, but it does not depict a surgical operation, not do the participants relate to each other psychologically. Eakins had to find his own personal solution, basing *The Gross Clinic* on what he had observed.

Gross is obviously the center of attention, deep in thought and completely in control. His associates are ranged around him, and it is almost as though Gross is the conductor of a small orchestra, holding a scalpel, not a baton, and directing his subordinates to produce a coherent result. Their attention seems all the more focused when one looks at the cringing figure of the young patient's mother at the left. Her overt emotion serves as a foil for the doctors' calm, concentrated efficiency.

Page 76
65. *The Gross Clinic*, 1875
Oil on canvas, 96 x 78 in.
Jefferson Medical College of
Thomas Jefferson University,
Philadelphia

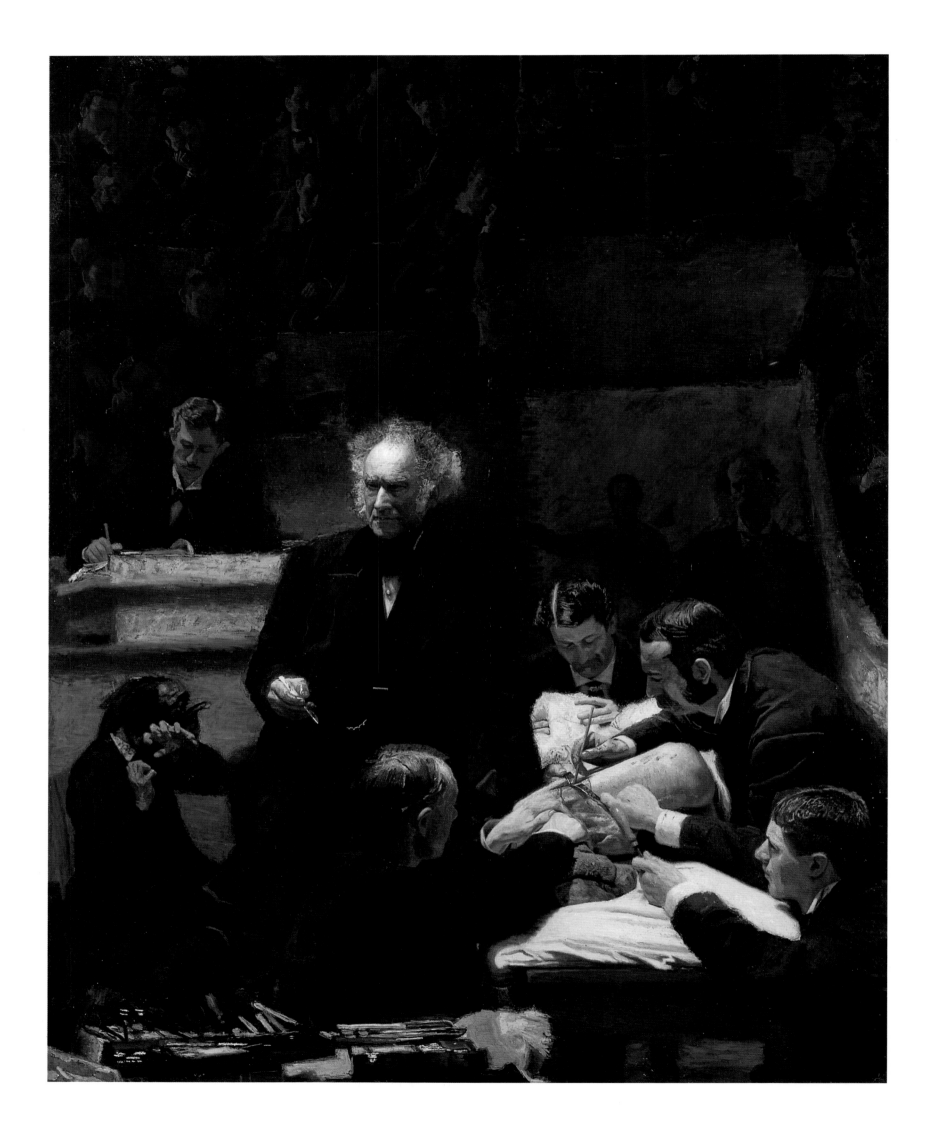

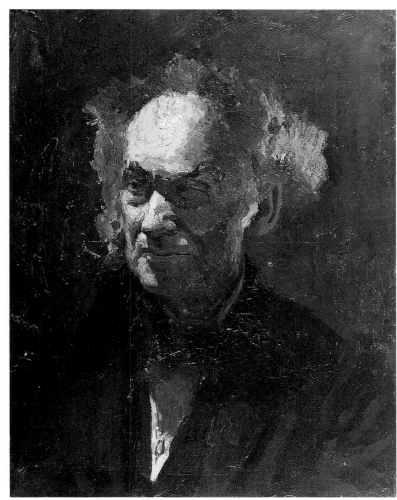

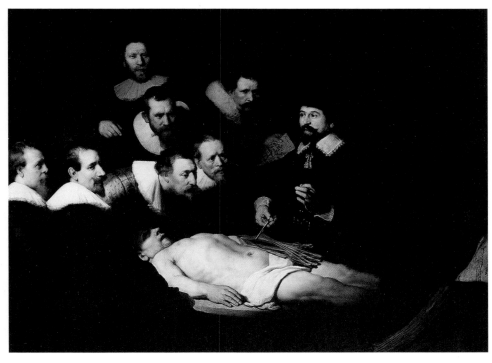

Top left

66. *Sketch for "The Gross Clinic,"*
c. 1875
Oil on canvas, 26 x 22 in.
Philadelphia Museum of Art;
Given by Mrs. Thomas
Eakins and Miss Mary
Adeline Williams

Top right

67. *Study of the Head of Dr. S. D.
Gross (Sketch for "The Gross
Clinic")*, 1875
Oil on canvas, 24 x 18¼ in.
Worcester Art Museum,
Worcester, Massachusetts

Bottom left

68. *Robert C. V. Meyers*, 1875
Oil on paper, 9 x 8½ in.
Mr. and Mrs. Daniel W.
Dietrich II

Bottom right

69. Rembrandt van Rijn
(1606–1669)
*The Anatomy Lesson of Dr.
Tulp*, 1632
Oil on canvas, 18½ x 25 in.
Mauritshuis, The Hague

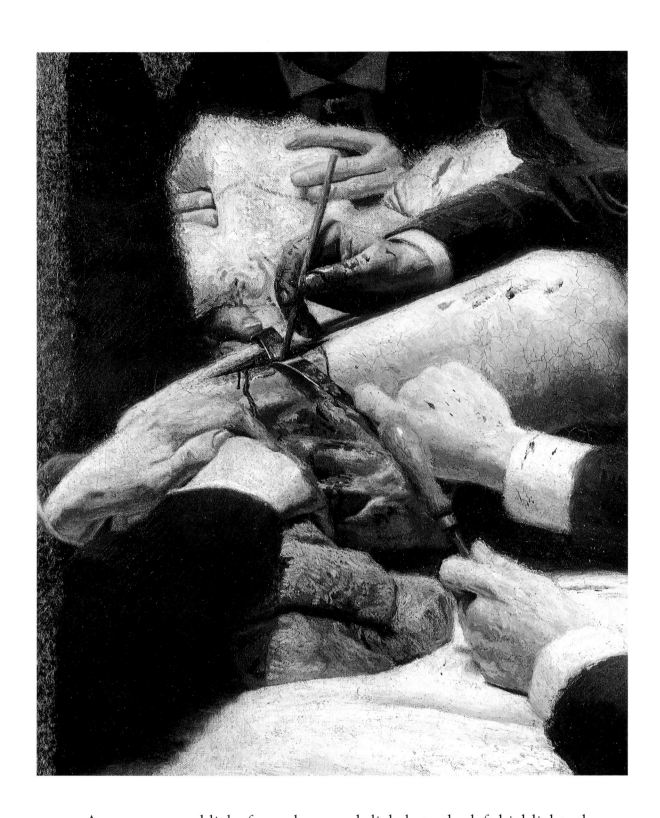

70. Detail of *The Gross Clinic*. See plate 65.

A strong natural light from above and slightly to the left highlights the great dome of Gross's forehead and his hand holding the scalpel; secondarily, it also strikes the heads and hands of the supporting doctors and the patient's thigh. As in the paintings of Rembrandt (more in the tradition of *The Night Watch* than *The Anatomy Lesson*), light helps to establish visual priorities in the composition, spotlighting what is most important and, by its absence, relegating nonessentials to the shadows. As in all great art, selection is essential; Eakins had learned what to stress and what to omit. By using light to emphasize the commanding figure of Gross, especially his head, Eakins created a center of attention to which everything else is subordinated.

While exercising admirable selectivity in his lighting and design of *The Gross Clinic*, Eakins also offered a great deal of descriptive detail. In the fore-

ground the surgical instruments—looking to our eyes like carpenters' tools—are laid out in their boxes, a still life that Eakins has obviously savored. The operation itself is presented in graphic detail. Gross's right hand, holding the scalpel that has just cut into the patient's flesh, is covered with blood, as is the edge of the scalpel. Retractors open the incision to be probed by the instrument in Dr. Barton's bloodstained hand. A final note of realism is supplied by the patient's grayish blue socks, which were traditionally used to alleviate the sensation of cold accompanying the use of the anesthetic.

The Gross Clinic is inventive yet accurate. It captures in a convincing, penetrating manner not only Gross's skill but also his psychological presence. (The portrait of his head alone is an achievement that has rarely been equaled in American art.) This is a grand, epic work, combining individual character with a concentrated narrative that lauds one of the proud moments in American surgical history.

In August 1875 John Sartain reported in a letter to Emily, "Tom Eakins is making excellent progress with his large picture of Dr. Gross, and it bids fair to be a capital work."[33] Sartain may have liked the idea of The Gross Clinic at that point, but his views seem to have changed in the following year. As the grand old man among the city's artists and a veteran administrator, Sartain was the logical choice to serve as superintendent of the art department, or chief of bureau, for the Centennial Exposition, which was to open on May 10, 1876. To the Committee of Selection, on which he served as an ex-officio member, he appointed such New York artists as Daniel Huntington, president of the National Academy of Design, and the sculptors John Quincy Adams Ward and Henry Kirke Brown, as well as the sculptor Howard Roberts and the painter Samuel B. Waugh, both Philadelphians. These and other, lesser-known committee members guaranteed that the works of art chosen would be safe and conventional.

The committee rejected The Gross Clinic. (Five of Eakins's other paintings—three oils and two watercolors—were accepted and installed in the Art Building.) William J. Clark, critic for the Philadelphia Evening Telegraph and a friend of Eakins, wrote on June 16, 1876: "It is rumored that the blood on Dr. Gross' fingers made some of the committee sick, but, judging from the quality of the works selected by them we fear that it was not the blood alone that made them sick. Artists have before now been known to sicken at the sight of pictures by younger men which they in their souls were compelled to acknowledge was beyond their emulation."[34] Perhaps one of those sickened in this way was Waugh, official portraitist for Jefferson Medical College, who had painted a commissioned bust-length portrait of Gross in 1874. The flattering sentimentality of his work is put to shame by Eakins's honest characterization of Gross's head.

The Gross Clinic had been placed on view in late April at Philadelphia's Haseltine Galleries, a commercial establishment, where it evoked the following praise from Clark:

> To say that this figure is a most admirable portrait of the distinguished surgeon would do it scant justice: we know of nothing in the line of portrai-

ture that has ever been attempted in this city, or indeed in this country, that in any way approaches it. The members of the clinical staff who are grouped around the patient, the students and other lookers-on, are all portraits, and very striking ones, although from the peculiar treatment adopted they do not command the eye of the spectator as does that of the chief personage. The work, however, is something more than a collection of fine portraits; it is intensely dramatic, and is such a vivid representation of such a scene as must frequently be witnessed in the amphitheater of a medical school, as to be fairly open to the objection of being decidedly unpleasant to those who are not accustomed to such things.

After noting the difficulty in deciphering the patient's position, he went on to say:

> Leaving out of consideration the subject, which will make this fine performance anything but pleasing to many people, the command of all the resources of a thoroughly trained artist, and the absolute knowledge of principles which lie at the base of all correct and profitable artistic practice, demand for it the cordial admiration of all lovers of art, and of all who desire to see the standard of American art raised above its present level of respectable mediocrity. This portrait of Dr. Gross is a great work—we know of nothing greater that has ever been executed in America.[35]

Be that as it may, *The Gross Clinic* was not to be seen in the crowded galleries of the exposition's palatial Art Building. A glance at the catalog and the installation photographs shows that traditional, mainly academic, art dominated the exhibition. Sartain's only concession to modernity was to include four paintings by the French realist Gustave Courbet, and that he did grudgingly.

The Gross Clinic did find its way into the Exposition, but through the back door. It was displayed in the Army Post Hospital (plate 71), a modest two-story structure that was part of the United States Government exhibit. A photograph taken at the exposition shows *The Gross Clinic* on the end wall of the hospital's ward, almost obscured by rows of plain metal beds filled with papier-mâché patients and covered with mosquito netting. Only one guidebook among the many dedicated to the Centennial cited the painting's presence in this display of medical paraphernalia. Its author, James D. McCabe, took Eakins's side, saying that *The Gross Clinic* was "one of the most powerful and life-like pictures to be seen in the Exhibition, and should have a place in the Art Gallery, where it would be but for an incomprehensible decision of the Selecting Committee."[36] Although the ordinary visitor might not have sought out the painting at this site, Eakins's admirers undoubtedly did so. At least one aspiring painter, Charles H. Fromuth, decided to enroll at the Academy on the strength of the impression made by *The Gross Clinic*.[37] Such interest, however, would have been small consolation to Eakins, who, David Wilson Jordan reported, "nearly cried when he saw where his picture that he had counted so much on was put."[38]

71. United States Army Post Hospital
at the Philadelphia Centennial
Exposition, 1876

The painting remained unsold for two years, until it was purchased by the Alumni of Jefferson Medical College, in March 1878. The price paid was two hundred dollars, an amount that barely would have covered the cost of the frame. *The Gross Clinic* hung in the lower lecture hall of the college's Ely Building until 1898, then was moved to the basement library of the new building at Tenth and Walnut streets, where it remained until 1929. For the next thirty years it graced a wall of the second-floor lobby of the college's building at 1025 Walnut Street, and from 1969 it hung in the Eakins Lounge in Alumni Hall. Finally, in 1982, a special Eakins Gallery was created for *The Gross Clinic* and two Eakins portraits owned by the college. It remains on view there today.[39]

From the time of the Centennial to the present, *The Gross Clinic* has been subject to widely varying interpretations and has evoked both lavish praise and brutal condemnation. The passage of time has at least allowed us to see it without the prejudices of early viewers who frowned on its frankly explicit subject and could not comprehend or sympathize with the bold realism of Eakins's style. The Philadelphia newspapers said little about *The Gross Clinic* when it was exhibited at the Centennial Exposition, nor were there more than a few critical comments made about the autotype (a photographic reproduction) of it that Eakins showed at the Penn Club and the Academy earlier in 1876. But when the painting went on view at the second exhibition of the Society of American Artists in New York in March 1879, it inspired a host of critical reactions in newspapers and magazines, most of them unfavorable. According to the critic William C. Brownell, many people who saw the work thought it "both horrible and disgusting."[40] Some critics attacked *The Gross Clinic* because the subject was not appropriate for art. An anonymous *New York Times* critic, for instance, wrote: "This violent and bloody scene shows that at the time it was painted, if not now, the artist had no conception of where to stop, or how to hint a horrible thing if it must be said, or what the limits are between the beauty of the nude and indecency of the naked. Power it has, but very little art."[41] Susan N. Carter

of the *Art Journal* remarked, "To sensitive and instinctively artistic natures such a treatment as this one, of such a subject, must be felt as a degradation of Art."[42]

Not only was Eakins chastised for depicting such a revolting subject, he was ridiculed for being incompetent in drawing, painting, and perspective. The most vehement of these denunciations came from the *New York Tribune*:

> There is no composition, properly so called; there is of course no color, for Mr. Eakins has always shown himself incapable of that, and the aerial perspective is wholly mistaken. . . . The patient lies extended upon the table, but all that we are allowed to see of the body is a long and shapeless lump of flesh which we conclude to be a thigh because, after eliminating from the problem all the known members, there seems nothing but a thigh to which this thing can be supposed to bear any likeness.

This same critic found fault with Eakins's sense of scale and proportion, saying that the scribe, or recorder, seemed "a mile or so away" and the mother of the patient "out of all proportion[,] small compared with the other figures, and her size is only to be accounted for on the impossible theory that she is at a great distance from the dissecting table."[43] The similarly negative reviewer for the *New York Times* said the addition of this figure was unnecessary and found the composition "confused."[44]

Sentiments of this kind permeate much of the criticism directed at the painting. But even those who disliked the work often reluctantly acknowledged its appeal. The *New York Daily Tribune*'s critic, for example, wrote: "As for the power with which it is painted, the intensity of its expression, and the skill of the drawing, we suppose that no one will deny that these qualities exist."[45] The *New York Herald*'s critic commented that the picture was "sickeningly real in all its gory details, though a startlingly life like and strong work."[46]

A few critics saw clearly what Eakins was trying to do and wrote eloquently about his achievement. Two of these in particular, Earl Shinn and William C. Brownell, knew Eakins personally—the former as a close friend, the latter as the writer who had interviewed him for an article about the Pennsylvania Academy. The earlier of the two reviews, by Shinn, compared *The Gross Clinic* to Rembrandt's *Anatomy Lesson of Dr. Tulp*, pointing out that Eakins had simply updated the seventeenth-century masterpiece in modern terms (not an entirely accurate comparison). Shinn praised Eakins for having successfully subdued the subordinate figures so that they were "all connected with the central action by the most vivid expression in interest." Whereas hostile critics had attacked the figures of Gross and the cringing mother, Shinn found them appealing: "The effect of the aged and quiet professor, in a sharp perpendicular light, as he demonstrates very calmly with a gesture of his reddened fingers, is intensely dramatic. Equally so is that of the horror-stricken mother." He did voice one reservation: "A tendency to blackness in the flesh-shades is the principal artistic infelicity in this curious and learned work."[47]

Brownell was even more emphatic in his approval:

A masterpiece of realism in point of technique, [it] is equally a masterpiece of dramatic realism, in point of art. The painter increased rather than diminished the intensity which it is evident he sought after, by taking for a theme a familiar and somewhat vulgar tragedy of every-day occurrence in American hospitals, instead of an historic incident of Rome or Egypt. The play of emotions which is going on is strong and vivid. The chloroformed patient is surrounded by surgeons and students whose interest is strictly scientific, his mother who is in an agony of fear and grief, and the operator who holds a life in his hand and is yet lecturing as quietly as if the patient were a blackboard. Very little in American painting has been done to surpass the power of this drama.[48]

Brownell went on to explain that "every element of ideality has been eliminated." The artist, Brownell observed, did not seek beauty in the conventional sense: for him, "whatever is is beautiful."[49]

This last phrase summarizes the aesthetic position of the realists in France, and it was just this stance that made Eakins so hard for his contemporaries to tolerate. The critical controversies over *The Gross Clinic* reflected not only individual differences in taste but also a generation gap: Eakins represented what in the mid- and late 1870s was a troubling new style, based on a selective and dramatic realism yet with a scientific cast. It was thus unnervingly novel to most in the Philadelphia and New York art worlds, an audience that was still enchanted with notions of ideal beauty and poetic sentiment. Eakins boldly discarded those traits in a powerful and courageous visual manifesto of his own beliefs.

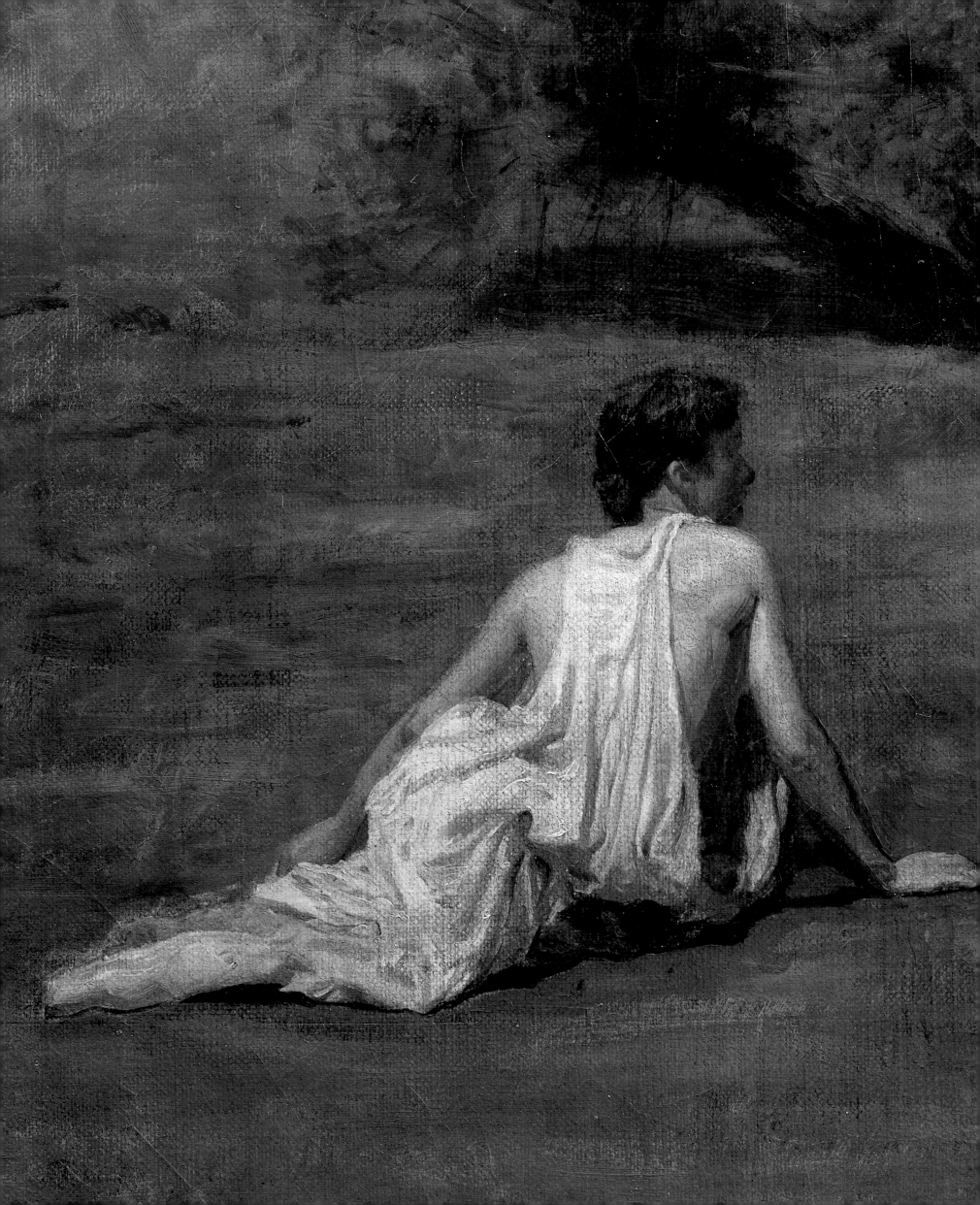

4.
In Search of Patrons and Independence

Between 1875, when Eakins painted *The Gross Clinic*, and 1886, when he would be driven out of the Pennsylvania Academy of the Fine Arts, was the period of his greatest and most varied achievement. During this time he became an accomplished figure painter, using the human body as his chief means of expression. He also continued to produce portraits and scenes he knew from his own daily life, and he turned as well to subjects from the earliest part of the nineteenth century, providing reflective, nostalgic glimpses of the American past. In addition, Eakins ventured into the field of history painting, portraying specific events, though these were the exception rather than the rule. And in one unique instance, he even painted a religious subject, a life-size Crucifixion.

This stage in Eakins's life as a painter was characterized by maturity and exceptional confidence. He seems to have found himself and no longer had to grope for an appropriate style. Indeed, Eakins's later work shows no particular changes, other than a gradual refinement in his technique. It is as though he established his language of representation and expression by the mid-1870s and essentially performed only variations on it throughout the rest of his life. He was a tonal artist, working primarily in tans, browns, and blacks, highlighted by an occasional vivid accent or broad area of bright color. His subdued tonalities and use of warm, revealing light are much like Rembrandt's, and in this way he joined the revival of seventeenth-century Dutch painting by American artists during the second half of the nineteenth century. Eakins may have learned something, too, from the realists in France and from the French Barbizon school and its American exponents. In his outdoor paintings, exceptions to his dark palette can often be found, but even so his tonalities never became brighter than Courbet's or Manet's.

In a curious sense, Eakins was both progressive and conservative. His style seemed radical to many Philadelphians, and as a result he found it difficult to

72. Detail of *An Arcadian*, c. 1883. See plate 94.

73. Frederick Gutekunst (1831–1917)
Thomas Eakins at about Thirty-five
Photograph
Mr. and Mrs. Daniel W. Dietrich II

attract buyers and admirers in his native city. Yet his manner of painting varied relatively little from the mid-1870s onward, and so he could be regarded as a conservative, seemingly immune to change. Seen in the context of the larger American art world, particularly the progressives associated with the New York–based Society of American Artists, Eakins's work may have appeared rather tame and traditional, especially in the 1880s and later. The variety of styles and the steady influx of new visual ideas from Europe must even have made him seem quite provincial, although he was highly respected by several critics and some of his fellow artists. Impressionism, Symbolism, and the Aesthetic movement, under the influence of James McNeill Whistler and the Japanese, had a strong constituency in New York. By contrast, Eakins's paintings were often viewed as literal, dry (in his most finished works), correctly drawn to the point of academic stiffness, and lacking in verve.

Previous writings on Eakins have suggested that he was a sturdy independent who painted as he pleased, without caring how his work affected other people, including possible patrons for his portraits. That image of the man, however, now appears to be inaccurate. Indeed, once he felt he had attained the necessary technical competence, Eakins wanted very much to exhibit his work, to sell it through regular channels, and to attain favorable recognition. His letters to his father from Paris suggest that Benjamin drove his son to achieve financial success through his painting. One can picture Benjamin's suggesting that Thomas paint sample portraits of distinguished sitters, without charge, to encourage paid commissions. One can also imagine Benjamin's agreeing with his son's choice of sporting subjects because of their wide appeal and easy accessibility to the public. And one wonders whether Eakins had his eye on the marketplace when he painted nostalgic scenes—almost always of women in costumes from earlier in the century—in vignettes that capitalized on the new interest in early America stimulated by the Centennial Exposition. Of course, Eakins may have had a genuine feeling for these subjects, but the possibility of his having chosen them for their commercial appeal cannot be ruled out.

Despite Eakins's skill as an artist, he sold relatively few paintings and won only a small number of portrait commissions in the years between 1875 and 1886. Worse, he had to endure a substantial number of negative criticisms of his paintings and periodic rejection of them by juries both in New York and Philadelphia. At the height of his power as an artist, he became increasingly disillusioned and jaded, feeling that he had put forth his best effort yet had failed to win support from collectors and critics. True, there was a small minority who always admired him, but this group remained exactly that—a minority. Lengthy articles about him and his work during his lifetime were conspicuous by their absence; the accolades that were heaped on Whistler, John Singer Sargent, and William Merritt Chase eluded Eakins. It is no wonder that from time to time discouragement outweighed optimism in his view of the art world and his place within it.

After concentrating on a single monumental painting in 1875, *The Gross Clinic* (plate 65), Eakins devoted his attention during the following year to a variety of different subjects—portraits; figures in interiors, both contemporary

and "nostalgic"; and history paintings—as if to release himself from the narrow focus on one major image. Of all those works produced in 1876, his portraits are the most interesting and revealing. *Dr. John H. Brinton* (plate 75), for example, shows how rapidly he had attained maturity and remarkable competence as a portrait painter. The artist obviously admired Brinton, whom he painted because he wanted to, not because he was paid to. Looking ahead, however, Eakins no doubt hoped that the work would bring him commissions for other portraits.

In 1876 Brinton was a member of the faculty of Jefferson Medical College, from which he had received his M.D. degree in 1852. After some years in private practice in Philadelphia, followed by staff duties at St. Joseph's Hospital in that city, he received a commission as a volunteer surgeon in the Union army early in the Civil War. That conflict tested his abilities as administrator, as surgeon, and even as author, for he was assigned the task of preparing *The Surgical History of the Rebellion*. For this, he assembled a comprehensive collection of specimens illustrating the variety of wartime wounds, items that became the core of the United States Army Medical Museum in Washington, D.C. (now part of the National Museum of Health and Medicine of the Armed Forces Institute of Pathology). After the war Brinton resumed his practice in Philadelphia and in 1866 was named to the faculty of Jefferson. There he became a protégé of Dr. Gross and, in the year after Eakins painted Brinton's portrait, he was named president of the staff. Following Gross's retirement from the chair of surgery in 1882, Brinton and Gross's son Samuel Weissel Gross were jointly named as his successors.

Although the tonality of *Dr. John H. Brinton* recalls Eakins's portrait of Professor Benjamin Howard Rand (plate 47), the amateurish quality of that cluttered earlier work has given way to a simple composition of great dignity. Eakins has carefully and thoughtfully placed Brinton in the center of the canvas and surrounded him with just enough space to encompass his forceful personality. Brinton is casually seated with legs crossed—a pose that is formal yet relaxed. Strong light coming from the left strikes his head, throwing approximately one-third of his face into shadow, and accents his hands. As so often happens in Eakins's later portraits, the figure is tilted at a diagonal, bringing energetic life to what might have been a stilted and rigid pose.

Later in the year that he made the Brinton portrait, Eakins asked Archbishop James Frederick Wood, a pillar of the Catholic church in Philadelphia, to pose for him. How the artist became acquainted with Wood is not known, but it was most likely through Dr. Gross, a close friend of the archbishop. Eakins probably decided to paint him to provide another example of his abilities as a portraitist, while also addressing himself to a reasonably large group of potential patrons—the local dignitaries of the Catholic church. The portrait (Saint Charles Borromeo Seminary, Overbrook, Pennsylvania), completed in 1877, is impressive, showing Wood seated, in full clerical robes, in a rigidly upright pose with his hands spread out on his knees. One senses that Eakins did not have the same vital personal interest in the archbishop as in Gross and Brinton but that he had nonetheless tried his best to create a telling likeness within the context of the formal portrait. Unfortunately, the painting has been

74. *Study for "Archbishop James Frederick Wood,"* 1876
Oil on canvas, 16 x 12⅛ in.
Yale University Art Gallery, New Haven, Connecticut; Bequest of Stephen Carlton Clark

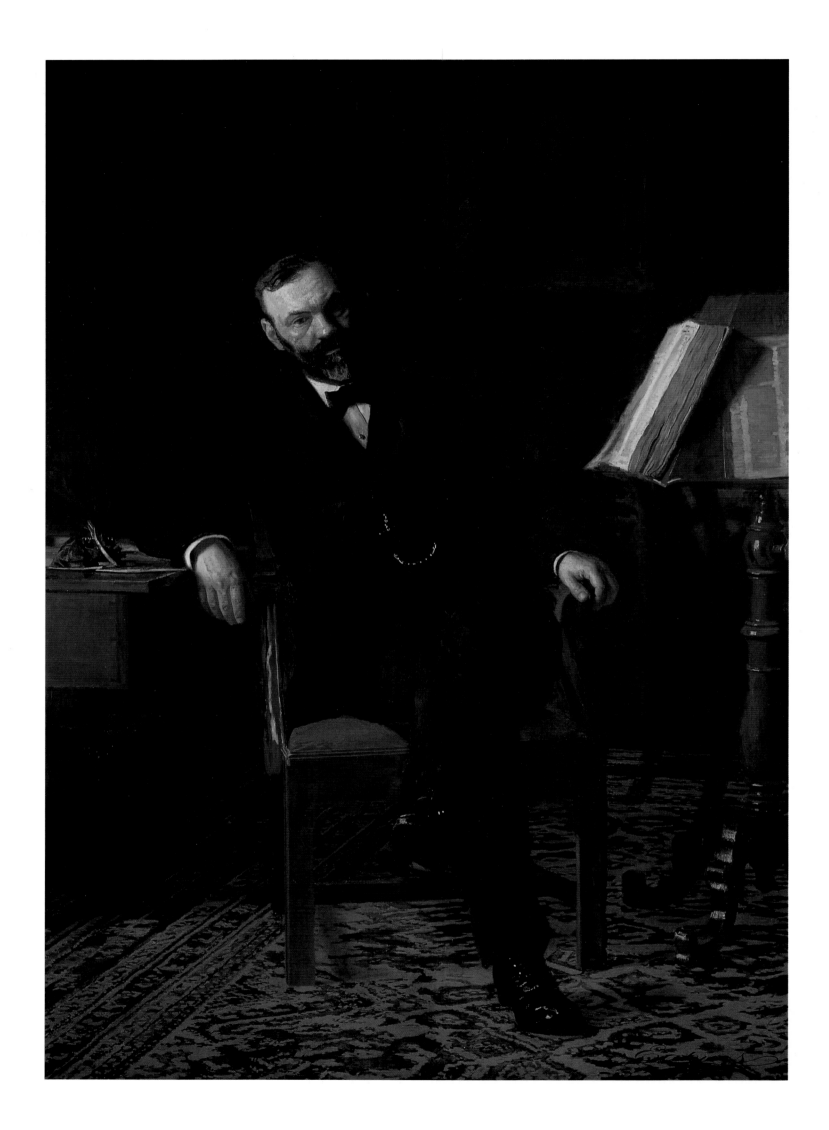

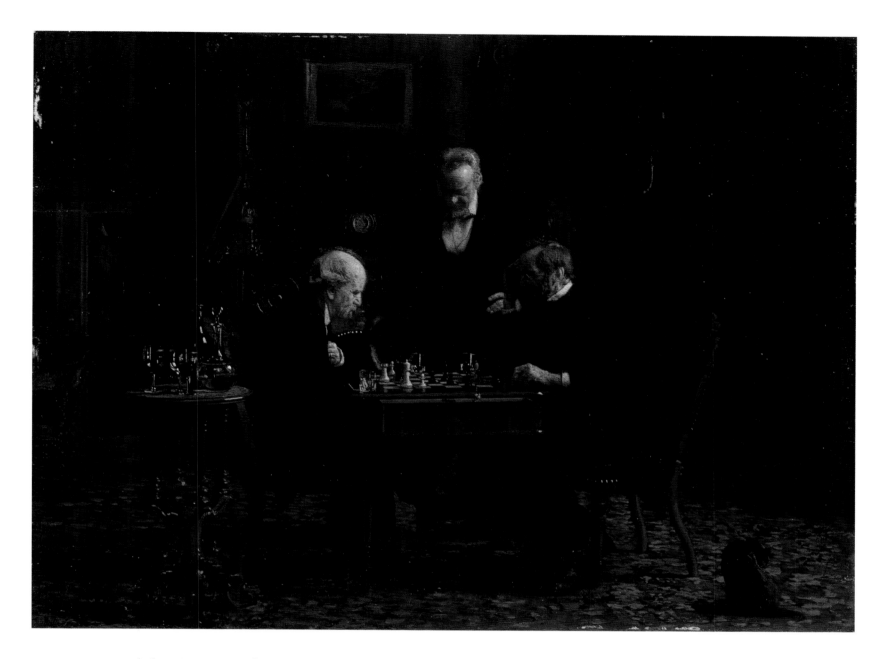

so overrestored that it is not what it originally must have been; only a small oil study (plate 74) preserves the breadth and vigor of Eakins's initial conception.

Soon after Eakins's portraits of Brinton and Wood were displayed at the Pennsylvania Academy in the spring of 1877, his voluntary efforts seem to have paid off: he received his first commission for a portrait, that of Rutherford B. Hayes, nineteenth president of the United States. Members of the Union League of Philadelphia, a socially elite stronghold of the Republican party, had decided that they wanted a portrait of Hayes to hang with those of other notables in their stately clubhouse on South Broad Street, just a stone's throw from City Hall. Eakins was offered four hundred dollars for the job. There is no record of how or why he was chosen, but in all probability a prominent club member connected with the Pennsylvania Academy—such as Fairman Rogers, a member of the Academy's board, or Dr. William W. Keen, professor of artistic anatomy—recommended Eakins. The painter himself was a staunch Republican, but he did not belong to the Union League, nor is it likely that he would have been elected. He was not a joiner, and he did not rank high enough socially to qualify for membership. His only known connection with the league before receiving the commission was his exhibition of two paintings there in

Opposite
75. *Dr. John H. Brinton*, 1876
Oil on canvas, 78⅜ x 57⅛ in.
On loan to the National Gallery of Art, Washington, D.C., from the National Museum of Health and Medicine of the Armed Forces Institute of Pathology, Washington, D.C.

Above
76. *The Chess Players*, 1876
Oil on canvas, 11¾ x 16¾ in.
The Metropolitan Museum of Art, New York; Gift of the artist, 1881

April 1871: a portrait of M. H. Messchert, now lost, and *The Champion Single Sculls* (plate 48).

Rutherford B. Hayes had been inaugurated as president only a few months before the portrait was ordered. His election had been tarnished by controversy, for Democrat Samuel J. Tilden had won the popular vote by three hundred thousand ballots; Hayes won the presidency in the electoral college by only one electoral vote. The Republicans' agile political maneuvering and promises to the Democrats sealed the victory, but to many it seemed a dirty campaign. Hayes himself tried to stay above the fray and once in office gave deserving Southern Democrats places in the federal government, promoted the rights of black Americans, eschewed the patronage system for political appointments, and advocated a "sound money" policy.

It was first suggested that Eakins paint Hayes from a photograph, but the painter insisted that the president sit for him in person. Eakins pressed for the opportunity to do a full-length portrait—a grander work than the league officials had in mind—though admitting that he would have to confine himself to the head alone if the president would not pose long enough. With characteristic aggressiveness he wrote to the chairman of the league's committee, George D. McCreary:

> If he [Hayes] is disposed, however, for a full-sized portrait similar to the Dr. Brinton composition I would undertake it with equal spirit but of myself I would select the size you mentioned. A hand takes as long to paint as a head nearly and a mans hand no more looks like another mans hand than his head looks like another's, & so if the president chose to give me the time necessary to copy his head & then each of his two hands, (for I would not be inclined to slight them) then it would seem a pity not to have the rest of him when I know how to paint the whole figure. The price in either case can remain the same as you mentioned.

Eakins then urged the committee to delay making a final decision until he could negotiate with Hayes.[1]

Eakins painted the president in August and September of 1877 and found him reluctant to cooperate. Having told Eakins that he had sat for another portrait painter for only fifteen minutes, Hayes remained still only briefly. The rest of the time "he wrote, took notes, stood up, swung his chair around." It is no wonder that Eakins was frustrated, for he "had to construct him as [he] would a little animal."[2] We will probably never know exactly what the finished product looked like, because it has disappeared. It is clear, however, that Eakins had to settle for something less than a full-length treatment. One newspaper account provided a general description, noting that the subject, "garbed in his old alpaca office coat," was seated at a table, his right hand holding a lead pencil.[3] Another critic complained that the portrait did not resemble the president and that by following Rembrandt's "most extreme theories of chiaroscuro" Eakins had too eagerly sought an "effect." According to this report, Eakins had placed his sitter in a dark room (his office) "with one ray of light striking his right temple from behind."[4]

The painting was placed on view at the Haseltine Galleries in Philadelphia in the winter of 1877–78 before being hung at the Union League. It was not long before certain members raised their voices in dissent. As the story goes, the president's red face—flushed with the summer heat and shown that way by Eakins—suggested that he was an intemperate drinker.[5] (Actually, just the opposite was the case; while in the White House, Hayes was a teetotaler.) The suggestion of drink invoked by Hayes's rubicund face may only have been an excuse. No doubt more troubling to many league members was Eakins's unconventional way of presenting the president in his everyday work clothes. In addition, the effect of the Rembrandtesque lighting probably disturbed those who were accustomed to portraits with a brighter, more even illumination. In any event, the painting was quietly taken down in 1880 and replaced by a much more flattering work by William Carl Brown, Hayes's favorite artist. Eakins's canvas was sent to the president in Washington, where it was most likely destroyed. His first opportunity to create an impressive portrait for pay was a failure.

Much like the Brinton and Wood portraits (and presumably that of Hayes) in its tonality and handling of light is Eakins's *Chess Players* (plate 76), a cross between a group portrait and a genre scene. This work portrays Bertrand Gardel (at the left), who taught French to Thomas and Frances Eakins, and George W. Holmes (at the right), an artist who had often gone sketching with Benjamin and Thomas Eakins and who operated an art school in Philadelphia. The players are overseen by the artist's father, standing at the center. The mood is one of utmost seriousness, with the players concentrating intensely on the game at a moment when Gardel is losing. Light plays on the heads of all three men, but only Gardel is fully illuminated. As was often the case, Eakins painted the objects in the scene as precise still lifes.

This was probably a scene that Eakins had observed many times at the family home on Mount Vernon Street. It is also a personal testament to his affection for two beloved family friends and, of course, his father. But the painting signifies more than that: it is a celebration of a highly intellectual game that had begun to enjoy great popularity in the United States and, more specifically, of a moment of intense concentration on the next move. *The Chess Players*, then, concerns the quiet, focused exercise of the intellect—a portrait of Eakins's own cast of mind. As the art historian Robert Torchia has pointed out, apropos of this period, "Creativity in chess has always been equated with creative genius in the fine arts."[6]

Much of the same sober intellectualism can be found in *Baby at Play* (plate 77). In this painting of his niece Ella, the first child of Frances and William Crowell, the artist endows the two-year-old with the solidity of the pyramids, her massive form articulated by direct sunlight on the brick patio behind the Eakins house. (A photograph of the child on this site, along with her mother and Maggie Eakins, presumably by Thomas Eakins, is reproduced as plate 78.) The title of the painting might suggest frivolity, but Eakins portrayed Ella concentrating solemnly on a construction of blocks. She has laid only the first of these, but the assorted blocks beside her suggest that she will soon build something of substance—a procedure that, in Eakins's mind, may have paralleled his rigorous

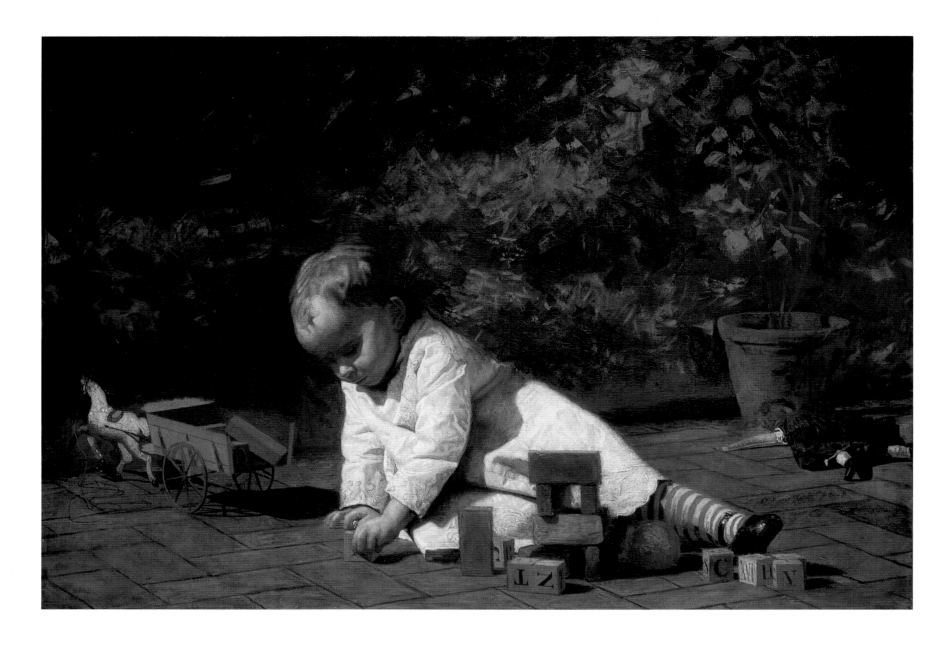

Above

77. *Baby at Play*, 1876
Oil on canvas, 32¼ x 48⅛ in.
National Gallery of Art,
Washington, D.C.; John Hay
Whitney Collection

Right

78. Thomas Eakins(?)
M. E. Eakins, Ella Crowell, and
Francis E. Crowell (in yard, Mt.
Vernon Street), c. 1874
Photograph
The Metropolitan Museum of Art,
New York; Gift of Joan and Martin
E. Messinger, 1985

structuring of the painting. To emphasize the child's mental effort, the artist has shown her doll cast aside, and her horse and carriage (representing movement and transience) are pointed away from Ella.

After *The Gross Clinic*, Eakins's *William Rush Carving His Allegorical Figure of the Schuylkill River* (plate 84) was his most ambitious and thoughtfully conceived painting. A noted Philadelphia sculptor and ship carver who was active in the late eighteenth century and the early part of the nineteenth, Rush is shown creating a wooden figure for a fountain in the waterworks at Center Square. This image, commemorating an event that took place in 1809, is one of Eakins's few historical subjects. Rush's female figure, portrayed in the style of a Greek or Roman sculpture, holds a bittern, a bird that frequented the banks of the Schuylkill and hence was an appropriate symbol for that body of water (plate 82). Rush used as his model Louisa Van Uxem, the twenty-seven-year-old daughter of a prominent merchant. Philadelphians are said to have raised a collective eyebrow when the sculpture was unveiled because too much of Van Uxem's voluptuous form was visible beneath the clinging drapery.

Eakins shows Rush carving from the nude model even though there is no evidence that the sculptor ever worked from the undraped figure. In all likelihood Eakins invented this scene for personal reasons. By citing the precedent of Rush, who had been a member of the City Council and on the board of the Pennsylvania Academy, Eakins sought to confer respectability on his own use of the nude in painting and teaching. The work is thus a statement of his beliefs about the crucial role of the nude figure in the creation of a work of art. Also, Eakins's choice of Rush's era may have been fostered by the interest in the American colonies and the early Republic that grew out of the Centennial Exposition. Indeed, he may have turned to the Rush theme in part to capitalize on this interest, to make a painting that was immediately salable in a way that *The Gross Clinic* had not been.

To guarantee the accuracy of *William Rush Carving His Allegorical Figure of the Schuylkill River*, Eakins followed the methods of history painting favored by French academic artists—particularly Gérôme, who investigated the archaeological details of his subjects with the greatest care. Eakins went to the site of Rush's original studio (which had been torn down) at Front Street below Callowhill, visited some elderly people who remembered it, and based the setting on their recollections. He found a similar shop and painted a small oil sketch of its interior (now in the Philadelphia Museum of Art). Moreover, he discovered a sketchbook by Rush that one of his apprentices had preserved (it is now lost), which recorded scrolls and drawings that would have been on the wall; those images became the subject of several preparatory sketches (now in the Bregler Collection, Pennsylvania Academy of the Fine Arts) and appear in the final painting. Eakins studied the costumes of the figures by looking at contemporary prints and a painting by John Lewis Krimmel, *Fourth of July Celebration at Centre Square* (plate 79), which shows Rush's *Water Nymph and Bittern* shortly after its installation.

Even more practical was Eakins's creation of small wax models for some of the subjects to be incorporated in the painting (plate 80): the nude model (now

lost), the carving of the nymph, and several other works by Rush, including *George Washington* and *The Schuylkill Freed* (apparently Eakins was unaware that these two pieces were not done until later). He also modeled a portrait head that resembled Rush—a composite probably taken from Rush's sculptural self-portrait and from the painted portrait of him by Rembrandt Peale in Independence Hall. By making these small preparatory sculptures, and very likely using them to paint from, Eakins was again following the example of Gérôme.

Several preliminary painted studies also illuminate Eakins's creation of this important work. The initial oil sketch for the entire composition (plate 81) shows the chief elements of the final painting but arranged in a rather different way: the chaperone is facing away from the nude model rather than toward her; the chair with the latter's clothing has not been introduced; and Rush appears clad as a workman rather than a gentleman. The statue of the nymph is turned away from us, whereas it appears in a three-quarter frontal view in the completed painting. Of particular note is the difference in the handling of the nude model. There is something earthy and awkward about the figure in the study that was changed considerably—and greatly improved in grace and rhythm. This shift was due, in part, to Eakins's replacing the original model with the more shapely Anna W. (Nannie) Williams, a friend of one of his sisters.

Another study of the figure alone (plate 83) suggests that Eakins was troubled by the nude in the larger sketch for the composition, because he brought the model's left arm away from the body and tilted her pelvis and shoulders at opposite angles from each other, providing a degree of rhythmic contrapposto absent in the earlier version. However, the secret to Eakins's final success in posing the

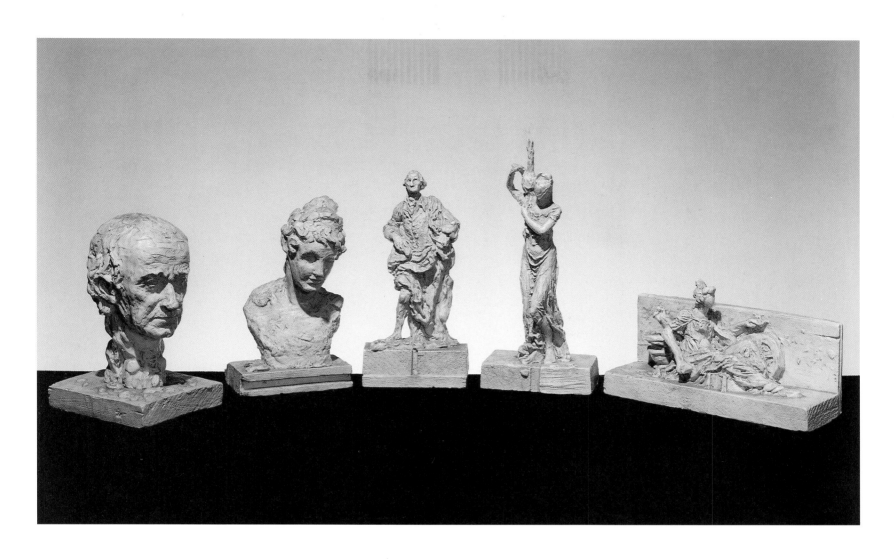

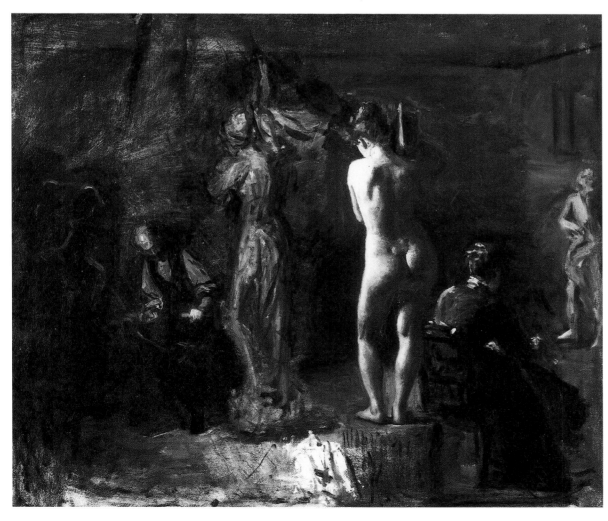

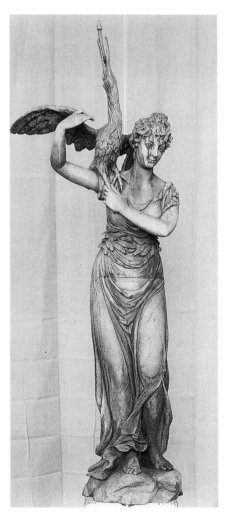

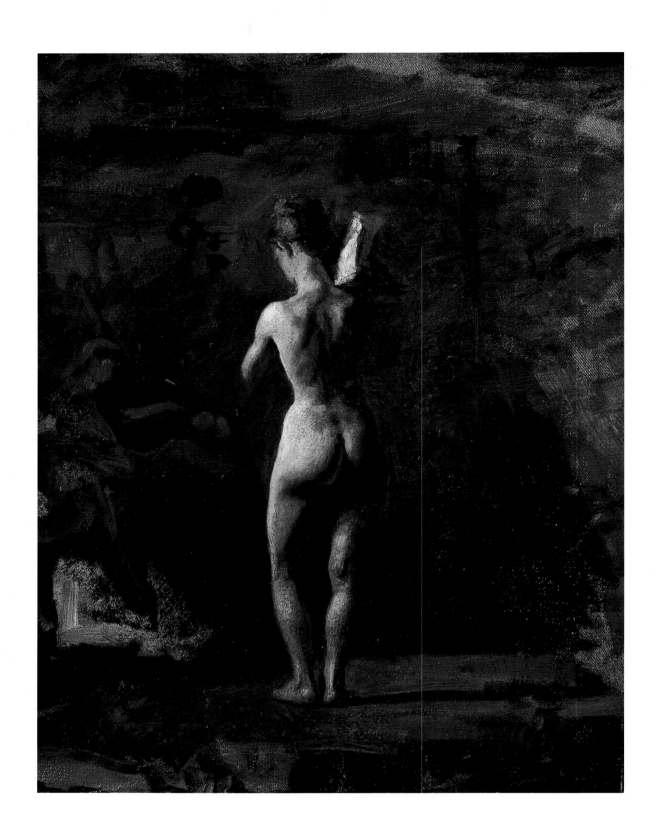

83. *Study for "William Rush Carving His Allegorical Figure of the Schuylkill River,"* 1877
Oil on canvas on cardboard,
14⅛ x 11¼ in.
The Art Institute of Chicago;
Bequest of Dr. John J. Ireland

nude figure was to turn her slightly to the left and thereby create a more graceful line from her armpit down to the tip of her left foot. Furthermore, he simplified the lighting so that only a few planes stand out. One might even say that he became somewhat more "classical," in the sense that the ideal and the real strike a harmonious balance.

The final painting makes the nude figure and her clothes draped over the chair the chief points of interest. There is an interesting visual play between these two elements, with the clothing's bright colors serving as a foil to the warm flesh of the model. Indeed, the juxtaposition of her garments with her stark nudity makes the effect of nakedness even more striking. This contrast did not escape the *New York Times* critic who wrote negatively about the painting when it was

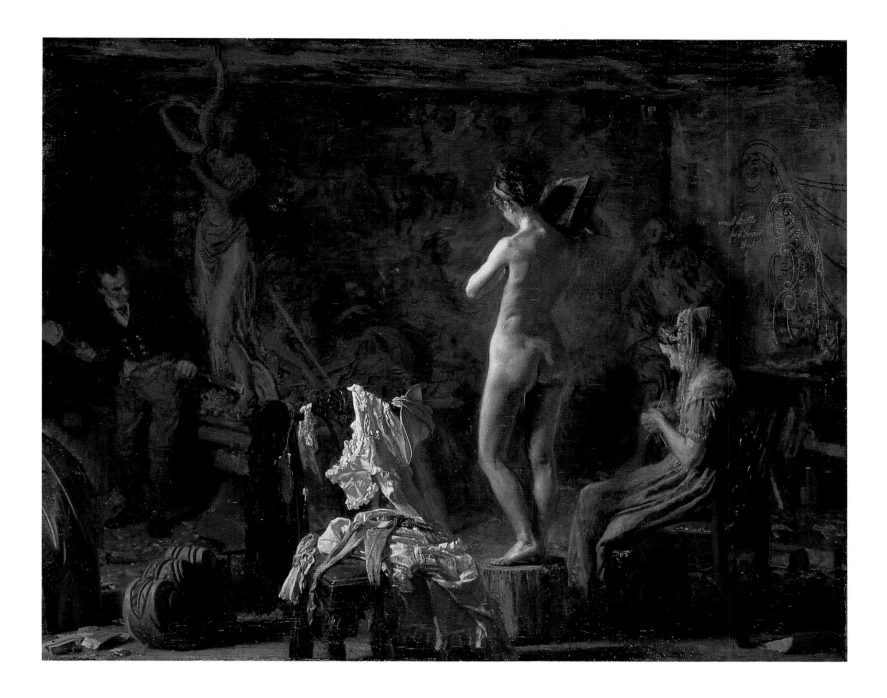

shown at the Society of American Artists in 1878: "What ruins the picture is much less the want of beauty in the nude model, (as has been suggested in the public press,) than the presence in the foreground of the clothes of that young woman, cast carelessly over a chair. This gives the shock which makes one think about the nudity—and at once the picture becomes improper!"[7]

It would be hard to argue that there is any overt eroticism in the picture. Eakins's inclusion of the chaperone is a bow to respectability, and even though his treatment of the nude is tactile it could hardly be called sensual. He seems to have gotten real pleasure from painting her accurately and honestly, and that effort constitutes a great part of the painting's message. The intense light striking her left side, giving her more importance than anything else in the painting, raises her almost to the status of an icon. She is a sacred presence in this secular statement of the importance of the nude human figure.

A series of pictures by Eakins pays homage to the American past and parallels his Rush paintings in costume and furniture, though their subjects are far more chaste. The first of these, *In Grandmother's Time* (plate 86), whose title sug-

84. *William Rush Carving His Allegorical Figure of the Schuylkill River,* 1877
Oil on canvas, 20⅛ x 26⅛ in.
Philadelphia Museum of Art; Given by Mrs. Thomas Eakins and Miss Mary Adeline Williams

gests a period around 1810, is not necessarily about his own grandmother but about age and tradition in general. In this sedate and peaceful image Eakins glorified hand labor in a manner quite the opposite of the celebration of medicine, science, and the machine in so many other of his works from this decade.

In several works from this period Eakins extracted from the Rush painting the image of the elderly chaperone doing her needlework. One of these is *Seventy Years Ago* (plate 85), a watercolor of an old woman deeply involved in knitting. Like *In Grandmother's Time,* it concentrates on a painstaking manual effort, and to reinforce this tradition of handwork the artist included a spinning wheel in the background.

Eakins's paintings of these early nineteenth-century subjects were not limited to the elderly; occasionally younger people are featured, as in *The Courtship* (plate 87), in which a young man relaxes in a chair, gazing at a young woman at a spinning wheel. She seems to have been borrowed from similar paintings of the same subject by Eakins, such as *Spinning* (1881; location unknown) and *Homespun*

(1881; Metropolitan Museum of Art), though the young man represents a new element. Perhaps *The Courtship* reflects Eakins's own relationship with Kathrin Crowell; if so, the degree of passion and involvement on the part of the male is tellingly limited, for he is a casual spectator rather than an urgent suitor.

These nostalgic paintings are not, with the exception of the Rush canvas, portrayals of specific events. Around 1876, however, Eakins turned briefly to history paintings as such, again possibly under the influence of the Centennial Exposition. That international fair included displays celebrating not only colonial society but all facets of the nation's past. Thus Christopher Columbus could easily have been brought to Eakins's attention as a worthy subject. Probably basing his painting on an episode from Washington Irving's popular four-volume *History of the Life and Voyages of Christopher Columbus* (1828), he painted a small

87. *The Courtship*, c. 1878
Oil on canvas, 20 x 24 in.
The Fine Arts Museums of San Francisco, Museum purchase by exchange; Gift of Mrs. Herbert Fleishhacker, M. H. de Young, John McLaughlin, J. S. Morgan and Sons, and Miss Keith Wakeman

88. *Columbus in Prison*, c. 1876
Oil on canvas, 5⅝ x 7¼ in.
Mr. and Mrs. William du Pont III

oil (plate 88) showing the explorer shackled to an iron ball—a study for a larger work that was never executed.

On his third voyage to the New World, Columbus had been charged with cruelty in his administration of Hispaniola, and Spain's emissary Francisco de Bodadilla had him sent home in chains. As Irving remarked: "This outrage to a person of such dignified and venerable appearance, and such eminent merit seemed, for the time, to shock even his enemies."[8] The site in Eakins's painting cannot be identified; perhaps it represents the ship's hold or a prison in Cádiz, where Columbus arrived near the end of November 1500. Originally he was shown sitting cross-legged on a bench, but his right leg was cropped out when the painting was cut down to its present dimensions. Columbus is obviously dejected, yet resigned. Irving observed, "There is a noble scorn which swells and supports the heart, and silences the tongue of the truly great, when enduring the insults of the unworthy."[9]

Did this subject mean anything more to Eakins than a traditional historical narrative? Unconsciously, he may have used it as a symbol of his own struggle with the established Philadelphia art world. *Columbus in Prison*, which was probably painted after the rejection of *The Gross Clinic*, could be seen as relating to Eakins's own plight. In both instances a prominent figure who had explored uncharted territory was condemned by his enemies.

Inspiration for another history painting came from a much later era: the surrender of General Robert E. Lee, leader of the Confederate army. Two small oil sketches for a contemplated (but never executed) canvas indicate in a sum-

89. *Sketch for "The Surrender of General Robert E. Lee,"* c. 1875
Oil on canvas on fiberboard,
13⅛ x 10 in.
Hirshhorn Museum and Sculpture Garden, Smithsonian Institution, Washington, D.C.; Gift of Joseph H. Hirshhorn, 1966

mary way the aging general, with one of his aides standing beside him. In one case (plate 89) the pair looks to the right, in the other (in the estate of Mrs. Charles Bregler), to the left. We cannot tell whether these sketches represent the complete design of the painting or whether, as is so often the case, they are studies for only part of it.

Eakins had not fought in the Union army—indeed, he bought his way out of military service[10]—but the Civil War was obviously of interest to him. Perhaps his Quaker roots led him to represent a scene of anticipated reconciliation rather than the conflict itself. And once again he portrayed a great man, a hero who demonstrated exceptional skill in battle and maintained the highest ideals of per-

90. *The Crucifixion*, 1880
 Oil on canvas, 96 x 54 in.
 Philadelphia Museum of Art; Given
 by Mrs. Thomas Eakins and Miss
 Mary Adeline Williams

sonal integrity. Lee's defeat, like Columbus's imprisonment, surely had some personal meaning for Eakins. Consciously or unconsciously, the painter may have identified with these two notable men who had maintained their dignity and self-control even under the most adverse circumstances.

Very different from these works—and from any other work by the artist— is a remarkable painting made in 1880: *The Crucifixion* (plate 90). It is astonishing that Eakins painted this picture. Best described as an agnostic, he was not a member of any church and his attacks on Christianity, particularly the Catholic church, were frequent. Eakins never gave any explanation for the painting, though he is supposed to have said that "he had never seen a picture of the Crucifixion in which the body was really hanging on the cross, or seemed to be in the open air."[11] It is possible that he painted *The Crucifixion* as a declaration of opposition to sentimentalized treatments of the subject. At the height of his powers as an artist and confident of his ability to make any visual statement he pleased, he may have created this work with a full awareness of the controversy it would inevitably generate. Eakins's belief in realism was so much greater than his concern for religious propriety that *The Crucifixion* could be read as a statement of his own painterly "religion."

The model for the picture was Eakins's pupil J. Laurie Wallace, who was strapped onto a cross outdoors under the direct light of the sun. (There are various stories about where this took place, either in the New Jersey countryside, or on the rooftop of the Eakins house in Philadelphia.) In any case, the final result is a convincing image of a human body, inert on the cross, its weight supported only by its outstretched arms. Every detail of the anatomy is visible, and nothing is left to the imagination except the face of the subject, which is shrouded in shadow—Eakins's only concession to mystery or spirituality.

Eakins submitted *The Crucifixion* to the fifth exhibition of the Society of American Artists, held in the spring of 1882, but it was rejected and shown only in a supplementary exhibition in May of that year. No one bought the work during Eakins's lifetime, even though it was displayed in a variety of exhibitions. For a number of years, the artist lent it to Saint Charles Borromeo Seminary in nearby Overbrook, Pennsylvania, where it apparently was accepted by the priests and seminarians without controversy.

Eakins spent most of his time in the late 1870s and early 1880s painting scenes of everyday modern life. That world was populated by ordinary working people, usually deep in quiet concentration, as in *The Zither Player* (plate 95). There is no flourish here, nothing spectacular or eye-catching. Although the subject was taken from Eakins's own time, there is an air of antiquity about the painting, thanks to the presence of a Chippendale tilt-top table and side chair as well as a Jacobean chair. Their inclusion provides a generalized sense of age and tradition rather than the re-creation of a particular period.

No such hints of history appear in Eakins's outdoor genre scenes—especially those executed at Gloucester, New Jersey. This was the site of an active shad-fishing industry, and Eakins and his family often crossed the Delaware by ferry to watch the fishermen and to partake of their catch. Fascinated by such fishing scenes, Eakins made a great many photographs there, both of figures and

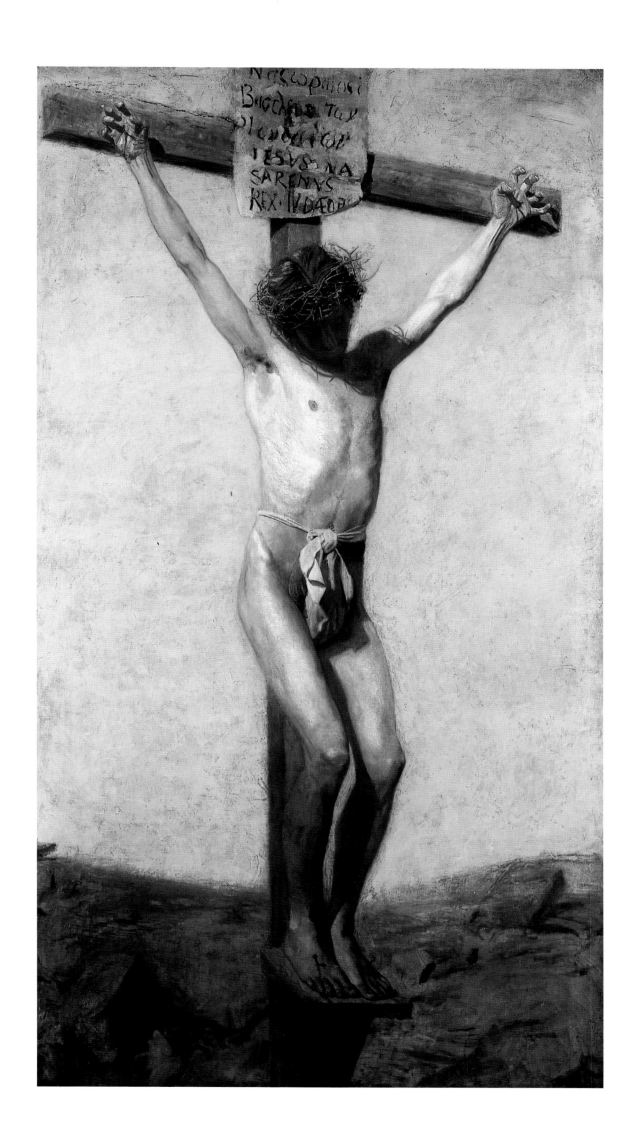

of the water. Based on his own observations and on information derived from these photographs, he composed several oils, a number of small oil sketches, and a group of watercolors.

Shad Fishing at Gloucester on the Delaware River (plate 91) and *Mending the Net* (plate 132) are two characteristic oils that resulted from these visits. Both are landscapes with figures, not figure paintings as such, and they offer a vivid sense of the setting. In *Shad Fishing at Gloucester* the fishermen stand almost motionless, holding or gently pulling their nets. Their activity is observed by a man and three women, possibly members of the Eakins family, who stand stolidly on the shore. In *Mending the Net* the primary focus is on the fishermen themselves, as they perform their tasks thoughtfully and without drama.

In both of these works, especially *Mending the Net*, the figures are spread across the landscape like actors on a stage. Paying particular attention to the stance, gesture, and silhouette of each, Eakins tried to chronicle their individual activities in a telling manner. He succeeded, but he placed so much emphasis on characterizing the individual that they tend to be visually isolated rather than integrated with each other, except in small clusters. Possibly his reliance on photographs for general study and as specific sources for some of the figures obscured the need for making certain adjustments required for pictorial unity.

Around 1883 (give or take a year or two) Eakins briefly abandoned his strong commitment to realism to explore Arcadian themes. From this campaign came an important oil painting, *Arcadia* (plate 138), and a smaller work, *An Arcadian* (plate 94), as well as oil sketches and photographic studies for these pictures. Also at this time he portrayed Arcadian subjects in sculptural relief—most notably, *Arcadia* (plate 93), *A Youth Playing the Pipes* (1884; Philadelphia Museum of Art), and *An Arcadian* (1883; Pennsylvania Academy of the Fine Arts). These subjects were inspired by the image of pastoral ancient Greece, celebrated by Theocritus and later by Virgil as a kind of paradise remote from the concerns of mankind. Arcadia is a specific region in Greece, but it is also a state of mind, a mood of nostalgic withdrawal.

Renaissance and Baroque painters populated their Arcadian scenes with nude or partially nude figures, often playing musical instruments such as the lyre or panpipe. Eakins may have turned to Arcadian subjects because they allowed him to portray the nude openly and without embarrassment, in a context acceptable to his contemporaries. Arcadian subject matter, too, was closely related to his feelings about the Avondale, Pennsylvania, farm owned by Frances and William Crowell. As the art historian John Lamb has pointed out, Avondale offered Eakins an escape from the rigid values of Philadelphia, an escape not unlike that available to French artists in the peaceful country village of Barbizon. Lamb has observed that Eakins "could dress and behave as he desired" at Avondale, and added: "With its association with freedom and innocence, Avondale was Eakins' closest connection to Arcadia."[12]

A more complex psychological explanation for Eakins's Arcadian subjects has been proposed by the art historian Julie Schimmel. She believes they relate to the sorrow Eakins felt at the death of his sister Margaret in 1883, an event followed a year later by his marriage to Susan Macdowell. As Schimmel points out,

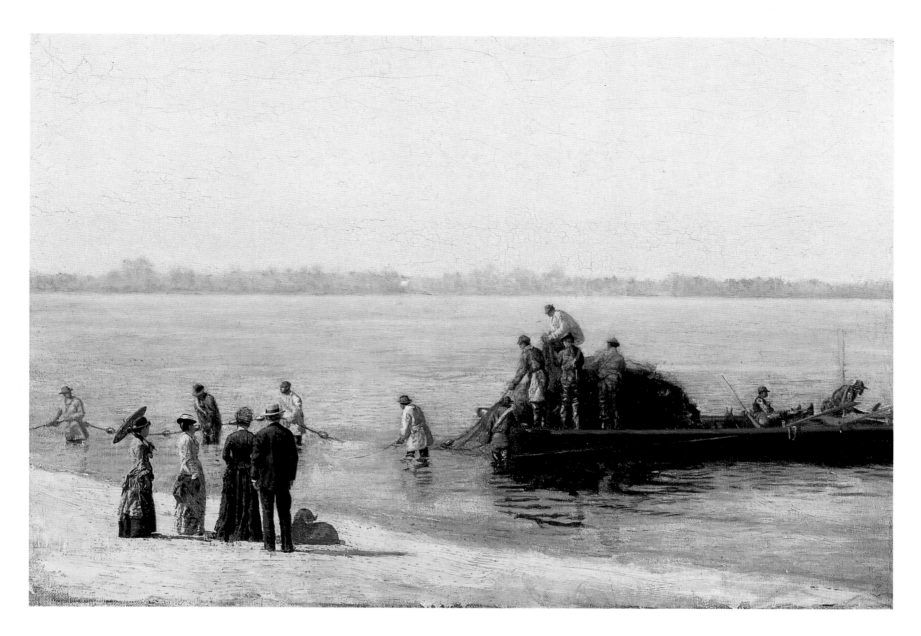

"In the one year between the loss of an important woman in Eakins' life and the securing of another, the Arcadian images are created." She goes on to observe that the Arcadian images by Eakins, particularly his sculptural reliefs, incorporate traditional symbols of mourning. The presence of these symbols, and the fact that a sense of nostalgia or loss is embodied in Arcadian images by other artists, seems to indicate that some or all of these works by Eakins do reflect his sadness at the death of his beloved sister.[13]

Another interpretation, which complements these, is that Eakins set himself the problem of reconciling his desire to portray nature accurately with his admiration for the art of antiquity, particularly that of the Greeks. Eakins's idea was not to imitate Greek art, as some of his academic colleagues in America and Europe had done, but rather to create a classic language of art by following the Greeks' methods. That is to say, he looked at nature and extracted ideal forms from what he saw, a process that is very different from copying forms already created by the Greeks. This was a common aspiration among the artists of the American Renaissance, his contemporaries who sought to ally themselves to the best traditions of antiquity and the Renaissance. Augustus Saint-Gaudens, John La Farge, and Olin Levi Warner had accomplished this goal in New York; Eakins, perhaps influenced by their ideas, was doing the same in Philadelphia. Although

91. *Shad Fishing at Gloucester on the Delaware River*, 1881
Oil on canvas, 12⅛ x 18⅛ in.
Philadelphia Museum of Art; Given by Mrs. Thomas Eakins and Miss Mary Adeline Williams

Eakins shared with the ancient sculptors the use of calm, dignified, partially nude figures stretched out against neutral backgrounds, his work would never be mistaken for a Greek relief. It has too much naturalism, too great a debt to the vision of the nineteenth century, and too much of his personal style—a kind of knobby awkwardness in modeling the figures.

The great majority of Eakins's works were executed not as paid commissions but because he chose to do them. He faithfully sent his uncommissioned paintings to exhibitions, mainly in Philadelphia and New York, where he hoped to sell them, but the tone of naïveté in his letters to Earl Shinn makes clear that he did not understand the mechanics and subtleties of the art market. Eakins said that he wanted to build his reputation and that his prices would rise as he made a name for himself. Yet he did not know quite how to go about this. When the paintings he would send to New York were rejected, or when the Pennsylvania Academy juries would turn them down, he would not change his painting or his personal style to curry favor. On the contrary, when some of his works were shunned by New York dealers, he said he would no longer go there but would insist on the dealers coming to him.

Eakins obviously recognized his own strength as an artist, boasting that he could paint the figure better than anyone in New York, and he could not understand why he was rejected so often. He explained to Shinn that his figures were well constructed and properly drawn, that he had received high compliments in letters from his teacher Gérôme, who considered him one of the best students he had ever taught, if not the very best. Writing again and again of doing better work all the time, Eakins could not comprehend why his honest efforts did not win more admiration. In the late 1870s, after a number of rebuffs and generally poor sales, he apparently decided not to worry too much about

Above
92. *Knitting*, 1882–83, cast 1930
Bronze, 18⅜ in. high
Philadelphia Museum of Art; Given
by Mrs. Thomas Eakins and Miss
Mary Adeline Williams

Below
93. *Arcadia*, 1883
Plaster, 12½ x 25 x 2¼ in.
Philadelphia Museum of Art;
Purchased: J. Stogdell Stokes Fund

94. *An Arcadian*, c. 1883
 Oil on canvas, 14 x 18 in.
 Spanierman Gallery, New York

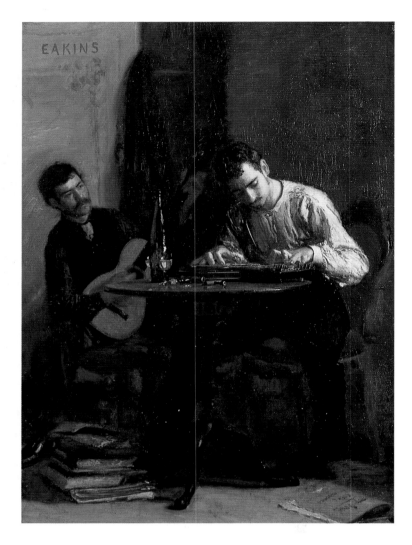

Above, left
95. *The Zither Player*, 1876
 Watercolor on paper, 12⅛ x 10½ in.
 The Art Institute of Chicago; Gift
 of Annie Swan Coburn in memory
 of Olivia Shaler Swan

Above, right
96. *Professionals at Rehearsal*, 1883
 Oil on canvas, 16 x 12 in.
 Philadelphia Museum of Art;
 Bequest of John D. McIlhenny

selling.[14] Because his father still supported him, he was able to continue to
paint and wait patiently for public acceptance. What Benjamin Eakins, previ-
ously so ambitious for his son's artistic success, thought of this attitude, we do
not know.

 Not only did Eakins fail to sell many of the works he sent to exhibitions,
but he was commissioned to paint only a handful of portraits: two of General
George Cadwalader (c. 1879–80, Green Tree Collection, Philadelphia; and c.
1880–81, Butler Institute of American Art), commissioned by the Mutual
Assurance Company, of which Cadwalader was chairman; *Mrs. William Shaw
Ward* (1884), sister-in-law of Dr. Brinton, never finished; and *Edwin M. Lewes*
(1885), now lost. Eakins fared somewhat better with commissions for works other
than portraits. In 1878 or 1879 Fairman Rogers, chairman of the Committee on
Instruction at the Academy, invited him to paint *A May Morning in the Park*
(plate 99); and in 1883 another commission came from Edward H. Coates, chair-
man of the Academy's board, to paint *The Swimming Hole* (plate 102). Eakins was
also asked by James P. Scott, through his architect Theophilus P. Chandler, to
produce a pair of chimneypieces in low relief for the house he was building at
2032 Walnut Street (plate 92). From Thomas B. Clarke, a prominent New York
collector of American art, he received an order for an oil painting, *Professionals at
Rehearsal* (plate 96), a variant of his 1876 watercolor, *The Zither Player* (plate 95).
But Eakins encountered difficulties even with some of these commissioned
works. Scott refused the reliefs, and the artist had to fight to get the five hundred

dollars owed him. Coates did not like *The Swimming Hole* and asked for and received *The Pathetic Song* (plate 107) instead.

Eakins's most important commissions of this period are *A May Morning in the Park* (also known as *The Fairman Rogers Four-in-Hand*) and *The Swimming Hole*. Rogers, the client for the former picture, came from a prominent Philadelphia family and was heir to a fortune amassed by his father, an iron merchant. That wealth enabled him to acquire not only a spacious house on Rittenhouse Square but also a stud farm near Springfield, outside Philadelphia (which Eakins visited with his students to study Rogers's horses), and an elegant summer "cottage" at Newport, Rhode Island. Rogers distinguished himself as a civil engineer, as a professor and trustee of the University of Pennsylvania (his alma mater), and as a backer of civic causes. He was one of the fifty original members of the National Academy of Sciences, a founder of the Union League of Philadelphia, a founding director of the Academy of Music, and a member of the American Philosophical Society. An avid coaching enthusiast, he wrote the definitive *Manual of Coaching* (1899) and was a charter member of the exclusive Coaching Club, whose ranks included Belmonts, Havemeyers, Vanderbilts, and Whitneys. He owned an impressive coach (known as a private coach or a park drag) built in London by Barker and Co., which he kept in the stable of his Philadelphia townhouse, along with its team of four horses.

Although Rogers's private coach shown in Eakins's painting resembles the functional coaches used to transport passengers from one city to another, it was built expressly for pleasure. The driver and his friends rode on the roof; the interior was used only by servants, except during inclement weather. Members of the coaching fraternity would take their friends for pleasure drives or attend meets with fellow coachmen. Sometimes coaching clubs took long trips together, traveling, for example, from New York to Philadelphia.

The sport of driving his coach and four obviously gave Rogers much satisfaction, and therefore it was a logical subject to ask Eakins to paint. He would have known well that Eakins possessed a great deal of knowledge about the anatomy and movements of the horse, and indeed the two of them may have discussed these matters as the painting evolved. Given his background as an engineer, Rogers was probably intrigued by the idea of having his coach and team be the first to be portrayed with absolute accuracy.

Eakins proceeded to document every possible facet of the subject: Rogers, his wife, two couples (Mr. and Mrs. Franklin A. Dick and Mr. and Mrs. George Gilpin), and two grooms riding atop the coach as it makes its way through the Gentlemen's Driving Park in Fairmount Park. Starting in the late spring of 1879 and possibly working through May 1880, he made oil sketches for various parts of the painting: heads of the riders (only two have been found), the landscape (plate 100), and the coach and four. Rogers invited him to Newport to make further studies. During the first of his visits Eakins had the coach driven past him again and again on Shore Drive to study its movement under natural light. The resulting oil sketch (plate 97), possibly painted on the spot, presents the configuration of the horses' legs with startling accuracy.

Eakins's solution to the perplexing problem of correctly depicting the

Above

97. *Sketch for "A May Morning in the Park,"* 1879
Oil on wood, 10½ x 14¼ in.
Philadelphia Museum of Art;
Given by Mrs. Thomas Eakins
and Miss Mary Adeline
Williams

Right

98. *A May Morning in the Park:*
Compositional Sketch with
Conestoga Wagon, 1879
Graphite on buff wove paper,
12⅛ x 18¾ in., irregular
The Pennsylvania Academy of
the Fine Arts, Philadelphia;
Charles Bregler's Thomas
Eakins Collection. Purchased
with the partial support of the
Pew Memorial Trust and the
John S. Phillips Fund. PAFA-
CB cat. 194

110

horse's gait came not from his own observations but from photography. Although Eakins had never, to our knowledge, tried to photograph rapidly moving horses, Rogers had done so, even designing a special shutter for that purpose, which he described to a meeting of the Photographic Society of Philadelphia in 1871. None of Rogers's equestrian photographs has been found, but it is unlikely that they would have equaled the spectacularly convincing sequential pictures of the horse in motion taken in 1878 by the English-born photographer Eadweard Muybridge at Palo Alto, California, and published in the summer of that year. Muybridge had urged Rogers to come to California to witness his photographic efforts, but there is no record that the Philadelphian made the trip. However, Rogers wrote to the photographer, as Eakins did, about his interest in the outcome of Muybridge's experiments. Rogers had a set of drawings made from Muybridge's photographs and had them mounted for viewing in the slotted drum of a zoetrope, a popular children's toy that he had constructed according to scientific principles. When the device was spun, the drawings conveyed the illusion of continuous motion.

Muybridge's prints became crucially important for Eakins and *A May Morning in the Park*. He made sculptural models based on them, which guaranteed the correctness of the position of the legs of the trotting horses in his painting—the first work in the history of art to be absolutely accurate in showing

99. *A May Morning in the Park (The Fairman Rogers Four-in-Hand)*, 1879–80
Oil on canvas, 23¾ x 36 in.
Philadelphia Museum of Art;
Given by William Alexander Dick

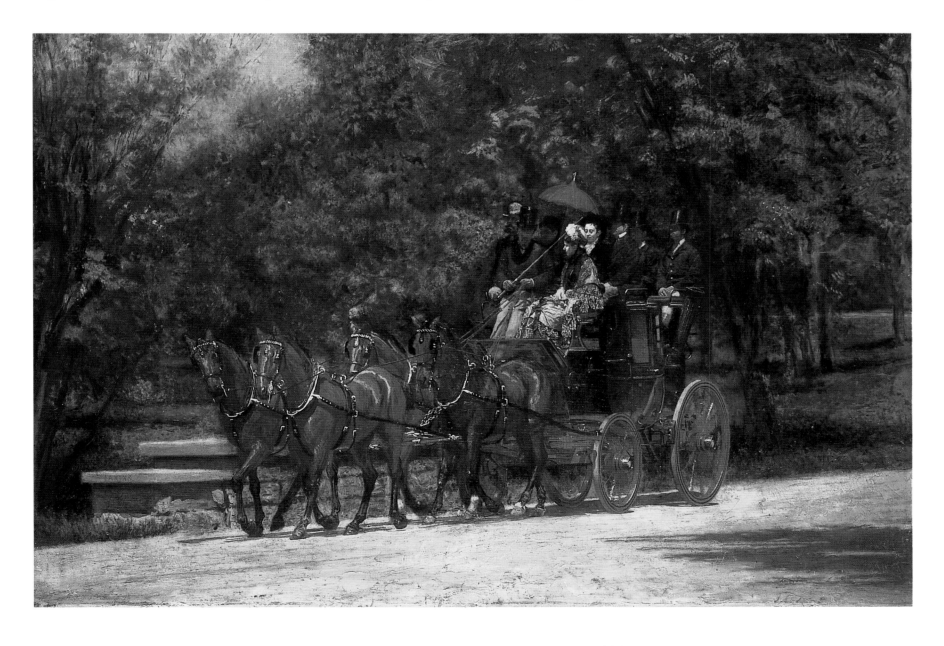

111

equestrian movement. (The evolution and use of this photographic data is discussed in detail in chapter 5.)

Extraordinary among the new discoveries in the Bregler Collection is a group of previously unknown drawings and studies for *A May Morning in the Park*. One of the drawings (plate 98) reveals that Eakins had explored the idea of having a rider on a horse at the left of the painting, moving toward the four-in-hand, and a man walking with a knapsack at the right. In the middle distance appears a Conestoga wagon, and even further behind this is a summary indication of a hilly

100. *Fairmount Park (Sketch for "A May Morning in the Park")*, 1879–80
Oil on panel, 14⅞₆ x 10¼ in.
Philadelphia Museum of Art;
Given by Mrs. Thomas Eakins and
Miss Mary Adeline Williams

landscape. Also associated with the painting is a drawing (plate 101) that presents the four-in-hand much as it looks in the final work, with small marginal sketches of a horse and rider, a man with a pole, two men in a skiff, and a sailboat, together with rough sketches of locomotives. On two additional sheets Eakins drew more-finished studies of locomotives and locomotive wheels. One of the engines is contemporary to his time, very simplified and geometric, and the other, on the same sheet, shows "Old Ironsides" (1832), made by Matthias Baldwin. We are not sure why he made this contrasting pair, but perhaps they had something to do with the idea of historical transportation that he had thought of embodying in *A May Morning in the Park*. In the end, Eakins satisfied himself (and presumably his client) by returning to a single moment in the present.

Although Eakins, with Rogers's support, was preoccupied with the technicalities of the horses' position and the motion of the coach's wheels, he produced an acceptable work of art. The coach and four, with its formally dressed driver and passengers, moves at a stately pace along a yellowish tan roadway. (The site in Fairmount Park still exists, unchanged but for asphalt paving on the road.) Except for the lush spring foliage, everything is painted in sharp detail, with all the precision of a photograph. Even the composition, unimaginative by Eakins's usual standards, seems photographic: the subject is placed squarely in the center of the rectangle of the canvas, almost as in a snapshot. And the wheels of the coach are blurred, as though the shutter had been unable to freeze their movement. Joseph Pennell, a student of Eakins, later explained that the picture as originally painted had "no action"; to rectify this flaw, Eakins "blurred the spokes" so they would appear to be moving.[15]

This documentary look troubled some of the critics who wrote about the work. One, from the *Philadelphia Press,* remarked:

> The instantaneous photograph has demonstrated that with all our looking at horses we have never seen how they move their feet, and in view of this discovery Mr. Eakins has formulated certain theories, mathematical and anatomical, which this work purports to illustrate. As a mechanical experiment it may be a success; on that point we express no judgment, but as to the matter of framing the experiment, hanging it in a picture gallery, and calling it A Spring Morning in the Park [*sic*], we have to express a judgment decidedly adverse.[16]

Whether Rogers liked the work or was troubled by criticism of it, we do not know. He did pay the agreed-upon five hundred dollars for the painting in November 1880 and later honored it by making it a principal illustration in his *Manual of Coaching.* (There no one would debate its aesthetic merit, only its fidelity to the facts.)

Eakins's other major commission at this time, *The Swimming Hole* (plate 102), was ordered by Edward H. Coates. The subject is a group of five muscular young men, assembled on or near a rocky pier. In the swimming hole itself appear Eakins and his setter, Harry. The location of this open-air scene has been identified as Bryn Mawr, a suburb of Philadelphia; that community is cited in Eakins's

101. *A May Morning in the Park: Compositional Study with Horseman, Locomotive, and Boats,* 1879
Graphite on foolscap, 17 x 14⅟₁₆ in. The Pennsylvania Academy of the Fine Arts, Philadelphia; Charles Bregler's Thomas Eakins Collection. Purchased with the partial support of the Pew Memorial Trust and the John S. Phillips Fund. PAFA-CB cat. 192

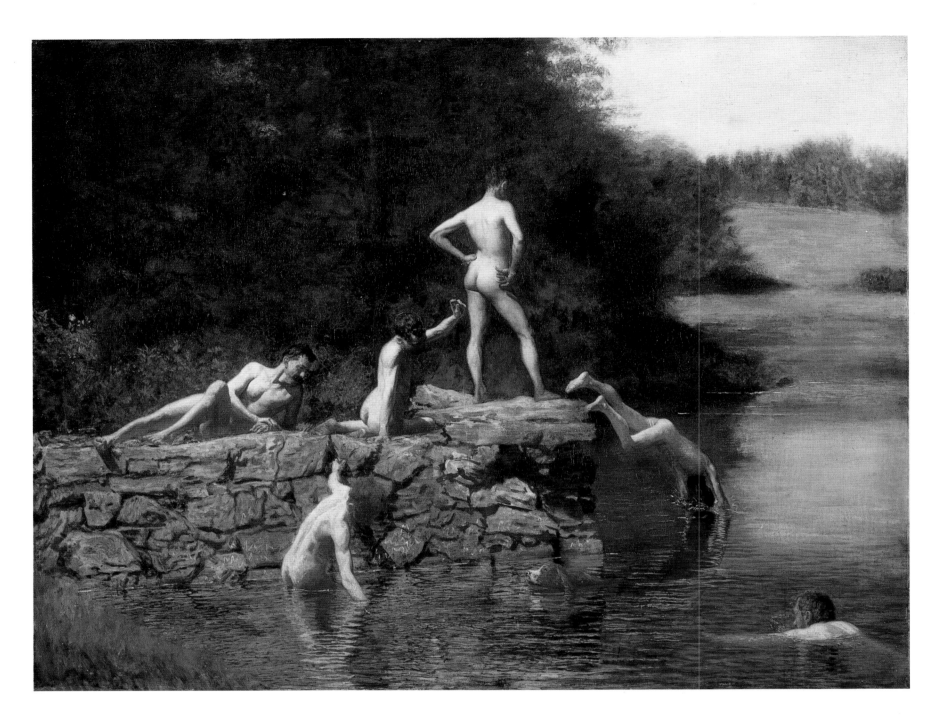

102. *The Swimming Hole*, c. 1883–85
Oil on canvas, 27�9/16 x 36�5/16 in.
Amon Carter Museum, Fort
Worth

Opposite, top
103. *Eakins's Students at the Site of "The Swimming Hole,"* 1883
Albumen print, 6⅟16 x 7¹³/16 in.
Hirshhorn Museum and Sculpture
Garden, Smithsonian Institution,
Washington, D.C.; Transferred
from the Hirshhorn Museum and
Sculpture Garden Archives, 1983

Opposite, bottom
104. *Sketch for "The Swimming Hole,"*
1883
Oil on fiberboard, 8¾ x 10¾ in.
Hirshhorn Museum and Sculpture
Garden, Smithsonian Institution,
Washington, D.C.; Gift of Joseph
H. Hirshhorn, 1966

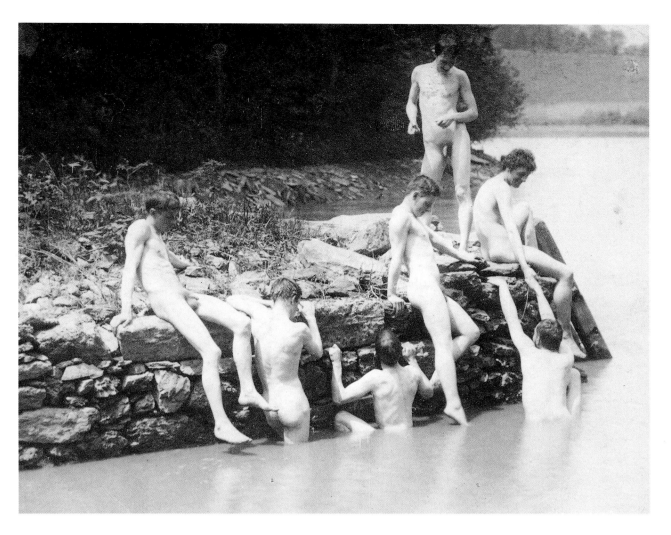

journal in connection with his preparations for *The Swimming Hole*.[17] That the artist was faithful to the appearance of a specific place is attested by a group of photographs he took of the site, each showing a different combination of swimmers (see plate 103 and chapter 5).

The Swimming Hole presents a relaxing moment of male companionship away from the cares, and the women, of the city. The young men, and Eakins himself, are free to frolic in the nude. The painting expresses Eakins's own relaxed openness about the human body exposed fully and without embarrassment. Nudity detached from allegory or a moralizing message was not easily accepted by his Victorian contemporaries. But the example of Walt Whitman, who celebrated the joys of nudity in the open air, may well have influenced Eakins, and Whitman, in turn, would certainly have enjoyed this scene glorifying male companionship. Whitman, a homosexual, cherished the friendship of other men, singly or in groups, and seemed to be more comfortable with them than with women. There is no evidence that Eakins was gay, but he encouraged a closeness among his male students and young artist friends that recalls the kind of bonding enjoyed in the Whitman circle. In fact, one of Eakins's students once referred to Eakins and his male friends as "us Whitman fellows."[18]

This commission for *The Swimming Hole* allowed Eakins to show off his skills in portraying a group of solidly built young men. (Each figure is turned away from the viewer so that frontal nudity did not become an issue.) They are arranged in an orderly, structured composition that resembles a pyramid; as in a Greek relief the figures become building blocks in a grand design and thus tend to lose any individual identity. Yet the pose of each one plays its special role, presenting a characteristic position that one would expect in a bathing scene of this kind.

In drawing and modeling these men, Eakins demonstrated his profound knowledge of anatomy, construction, and movement. They are posed so that their musculature is revealed by strong light coming from above and from the left. Yet their poses are oddly stiff and frozen, resembling academic studio studies. Especially rigid are the central bather, seated with his left arm raised, and the diving figure at the right. The diver, based on a wax model by Eakins (now lost), looks as though he had been captured by the high-speed shutter of a camera. There is an unhappy visual conflict between that figure and the reclining young man at the far left, the most calm and stable among them. It is as if the classical tradition of antiquity and the Renaissance has collided head-on with the scientific naturalism of the nineteenth century.

Just as the figures seem overly studied and tightly drawn, so the water is brittle and lacking any sense of fluidity. Eakins was characteristically doctrinaire in calculating the reflections, so they look as though they were done with a straight edge. Coupled with this is a curious mismatch between the impression of strong light that falls on the nude bathers and the generally overcast atmosphere. It is as though these nudes had been abruptly transplanted from the studio into nature.

Much more integrated and interesting as compositions are the two oil studies (plate 104) that Eakins made prior to undertaking the final work. In both, the tones and textures are integrally related to each other, and the

116

figures seem to be cut of the same fabric. It is a shame that in his desire to be "correct" in finishing the work in fine detail he lost the freshness that enlivens the studies.

One other kind of commission enjoyed by Eakins deserves mention here, though it is not in the realm of the fine arts: the five magazine illustrations that he did in 1878–81 for *Scribner's Monthly,* the popular New York–based periodical. *Scribner's* ambitious art editor, Alexander W. Drake, wished to elevate the quality of visual material in the magazine to a high level. To this end, he commissioned many of the best artists of the day to contribute drawings. The artwork was usually submitted in the form of a monochrome (black or sepia) wash drawing on board, heightened with white, and several such examples by Eakins have survived (plate 105). These were translated by craftsmen into wood engravings that, when expertly done, conveyed much of the look of the original (plate 106). Two related oil paintings by Eakins have come to light: a study for the seated figure of Neelus Peeler in "Thar's Such a Thing as Calls in This World" (New Britain Museum of American Art), for Richard M. Johnson's short story "Mr. Neelus Peeler's Conditions," and a figure study for "Thar's a New Game Down in Frisco," for Bret Harte's poem "The Spelling Bee at Angel's," in the recently discovered Bregler Collection.

Eakins's magazine work was perfectly competent, but it seems never to have been truly exciting to him—or profitable. Two drawings for "The Spelling Bee at Angel's" sold for a total of forty dollars; one for "Mr. Neelus Peeler's Conditions," for twenty-five dollars; and two for a piece on rail shooting along the Delaware River, both for fifty dollars.[19]

Although Eakins tried his best to satisfy clients who commissioned his work, he produced better and more convincing results when he painted to satisfy himself. The subjects most congenial to him were those he knew well, often from his own family. During the early and middle 1880s he produced three works of this kind that reveal him to have been at the height of his power as an artist and as an interpreter of human character. Two of these, *The Writing Master: Portrait of the Artist's Father* and *The Artist's Wife and His Setter Dog* (plates 108, 111), are family portraits; the third, *The Pathetic Song* (plate 107), combines elements of portraiture and genre painting. The singer, Margaret Alexina Harrison, is flanked by the cellist Charles Stolte, a member of the Philadelphia Orchestra, and by Susan Macdowell (Eakins's future wife) at the piano. Of these three paintings, this is the most impressive.

Miss Harrison is painted with exceptional facility. She appears to be sounding her final note, slowly lowering the sheet of music as the performance comes to an end. Her stance and facial expression perfectly express the act of singing; one can almost hear her voice blending with the resonant tones of the cello and the somber chords of the piano. For the first time Eakins chose to celebrate the skill of a woman; up to this point males had been the only heroes in his paintings. Miss Harrison, spotlighted by a raking light from the left, is treated with so much empathy that she becomes iconic—much like the nude model for Rush's nymph—though in this instance the subject is securely clothed in an elaborate lavender dress. Just as the flesh and muscle of Rush's model were portrayed

105. *Illustration for "Mr. Neelus Peeler's Conditions,"* c. 1878–79
Ink and Chinese white drawing on paper, 10⅞ x 12¼ in.
The Brooklyn Museum

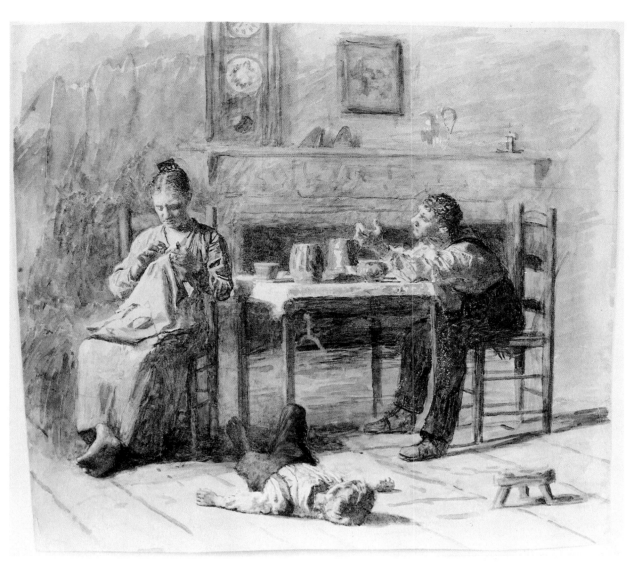

106. *Thar's Such a Thing as Calls in This World ("Mr. Neelus Peeler's Conditions"),* from *Scribner's Monthly,* June 1879
Wood engraving

Opposite
107. *The Pathetic Song,* 1881
Oil on canvas, 45 x 32½ in.
The Corcoran Gallery of Art, Washington, D.C.; Museum purchase

118

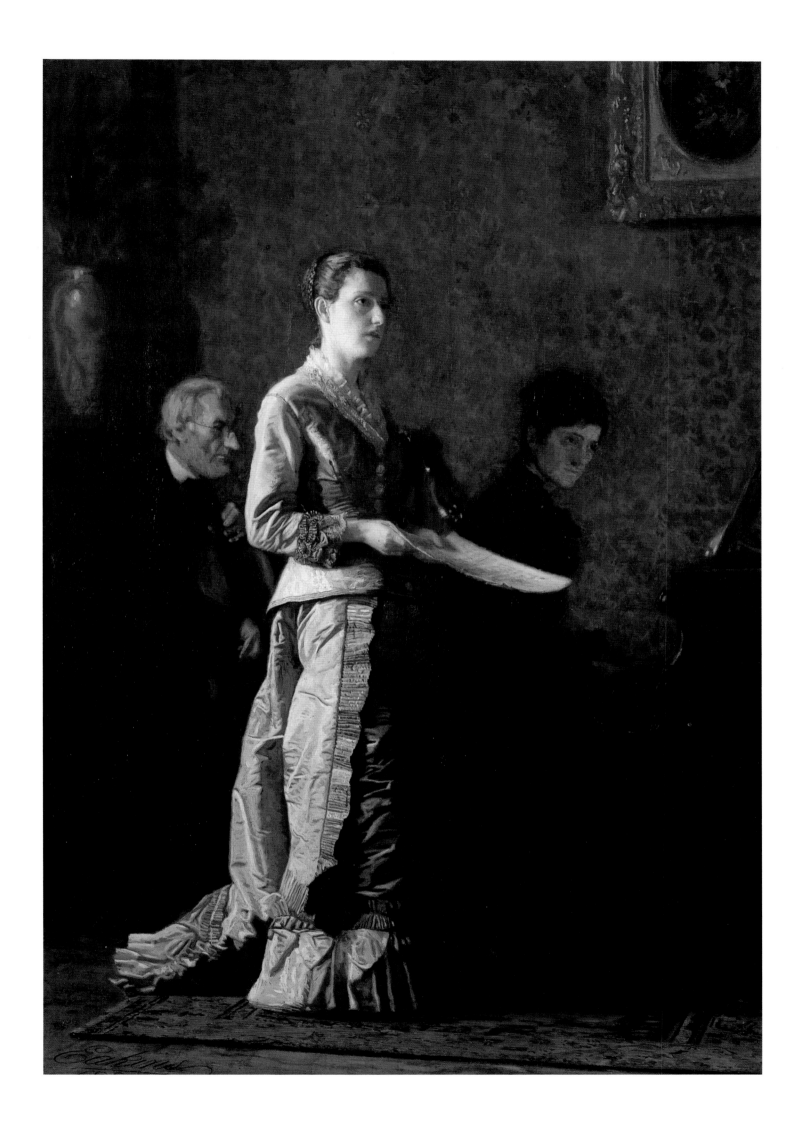

with thoughtful respect, so is the garment of Miss Harrison depicted in all of its richness and detail.

Yet the painting concerns more than the principal vocalist. Eakins has summoned up every bit of his skill to capture the spirit of the ensemble. The three, who perform not on a concert stage but in a private home, are linked psychologically by their concentration. This is no raucous merrymaking, but a solemn moment in which each performer not only plays but also listens to the others with rapt attention. It would be hard to find a more skillful representation of a musical moment anywhere in the history of art.

Eakins's admiration for a job well done is also evident in his painting of his father, *The Writing Master* (plate 108). He portrayed the sixty-four-year-old penman in the act of inscribing an elaborate official document. The Rembrandtesque light carves out his facial features and accents his shirtfront, hands, and the vellum on which he writes. Everything else falls into darkness, leaving his labor as the principal focus. As in so many other pictures, Eakins presents a serious moment, when his subject is concentrating on a task that requires intellectual or manual skill, or both. But this is not just any sitter: it is his father, his hunting and fishing companion, his primary source of financial support. Because Caroline Cowperthwait Eakins (Benjamin's wife and Thomas's mother) had died in 1872, the younger Eakins and his father must have developed even closer ties than before, and in the painting he treats Benjamin as a venerable figure.

A couple of years after completing *The Writing Master,* Eakins undertook still another portrait of a subject close to him: Susan Macdowell Eakins, whom he had recently married (plate 110). She sits pensively in a Queen Anne chair, a book of Japanese prints open in her left hand. Just to her left, Eakins's setter, Harry, lies contentedly on the floor, his eyes, like those of Mrs. Eakins, directed at the viewer. Entitled *The Artist's Wife and His Setter Dog* (also known as *Lady with a Setter Dog*), the painting is undated, but it was likely started in 1884, shortly after Eakins married Macdowell and moved with her into his studio at 1330 Chestnut Street. That mahogany-colored Victorian interior is the setting for the portrait.

Eakins's bride, the former Susan Hannah Macdowell, came from an artistic family. Her father, William, was a master engraver who specialized in lettering on invitations, diplomas, birth certificates, and other official documents, along with inscriptions on reproductive engravings by others, including John Sartain. The Macdowells lived at 2016 (later 2108) Race Street, quite close to Peter F. Rothermel, a noted Philadelphia history painter with ties to the Academy, who was related to Susan's family by marriage. He had produced a delightful if somewhat prettified miniature portrait of her when she was about eight years old (Mr. and Mrs. John R. Garrett, Jr.).

William Macdowell and his wife, Hannah, had eight children, of which Susan was the fifth. They must have been a feisty lot, strong-willed and independent. The elder Macdowell was a professed atheist whose free-thinking views led him to champion the American political theorist Thomas Paine. He gave his children, including the three girls, freedom to develop on their own. Susan flourished, becoming a private student of Schussele's. Her nephew,

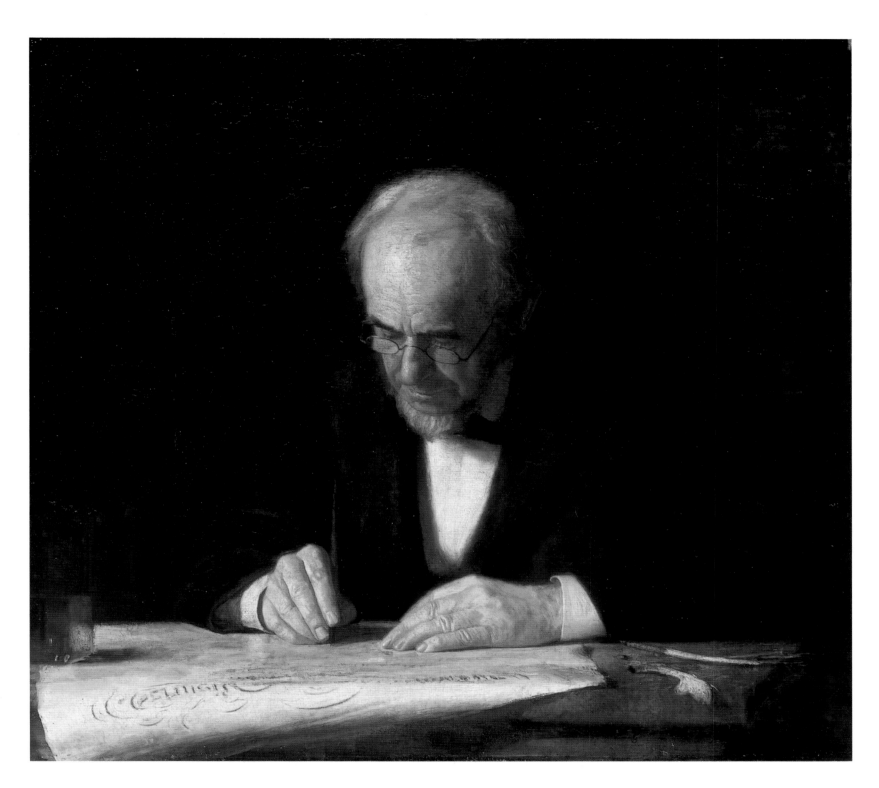

108. *The Writing Master: Portrait of the Artist's Father*, 1882
Oil on canvas, 30 x 34¼ in.
The Metropolitan Museum of Art,
New York; John Stewart Kennedy
Fund, 1917

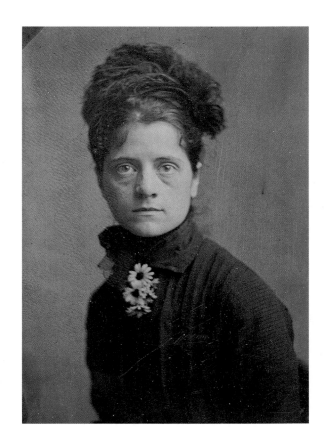

Walter G. Macdowell, recalled: "Throughout her life the Macdowells were a source of approval and encouragement. They were proud and pleased to have a woman artist in the family."[20] Susan's sister Elizabeth was an able artist, too, though in her later years she did not remain as committed to her painting as Susan did.

Susan Macdowell was much impressed by Eakins's *Gross Clinic* in the spring of 1876, when it was on view at the Haseltine Galleries. She also took notice of the artist, who was present there, but her shyness kept her from approaching him. She recalled having fallen in love with Eakins later that spring when, at Schussele's studio, he "made a French bow" and offered to help her button her glove.[21]

The powerful impact of *The Gross Clinic* inspired her to study with Eakins. She first asked for private criticisms of her work, then entered his, as well as Schussele's, classes at the Academy. After Schussele's death in 1879, she remained under Eakins's tutelage until the 1882–83 season, and he was the primary influence on her work. Her subjects were often quite similar to Eakins's—sometimes identical—and her style, like his, was naturalistic and descriptive, low in key, rich in warm earth tones. Her watercolor *Spinning* (plate 112), for example, recapitulates much of Eakins's oil *In Grandmother's Time* (plate 86), except that in Macdowell's painting the subject is turned more to the viewer's left.

Macdowell was less dependent on Eakins's style in *Two Sisters* (plate 113), a large, impressive canvas portraying her sisters Dolly (Mary), on the left, and Elizabeth, on the right. She painted with admirable fidelity and grace, producing the kind of work that opened the doors of the Academy annual exhibitions to her and enabled her to win the Mary Smith Prize in 1879, the first time it was awarded. In 1882 she received the second Charles Toppan Prize.

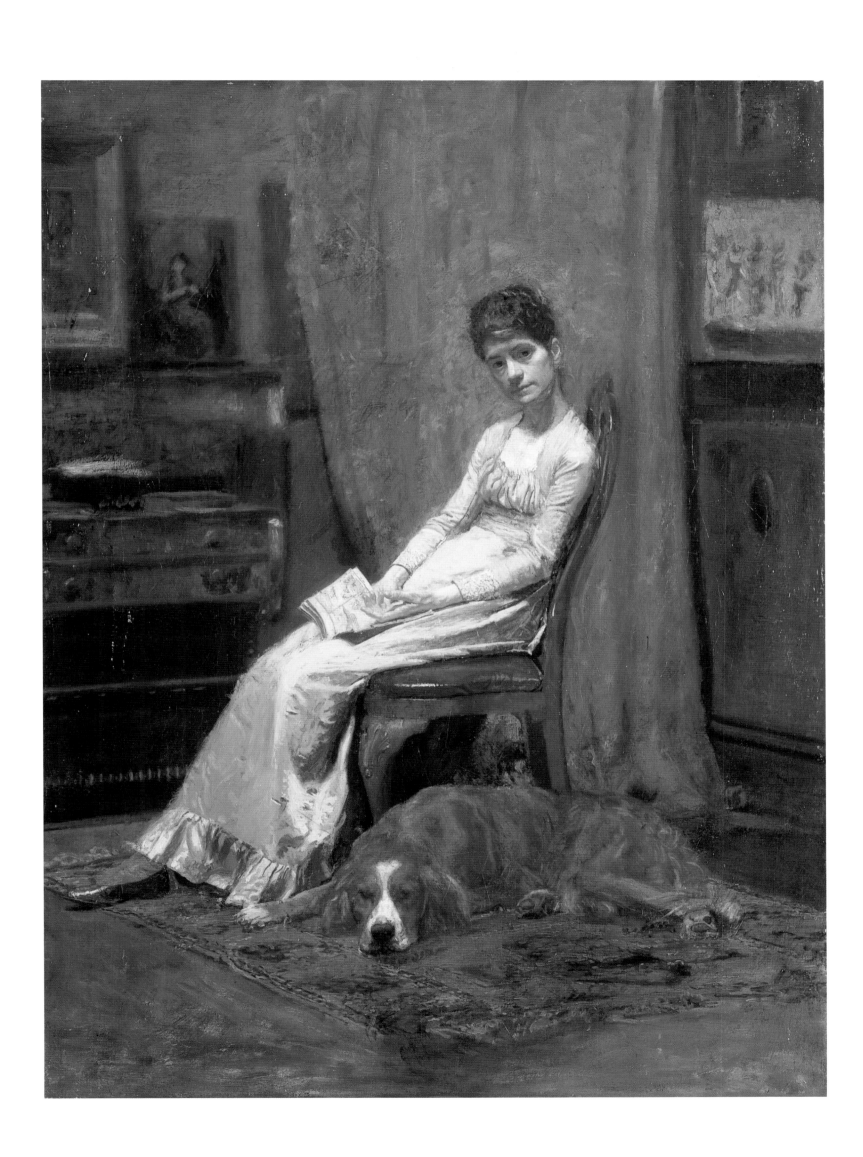

112. Susan Macdowell Eakins
(1851–1938)
Spinning, c. 1878
Watercolor on paper, 7¾ x 5¼ in.
Private collection

Also an energetic organizer and leader among the students, Macdowell served for a time as secretary of the school. In 1879 she was portrayed by her fellow pupil Alice Barber (later Stephens) in the women's life class, confidently applying brush to canvas (plate 114). A handsome, if not a beautiful, young woman, Macdowell had a gracious personality that, along with her talent, must have captivated Eakins. They saw each other regularly during the late 1870s and early 1880s, often in family gatherings. Just how Kathrin Crowell, Eakins's fiancée, fit into this picture we do not know, but after her death from meningitis in 1879, Eakins was free to direct his full attention to Susan. To our knowledge, he had no other prospects for matrimony.

Thomas Eakins and Susan Hannah Macdowell, seven years his junior, were married in a Quaker ceremony in the Macdowell house on January 19, 1884. The couple lived in the Chestnut Street studio for only two and a half years before returning to the house on Mount Vernon Street. There they rejoined what remained of the family circle: Benjamin Eakins, Aunt Eliza Cowperthwait, and various visiting nieces and nephews. Susan had her own studio on the top floor of the house, as did her husband (he also retained his Chestnut Street studio until 1900), but she painted little during their years of marriage. Most of her attention was focused on Thomas's well-being and advancement as an artist. Only after his death in 1916 did she once again come into her own as an independent painter, showing just as much talent as before her marriage.

113. Susan Macdowell Eakins
(1851–1938)
Two Sisters, 1879
Oil on canvas, 57½ x 45¾ in.
Private collection

114. Alice Barber Stephens
(1858–1932)
The Women's Life Class, 1879
Oil on cardboard, 12 x 14 in.
The Pennsylvania Academy of the
Fine Arts, Philadelphia; Gift of
the artist
Susan Hannah Macdowell is in
the left foreground.

Susan Eakins was strong-minded, not given to conventional religion or conformity of any kind. Lloyd Goodrich, who became well acquainted with her in the early 1930s, found her "endowed with inexhaustible nervous energy." He went on to describe her as "intelligent and responsive, interested in all kinds of people and things," noting that "she was as liberal in her opinions as her father."[22] Charles Bregler, Eakins's student, remembered her as "very romantic." She was a great reader of fiction, he said, remarking that Eakins did not read anything of that sort.[23] Susan was also an accomplished pianist, the role in which she is shown in *The Pathetic Song* (plate 107).

Although Goodrich mentioned her "buoyant nature,"[24] it does not come through in any representation of her, painted or photographic. In *The Artist's Wife and His Setter Dog*, Eakins portrayed her as a sad, resigned woman; just thirty-two or thirty-three, she looks ten years older than that. An explanation

was offered by Ellwood C. Parry III, who has shown that Eakins reworked the canvas, probably between 1886 and 1888, and that its original appearance can be appraised only by looking at the photogravure reproduction of it (plate 110) in *The Book of American Figure Painters* (1886).[25] Susan does not look as old, but she remains a frail, melancholy spirit, slouched in her chair and seemingly incapable of action. Is this the image of a woman Eakins loved, a woman who excited and challenged him? Or, at age thirty-nine, did he merely settle for her as a congenial, respected partner, having forsaken the prospect of more passionate relationships? In an era when romantic love was often expressed poetically and vividly, his letters to her are remarkably abstract and detached—cordial, to be sure, but more like those written to a friend than a lover. It is telling that Eakins painted his dog with more warmth and sympathy than his bride.

5.
Eakins as Theorist

Making a painting was a rational process for Eakins, requiring slow, logical steps. It entailed exhaustive study of the anatomical structure of the subject, whether human or animal, and the exact positioning of this form in the visual field. Eakins often created detailed perspective drawings that enabled him to rationalize completely the depiction of space. If he had to deal with a moving subject, he sometimes resorted to still or motion photography, or both, to gauge the exact position of his subject in the relevant phase of its movement. Eakins was a literal, sometimes even plodding, recorder of what lay before him. Except for a few history paintings and Arcadian scenes, he did not paint anything he could not see. Little room was left for intuition or guesswork.

Eakins would often create one or more small, broadly brushed oil studies for a picture he was planning (plate 116). In these he would capture the general masses he perceived in his model or models—or rarely, in an imaginary subject—then square off the sketch. Next he would inscribe a grid onto the final canvas and transfer the painted information from the sketch to that surface (plate 117). Having done this, he would proceed to finish the picture.

When painting from a model Eakins would work deliberately and at length. Stories are told of how faithfully he recorded the visual information the model provided, often prolonging the posing sessions until the subject was exhausted or hopelessly bored. As one sitter, Harrison S. Morris, recalled: "I stood day after day while he patiently transcribed me—for his method stuck closely to the object. . . . I posed on my feet for so many hours that I was seized of an irruption on my weary legs and had to go to a doctor for a remedy."[1]

Eakins could be counted on to devise a method for analyzing any visual problem that confronted him. When he had to portray reflections in water—a motif that would not remain still—he devised a set of rules governing every eventuality. Viewing this system as an extension of the science of perspective, he was able to create "correct" images that obeyed optical principles he had extracted, or abstracted, from nature. Unfortunately, because of his highly intellectualized approach, his images of water tend to appear stiff and schematic (plate 118), quite unlike the liquid, flowing waves that his contemporary Winslow Homer pictured with such evident ease.

115. Detail of *The Oarsmen (Study)*, c. 1874. See plate 120.

129

Below
116. *Study for "The Old-Fashioned Dress,"* c. 1908
Oil on cardboard, 11⅛ x 7 in.
Mr. and Mrs. Daniel W. Dietrich II

Right
117. *The Old-Fashioned Dress—Portrait of Miss
Helen Parker,* 1908
Oil on canvas, 60⅛ x 40⁵⁄₁₆ in.
Philadelphia Museum of Art; Given by Mrs.
Thomas Eakins and Miss Mary Adeline
Williams

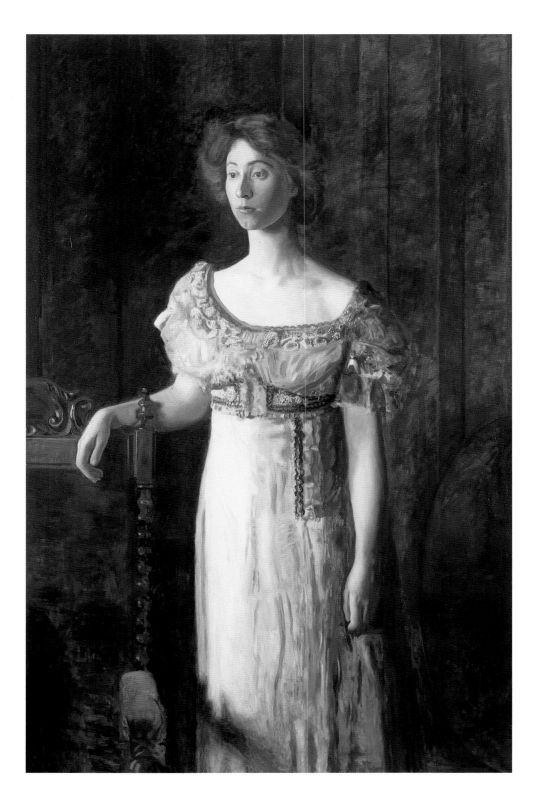

When Eakins needed to capture how sunlight of various degrees of warmth
fell on his subjects—for example, his rowers—he fashioned small dummies out of
fabrics of different colors and painted them outdoors to capture just the right
effect. Of course he could, and did, sketch in oil outside (plate 119) as a way to
study light and color for larger paintings to be executed in the studio. But Eakins
did not paint his major canvases on site; nature was there to provide information,
which he accurately transcribed and then integrated with the other visual data
he had gathered.

In almost every respect Eakins's procedures reiterate what he had learned
during his student years in Paris. Gérôme, of course, was his chief model, whose
methods of preparing for and executing a painting Eakins followed almost ex-

actly. (Not that Gérôme was unique; virtually all of his peers working in the academic tradition used the same methods.) Eakins differed from Gérôme in making more painterly and sketchy works—not only his studies but also his final versions. And while Gérôme often started at the top of his canvas and worked straight down to the bottom, carefully filling in linear outlines with color, Eakins kept everything going at one time (plate 120). For the American, the fundamental unity of the work was always present, even in its early, unfinished stages.

In one other respect, too, Eakins parted company with Gérôme: he pressed much further than his French master in the use of contemporary subjects, forming a link between academic practice and painterly realism as it was understood by artists such as Gustave Courbet in the 1860s and 1870s. Eakins never fully escaped from Gérôme's influence, but he was able to take the Frenchman's respect for nature's data and parlay it into something convincingly real, without resorting to contrived historical or exotic subject matter.

Eakins clearly shared the scientific spirit of his age, a time when there was a preoccupation with objective data and scientific theories. The scientific ethos tolerated little of the romantic or the mystical, for these approaches threatened to interfere with the empirical knowledge of the world. Nor was there any longer a place for philosophical idealism, with its belief in absolutes external to the perceivable world. Valid explanations could flow only from an approach that shunned everything transcendental in favor of an individual's disciplined perceptions of the material world. The scientist, reinforced by the philosophy of positivism, found truth only in what could be observed, classified, and analyzed empirically, preferably in the laboratory.

The terms "realism" and "naturalism," which apply equally to the visual arts and literature, indicate the materialist orientation that dominated the period. Advanced painters in Europe and the United States, such as Courbet and Homer, confined themselves to the visible and tangible, free of mystical or metaphysical speculation, but often lacking a charged emotional response by the artist. Literature shared this spirit, perhaps best epitomized by the French author Emile Zola's belief that the writing of novels should follow the "experimental method" of the sciences. Many progressive architects, too, actively embraced science and technology. For example, the great American architect H. H. Richardson wrote, "The things I most want to design are a grain-elevator and the interior of a great river-steamboat."[2]

It is hard to comprehend today how much excitement science and technology generated among forward-looking intellectuals and artists in this period. Remarks by a French architect, Gabriel Davioud, writing in 1877, are typical: "The accord [between science and art] will never become real, complete, and fruitful until the day that the engineer, the artist, and the scientist are fused together in the same person. We have for a long time lived under the foolish persuasion that art is a kind of activity distinct from all other forms of human intelligence, having its sole source and origin in the personality of the artist himself, and in his capricious fancy."[3] Such a fusion of art and science would have been entirely satisfying to Eakins.

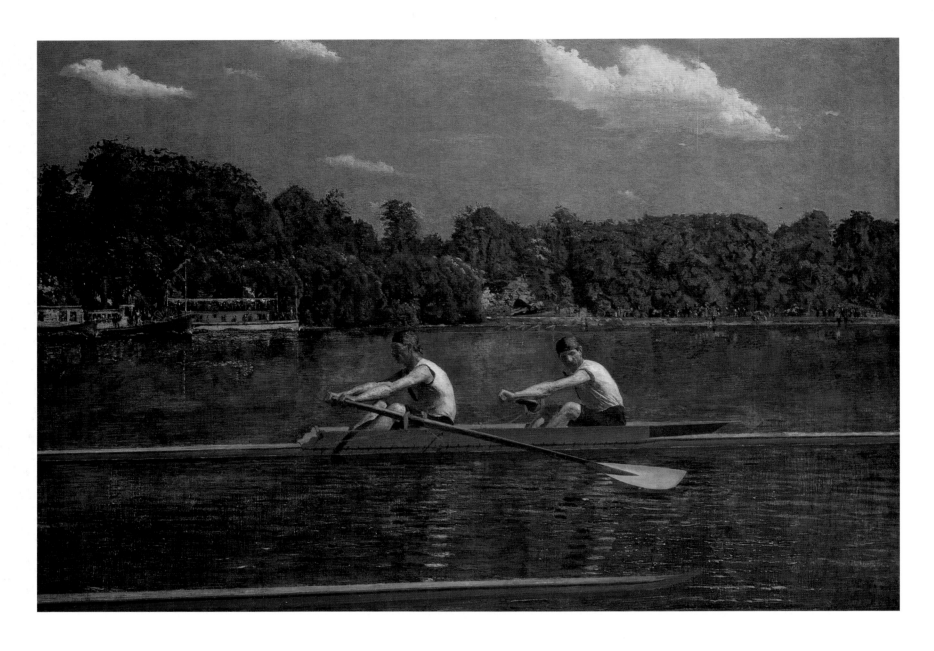

Above
118. *The Biglin Brothers Racing*, c. 1873
Oil on canvas, 24⅛ x 36⅛ in.
National Gallery of Art,
Washington, D.C.; Gift of Mr. and
Mrs. Cornelius Vanderbilt
Whitney

Right
119. *Sketch of "Max Schmitt in a Single
Scull,"* c. 1870–71
Oil on canvas, 10 x 14¼ in.
Philadelphia Museum of Art;
Given by Mrs. Thomas Eakins and
Miss Mary Adeline Williams

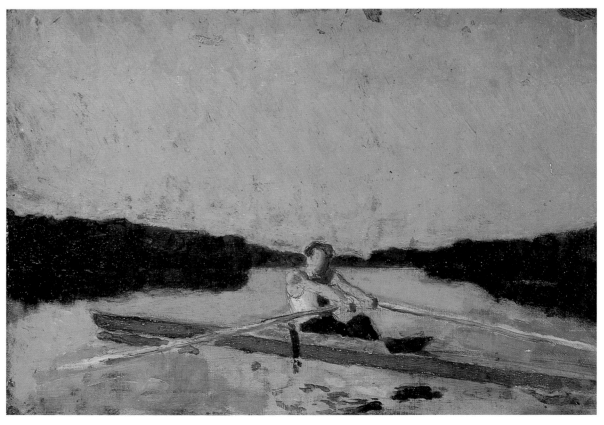

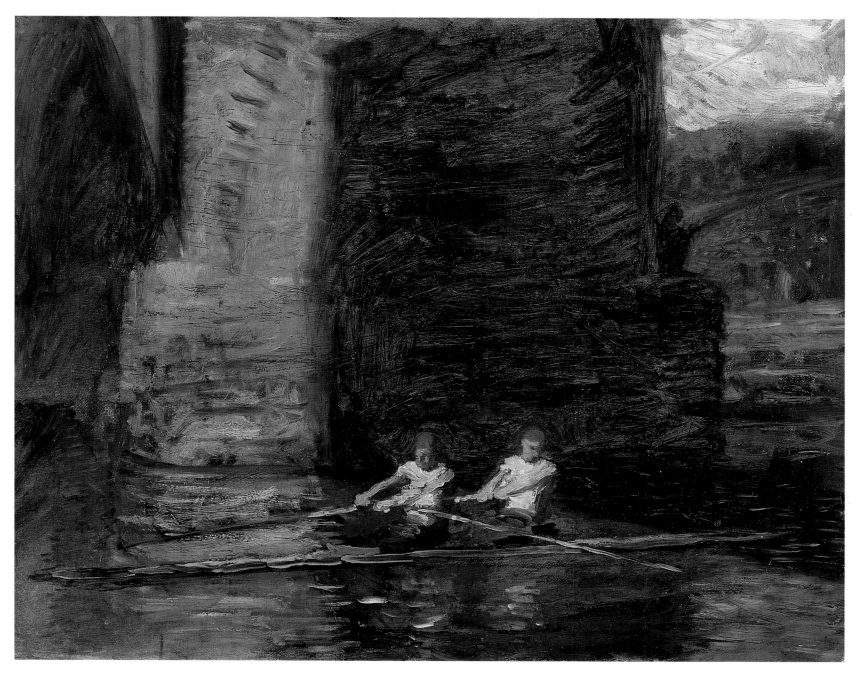

It is not easy to identify national styles in scientific thought, but in the United States, science and its offshoot, practical invention, have leaned toward a kind of pragmatic objectivity. American scientists, of course, were usually well aware of European discoveries, but the Americans were often able to break new ground precisely because they did not readily agree with the canonical, and sometimes erroneous, formulations of their European counterparts. Scientists and inventors in the United States were, in general, more willing to test their hypotheses. The Wright brothers, for example, were typical American tinkerers, and their successful invention of a powered flying machine occurred only after they cast aside internationally accepted but incorrect data and redid all of the necessary tests in a homemade wind tunnel.

Philadelphia is a city particularly devoted to the sciences—especially medicine and engineering. The University of Pennsylvania and Jefferson Medical College, with which Eakins had important contacts among the faculty, were (and still are) major centers for medicine, and in the case of the university, for engineering as well. The Academy of Natural Sciences—with which Eakins was tan-

120. *The Oarsmen (Study)*, c. 1874
Oil on canvas, 14 x 18 in.
Portland Art Museum, Oregon Art Institute; Bequest of Blanche Hersey Hogue

gentially involved—is another esteemed Philadelphia center for study and research. The city's devotion to the sciences was not matched by any love for the visual arts. Why Philadelphia has nurtured so few important artists is hard to ascertain. Perhaps the Quaker distrust of images and of luxury has something to do with it; perhaps the concentration of social and financial power in the hands of merchants and bankers who had little interest in art was another reason. Whatever the cause, there was no strong tradition of artistic excellence in Philadelphia when Eakins was growing up there. It was the men who had triumphed in the sciences that fired his imagination; they furnished not only some of his subjects but also his analytic methods.

Among the scientific subjects that interested Eakins, anatomy was one of the most important. The lectures on anatomy attracted him while he was a student at the Pennsylvania Academy, and he voluntarily attended more classes on the subject at Jefferson Medical College, offered by Dr. Joseph Pancoast and assisted by his son William. Eakins presumably learned to dissect in these sessions, for he wrote in 1886 that he had been doing it for twenty-four years.[4] Eakins studied anatomy again in Paris. He must have attended the lectures at the Ecole des Beaux-Arts by Dr. Mathias Duval, a distinguished expert and author of the comprehensive manual *Précis d'anatomie à l'usage des artistes*. Eakins no doubt continued to dissect at the Beaux-Arts or at the Ecole de Médicine, or both, though there is no record in his voluminous correspondence of where this activity took place. Certainly his letters home reflect his intense desire to understand the construction of the human body. As he wrote to his father: "My anatomy studies & sculpture, especially the anatomy[,] comes to bear on my work & I construct my men more solid & springy & strong."[5] And when he returned to Paris from Spain, in 1870, to see the Salon before departing for home, he wrote in his notebook, as a reminder to himself:

> Never draw the head and neck with the *sterno cleido mastoidiens* muscles. They seem to be added only to complicate the interior muscles, being more prominent, simpler in movement, each one just performing its part and fitting into the large planes of movement. Always draw the neck and the head in connection with the back, and the shoulders with the back, but never draw the shoulders from the neck nor the neck from the shoulders, which would be points of departure contrary to anatomy and contrary to nature.[6]

In 1873 and 1874, after Eakins had returned to Philadelphia, he went back to Jefferson Medical College to study anatomy and dissection again and to observe Dr. Gross in his clinic. Whether the artist received any instruction from Gross is uncertain, but in 1876 Eakins began to serve as preparator and demonstrator of anatomy at the Pennsylvania Academy, under the young Dr. William W. Keen, Jr., who had been invited the previous year to lecture and offer demonstrations on anatomy (he served until 1890). Dr. Keen was a distinguished surgeon, a graduate of Jefferson, a prolific author of works on anatomy, and head of the Philadelphia School of Anatomy (1866–75). Eakins must have learned a

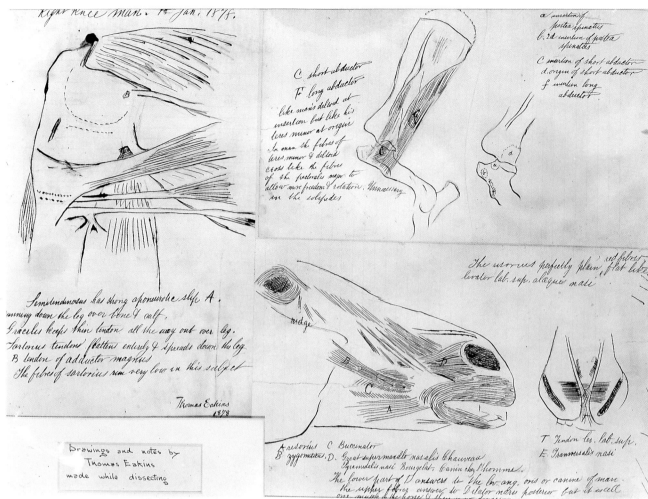

great deal from him as he observed his lectures at the Academy and, under his supervision, prepared cadavers for the doctor's classes.

At the Academy, Eakins regularly carried out dissections for the benefit of his students and took numerous casts of human and animal specimens, marked with colored inks and inscribed with anatomical terms (plate 121). He made numerous drawings and diagrams in the course of such studies (plates 122), most of them recently discovered in the Bregler Collection. They range in subject from the human hand, thorax, leg, heel, and scapula to the various bodily parts of the horse, lion, dog, and cat. Many of them were executed in a combination of lead pencil, pen and ink, and colored pencil (usually red and blue), with clusters of strokes delineating bones, muscle, cartilage, and tendons. Eakins inscribed each element with its Latin name, and often these sheets are filled with his precise descriptions of the movement or structure of the limb or joint in question. The more carefully drawn anatomical diagrams in the Bregler Collection may have been designed as illustrations for a possible book by Eakins on the subject of anatomy.

On one occasion in the early 1890s Eakins made a noteworthy contribution to the literature of anatomy and physiology. In the course of his studies he became fascinated with the action of a horse's leg in pulling a cart. The textbooks of the day classified muscles as "flexors and extensors" and pointed out that they worked and rested alternately, but Eakins found something different. When he observed the leg muscle of the horse straining to start a cart rolling, he

Above, left

121. *Casts of Anatomical Dissections*, 1877–80, cast 1930
Bronze
Philadelphia Museum of Art; Given by R. Sturgis Ingersoll and Given by Mr. and Mrs. R. Sturgis Ingersoll

Above, right

122. *Anatomical Drawings and Notes Made While Dissecting*, 1878
Pen, ink, and pencil on ruled paper, three sheets: 12½ x 7¾ in., 7⁵⁄₁₆ x 11¹¹⁄₁₆ in., 7⅞ x 11⅞ in.
Hirshhorn Museum and Sculpture Garden, Smithsonian Institution, Washington, D.C.; Gift of Joseph H. Hirshhorn, 1966

135

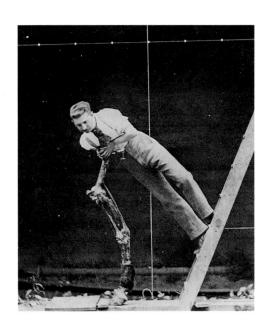

123. Thomas Eakins(?)
Young Man Leaning on a Horse's Leg, 1884
Philadelphia Museum of Art; Gift of Charles Bregler
Photograph used by Eakins in 1894 lecture.

found that both the flexors and extensors were contracting at the same time. He confirmed his observation by experiment and photographed the result (plate 123). After calling the discovery to the attention of one of his scientific friends, he was invited to deliver two lectures on the subject at the Academy of Natural Sciences and to publish his findings in their journal, *Proceedings.* His article, "The Differential Action of Certain Muscles Passing More Than One Joint," appeared in 1894.[7]

Eakins made it clear in his written remarks and recorded sayings that a comprehensive grasp of anatomy was essential to his own and anyone else's painting. As he said: "To draw the human figure it is necessary to know as much as possible about it, about its structure and its movements, its bones and muscles, how they are made, and how they act."[8] One noted Philadelphia surgeon, Dr. John B. Deaver of Lankenau Hospital, reported that "Eakins knew more about anatomy than ninety per cent of the doctors."[9] Evidence for this claim is most evident in Eakins's *Crucifixion* (plate 90), a work that shows phenomenal fidelity to the flesh, muscles, and bones of the subject. On the basis of such paintings, Eakins's student Charles Bregler said he thought no other painter or sculptor "understood the anatomy of the human form or the horse, as he did."[10] This is a sweeping claim but perhaps not far from the truth.

A related but very different aspect of Eakins's rational approach to making art is found in his interest in perspective. He had learned the rudiments of this science at Central High School, and he must have attended lectures on the subject while at the Ecole des Beaux-Arts. There is no record of such study in his Parisian letters, but by the time he returned to Philadelphia he had a detailed and profound knowledge of perspective. Drawings in the Bregler Collection show that Eakins established a perspective framework for many more paintings than previously thought. Also in that collection are perspective studies that seem not to relate to any known works but are, rather, experiments or exercises. Even though Eakins did not value his perspective drawings as works of art to be saved, he must have experienced satisfaction in executing them. These sheets serve as battlegrounds on which to solve the most challenging problems.

"Strain your brain more than your eye," Eakins once said. "You can copy a thing to a certain limit. Then you must use intellect."[11] Clearly he did not trust the naked eye but wanted to regulate the visual field according to a comprehensive and rational system. The method he chose, that of one-point perspective, had been a major subject at the Ecole and was used especially by Gérôme; Eakins, in turn, applied it with a seriousness and devotion unmatched by any other American painter, before or since.

Perspective of this kind had been discovered by the Italian Renaissance architect Filippo Brunelleschi in 1425; ten years later his ideas were codified and publicized in a treatise by his contemporary, also an architect, Leon Battista Alberti. From that moment on, it became an essential framework for a great many fifteenth- and early sixteenth-century Italian paintings. Leonardo da Vinci's perspective study for *The Adoration of the Magi* (plate 124) is a prime example: the floor is laid out in a checkerboard pattern, and all the lines moving from the foreground to the distance converge at a single vanishing point on the

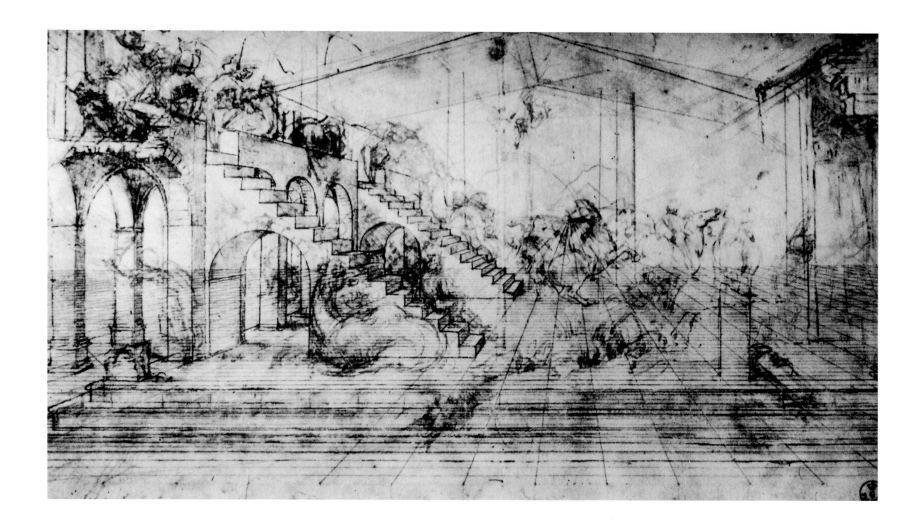

124. Leonardo da Vinci (1452–1519)
*Perspective Study for "The Adoration
of the Magi,"* 1481
Uffizi, Florence

horizon.[12] As a result, every object in the painting, and the space itself, is geometrically ordered.

Eakins, too, was fascinated by one-point perspective, and he used it in much the same way as Leonardo, but with one major difference: the perspective framework underlying Eakins's paintings is not as obvious. Looking at a typical example by Eakins, *The Pair-Oared Shell* (plate 125), it is apparent that the entire painting was painstakingly constructed and that the position of the subject within it was carefully thought out. Eakins's procedure in the principal perspective study (plate 126) was to divide his sheet of paper into four sections with one vertical line and one horizontal. Then he laid out the plane of the water in perspective, with each unit in the grid representing one square foot. The distance between each horizontal line represents a one-foot step into the distance, starting at sixteen feet from the viewer and progressing to sixty-four. For measurements of inches, Eakins provided three separate scales at the far left, set off from the main activity of the painting.[13]

By following his calculations, the precise position of the boat within the perspective system can be determined. As the art historian and conservator Theodor Siegl observed: "The stern is 30½ feet from the spectator and 5½ feet to the right center. The bow is 63 feet away and 4½ feet to the left of center." Siegl projected these points onto a ground plan (plate 128) that he reconstructed from Eakins's measurements and found that the boat was "36 feet long, moving at an angle of 67 degrees away from the viewer." From the drawing and from a contemporary map of the area, Siegl determined not only the depth of the pier (sixty

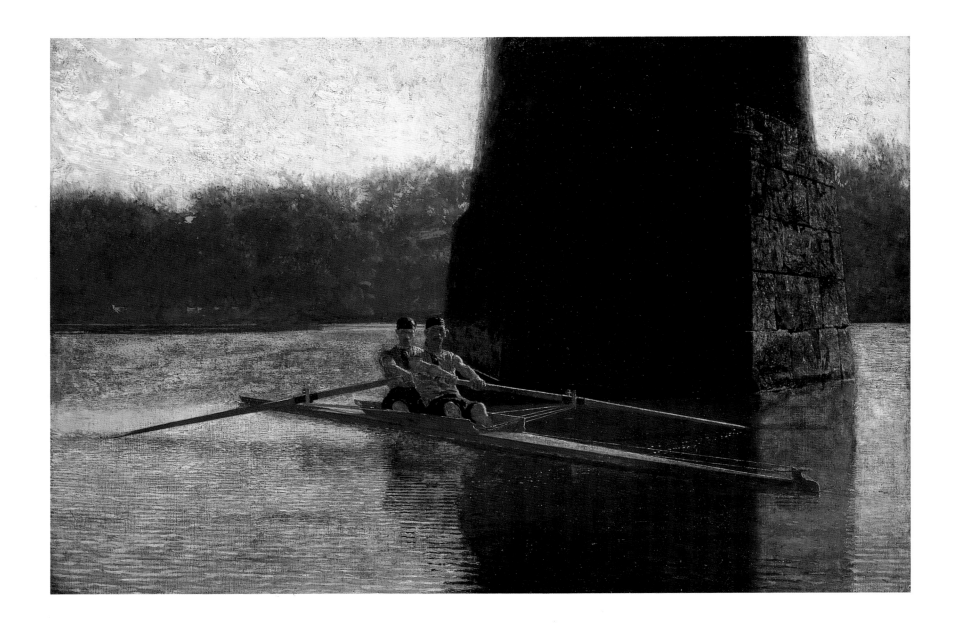

Above

125. *The Pair-Oared Shell*, 1872
Oil on canvas, 24 x 36 in.
Philadelphia Museum of Art;
Given by Mrs. Thomas Eakins and
Miss Mary Adeline Williams

Right

126. *Perspective Drawing for "The Pair-Oared Shell,"* 1872
Pencil, ink, and watercolor on
paper, 31¹³⁄₁₆ x 47⁹⁄₁₆ in.
Philadelphia Museum of Art;
Purchased: Thomas Skelton
Harrison Fund

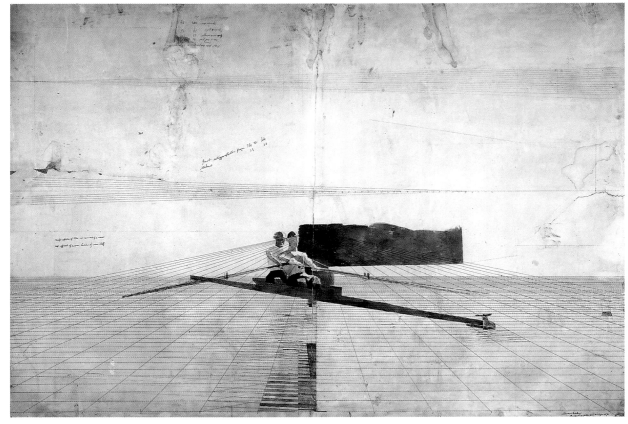

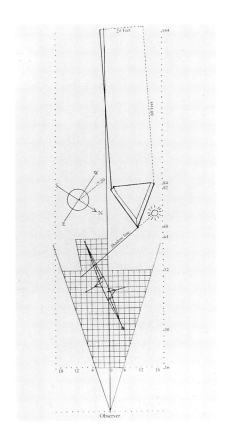

feet) but also, by following the shadow line, the time of the day—7:20 P.M.—in late spring or early summer.[14]

To calculate the reflections on the water for this painting, Eakins transferred the data on the sheet just discussed to a new drawing (plate 127), accented with watercolor, on which he noted detailed structural information about the reflections. As Siegl observed:

To construct the reflections of the rowers, Eakins assumed that each ripple was composed of three planes—one parallel to the surface, one slanted toward the viewer, one away from the viewer. Since the reflections on the hidden plane cannot be seen, there is no need to calculate it. For the two visible reflections Eakins constructed two converging scales in the sky area and numbered them according to the distance. The lower scale is numbered from 16 to 30, the higher scale from 20 to 80. Specific dimensions are noted in pencil. Ink and pencil lines specify the direction of the waves in the foreground.[15]

Thus even the most ephemeral and fluctuating aspects of nature were dominated by Eakins's intellect; nothing was too minute to escape the marvelous internal logic of his paintings.

Eakins usually proceeded by working out his problems mathematically on paper, and he had several shortcuts to help him visualize things, especially interiors, in perspective. Eakins's biographer Margaret McHenry, who took much of her information from Eakins's students Bregler and Samuel Murray, reported that in painting *The Chess Players* (plate 76) the artist would draw a chalk line on the studio floor and a corresponding line on his perspective drawing (plate 129).

Above, left
127. *Perspective Drawing for "The Pair-Oared Shell,"* 1872
Pencil, ink, and wash on paper, 31⅟₁₆ x 47⅛ in.
Philadelphia Museum of Art; Purchased: Thomas Skelton Harrison Fund

Above, right
128. Theodor Siegl
Ground Plan of "The Pair-Oared Shell," reconstructed from Eakins's perspective drawings
Philadelphia Museum of Art

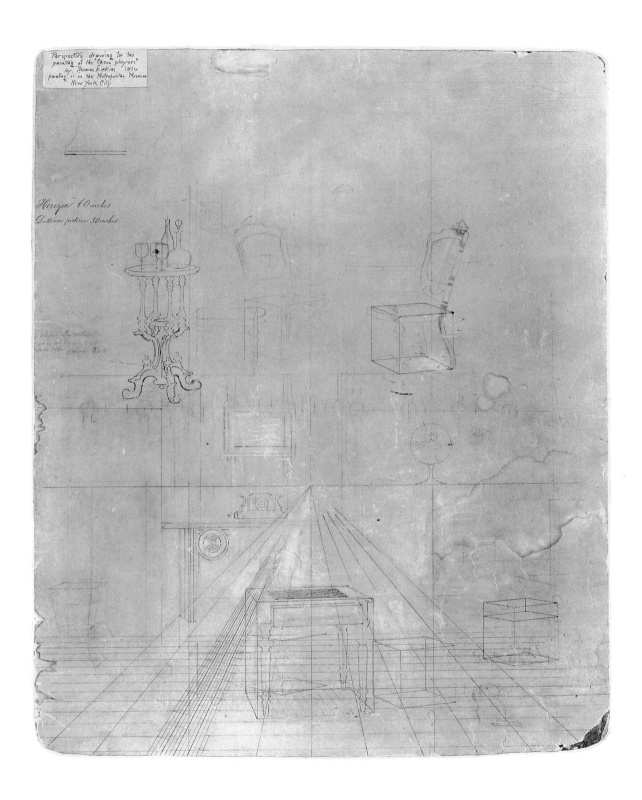

129. *Perspective Drawing for "The Chess Players,"* 1876
Pencil and ink on cardboard,
24 x 19 in.
The Metropolitan Museum of Art,
New York; Fletcher Fund, 1942

Then he would establish a uniform grid of lines, again presumably one foot apart, on the floor and place the furniture where he wanted it. He repeated that grid in one-point perspective on the drawing. By measuring the actual distance of the furniture from the line he had drawn on the floor and by transferring this data, in reduced scale, to the perspective drawing he would be assured of absolute accuracy in his pictorial placement.[16]

Through his perspective studies Eakins could analyze space with the same thoroughness with which he dissected the human body. His foolproof procedure allowed him complete certitude in placing figures or objects in space and eliminated any reliance on perceptual estimates or guesswork. We do not know how many of Eakins's paintings were based on perspective studies, but it is likely that all or most of them were, except for his portrait heads. The surviving studies indi-

cate a remarkable uniformity in the way he followed the laws of the one-point system and applied it to every kind of subject: interiors, full-length portraits, rowers, hunters, and other figures in motion (plates 130, 131).

Eakins's reluctance to depart from the one-point method yielded a certain sameness in the way he visualized the world. The more dynamic two-point method, with dual vanishing points at left and right (which was often employed by Gérôme) was available to him, but the simpler one-point system, with its ample stagelike space and centralized point of focus apparently offered Eakins the secure, almost classical stasis he needed. Whatever his reasons for using it, one-point perspective blended appropriately with his usually serene and architectonic compositions.

Another tool in Eakins's campaign to master the portrayal of physical reality was the medium of photography. For his painting, he occasionally relied on still photographs, mostly ones he took himself, and in several special cases he used motion or sequential photography to freeze the action of his subjects. In still photography Eakins, with one exception, did not contribute anything new; but in the latter types he was a pathfinder.

Daguerre's invention of 1839 was seen by artists as both a boon and a threat. After viewing a daguerreotype for the first time, the painter Paul Delaroche (Gérôme's teacher) made the often-quoted remark "From today painting is dead!"[17] Whether or not that assertion has proven to be true is open to debate, but what is certain is that during the nineteenth century photography developed along three parallel tracks, becoming a fine art, a source of factual record, and a utilitarian aid for painters. Eakins used all three facets of the medium, but for the present discussion the last two are the most important.

It is not known exactly when Eakins started to photograph. The date of about 1880 has usually been put forward, but several photographs of his baby niece Ella (plate 78) from around 1874 may represent his first efforts with the camera. In any event, he was in his early or mid-thirties when he took up the medium, having purchased his first camera along the way, and he practiced photography off and on until his last years.

At first Eakins made pictures as records, mostly souvenirs and documents of family activity. But as he began to develop his photographic skills, he recognized that the medium could aid his painting by holding a subject in memory for leisurely study. At times he would mirror a photograph quite literally in his treatment of figural or landscape motifs, although only rarely would he base an entire painting exactly on a photograph. As his widow explained, "Eakins only used a photograph when impossible to get information in the way he preferred, painting from the living and moving model."[18]

Eakins's involvement with photography comes as no surprise. He had, after all, immersed himself in the Beaux-Arts tradition in France, where photographic documentation was not only allowed but expected—especially by Gérôme. He also had a scientific bent that welcomed the precise images offered by the camera. Thanks to the discovery of the Bregler Collection, Eakins's fascination with photography is now known to be much greater than was previously realized. Over six hundred vintage prints and more than two hundred negatives have come to

Right

130. *Negro Boy Dancing: Perspective Study,* 1878
Pen and black, red, and blue ink over
graphite on two sheets of foolscap, 17 x 14
in. each sheet
The Pennsylvania Academy of the Fine
Arts, Philadelphia; Charles Bregler's
Thomas Eakins Collection. Purchased
with the partial support of the Pew
Memorial Trust and the John S. Phillips
Fund. PAFA-CB cat. 191

Below

131. *Negro Boy Dancing,* 1878
Watercolor on paper, 18⅛ x 22⅝ in.
The Metropolitan Museum of Art, New
York; Fletcher Fund, 1925

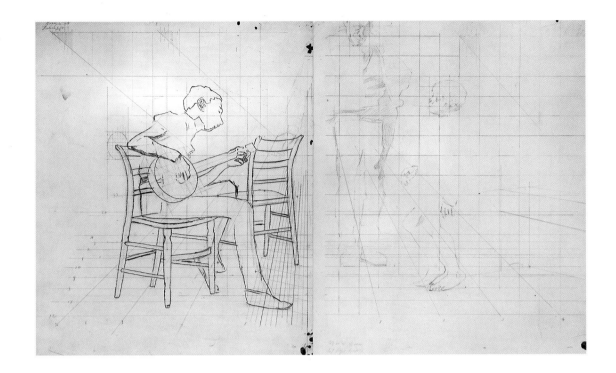

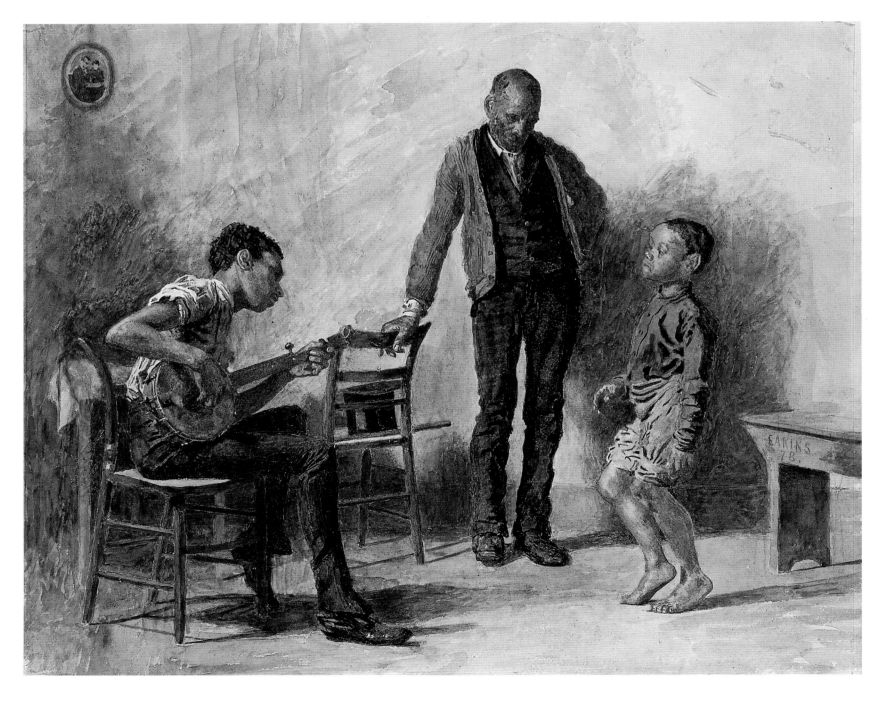

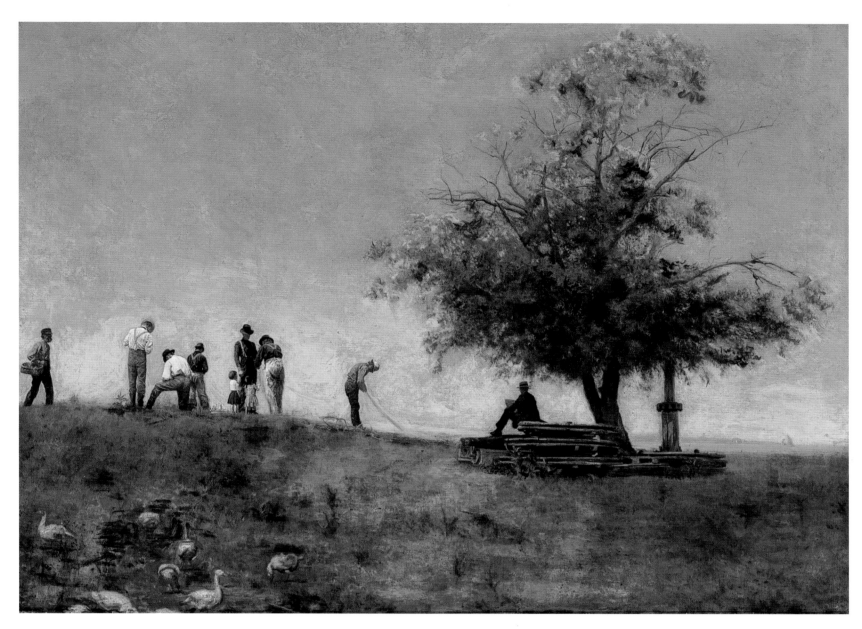

Above, top
132. *Mending the Net*, 1881
 Oil on canvas, 32⅛ x 45⅛ in.
 Philadelphia Museum of Art; Given by
 Mrs. Thomas Eakins and Miss Mary
 Adeline Williams

Above, left
133. *Geese at the Site of "Mending the Net,"*
 Gloucester, New Jersey, 1881
 Platinum print, 4 x 7⁵⁄₁₆ in.
 Hirshhorn Museum and Sculpture
 Garden, Smithsonian Institution,
 Washington, D.C.; Transferred from
 the Hirshhorn Museum and Sculpture
 Garden Archives, 1983

Above, right
134. *Two Fishermen Mending Nets*, 1881
 Modern print from dry-plate negative,
 4 x 5 in. plate
 The Pennsylvania Academy of the
 Fine Arts, Philadelphia; Charles
 Bregler's Thomas Eakins Collection.
 Purchased with the partial support of
 the Pew Memorial Trust.

Right
135. *Standing Piper (Study for "Arcadia")*, c. 1883
Albumen print, 3⁷⁄₁₆ x 3⅜ in.,
irregular
Hirshhorn Museum and Sculpture
Garden, Smithsonian Institution,
Washington, D.C.; Transferred
from the Hirshhorn Museum and
Sculpture Garden Archives, 1983

Below
136. *Ben Crowell(?) (Study for
"Arcadia")*, c. 1883
Sepia photograph, 4¼ x 6 in.
Hirshhorn Museum and Sculpture
Garden, Smithsonian Institution,
Washington, D.C.; Transferred
from the Hirshhorn Museum and
Sculpture Garden Archives, 1983

Opposite, top
137. *Unidentified Man in Dakota
Territory*, 1887
Albumen print, 3⅜ x 4⁷⁄₁₆ in.
The J. Paul Getty Museum,
Malibu, California

Opposite, bottom
138. *Arcadia*, c. 1883
Oil on canvas, 38¼ x 45½ in.
The Metropolitan Museum of Art,
New York; Bequest of Miss
Adelaide Milton de Groot, 1967

light in that collection, many of them directly or indirectly related to the subjects of his paintings. These photographs show that Eakins took an almost anthropological approach to recording the people and landscape of a particular region where he was painting. For example, he made scores of exposures of shad fishing in Gloucester, New Jersey, and of cowboy life at the B-T Ranch in the Dakota Territory (plate 137).

It has long been known that Eakins used a photograph in painting *Mending the Net* (plate 132). The geese at lower left were obviously borrowed—though rearranged—from a photograph of the same subject (plate 133), presumably taken by the artist. It was a logical move, given his usual desire to paint from his subject; the geese would not stay still, so the photograph was the only solution. The Bregler Collection, however, makes it clear that more than the geese

145

were borrowed from photographs. Prints from recently discovered glass negatives (plate 134) show that the poses of the two standing men facing each other, the little girls beside them, the single net mender to the right, and the man seated under the tree were all derived from photographic images. Similarly, photographic studies for the figure groupings in *Shad Fishing at Gloucester on the Delaware River* (plate 91) are found in the Bregler Collection.

For *Arcadia* (plate 138) Eakins again depended on photographs. In this case he posed a nude male (probably his student J. Laurie Wallace) and his young nephew Ben Crowell, also nude, and photographed them separately so that they could be inserted into the composition with relatively little alteration (plates 135, 136). Similarly, a photographic study for the wooded landscape setting for *An Arcadian* (plate 94) establishes the environment for the classically robed young woman seated alone on the grass; a photograph of a nude female in her position has been found in the Bregler Collection. The static pose and the harsh shadows in the Hirshhorn Museum's oil study of the clothed figure suggest that it may also have been derived from a related photograph, now lost.

The Swimming Hole (plate 102) reveals a slightly different relationship to the photographic image. In preparing for the work, Eakins made a series of exposures (plate 103) of young men in the nude, mostly his students, at the site—a rocky ledge where they rest, prepare to dive, or plunge into the calm water. These photographs are variations on a theme, each one slightly different from the other. None is copied specifically in the oil studies or the final painting, but these prints must have been useful in allowing Eakins to study the individual poses or the groupings at his leisure. Clearly, it would have been difficult to arrange and paint these unclothed young men directly at the site. There is a similar connection between Eakins's photographic studies and his major portraits such as *Walt Whitman* (plate 200). The artist went to visit Whitman in Camden, New Jersey, to paint his portrait from life, but he also photographed him; asking Whitman to sit for the long hours Eakins usually needed for a portrait would have been an imposition. Photographs helped solve the problem.

On several occasions Eakins either made paintings directly from photographs or relied on them so heavily that he seemed almost to have copied them. The most prominent example is *Drawing the Seine* (plate 140), a watercolor of a scene from Gloucester, New Jersey. The composition of the work is taken directly from a photograph (plate 139), the only difference being that the painting is multicolored, lighter in tone, and more sketchy in execution. Similar fidelity to the camera image is found in the two versions of *The Wrestlers* (plates 228, 230) and in *Frank Hamilton Cushing* (plates 141, 142). In *The Wrestlers* the entwined figures are verbatim transcriptions from the same photograph (plate 229). There is something dry and mechanical about both of *The Wrestlers,* but *Frank Hamilton Cushing* does not seem "photographic" in the same way. This is because Eakins executed it in such a painterly manner that he transformed the camera image into something personally expressive.

Eakins not only utilized photography to support and to advance his own art, he also contributed to the development of camera technology. The *Philadelphia Photographer,* the journal of the Photographic Society of Philadelphia,

reported that at the society's meeting on December 5, 1883, Eakins demonstrated an improved shutter of his own making:

> Two equal weights attached to the cords of different lengths, were dropped simultaneously. When the weight on the short cord had fallen as far as the cord allowed, the tension released a slide which uncovered the lens. The exposure continued while the other weight was falling. When the end of its string was reached, it in turn released a second slide which covered the lens. By altering the length of the second cord, in accordance with the table he has prepared, changing thereby the distance the weight is allowed to fall, Mr. Eakins can accurately vary his exposures from one-quarter to one-hundredth of a second.[19]

This was only the beginning of Eakins's venture into the mechanics of photography. He went much further than this in the next couple of years, during which time he gradually positioned himself in the vanguard of those inventing the motion-picture process. As noted in chapter 4, in 1878 or 1879 Eakins had received a commission from Fairman Rogers for *A May Morning in the Park* (plate 99). Six or seven years before Eakins began to plan this picture, Eadweard Muybridge was working in Palo Alto, California, for Leland Stanford, who is said to have made a bet that a trotting horse had all four feet off the ground at once. To settle the matter, he hired Muybridge to take instantaneous photographs of his horse Occident. The photos proved him to be correct, and Stanford became so interested in Muybridge's method that he employed him to carry out large-scale photographic investigations at his horse farm in 1877–79.

With Stanford's support, Muybridge developed a new technique: he lined up twelve or twenty-four cameras in a row and activated them in rapid succession as a horse ran down the track. They were triggered either by having the horse break a row of threads that released the shutters or by having the wheels of a sulky pass over a series of wires that completed an electric circuit and tripped the shutters. With such techniques Muybridge produced the first successful serial photographs of a rapidly moving horse in June 1878. Some of them were published that year in widely read American and European periodicals, and they immediately attracted the attention of horsemen, artists, and scientists.

One whose interest was particularly aroused by the Muybridge photographs was the French physiologist Dr. Etienne-Jules Marey, who had been studying the movement of horses through a system he called chronography. This involved the measurement of successive phases of an animal's gait by attaching to its feet pneumatic devices that were, in turn, connected to a recording apparatus carried by the rider. Muybridge's photographs came as a revelation to Marey, who had obtained rough approximations of the same results by having drawings of horses in motion made from his chronographic measurements. Marey had also devised a practical system of notation with which he could graphically diagram the sequential movements of the horse's legs—a method that was known and used by Eakins (see chapter 6).

Marey and Muybridge met in September 1881 when the photographer vis-

139. *Horses and Fishermen in Gloucester, New Jersey*, c. 1881-82
Modern print from dry-plate negative, 4 x 5 in. plate
The Pennsylvania Academy of Fine Arts, Philadelphia; Charles Bregler's Thomas Eakins Collection. Purchased with the partial support of the Pew Memorial Trust.

ited Paris during an extended lecture tour in Europe. He was welcomed enthusiastically by Marey and presented his discoveries to him and a distinguished group of colleagues, including the scientists Hermann von Helmholtz and William Crookes, as well as the photographer Nadar. At this meeting, and at another one held in Meissonier's studio, Muybridge successfully employed a device he called a zoopraxiscope, which projected sequentially taken photographs on a screen in rapid succession, thus giving the spectator the illusion of continuous movement similar to that obtained with a modern motion-picture projector.

Using his knowledge of Muybridge's work, in 1882 Marey perfected a photographic device that permitted a variation on the former's methods. Using a single camera with a slotted disk revolving in front of or behind the lens, Marey recorded a number of separate images of a moving subject on one photographic plate (plate 143). Because he relied on one rather than several cameras and made a series of exposures from a single point of view, his device can be said to foreshadow the motion-picture camera. Even closer in conception to such a camera was another of Marey's inventions, made in the winter of 1881–82, which seems to have interested Eakins but not Muybridge: this was a *fusil photographique*, or photographic gun, which took twelve exposures of a moving subject through a single lens and registered them on a series of negatives mounted on a disk that rotated behind the lens.

While Marey was conducting his early experiments in Paris and Muybridge was working at Palo Alto, Eakins was investigating animal locomotion from an artistic point of view. He must have been frustrated by trying to decode the mystery of the movement of horses' legs, but fortunately Muybridge offered the solution. In an article published in the *Art Interchange*, July 9, 1879, Fairman Rogers stated that "shortly after the appearance of the [Muybridge] photographs, Mr. Thomas Eakins . . . took them up for examination."[20] In a letter of May 7,

140. *Drawing the Seine*, 1882
Watercolor on paper,
11¼ x 16½ in.
Philadelphia Museum of Art; The John G. Johnson Collection

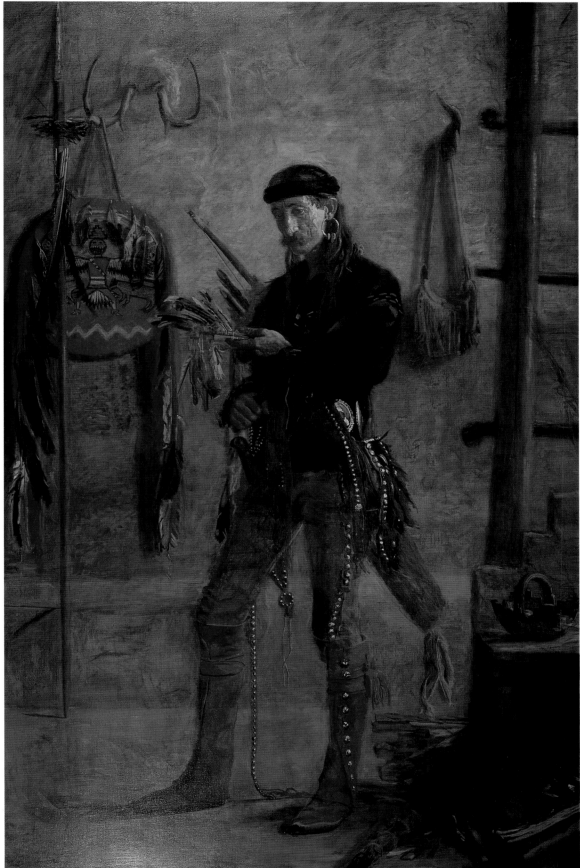

Left
141. *Frank Hamilton Cushing*, 1895
Oil on canvas, 90 x 60 in.
The Thomas Gilcrease Institute of
American History and Art, Tulsa,
Oklahoma

Above
142. *Frank Hamilton Cushing*, c. 1895
Platinum print, 3½ x 2⅝ in.,
irregular
Hirshhorn Museum and Sculpture
Garden, Smithsonian Institution,
Washington, D.C.; Transferred
from the Hirshhorn Museum and
Sculpture Garden Archives, 1983

1879, which must have been a reply to one from Eakins, Muybridge had written
to the painter: "I am much pleased to hear that the few experimental photos we
made last year have afforded you so much pleasure, and not withstanding their
imperfections have been so serviceable."[21] It was undoubtedly the portfolio of
serial photographs Muybridge published in 1878 under the title of *The Horse in
Motion* that Eakins studied. He corresponded with Muybridge in 1879, while *A*

143. Etienne-Jules Marey (1830–1904)
Photograph of Man Jumping
Heliogravure reproduction from *La Nature*, 1883

May Morning in the Park was underway, and suggested a better way to incorporate scales of measurement in Muybridge's serial photographs of horses.

Careful inspection of Eakins's painting and the sculptural studies he made for it reveals his close knowledge of Muybridge's sequential photographs: there is a high degree of correspondence between the side views of the four sculptures of Rogers's horses (plate 144), which undoubtedly served as models from which Eakins painted, and Muybridge's photographs of the horse Edgington in the trotting gait (plate 145). Eakins based the positions of his sculptural models on four consecutive frames in one of Muybridge's photographic sequences.

Eakins and Muybridge must have met in the spring of 1883, when the photographer went to Philadelphia to lecture on the movements of the horse at the Pennsylvania Academy. The two worked side by side in 1884–85, when Muybridge was conducting an extended photographic study of animal and human locomotion under the auspices of the University of Pennsylvania. Along with a number of scientists and engineers Eakins was appointed to a commission organized to supervise Muybridge's work, and in Goodrich's opinion, Eakins may have played a part in backing the photographer's appointment.[22] They all agreed that the Palo Alto experiments should be duplicated, but with many technical improvements. On the grounds surrounding the University Hospital, Muybridge built an outdoor studio with a shed containing twenty-four cameras placed parallel to the track along which his subjects moved. The shutters were equipped with electromagnets that were released in a sequence of equal intervals by a device called a contact-motor—a method that represented a marked advance over the techniques he had used at Palo Alto. From the spring of 1884 to the fall of 1885 Muybridge made about one hundred thousand negatives, selections from which were published in his monumental 781-plate work entitled *Animal Locomotion; an Electro-Photographic Investigation of Consecutive Phases of Animal Movements, 1872–1885* (1887).

Although it is rarely mentioned in accounts of Muybridge's work at the University of Pennsylvania, while there he also utilized Marey's technique of photographing a moving subject on a single plate. Muybridge used this method

150

Above
144. *Trotting Horses: Models for "A May Morning in the Park,"* c. 1879, cast 1946
Bronze, each 10¼ in. high, including base
Mr. and Mrs. Paul Mellon, Upperville, Virginia

Left
145. Eadweard Muybridge (1830–1904)
Photograph of "Edgington" Trotting, 1878/1879
Free Library of Philadelphia

to record abnormal movements under the guidance of Dr. Francis X. Dercum, an instructor in nervous diseases at the university, who published the results of their investigations in 1888. Asserting that Muybridge was "very familiar" with Marey's approach, Dr. Dercum explained:

> An old sulky wheel was taken and was converted into a Marey wheel with heavy black paper. In this a small fenestration of given size was made. Apparatus borrowed from the physiological laboratory of the University was then adjusted and we were able to determine accurately the time of exposure. A camera was then placed in position, Mr. Muybridge himself acting as the subject ascending a stairway, with the result that a series of pictures was taken upon one plate, according to the method of Marey.[23]

Muybridge subsequently devised a second, improved camera, based on Marey's principles, that utilized two large perforated disks running at high speed

in opposite directions and making instantaneous exposures when the openings overlapped. In pictures taken with both the one- and the two-disk versions of the camera, the subject was shown in a series of overlapping images, much as in today's stroboscopic photography. This method seems to have had little value for Muybridge, who preferred his own original technique of taking a series of separate photographs with a row of cameras. Perhaps he liked this procedure better because he could project the results onto a screen and amaze his audience and because the discrete images, lined up one after the other, would be easier for artists to copy or imitate.

Eakins, however, began to see the drawbacks of Muybridge's preferred method because each picture differs slightly in its point of view, and thus the results are scientifically inaccurate. To remedy this defect Eakins set up an enclosure near Muybridge to conduct photographic experiments of his own. Using a one- or two-disk camera of his own design, he photographed young men—mostly his students—running, jumping, walking, swinging a ball, throwing a baseball, and so on. The work Eakins did with his own camera was deemed important enough to publish; it reappeared, with an introduction by Professor William Dennis Marks, an engineer on the faculty of the university, in a report on the Muybridge work.[24]

Several explanations of the importance of Eakins's two-disk cameras have been offered. Goodrich suggested that his method substantially reduced the size of the equipment.[25] McHenry stated that two rotating disks cut the time of exposure to one-eighth of what it was when only one disk was used.[26] But the most rewarding answer was provided by Marks. Writing about a photograph Eakins took of a jumping figure, he observed: "The reproduction of a boy jumping horizontally . . . which Professor Eakins has photographed on a single plate by means of his adaptation of the Marey wheel, is of exceedingly great interest, because, in this picture each impression occurred at exact intervals. The velocity of motion can be determined, by measurement of the spaces separating the successive figures, with very great precision, as also the relative motion of the various members of the body."[27] The high degree of accuracy in Eakins's measurements of the intervals between exposures is attested by his or Muybridge's annotations on the photograph reproduced as plate 146, the same image cited by Marks. This print carries great historical importance because it provides both a graphic and a mathematical record of Eakins's procedures.

Even closer in conception to the modern motion-picture camera was a little-known camera constructed by Eakins for taking a series of individual exposures on a revolving octagonal glass plate (plate 147). Professor Marks's description of this device, based on a manuscript by Eakins, reads as follows:

A second camera was devised for investigating the class of movement in one place, as that of a man throwing a stone, where in the Marey camera, the image would superimpose. In this camera the plate is revolved on a frame at the end of an axle, which pierces the back of the camera. Belting and pulleys connect the movement of the disks and of the plate, and a pair of friction-wheels allows such an adjustment of speed from the disks to the sensitive plate that the images may be made just to clear one another.[28]

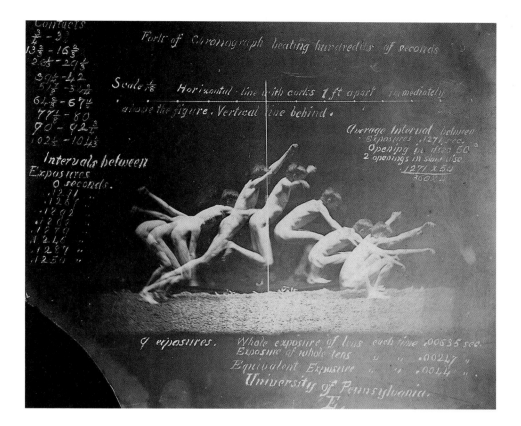

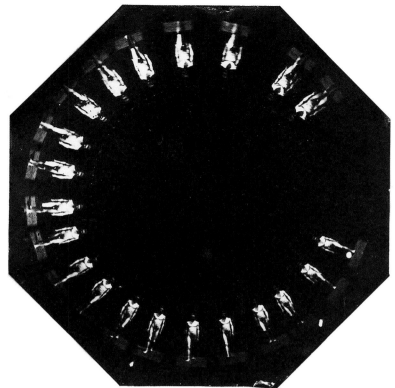

In principle this apparatus is almost identical to the "photographic gun" that Marey had invented in 1881–82, and it is unlikely that Eakins developed it independently of the French scientist, considering that his publications were well known among the experimenters working at the University of Pennsylvania. But Eakins, working with excellent dry plates, an accurate chronograph, and the two-disk apparatus, was able to produce photographs of higher quality and definition than had previously been possible with a rotating plate. It is true that Marey had succeeded in taking twenty-one sequential pictures on a rotating plate in 1884, but his subject was a portrait, not a full-length moving picture, and the images were smaller than those obtained by Eakins. Since Eakins's camera successfully took very legible photographs through a single lens and from a single point of view, thus avoiding the distortions inherent in Muybridge's series method, it can be said to foreshadow the motion-picture camera that was perfected and used by Thomas Edison and others during the 1890s.

Eakins's photographic work, like his investigations of anatomy and perspective, represented just another tool that would augment his understanding of the human figure. Once he had satisfied his curiosity about human locomotion and had solved the technical problems that confronted him, he abandoned serial photography; there is no evidence that he pursued it after 1885. It was Marey, continuing to use photography as a means of studying movement, who in the fall of 1888 perfected a primitive motion-picture camera that took successive images on a flexible strip of film. Instead of capitalizing on his invention, however, he saw it primarily as a scientific instrument that would increase man's knowledge of animal locomotion. It remained for Edison, who drew heavily on his assistant W.K.L. Dickson's perfecting of the Kinetoscope and Kinetograph between 1889 and 1891, to exploit such devices commercially.

Above, left

146. *Photograph of Unidentified Model, with Eakins's or Muybridge's Notations*, 1884–85
Albumen print, 9⅛ x 11¼ in.
The Library Company of Philadelphia

Above, right

147. *Sequential Photograph of Man Walking*, 1885
Modern print from Eakins's original glass-plate negative
The Franklin Institute Science Museum, Philadelphia; Thomas Eakins Collection

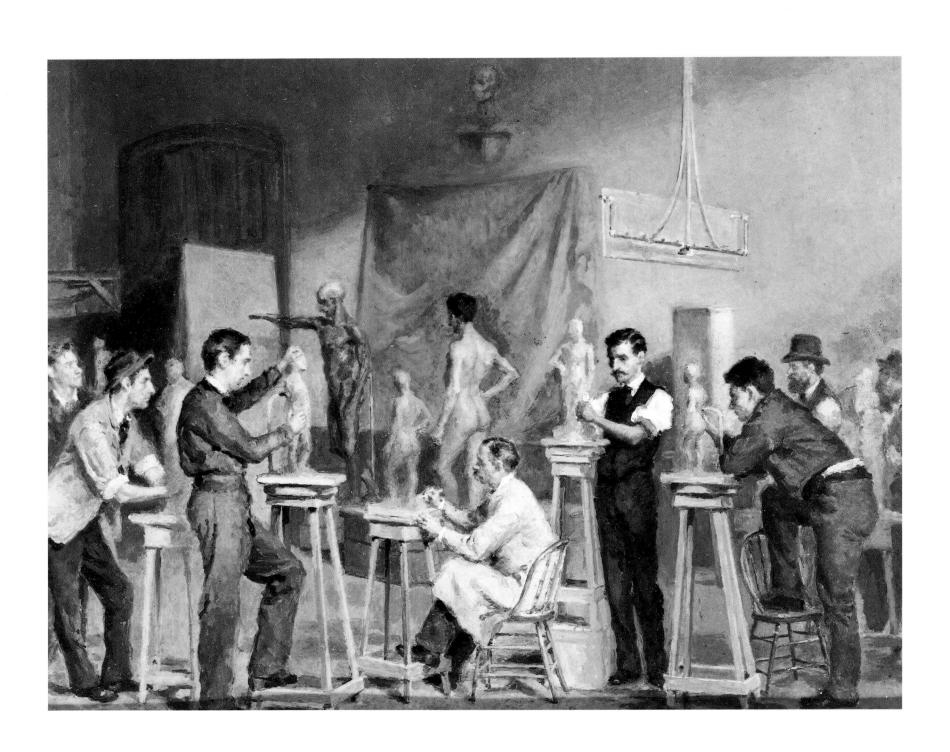

6.
Eakins as Teacher

Eakins's principal objective in life was to become an accomplished painter, and by the early 1870s he was well on his way to that goal. However, he also seems to have taken easily to teaching, perhaps because it helped him clarify his own thinking. In addition, Eakins may have believed so strongly in his own methods of painting and drawing that he felt compelled to spread the word to a larger audience. In any case, he did it well and became a major influence in American art education.

Eakins started teaching in a modest and informal way. Prompted by Earl Shinn, the Philadelphia Sketch Club in 1874 asked Eakins to teach life classes twice a week. He agreed to serve as instructor, without charge, writing to Shinn, "It is always a pleasure to teach what you know to those who want to learn."[1] Club members, as well as some nonmembers, all male, came from different corners of the art world: experienced artists such as Alexander Milne Calder, William Sartain, and Charles L. Fussell; commercial artists with a bit of previous experience in life drawing; and some who were just beginning. In the last category were a few, such as Thomas Anshutz, James P. Kelly, and Charles H. Stephens, who later attended the Academy and became Eakins's assistants there.

Eakins's classes, held on Wednesday and Saturday evenings, were a great success. His profound knowledge of the human body and his ability to communicate it made him popular. More students wanted to attend than the rooms could hold, thanks to his "distinct genius for teaching."[2] Some of his students were able to reach toward the high standards he set, but others, Eakins reported, "continue to make the very worst drawing that was ever seen."[3] Eakins may have joined in drawing from the model for his own practice, producing a group of charcoal drawings of male and female nudes (plate 150) that testify to his remarkable skill and maturity as a draftsman.[4] They are true to nature, yet the realistic detail does not interfere with the grand rhythms of the figure, captured in broad masses of tone.

The Sketch Club classes filled a void created by a lengthy hiatus at the Pennsylvania Academy. In 1870 the old Academy building had been torn down, to be replaced by a larger and more elaborate structure at Broad and Cherry streets. Fairman Rogers was chairman of the Building Committee, and John

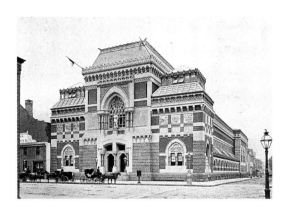

Opposite
148. James B. Kelly
The Modeling Class, 1879
Oil on cardboard, 10⅛ x 12¾ in.
The Pennsylvania Academy of the
Fine Arts, Philadelphia; Gift of
the artist

Above
149. Frederick Gutekunst (1831–1917)
*The Pennsylvania Academy of the
Fine Arts*
Photograph
Mr. and Mrs. Daniel W. Dietrich II

155

150. *Study of a Seated Woman Wearing a
Mask*, 1874–76
Charcoal on paper, 24¼ x 18⅞ in.
Philadelphia Museum of Art;
Given by Mrs. Thomas Eakins and
Miss Mary Adeline Williams

Sartain helped to lay out the studio and gallery spaces (Eakins is said to have
offered advice in these matters).[5] It took six years, four of them in the construc-
tion phase, to bring their plans to completion. The designer of the building, the
Philadelphia architect Frank Furness, created what was then a startling structure
in the Venetian Gothic manner, not a copy of any other building, but a bold, col-
orful, eclectic mixture of styles. Furness was a source of inspiration to Louis
Sullivan, the celebrated American architect who coined the phrase "form ever
follows function." With the new Academy, Furness had indeed created a func-
tional interior that was better suited to the teaching of art than any other build-
ing in the country.

156

Unlike the National Academy of Design in New York, where classes were held in the basement, the Pennsylvania Academy allocated most of the first floor to instruction. The room for life classes was believed to be the largest in the nation. These studios and the second-floor galleries were well lit with natural light from above. There were, moreover, dissection rooms, a commodious lecture hall, a well-stocked print room, and a library. A large collection of photographs of paintings by the Old Masters graced the walls of the school. An extensive hall of casts from the antique provided models for the novice student to draw.[6]

Classes began at the Academy in October 1876, with Schussele, now partly paralyzed, serving as professor of drawing and painting (at a salary of twelve hundred dollars per year), and with Dr. William W. Keen, professor of artistic anatomy, offering lectures on anatomy. The noted French-born sculptor J.-A. Bailly lectured on modeling in clay, and beginning in 1877 James H. Kirby offered instruction in perspective. Eakins had signed a petition a few months earlier, in January, asking that he and the Sketch Club members be permitted to use the nearly completed facilities for their own classes, but the request was denied—in part because the Academy was concerned about maintaining its own enrollment. Once the new building opened, Eakins gained a foothold in the Academy by volunteering to help the aging Schussele with the evening life classes, by assisting Dr. Keen as chief demonstrator of anatomy, and by offering lectures on perspective. All of these tasks he performed without pay.

This must have been a difficult situation for Eakins. Though already an accomplished teacher and full of new ideas that he had absorbed in Paris, he was not in a position to radically contradict Schussele's views. Nevertheless, Eakins apparently instituted some reforms in his teaching of evening classes while the older man was absent. These must have disturbed the Academy officials, because in May 1877 Schussele was told not to "delegate his authority or duties to any other person" and that he would have to be present at those classes.[7]

Two months earlier a group of Academy students had formed the Art Students' Union and persuaded Eakins to serve as their instructor. The students had argued that "only nine hours a week were devoted in the Academy to the study of models by daylight" and complained that Eakins had lost favor with the Board of Directors.[8] As at the Sketch Club and the Academy, he served without salary.

Although Eakins may not have consciously tried to undermine the Academy, where he continued to teach, he had taken on a large number of its students at the union, a step that undoubtedly concerned the Academy's directors. Troubling to the Academy, too, was Schussele's physical condition: his palsy was getting worse, and his enrollments were declining. On top of this, a group of dissatisfied women students at the Academy submitted a petition, dated November 2, 1887, to the Committee on Instruction asking for an evening life class to supplement the existing morning one. The cover letter reminded the committee of Eakins's absence from the school's faculty and expressed the view that "his good work of last winter at the Academy, proved him to be an able instructor and a friend to all hard working students." Diplomatically, the letter requested that "both Prof. Schussele and Mr. Eakins . . . overlook our work."[9] It

151. Photographer unknown
Eakins as a Young Man in the Garden at 1729 Mount Vernon Street, c. 1876–79
Mr. and Mrs. Daniel W. Dietrich II

bore the signature of "Miss S. H. Macdowell"—Susan Hannah Macdowell—as advocate for her fellow women students. One might legitimately surmise that she and Eakins had conspired to get him reinstated without hurting Schussele's feelings. An extra life class for women was added a few days after the petition was delivered, but Eakins was not appointed as an instructor—at least not yet. That took the firm hand of Fairman Rogers, who had replaced John Sartain as chairman of the Committee on Instruction in February 1877. He asked Eakins in March 1878 to write the directors and offer his services once again—a proposal that was accepted.

That fall Eakins was named assistant professor of painting and chief demonstrator of anatomy—a title that suggests he had gained the confidence of the Committee on Instruction. In the meantime, Schussele's health continued to fail, and early in 1879 the board tried to get him to resign. (Eakins honorably said that he would not fill Schussele's place if he were forced out of the Academy.) On August 21, 1879, Schussele died, and in a matter of weeks Eakins was promoted to professor of drawing and painting—at six hundred dollars a year, half of Schussele's salary.

Full of pride and delight, he wrote to Susan Macdowell about his triumph, adding that he would be in Newport (working on *A May Morning in the Park*, for Fairman Rogers) at the start of classes and that William Sartain would substitute for him: "When old [John] Sartain learns not only that I have the place, but that the other young firebrand Billy is keeping it for me, I fear his rage may bring on a fit."[10] This brief comment says a great deal. Not only does it reveal Eakins's pleasure in his new appointment, but the phrase "I have the place" suggests that he had patiently conducted a campaign to wrest control of the Academy from the old guard—Schussele and his backer John Sartain. These two represented traditional ways of painting and teaching, and Eakins symbolized the new. Quietly, but with great determination, he had gotten his foot in the door, then kicked it wide open.

Philadelphia was fortunate to have someone with Eakins's intelligence and fierce pride in the city who was both determined to improve art education at the Academy and well equipped to do so. No doubt there was a personal element, too—the drive of an aggressive young reformer who wanted to do things the way he believed they must be done. Whatever his motivations, Eakins significantly raised the level of professionalism at the school. It has often been said that he radically changed the curriculum and totally revamped the methods of the Academy. However, a close look at what was offered before Eakins's arrival shows that he did not add much in the way of new subjects. Under Schussele, anatomy and dissection had been taught; lectures in perspective were offered; and students worked first from plaster casts, then the live model. These were the three key elements in virtually every art school based on the French system. The Academy was certainly sympathetic to that system, for Schussele had studied in Paris under Paul Delaroche and Adolphe Yvon. And Schussele's friend and ally, John Sartain, was thoroughly versed in French methods.

Beginning in 1876, the year the new building opened, lectures were given intermittently, in emulation of what was done at the Ecole des Beaux-Arts. A

series of three offered in 1876–77 by Earl Shinn treated the history of aesthetics, with much stress being placed on the ideas of Hippolyte Taine, the French advocate of positivism who had lectured at the Ecole. Other lecturers covered the history of art (William Henry Goodyear) and the history and practice of engraving (John Sartain). From time to time distinguished foreign artists—such as Sir Francis Seymour Haden, a noted English etcher, and Sir Hubert von Herkomer, an English painter, etcher, and illustrator—were invited to speak. On other occasions local talent was brought in: J. Liberty Tadd, recently an Academy student, spoke on Michelangelo and Raphael; George C. Lambdin, a noted portrait and miniature painter, discussed the development of painting in oil.

After Eakins gained a foothold as a teacher at the Academy, he continued to follow, and to support, the traditional curriculum. The initial changes he brought about were mainly in his own teaching: he allowed students to move quickly from cast drawing into the life classes, encouraging them to paint as soon as he thought they were ready. The sequence of classes was no different from what Eakins had experienced in his own studies at the Ecole, but the rapid progression from drawing to painting was his own idea. His credo as an artist, formed as much in Spain as in Paris, was that a broad, immediate, painterly grasp of the subject was essential; too much drawing would defeat that goal. He had come to despise the worship of classical statuary while in Paris, so it is not surprising that he viewed prolonged cast drawing as detrimental.

William C. Brownell's 1879 article on the Academy, based on an interview with Eakins, quoted him: "I don't like a long study of casts, even of the sculptors of the best Greek period. At best, they are only imitations, and an imitation of imitations cannot have so much life as an imitation of nature itself."[11] Brownell, no doubt prompted by Eakins, observed that Schussele was "conservative" because he preferred "a long apprenticeship in drawing,"[12] as opposed to Eakins, who gave the revolutionary advice that students should begin to paint right away. Quoting Eakins: "I think he [the student] should learn to draw with color." The artist felt the brush was "a more powerful and rapid tool than the point or stump" because it allowed the student to grasp "the grand construction of the figure." Eakins went on to say: "The first things to attend to in painting the model are the movement and the general color. The figure must balance, appear solid and of the right weight. The movement once understood, every detail of the action will be an integral part of the main continuous action; and every detail of color auxiliary to the main system of light and shade."[13] (Two surviving figure studies, one male [plate 152] and one female, testify to the application of Eakins's methods by one of his students, unfortunately not identified.)

Another of Eakins's innovations was the introduction of modeling from life, in three dimensions, as an aid to students of painting. As Fairman Rogers reported in an 1881 article on the school (basing his remarks, in part, on a manuscript by Eakins): "Nothing increases more rapidly the knowledge of the figure than modelling it. The student studies it from all sides and sees the relation of the parts, and the effect of the pose upon the action of the muscles, much more distinctly than when painting from the one side of a model exposed to him from his fixed position in the painting class."[14] Rogers stated with pride that

152. Artist unknown
Figure Study (Male), c. 1879–86
Oil on canvas, 25 x 17½ in.
John Randolph Garrett

153. Walter M. Dunk
The Men's Life Class, 1879
Oil on cardboard, 10¼ x 12¾ in.
The Pennsylvania Academy of
the Fine Arts, Philadelphia;
Gift of the artist

Academy students produced work fully in the round, not just in bas-relief, as was the custom at the Ecole. Clay was the material of choice, though wax was employed for modeling horses or other animals.

Because the curriculum concentrated so heavily on the figure, both human and animal, Eakins urged his students to engage in dissection under his supervision. The Academy had its own dissecting room, mainly for human cadavers, but students were also encouraged to go with Eakins to dissect horses at Shoemaker's oil factory in North Philadelphia. Dissection was closely linked to Dr. Keen's lectures on anatomy. Praised for his enthusiasm and for the lucidity of his lectures, Keen used not only a blackboard to illustrate his points, but also drawings, a skeleton, a mannequin whose muscles were activated by electricity or weights, living models, and dissected cadavers prepared by advanced students. This was no casual course of study: Brownell reported that there were thirty lectures on all phases of human and animal anatomy, including "postural expression, the proportions of the body, and the influence of sex upon physical development."

160

Comparison of the dissected figure and the living model was a principal feature of the lectures, as was the juxtaposition of dissections of the human head with those of animals to show "comparisons and variations."[15] Observing the massive amount of anatomical data offered to the Academy students, Brownell wondered if such information would enable a student "to draw a leg better." Eakins replied: "Knowing all that will enable him to observe more closely, and the closer his observation is the better his drawing will be."[16]

Eakins directed his system of education to those who intended to become professional artists. Knowledge of the human body was the principal means toward that end. As Rogers reported: "Great stress is laid upon the weight and solidity of the figure; it must stand upon its legs and show exactly what part of the general movement each portion of the body is bearing, and must look as if it is made from a real living body, and not from a pasteboard silhouette." And: "Mr. Eakins teaches that the great masses of the body are the first thing that should be put upon the canvas, in preference to the outline, which is, to a certain extent, an accident, rather than an essential; and the students build up their figures from the inside, rather than fill them up after having lined in the outside."[17]

The ability to seize the model's character accurately, without succumbing to convention, was prized by Eakins. If the school could provide an environment that would help the student to do this, then he would be satisfied. But he would not lead the student by the hand. As the Committee on Instruction's report stated: "The Academy does not undertake to furnish detailed instruction, but rather facilities for study, supplemented by the occasional criticism of the teachers." Rogers compared the school to a "club of artists," like the Art Students

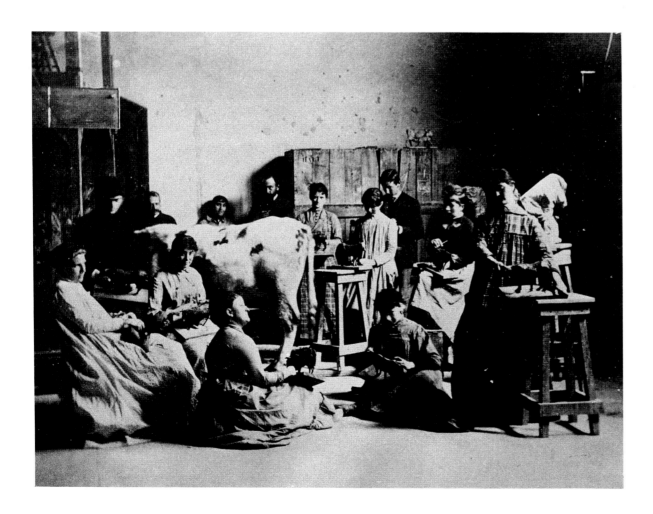

154. Photographer unknown
Ladies' Modeling Class at the Pennsylvania Academy of the Fine Arts, 1881–83
Philadelphia Museum of Art; Gift of Charles Bregler

League of New York or the independent ateliers in Paris, where students joined together to work from a model with aid from an instructor or critic.[18] The role of the Academy was to enhance the self-instruction of the students who, it was thought, would learn as much from each other as from their teachers. Eakins enforced this idea by spending relatively little time in the classroom, usually appearing only twice a week—as Gérôme had done.

For models, Eakins tried to find the best possible physical specimens, though doing so was difficult. By advertising in the newspaper for suitable models, he fought against the tradition of hiring prostitutes and others who were not well formed. Occasionally, Rogers reported, "athletes, trapeze-performers, and the like, have been secured."[19] Even horses and cows were brought in to serve as subjects for the students' drawings and paintings (plate 154).

The Academy in the early 1880s was like a giant laboratory, fully equipped to teach motivated students the structural basis of painting. There were as well classes in portraiture and still-life painting, a cooperative sketch class for rapid work from a costumed model, and lectures on perspective. Nonetheless, critics claimed that the school failed to deal with composition and aesthetics. Rogers, probably echoing Eakins, stated:

> The objection that the school does not sufficiently teach the students picture-making, may be met by saying that it is hardly within the province of a school to do so. It is better learned outside, in private studios, in the fields, from nature, by reading, from a careful study of other pictures, of engravings, of art exhibitions; and, in the library, the print room and the exhibitions which are held in the galleries, all freely open to the student, the Academy does as much as it can in this direction.[20]

This approach to art education was heavily indebted to the Beaux-Arts methods that were already in place in the Academy when Eakins started to teach there and which he improved and augmented as he gained influence. Early in 1882 this direction was largely reaffirmed by a study on the reorganization of the school undertaken by Eakins and Rogers for the Committee on Instruction. Certain changes were recommended: to charge tuition (classes had previously been free), to augment the ranks of aspiring painters and sculptors with those who were or wanted to be commercial artists, and to allow amateurs "to profit by the same facilities."[21] Even though students were compelled to pay, enrollments remained high. In the year of the reorganization Eakins was named director of the schools at a salary of twelve hundred per year, to be doubled if increased revenues permitted. His former assistant Thomas Anshutz was promoted to assistant professor of painting and drawing at thirty dollars per month, and a promising student, J. Laurie Wallace, became chief demonstrator of anatomy, without pay. (After Wallace resigned in December 1883 to go to Chicago, he was replaced first by Fred Wagner, then by William MacLean.)

After the reorganization and Eakins's promotion to director, the Academy became even more rigorous in its professional programs. Scientific methods of analyzing the human figure grew in importance between 1882 and 1886.

Dissections continued unabated, and the number of Dr. Keen's lectures increased from thirty to thirty-five—though the one on sexual differences was withdrawn in response to a student petition. Lectures on other art-related topics were offered, though it is doubtful that Eakins played a significant role in planning them.[22]

Eakins had no interest in art history or aesthetics.[23] At the Academy he taught the subjects that *he* thought were valuable: anatomy, perspective, and more specific topics, such as reflections in water and sculptural relief. In 1884 he wrote to J. Laurie Wallace that he was lecturing on "perspective and composition,"[24] but there is no evidence to indicate that, by the latter, he meant pictorial design or arrangement. If the manuscript he wrote for eventual publication accurately echoes what he said in his lectures (all but a few pages of his anatomy lectures are lost), then his level of intellectual rigor was extraordinarily high. The following excerpts are typical. On perspective:

155. *Illustration for Perspective Manual,* 1882–86
Pen and ink over graphite on paper, 17¹⁄₁₆ x 9¾ in.
The Pennsylvania Academy of the Fine Arts, Philadelphia; Charles Bregler's Thomas Eakins Collection. Purchased with the partial support of the Pew Memorial Trust and the John S. Phillips Fund.

> I am sitting with my eye 48 inches above the floor. The picture plane is to be 1½ ft. forward of the eye. Draw the perspective plan of a number of square feet marked upon the floor parallel with the picture & in the neighborhood of from 20 to 30 ft. where I wish afterwards to place some principal objects.
>
> Draw the horizon and middle vertical line, and let us start from a point on the floor 18 ft. off from the eye; that is 12 times as far as the picture, and then mark on the middle vertical line of the picture 4 inches down for the picture of this point; because an upright stick 48 inches long from the level of the eye to the floor & held off at 18 ft. would be represented on the picture by a line ¹⁄₁₂ of 48 inches long or 4 inches long. The horizontal line through this lower point is then divided right & left into inches representing feet, and one of the last divisions into twelfths to represent inches.
>
> We could have started to get first the 20 ft line instead of the 18 ft. one, 20 feet is 13⅓ times as far off as 1½ ft the distance of the picture and the picture of the things at that distance would be 1/13⅓ as big as the real things, so that a foot would represented by 1/13⅓ of 12 inches. Now this fraction would be inconvenient to measure and unnecessary.

On reflections in water:

> To demonstrate the apparent bend of a straight stick entering the water, let LO [referring to an illustration, plate 155] be a ray of light travelling through the water & refracted in the air in the direction ODS, & entering the eye situated somewhere on a prolongation of this line ODS. Then to this eye the point L would seem to be at K. Now let GIKLH be the trace of a plane at right angles to the paper which contains the incident & refracted rays, and suppose a stick set at any angle in that plane & touching the point L.
>
> Revolving about the axis GIKLH the drawing & eye of spectator through an angle of 90° to lay the plane through GIKLH in the plane of the

163

156. *Untitled (Perspective Study of Table)*, c. 1883
Pen, ink, and pencil on paper, 23¾ x 16 in.
Hirshhorn Museum and Sculpture Garden, Smithsonian Institution, Washington, D.C.; Gift of Joseph H. Hirshhorn, 1966

paper we have L for the lower end of the stick and K for its apparent depth to the eye situated as described.

Drawing through L the stick at different angles we have its appearance KMN, KQP, KVW, and so forth.

Between the very near water where you see into it, & the farther water that you see only reflections from, there is a doubtful space where you see either the things in it by refraction, or the things out of it by reflection, according as you focus your eye for near or for far.

On sculptural relief:

Relief holds a place between a painting or drawing on a flat surface and a piece of full sculpture.

If a man looking into a hollow box ABCD wished to make a relief of it, he would draw lines from the corners to his eye [reference to lost drawing].

Now any point on the line AE as a, a' or a" may be made to represent in relief the point A & so on the BE line the representation may be made of the point B[.]

If the points are so chosen that the lines ab & cd are long, the relief is a deep one alto-rilievo. If they are so chosen that the lines a'b' & c'd' are short, we have low relief, basso rilievo. If the relief is brought near the eye, it is a small piece of sculpture, if carried farther off, it is larger just in proportion as it is taken away from the eye.[25]

Not only did Eakins explain these matters in theoretical terms, he also invited his students to solve their problems in down-to-earth ways. Following his own practice in *The Chess Players* (plates 76, 129), he suggested that in drawing a table, for example, they establish a gridwork of lines forming squares one foot apart on the floor of the studio. Then it would be simple, he asserted, to place the table on the floor, observe its position within the grid, and copy the table onto the corresponding ground plan laid out in perspective in the drawings.[26] He appears to have employed his own method in a drawing of a tilt-top table (plate 156). According to the museum director and writer Homer Saint-Gaudens: "To keep his point of view correct Eakins taught his class to set up before the subject a screen of tight strings placed in rectangles. Then he would put tacks in the floor to remind them where to place their feet."[27]

Several of Eakins's students left accounts testifying to his abilities as a teacher. Those by Charles Bregler, who entered the Academy in late 1884 or early 1885, are the most complete and give the most personal portrait of Eakins in the classroom. Here are some of Eakins's words of advice, as recorded by Bregler:

To study Anatomy out of a book is like learning to paint out of a book. It's a waste of time.

Get life into the middle line. If you get life into that the rest will be easy to put on.

164

Get the foot well planted on the floor. If you ever see any photograph of Gerome's works, notice that he gets the foot flat on the floor better than any of them.

Think of the big factors.

Strain your brain more than the eye.

You can't compare a flat thing with a round thing. You have to get it round as quickly as possible.

Always think of the third dimension.

Get the character of things. . . . If a man's fat, make him fat. If a man's thin, make him thin. If a man's short, make him short. If a man's long, make him long.

Think of the cross sections of the parts of the body when you are painting.[28]

Occasionally Eakins would recommend that his students paint eggs "to learn nicety of drawing" and depict colored ribbons—as he himself had done at the Ecole—to develop "the range of their colors."[29] Eggs, he thought, were similar to human flesh in color and texture, and since their form was already so familiar they would offer the student a way to concentrate on the act of painting.[30] To solve the problem of the eggs' impermanence, Eakins would make wooden egg shapes on his lathe (plate 157) and have his students color them red, black, and white. Instructing his charges to depict the eggs separately, then all together, he would explain, "I painted these in sunlight, in twilight, indoors,—working with the light, and the light just skimming across them [see plate 158]."[31]

157. *Three Wooden Forms, Painted Red, White and Black*, c. 1879–86
Wood, 1½ x 2 in. each
Hirshhorn Museum and Sculpture Garden, Smithsonian Institution, Washington, D.C.; Charles Bregler Archival Collection

158. *Two Cylinders and Ball*, c. 1884
Oil on canvas, 3½ x 13¼ in.
Joslyn Art Museum, Omaha; Gift of Mr. and Mrs. Joseph I. Barker in memory of George Barker, April 22, 1966

Just the word that Eakins was about to enter the classroom was enough to make students realize the failings of their work. As one of them later recalled: "Our careful studies suddenly seemed poor things, all out of drawing, and we felt like turning them around and sneaking from the room before the master got a chance to look at them."[32] Eakins would spend no more than thirty minutes on each visit, patiently offering individual criticisms to the more able artists. In the case of a weaker student, Eakins would sit down at his easel, "then look up at him [the student] with disappointment written on his face, arise and not utter a word." His silence was "sufficient criticism." Sometimes Eakins would solve a student's painting problem by taking up brush and palette and "with a few strokes push it into correct shape."[33]

Eakins eliminated the French practice of giving prizes and ranking student work. The only honor, one of his former pupils reported, was for Eakins to inscribe an *E* on the canvas or sheet of drawing paper: "The capital E was a real prize, carrying many times over the thrill of the prizes and scholarships today." Reports from Eakins's students reveal that he was much admired as a person and as a teacher. Although demanding, he was also seen as "an understanding fellow."[34] There was a strong sense of camaraderie between Eakins and the male students, and from them he received "the love, loyalty, devotion and complete faith in ultimate recognition of his masterly painting."[35]

Even though Eakins and "the boys" were close, he did not ignore the professional needs of his women students. The Academy offered separate life classes and sessions on dissection for women (males and females attended Dr. Keen's anatomy lectures together), this being "the one school in the world," Eakins noted, "where women could study the figure without annoyance."[36] He acknowledged that "professional privileges" had come more slowly to women than men, but claimed that there was "a decided advance" in the education of women, especially in the United States.

Eakins clearly wished to contribute to that progress, though he held restrictive views, common in his time, that seem old-fashioned today. He said, "I do not believe that the great painting or sculpture or surgery will ever be done by women, yet good enough work is continually done by them to be well worth their doing, and as the population increases, and marriages are later and fewer, and the risks of losing fortunes greater; so increases the number of women who are or may be compelled at some time to support themselves, and figure painting is not now so dishonorable to them." He cited Elizabeth Gardner, who was influenced by and later married Adolphe-William Bouguereau, as an able and financially successful figure painter among "many other women both painters and sculptors who are honorably supporting themselves." Though pleased that his female students' education allowed them "to decline ineligible offers" of marriage, he cautioned that independence carried responsibilities:

> She must assume professional privileges. She must be the guardian of her own virtue. She must take on the right to examine naked men and women. Forsaking prudery, she locks her studio door whenever she wishes, and refuses admittance on the plea that she has a model. And without

these privileges, she could not hope in any way to compete with men nor with the intelligent of her own sex, and a certificate of prudery would not in this age help sell a figure piece by a young lady.[37]

Eakins likened women's study of the human figure to the way they would be expected to study medicine: "Within the last few years the young women medical students attend the same clinics as the men. The most dreadful diseases are shown them, described, and operated on. . . . And while students, these young women spy into each others' piddle with a microscope and do a hundred other unconventional things, from which the novelty now being worn off, even mild derision can hardly be excited against them.[38] Such scientific impartiality also governed Eakins's views on teaching. He did not hesitate to pose male and female models together in the life classes "in order that the student would get a better understanding, by comparison, of the construction and movement of spine and pelvis in walking.[39]

On occasion, Eakins would have students pose for each other in their homes or in his studio, where he could offer criticisms without charge. Once, when one of his most promising students, Amelia Van Buren, asked him in the dissection room about the movement of the pelvis, he encouraged her to come to his studio where he could explain the matter privately. He proceeded to undress and "gave her the explanation as I could not have done by words only."[40]

Not only did Eakins's students of both sexes pose for each other, they allowed themselves to be photographed by him and his assistants. In a group of photographs from around 1883 known as the "Naked Series," sequential poses, usually seven in number, were taken of students and professional models and mounted on heavy board (plate 159), no doubt to be used as a teaching aid. Males and females are shown from the front, back, and side, each pose differing slightly from the next. Translating some of the photographs into schematic drawings in which the "centre lines," or axes, are indicated (plate 161), Eakins observed that lines of this kind constituted the fundamental foundation for the construction of the human figure.[41] As he said in class: "Carefully follow the middle bone, it's not the back bone, it's in the middle of the body, find out where it bends and where it's rigid, don't break bones, find out where they are. Then put the muscles on them."[42]

From time to time, Eakins and his assistants would dress pupils in classical garb, pose them next to casts of Greek and Roman statuary or his own sculptural reliefs, and take pictures of them (plates 160, 162). Eakins never specified why he made these photographs, but his belief that artists should not imitate antiquity but instead create their own translation of nature, as the Greeks had done, suggests one explanation. By studying the draping of a classical costume on a living human body, modern artists would discover that the ancients were not as "ideal" as usually thought, but had actually imitated nature. The resulting effects possessed simplicity and dignity—traits that Eakins cherished.

Eakins also obtained—and made his own—sequential photographs of moving humans and animals to improve his students' understanding of "animal locomotion." At the time Muybridge lectured at the Academy in 1883 (see chap-

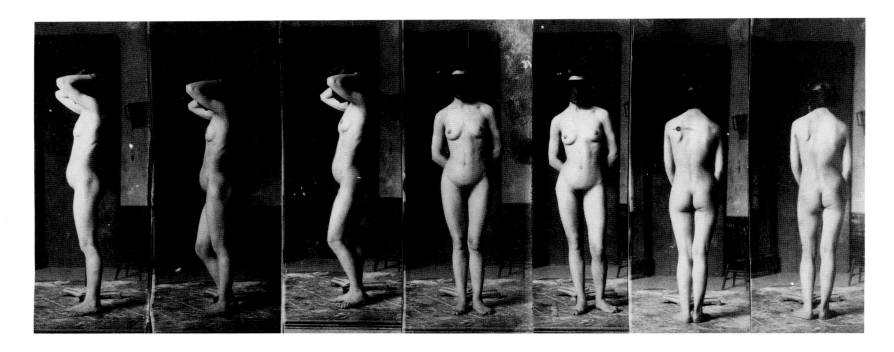

Above

159. *Naked Series: Brooklyn Nr 2 (Masked Model)*, c. 1883
Albumen print, 3 x 1¾₆ in. each print
The Detroit Institute of Arts; Founders
Society Purchase, Edsel and Eleanor
Ford Fund and Eleanor and Edsel Ford
Exhibition and Acquisition Fund

Right

160. *Two Pupils in Greek Dress, beside Plaster
Cast of Eakins's "Arcadia,"* c. 1883
Platinum print, 14½ x 10½ in.
The Metropolitan Museum of Art, New
York; David A. McAlpin Fund, 1943

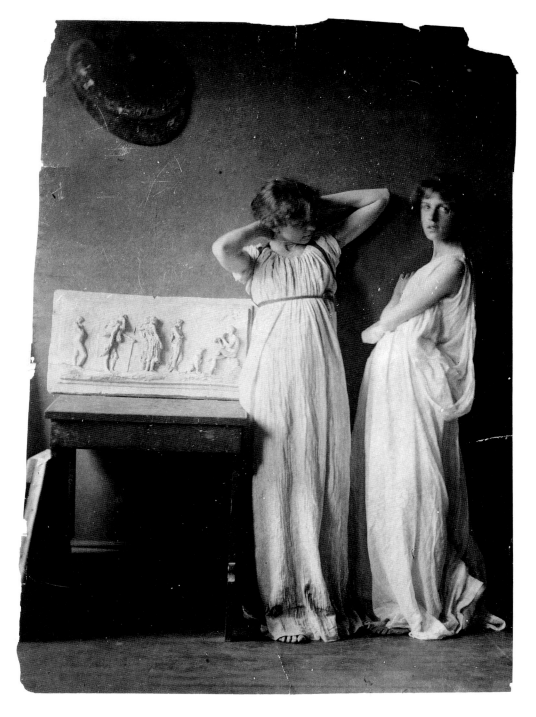

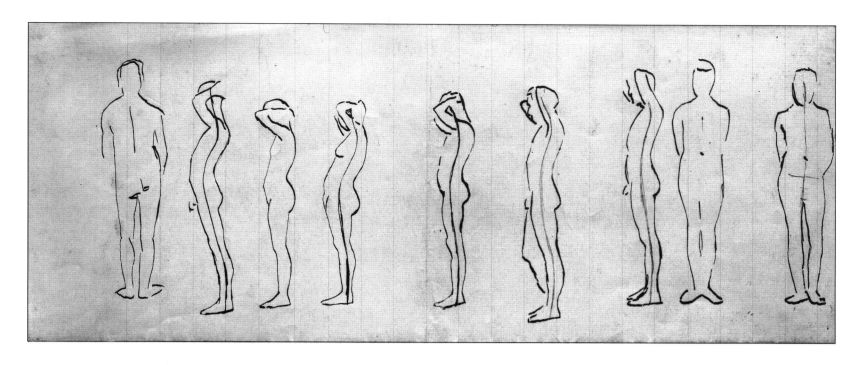

Above
161. *Nine Figure Studies after Photographs of Nude Models*, c. 1883
Pen, ink, and pencil on paper, 3⅛ x 9¾ in.
Hirshhorn Museum and Sculpture Garden, Smithsonian Institution, Washington, D.C.

Left
162. Photographer unknown
Elizabeth Macdowell in Classical Dress, c. 1877–83
Private collection

163. *Pole Vaulter (George Reynolds)*,
c. 1884–85
Photograph
Philadelphia Museum of Art; Gift
of Charles Bregler, 1941

ter 5), Eakins persuaded some of his advanced students to pose in the nude for
Muybridge. Eakins also used them as models and assistants in daring experiments
of his own that recorded multiple images on a single negative (plate 163).
Whether he circulated these in the school is not known, but the results of
Muybridge's investigations—sequential photographs both from Palo Alto and
from Pennsylvania—were made available to the students. (Eakins had a set of
four slides made from some of Muybridge's Palo Alto photographs of horses, pre-
sumably for his lectures.[43]) These images were cut up and mounted on strips
inside a zoetrope that was kept on a table in the library. Students could spin the
slotted drum, study the photographs blending into each other in rapid succession,
and learn to re-create movement in a convincing, accurate manner. As the *Art
Interchange* reported, "The Pennsylvania Academy of Fine Arts has evinced its
interests in the utilisation of this instrument in art studies, where, it is predicted,
a complete revolution will occur in the portrayal of the mechanism of motion."[44]

With the assistance of a student, Eakins also produced four schematic
drawings, reproduced as lantern slides, in which he plotted the trajectories of var-
ious points of the moving horse in Muybridge's photographs of 1878. Detailed
information about the time and sequence of the motion of the animal's legs is
given on these slides—more data than Muybridge himself had been able to
deduce from his own photographic experiments.[45] Much more of a scientist than
Muybridge, Eakins tried to discover the principles underlying the horses' move-
ment so that he could transmit this information to his students.

The program of instruction at the Academy, permeated as it was by sci-
ence, was a clear projection of Eakins's personal interests as an artist and a
thinker, but it represented, as well, his drive to raise the quality of the institution.

170

Above

161. *Nine Figure Studies after Photographs of Nude Models*, c. 1883
Pen, ink, and pencil on paper, 3⅛ x 9¾ in.
Hirshhorn Museum and Sculpture Garden, Smithsonian Institution, Washington, D.C.

Left

162. Photographer unknown
Elizabeth Macdowell in Classical Dress, c. 1877–83
Private collection

169

163. *Pole Vaulter (George Reynolds)*,
c. 1884–85
Photograph
Philadelphia Museum of Art; Gift
of Charles Bregler, 1941

ter 5), Eakins persuaded some of his advanced students to pose in the nude for
Muybridge. Eakins also used them as models and assistants in daring experiments
of his own that recorded multiple images on a single negative (plate 163).
Whether he circulated these in the school is not known, but the results of
Muybridge's investigations—sequential photographs both from Palo Alto and
from Pennsylvania—were made available to the students. (Eakins had a set of
four slides made from some of Muybridge's Palo Alto photographs of horses, pre-
sumably for his lectures.[43]) These images were cut up and mounted on strips
inside a zoetrope that was kept on a table in the library. Students could spin the
slotted drum, study the photographs blending into each other in rapid succession,
and learn to re-create movement in a convincing, accurate manner. As the *Art
Interchange* reported, "The Pennsylvania Academy of Fine Arts has evinced its
interests in the utilisation of this instrument in art studies, where, it is predicted,
a complete revolution will occur in the portrayal of the mechanism of motion."[44]

With the assistance of a student, Eakins also produced four schematic
drawings, reproduced as lantern slides, in which he plotted the trajectories of var-
ious points of the moving horse in Muybridge's photographs of 1878. Detailed
information about the time and sequence of the motion of the animal's legs is
given on these slides—more data than Muybridge himself had been able to
deduce from his own photographic experiments.[45] Much more of a scientist than
Muybridge, Eakins tried to discover the principles underlying the horses' move-
ment so that he could transmit this information to his students.

The program of instruction at the Academy, permeated as it was by sci-
ence, was a clear projection of Eakins's personal interests as an artist and a
thinker, but it represented, as well, his drive to raise the quality of the institution.

170

His standard of comparison was not other local art institutions—there was no significant competition in the city—but Philadelphia's facilities for the study of science, engineering, and medicine. And his ambitions extended beyond the city: written and unwritten evidence make it clear that he wanted the Academy to be the best art school in the nation, if not the world.

Despite his many achievements, there were two major flaws in Eakins's approach to teaching. His narrow focus on the figure left little room for any other vision of the world. For example, decorative art (architectural painting and sculpture, including murals; tapestries and textiles; stained glass and screens, and so on), which was then enjoying a vogue in New York, was ignored in the Academy curriculum. So was landscape painting, whether in the manner of Whistler or the Barbizon school. And Impressionism—then beginning to come to the fore in America—appears to have been neglected. These currents began to interest younger artists in the United States during the 1880s, and Eakins was ill equipped to deal with such changes in taste. His entire program had been found-ed on the French academic method of creating figure paintings in the studio. Although academic artists often produced sketches from nature as a way of gath-ering information—as Eakins himself had done—the end result was a contrived intellectual product, carried out indoors, often with the aid of photographs. Just as Eakins's approach to his own painting changed little once it had taken shape in the mid-1870s, so his views on how and what his students should paint remained much the same over the years. If there was any noticeable change in both areas, it was his increasing dependence, from the late 1870s through the mid-1880s, on science and photography.

During Eakins's heyday as director of the Academy schools, some of the younger artists in Philadelphia and elsewhere in the nation began to search for broader training that would enable them to deal with newer aesthetic issues. This intergenerational tension is normal, but in Eakins's case it was aggravated by his own stubbornness in holding on to outdated ideas. He was not a philosopher, nor did he theorize about aesthetics or design: his strength was revealing and portray-ing the structural basis of nature's proudest creation, the human body. This nar-row view was not enough to satisfy the growing interest both in psychological introspection and in decorative pattern—elements that came to dominate much late nineteenth-century painting.

7.
Scandal

One of the hazards of Eakins's scientific objectivity—at least in the eyes of Philadelphia's polite society—was his utter frankness in dealing with the nude. Teaching the essential structure and workings of the human body seemed a sacred duty to him, and he would not allow anyone to stand in his way. Taking inspiration and courage from the celebrated surgeons of his day, such as Dr. Gross, he sought to perform his duty with the same dedication and impartiality as they performed theirs. It never bothered Eakins to disrobe in front of a female student in his studio, nor did he hesitate to have his pupils pose nude for his classes or for the camera. In his singleminded devotion to scientific truth in art, he overlooked the fact that his Victorian contemporaries might accept a detached, scientific attitude toward the body in medicine, but not in the realm of art. The nude in painting and sculpture was tolerable as long as it carried some moralizing or Christian message. But by itself, stripped of any soothing context, it was far too potent an image.

Eakins's uninhibited attitude toward the nude in his teaching caused some female students and their families to complain to members of the Pennsylvania Academy's board. As a result, he was warned to exercise discretion and in no event ever to completely expose the male nude to his women students. Eakins defiantly maintained an independent course. In a class that included women, held early in February 1886, he is said to have removed the loincloth from the male model, though the details of the incident remain unclear. The response was decisive. Acting on behalf of the board, Edward H. Coates (Fairman Rogers's successor as chairman of the Committee on Instruction) asked Eakins to resign on February 8. Eakins replied the following day: "In accordance with your request just received, I tender you my resignation as director of the schools of the Pennsylvania Academy of the Fine Arts."[1]

For years it was thought that Eakins's resignation was forced solely by the board's horror at the loincloth incident, but this was only part of the explanation. There were other reasons for getting Eakins out of the Academy. As early as 1977 the art historian David Sellin pointed out that there was a conspiracy among Eakins's younger associates, all of them former students, to oust him and take over themselves.[2] Thomas Anshutz was a prime mover within what was

164. Photographer unknown
Eakins at Thirty-five to Forty,
1879–84
The Metropolitan Museum of Art,
New York; Gift of Charles Bregler,
1961

173

165. Photographer unknown
Thomas Anshutz, c. 1885
Private collection

called the "inner circle," which included Frank Stephens and his brother Charles, James P. Kelly, and Colin Campbell Cooper, Jr. Their revolution was driven not merely by a desire for power but also by aesthetic issues. The inner circle had expressed objections to Eakins's approach a year and a half before he was forced to resign. In a letter to J. Laurie Wallace, Anshutz reported on activities at the school:

> We have seen many life studies, and painted some (I speak of myself) which were moderately good pictures of the model, of his character[,] color[,] roundness[,] solidity &c. but which were made almost without one grain of true art. Except conscientiousness. They were the result of laboriously following the sign of the eye mechanically. Where true art appreciating the character and quality of the model and the light in which he stood, would endeavor to create them in a picture using the natural sense of sight as an instrument.[3]

Anshutz went on to say that it was better for an artist to feel, "unconsciously," the placement of the model's feet rather than to be "governed by his eye," observing the "angle of the leg with the trunk," or using a plumb line. Eakins was not mentioned by name, but Anshutz repeatedly contrasted his teacher's approach to the way "the true artist" expressed himself. The latter would "feel light in his picture as light and shade" and boldly present his view on canvas, rather than "paint cautiously after the most careful comparison." The kind of artist Anshutz admired would use "mechanical methods" only as an aid, without limiting himself to those means. Obviously alluding to Eakins, Anshutz wrote: "As his conscious methods are all mechanical he credits all the good in his pictures to those methods and he feels that without them he would have nothing." Even in the matter of perspective, Anshutz wanted to bypass Eakins's rigidity: "As in perspective we can blindly follow its rules or with clear sight we can use them to interpret the law of nature which governs them. I, too often, am dependent on the lower ways but still I think I can see beyond."[4] In a word, Anshutz favored subjectivity, allowing experience combined with intuition to broaden the artist's horizons.

Anshutz and his young colleagues were members of the Philadelphia Sketch Club, a convivial all-male artist's society whose members at that time also included Harry Cariss (president in 1886), William J. Clark, Jr., Walter M. Dunk, Henry R. Poore, John V. Sears, C. Few Seiss (secretary in 1886), J. Liberty Tadd, and Joseph C. Ziegler. (Eakins, who had taught there at Earl Shinn's request, had been elected an honorary member, but he never participated in the activities of the club.) All of these individuals were, or recently had been, students at the Academy. The club was devoted to good fellowship, including considerable drinking, and to the advancement of the members' interests in the arts. Costumed models were posed in the club for members to sketch, and an etching press was purchased in 1883 so that a small class in etching could be taught by one of the members. Members also offered lectures and debates on a far greater variety of topics in the visual arts than was found at the Academy. For example,

in 1885 they debated: "Is Realism or Ideality the Greater Quality in Art?" and in the following year, "Is Modern Art Progressive?" The club had apparently fallen under the influence of Whistler and of Oscar Wilde, who visited Philadelphia in 1882 during his American lecture tour. The club had a competition along Whistlerian lines, with a monthly sketch devoted to an arrangement in a certain color.[5]

The club activities were obviously filling an educational need not satisfied by Eakins, and as that need grew the inner circle felt compelled to do something about the situation at the Academy. Behind Eakins's back they went to the board and voiced their complaints—unfortunately not recorded. A letter signed by Anshutz, Cooper, Kelly, and the two Stephens brothers expresses their objections to Eakins's "abuse of his authority."[6] This phrase could refer to his control of the Academy's teaching program, but these words also have a more sinister connotation.

Frank Stephens, a vocal member of the inner circle, began to spread stories about Eakins's immorality and improper involvement with the female nude, saying that he used his position of power at the school to do as he pleased.[7] These tales were circulated throughout the Philadelphia art community, and especially in Academy circles, with devastating effect. As Eakins saw it, Stephens was clearly trying "to turn me out of the Academy, the Philadelphia Sketch Club, & the Academy Art Club, and . . . to drive me from the city."[8] Stephens's vehement antagonism is particularly difficult to explain in the light of his 1885 marriage to Eakins's sister Caroline, who sided with Stephens in opposing her brother (Caroline and Thomas were never reconciled).

The allegations about Eakins's lack of morality were circulated by others as well, including his wife's friend Alice Barber (who married Frank's brother, Charles Stephens, in 1890) and Susan's sister Elizabeth. Much of the trouble was based on reality: Eakins's frank exposure of the nude and his encouragement of students' posing for each other in the nude, sometimes in his presence. There was also vague talk about a risqué story he told his women students about "plums" and about a controversial incident, details of which remain scanty, that took place in the school's dissecting room.[9]

By the opening weeks of 1886 the Academy's board and Committee on Instruction had reached the limits of their tolerance and made it clear that Eakins would have to exercise restraint or quit. He chose the latter. A week after he resigned, many of his students came to his defense. The men and women circulated separate petitions—dated February 15 and 16, respectively—pledging their support and asking that he be rehired. After meeting with the board on the fifteenth, the male students trooped to his studio on Chestnut Street, each one sporting the letter *E* on his hat as a sign of loyalty.

Several Philadelphia newspaper writers backed Eakins, but he himself made no public statements. However, he did address a long letter to Coates on February 15, explaining and justifying his actions. Hoping that Coates would sympathize, Eakins asserted he had been the victim of "vicious attacks" and argued in some detail about his professional requirement of using nude models— even students, if need be.[10] Early in March he wrote to Coates again, amplifying

his points and vehemently accusing Frank Stephens of treachery.[11] Perhaps he hoped that these letters, together with clear evidence of student support, would persuade the Academy to rehire him. That was not to happen.

Insult was added to injury when the Philadelphia Sketch Club expelled Eakins in March for "conduct unworthy of a gentleman & discreditable to this organization."[12] Again, this was done at Frank Stephens's instigation. To these charges Eakins responded in a series of defensive letters, attacking the motives of the ringleaders and claiming that they had no right to throw him out because he had never been a regular member, only an honorary one.[13] Stephens and his cohorts brought similar charges against Eakins in the Academy Art Club, open to students and graduates, where Eakins had again been an honorary member. He responded defensively, arguing that the club had not followed correct procedures in accordance with its bylaws. But the tone of his remarks suggests that he did not really expect justice to be done.[14] A year later, thanks to a speech by a supportive Academy Art Club officer, he was reinstated.

Was there any truth to the allegations about Eakins's immoral behavior? In a series of letters to Academy officials, friends, and former students written over a year and a half, he patiently and rationally defended himself, insisting that he had done nothing improper. However, these letters, as well as some supportive documents by his wife and his brother-in-law William Crowell and the recollections of his friends, provide some telling clues to his troubles.

In all likelihood the impression that Eakins indulged in seductive behavior developed from his practice of posing nude female students in his studio so that they could work from each other and receive his criticisms. Admitting that he had hoped "to make good pupils" by giving these students extra attention, he explained that his wife was always present as a "safeguard" at these sessions.[15] But suspicions were inevitably raised when the story was circulated of his disrobing to demonstrate an anatomical point to Amelia Van Buren. Although he claimed she showed "not the slightest embarrassment or cause for embarrassment,"[16] it is hard to believe that she was not shocked. And, as William Crowell reminded Eakins, the "habit while dressing of walking back and forth in your shirt tail from your room to that occupied by her [his sister Maggie] and Aunt Eliza and Caddy, regardless of who was present"[17] was a cause of family concern. And apparently Frank Stephens had heard incriminating stories from Maggie, now dead, which he used to defame Eakins. What these were we do not know, but "the charge of bestiality" that Stephens brought was supposedly based on what Maggie had told him.[18]

Frances and William Crowell—Eakins's sister and brother-in-law, who knew him as well as anyone—had grave misgivings about allowing their daughters Ella and Margaret to study with him at the Art Students' League of Philadelphia (where Eakins taught after leaving the Academy) and to live in the Eakins house, where additional instruction would take place. They wrote to Eakins to plead that he not treat their daughters like other students, who were expected to pose in the nude when no other model was available.[19] Despite their parents' concern, the girls went to Philadelphia and embarked on their course of study in April 1890. Eakins wrote to his sister saying that he and Susan would

provide "watchful and loving care,"[20] but according to one account, he did force Ella to model in the nude.[21]

Eakins often asked women whose portraits he was painting if they would pose without their clothing. Given the strict societal codes of his time, it is not surprising that most of his proposals were turned down (Maud Cook was one of the few who accepted[22]). He had no inhibitions about touching his female subjects, whether paid models or friends who posed for him. When a proponent of the Delsarte method (a formulaic system of dramatic training and bodily deportment) entered his studio while Eakins was painting a full-length portrait of Mrs. Talcott Williams (plate 166), Mrs. Williams proceeded to suck in her stomach, and the artist could not persuade her to relax. Finally he went up to her, touched her on that spot, and said, "Don't hold yourself in here." Offended, she left and would not return, leaving the painting unfinished.[23] A less-impulsive but still shocked

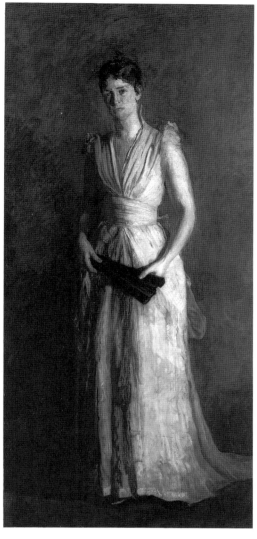

Above
166. *The Black Fan—Portrait of Mrs. Talcott Williams*, c. 1891
Oil on canvas, 80¼ x 40 in.
Philadelphia Museum of Art;
Given by Mrs. Thomas Eakins and Miss Mary Adeline Williams

Left
167. *Mrs. James Mapes Dodge*, 1896
Oil on canvas, 26¼ x 20¼ in.
Philadelphia Museum of Art;
Given by Mrs. James Mapes Dodge

reaction under similar circumstances came from Mrs. James Mapes Dodge. She was posing for a portrait (plate 167) at a time when she was in a condition to nurse her small child and pregnant with another. During one sitting Eakins walked up to her and "started to dig his fingers into her chest." Startled, she exclaimed, "Tom, for Heavens's sake what are you doing?" He replied: "I'm feeling for bones."[24]

Thoroughly aware of the shock value of his own naked body, Eakins once entered a studio where Samuel Murray was sculpting a portrait of a girl, stepped into an adjoining room, and reappeared without a stitch of clothing. Eakins walked up to the girl and said: "I don't know whether you ever saw a naked man before; I thought you might like to see one."[25]

That Eakins's manner was unrefined and offensive, especially to women, can hardly be disputed. For example, he seems to have delighted in asking them publicly if they wanted "to pea."[26] His enemies attacked his " 'wolfish looks,' 'his boorish manners,' his 'brutal talk,' and the like."[27] Even William Crowell would not deny that Eakins's personal behavior was troublesome:

> I own that he sometimes uses coarse expressions in his talk;—that he is apt not fitly to respect the periphrases in which society has decreed that certain notions shall be enveloped; that his manner is, at times, unpleasant to the fastidious and super-sensitive, too often, perhaps, to those also who cannot justly be called super-sensitive;—that he is often openly contemptuous of the opinions and sentiments of others, thereby exposing himself to just resentment; that he occasionally disregards the conventional properties of life to an extent that I consider injudicious and dangerous.[28]

Eakins's behavior toward women, especially compared to his relations with men, indicates an undeniable, if unconscious, hostility. At no time did he ever declare a belief in women's equality with men. Although he welcomed women into the Academy's classes, he openly credited Fairman Rogers as the instigator of this policy. Eakins took a realistic and tolerant view of the education of women in the arts, saying somewhat grudgingly, "If women are to be taught at all I think they should have good teaching."[29] That he welcomed female students into his private studio for individual instruction, free of charge, might be interpreted as a gesture of concern for them; but when he asked them to pose nude it might also be seen as a way to exercise power over them. He must have known that no matter how liberal these women might have thought they were, this act would have been troubling to them and their parents. Although Eakins had admired, then married, one of his most promising students, he gave her no encouragement to paint after they were married, and she did little of it until after his death in 1916. He accepted without apparent question or guilt her complete devotion to his needs.

From the available accounts of Eakins's behavior it appears that he wanted to defeminize women, to make them like men. And by forcing women to become more like men Eakins was saying, in effect, that they were inadequate as they were. He thought that women, to survive as professionals, would have to shed their usual "feminine" inhibitions and deal with the unpleasant and often ugly

provide "watchful and loving care,"[20] but according to one account, he did force Ella to model in the nude.[21]

Eakins often asked women whose portraits he was painting if they would pose without their clothing. Given the strict societal codes of his time, it is not surprising that most of his proposals were turned down (Maud Cook was one of the few who accepted[22]). He had no inhibitions about touching his female subjects, whether paid models or friends who posed for him. When a proponent of the Delsarte method (a formulaic system of dramatic training and bodily deportment) entered his studio while Eakins was painting a full-length portrait of Mrs. Talcott Williams (plate 166), Mrs. Williams proceeded to suck in her stomach, and the artist could not persuade her to relax. Finally he went up to her, touched her on that spot, and said, "Don't hold yourself in here." Offended, she left and would not return, leaving the painting unfinished.[23] A less-impulsive but still shocked

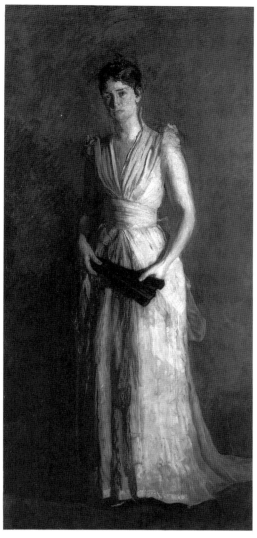

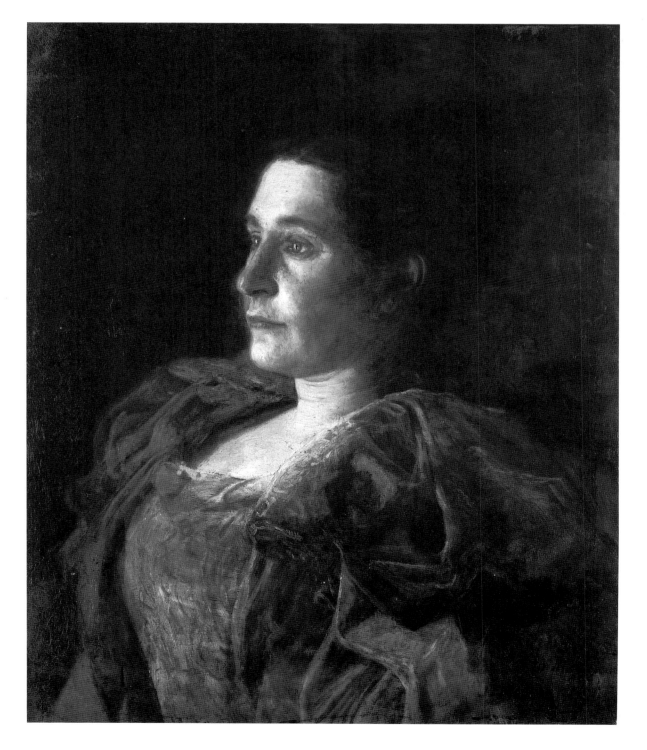

Above
166. *The Black Fan—Portrait of Mrs. Talcott Williams*, c. 1891
Oil on canvas, 80¼ x 40 in.
Philadelphia Museum of Art;
Given by Mrs. Thomas Eakins and
Miss Mary Adeline Williams

Left
167. *Mrs. James Mapes Dodge*, 1896
Oil on canvas, 26¼ x 20¼ in.
Philadelphia Museum of Art;
Given by Mrs. James Mapes Dodge

reaction under similar circumstances came from Mrs. James Mapes Dodge. She was posing for a portrait (plate 167) at a time when she was in a condition to nurse her small child and pregnant with another. During one sitting Eakins walked up to her and "started to dig his fingers into her chest." Startled, she exclaimed, "Tom, for Heavens's sake what are you doing?" He replied: "I'm feeling for bones."[24]

Thoroughly aware of the shock value of his own naked body, Eakins once entered a studio where Samuel Murray was sculpting a portrait of a girl, stepped into an adjoining room, and reappeared without a stitch of clothing. Eakins walked up to the girl and said: "I don't know whether you ever saw a naked man before; I thought you might like to see one."[25]

That Eakins's manner was unrefined and offensive, especially to women, can hardly be disputed. For example, he seems to have delighted in asking them publicly if they wanted "to pea."[26] His enemies attacked his "'wolfish looks,' 'his boorish manners,' his 'brutal talk,' and the like."[27] Even William Crowell would not deny that Eakins's personal behavior was troublesome:

> I own that he sometimes uses coarse expressions in his talk;—that he is apt not fitly to respect the periphrases in which society has decreed that certain notions shall be enveloped; that his manner is, at times, unpleasant to the fastidious and super-sensitive, too often, perhaps, to those also who cannot justly be called super-sensitive;—that he is often openly contemptuous of the opinions and sentiments of others, thereby exposing himself to just resentment; that he occasionally disregards the conventional properties of life to an extent that I consider injudicious and dangerous.[28]

Eakins's behavior toward women, especially compared to his relations with men, indicates an undeniable, if unconscious, hostility. At no time did he ever declare a belief in women's equality with men. Although he welcomed women into the Academy's classes, he openly credited Fairman Rogers as the instigator of this policy. Eakins took a realistic and tolerant view of the education of women in the arts, saying somewhat grudgingly, "If women are to be taught at all I think they should have good teaching."[29] That he welcomed female students into his private studio for individual instruction, free of charge, might be interpreted as a gesture of concern for them; but when he asked them to pose nude it might also be seen as a way to exercise power over them. He must have known that no matter how liberal these women might have thought they were, this act would have been troubling to them and their parents. Although Eakins had admired, then married, one of his most promising students, he gave her no encouragement to paint after they were married, and she did little of it until after his death in 1916. He accepted without apparent question or guilt her complete devotion to his needs.

From the available accounts of Eakins's behavior it appears that he wanted to defeminize women, to make them like men. And by forcing women to become more like men Eakins was saying, in effect, that they were inadequate as they were. He thought that women, to survive as professionals, would have to shed their usual "feminine" inhibitions and deal with the unpleasant and often ugly

realities of the world—and for women artists that required a detached and objective attitude toward the human body. He urged the women in the Academy to join equally with the men in the grisly work of the dissecting room, denigrating by contrast the common female occupation of china painting. There was no place in the Academy for such "feminine" concerns.

What was Eakins like? There are certain traits that everyone agreed on: he was hardworking, intense, persistent, honest, and possessed of a strong sense of justice. When he spoke, he was candid, sometimes blunt, but "he did not express himself much in words."[30] He admired "real sincerity and strength," Eakins's friend the singer Weda Cook recalled, and "was always interested in people who could do things."[31] He hated pretense and liked to go against respectable public opinion; thus, he did not hesitate to say what he thought or to dress as he pleased. But beyond these common characteristics, two very different pictures emerge.

Some people found him gentle, kind, helpful, and honorable. Adolphe Borie, a young artist, remarked that he was "the grandest man he ever met," and a former student said Eakins's glance was "very kindly and humorous."[32] Catherine A. Janvier, a friend who knew him for many years, spoke of "his delightful friendly side . . . how full of fun he could be—like a boy—and what good company he was, and very lovable." She recalled:

> Once in Philadelphia I took him to see two dear old ladies who lived in an old house way down town. The visit was rather formal at first but he made himself so charming that all became informal, and one of the old ladies actually brought her mother's stays to show him, first whispering to me to ask if I thought it could be done without impropriety, as he was an artist. He was really much interested.[33]

On the other hand, others considered Eakins brusque, immoral, vindictive, and capable of prejudice and intense hatred. A former student, James L. Wood, said that he flew into a rage and smashed a student's sculpture because it was "too carefully finished." "If anyone did him an unfair injury," Eakins's friend Nicholas Douty recalled, "he would never forgive them—would simply have no more to do with them."[34]

Eakins was portrayed by some as sex-driven, by others as thoroughly and intentionally immoral. Mrs. Nicholas Douty lent him a book of "dirty stories" and found she "could never get [it] away from him."[35] Wood claimed that Eakins's wife "suffered from his affairs." In Wood's view, Eakins did not try to restrain himself because he felt it was "nature" to behave in this way.[36] Even Eakins's student and close friend Samuel Murray, ordinarily circumspect and loyal, publicly stated that Eakins had had an affair with Addie Williams, who lived with the artist and his wife as companion and housekeeper.[37] Certainly Eakins's radiantly affectionate portrait of her, *Addie* (plate 169), contrasts sharply with the worn and strained image of Susan Eakins he painted about the same time (plate 168).

It is impossible, of course, to judge a person's sexuality from a painting or a photograph, but the word *blighted,* which Weda Cook used in referring to Susan,

Page 180
168. *Mrs. Thomas Eakins*, c. 1899
Oil on canvas, 20⅛ x 16⅛ in.
Hirshhorn Museum and Sculpture Garden, Smithsonian Institution, Washington, D.C.; Gift of Joseph H. Hirshhorn, 1966

Page 181
169. *Mary Adeline Williams (Addie)*, 1900
Oil on canvas, 24⅛ x 18⅛ in.
Philadelphia Museum of Art; Given by Mrs. Thomas Eakins and Miss Mary Adeline Williams

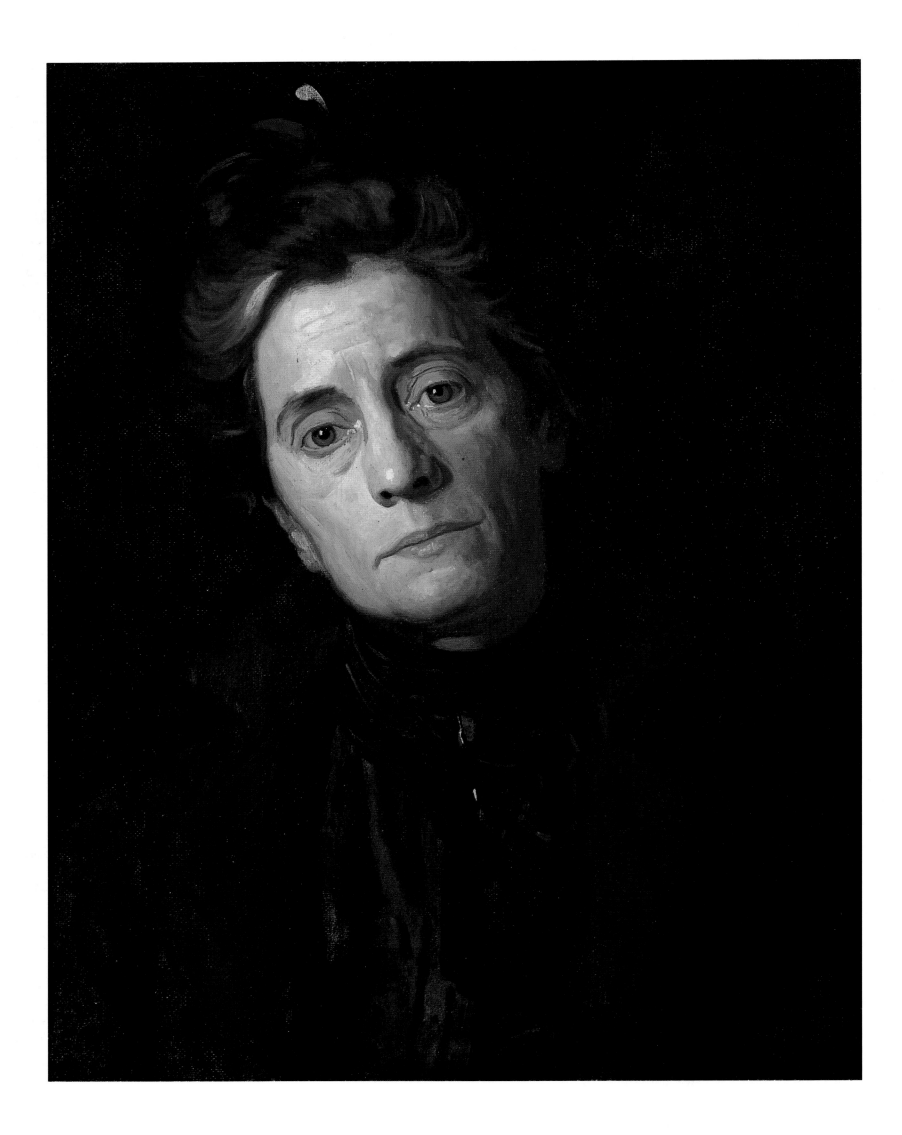

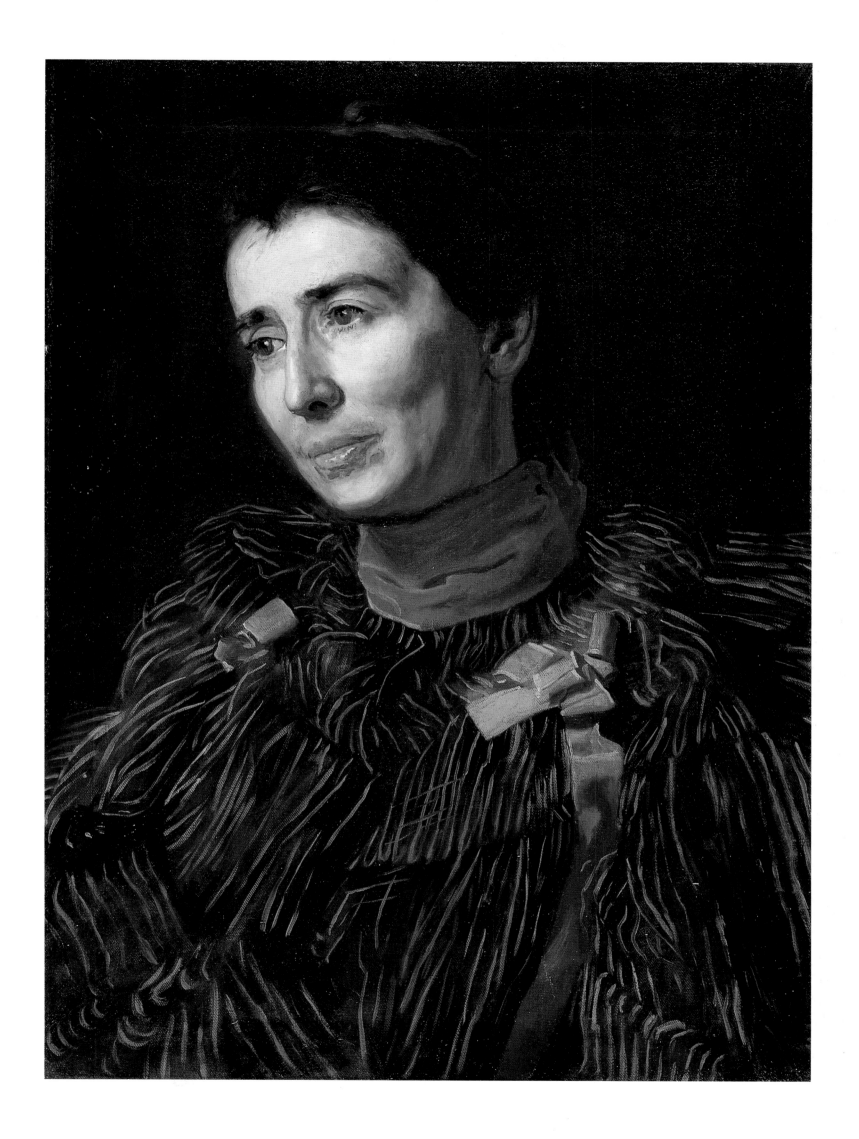

seems somehow appropriate. She went on to say that, in her opinion, Eakins's wife was "not highly sexed."[38] Lucy Langdon W. Wilson—an educator, feminist, and friend of Eakins who was painted by him—said that he was "very selfish" in his relationship to his wife.[39] Although he treated her respectfully in public ("like a queen," Cook said[40]) and praised her as an artist, he kept a menagerie—dogs, cats, and a monkey—for his own enjoyment, which Susan was expected to take care of even though she disliked them. Not until the monkey bit her twice could Murray persuade him to dispose of the animal.

Eakins's forced resignation from the Pennsylvania Academy scarred him for life. He was deeply hurt not only by his expulsion but also by the charges and insinuations of immorality. The truth or falseness of those claims will be debated for years to come, but the fact remains that to many in the upper echelons of the Philadelphia art world, including artists as well as patrons, Eakins was permanently tainted.

Even at the height of his power at the Academy, Eakins had made little effort to act the part of a distinguished professor; having been driven out of the Academy, he was free to act however he pleased, and for the rest of his life he paid little attention to the rigid prescriptions of Philadelphia society. He did not have to depend on patronage or commissions for a living, as his father continued to pay most of the bills. When Benjamin died in 1899, he left his son the Mount Vernon Street house and an inheritance that enabled Thomas and Susan to live comfortably. For about two years after his expulsion from the Academy, Eakins was less productive than usual, partly because so much of his time was taken up with writing letters of explanation and self-defense. The entire experience seems to have thoroughly disoriented him, for he never recovered the confidence and self-respect he had shown previously. Even his goals in art were different from what they had been before.

Eakins hardly ever left Philadelphia, and when he did it was to carry out one of his rare commissioned portraits, to serve on a jury for a national or international exhibition, such as the Carnegie International in Pittsburgh, or to teach in Manhattan, Brooklyn, or Washington, D.C. Unlike his more cosmopolitan contemporaries, he had no interest in traveling to Europe. Although he had once thought of moving to New York,[41] he had now definitely settled on Philadelphia as his permanent home. When he was not painting, sculpting, or teaching—the Art Students' League of Philadelphia occupied much of his time from 1886 until 1893—Eakins attended vocal or orchestral concerts, plays, or enjoyed a musical evening at his own or a friend's house. Boxing and wrestling matches attracted him, particularly in the late 1890s. He was not a joiner, but he did meet informally for conversation with a small group of men who shared his interests, including an engineer, William D. Marks; a physiologist, Harrison Allen; and a musicologist and composer, Hugh A. Clarke—all professors at the University of Pennsylvania.

More and more Eakins focused on his family—especially his father, his sister Frances, and her husband, William Crowell—as a source of companionship. His friends were mostly found among his students at the Art Students' League, especially Samuel Murray, who became like a son to him. Judging from the large number of uncommissioned portraits he inscribed "to my friend," followed by the

seems somehow appropriate. She went on to say that, in her opinion, Eakins's wife was "not highly sexed."[38] Lucy Langdon W. Wilson—an educator, feminist, and friend of Eakins who was painted by him—said that he was "very selfish" in his relationship to his wife.[39] Although he treated her respectfully in public ("like a queen," Cook said[40]) and praised her as an artist, he kept a menagerie—dogs, cats, and a monkey—for his own enjoyment, which Susan was expected to take care of even though she disliked them. Not until the monkey bit her twice could Murray persuade him to dispose of the animal.

Eakins's forced resignation from the Pennsylvania Academy scarred him for life. He was deeply hurt not only by his expulsion but also by the charges and insinuations of immorality. The truth or falseness of those claims will be debated for years to come, but the fact remains that to many in the upper echelons of the Philadelphia art world, including artists as well as patrons, Eakins was permanently tainted.

Even at the height of his power at the Academy, Eakins had made little effort to act the part of a distinguished professor; having been driven out of the Academy, he was free to act however he pleased, and for the rest of his life he paid little attention to the rigid prescriptions of Philadelphia society. He did not have to depend on patronage or commissions for a living, as his father continued to pay most of the bills. When Benjamin died in 1899, he left his son the Mount Vernon Street house and an inheritance that enabled Thomas and Susan to live comfortably. For about two years after his expulsion from the Academy, Eakins was less productive than usual, partly because so much of his time was taken up with writing letters of explanation and self-defense. The entire experience seems to have thoroughly disoriented him, for he never recovered the confidence and self-respect he had shown previously. Even his goals in art were different from what they had been before.

Eakins hardly ever left Philadelphia, and when he did it was to carry out one of his rare commissioned portraits, to serve on a jury for a national or international exhibition, such as the Carnegie International in Pittsburgh, or to teach in Manhattan, Brooklyn, or Washington, D.C. Unlike his more cosmopolitan contemporaries, he had no interest in traveling to Europe. Although he had once thought of moving to New York,[41] he had now definitely settled on Philadelphia as his permanent home. When he was not painting, sculpting, or teaching—the Art Students' League of Philadelphia occupied much of his time from 1886 until 1893—Eakins attended vocal or orchestral concerts, plays, or enjoyed a musical evening at his own or a friend's house. Boxing and wrestling matches attracted him, particularly in the late 1890s. He was not a joiner, but he did meet informally for conversation with a small group of men who shared his interests, including an engineer, William D. Marks; a physiologist, Harrison Allen; and a musicologist and composer, Hugh A. Clarke—all professors at the University of Pennsylvania.

More and more Eakins focused on his family—especially his father, his sister Frances, and her husband, William Crowell—as a source of companionship. His friends were mostly found among his students at the Art Students' League, especially Samuel Murray, who became like a son to him. Judging from the large number of uncommissioned portraits he inscribed "to my friend," followed by the

sitter's name, he socialized with a wide range of individuals, mostly male but some female, from all walks of life.

The dinner hour at 1729 Mount Vernon Street was a magnet for the Eakinses' friends—"very interesting people," Murray remembered: "artists, judges from exhibits, mathematicians, engineers, surgeons, anatomists, doctors."[42] There was a blackboard on the dining-room wall which Susan Eakins would use to illustrate subjects talked about at the table. She would draw "cartoons of the people she had seen on the trolley car, or after dinner make caricatures of people they all knew."[43]

Margaret McHenry based a splendid chronicle of Eakins's activities with friends and students on her extended interviews with Murray, Bregler, Eakins's student Tommy Eagan, and many members of the Crowell family, beginning about 1940. From her text we learn that one of Eakins's favorite recreations was to take bicycle trips with Murray, sometimes riding as far afield as Atlantic City

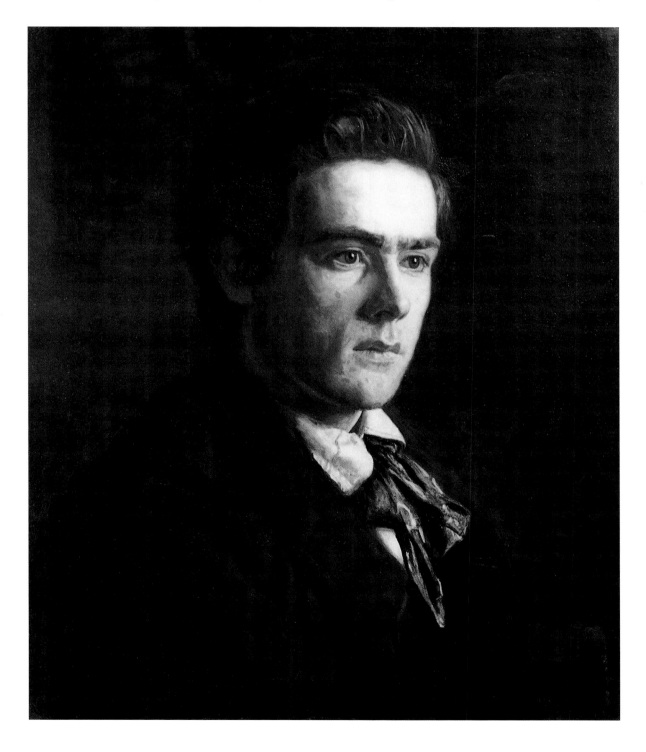

170. *Samuel Murray*, 1889
Oil on canvas, 24 x 20 in.
Mitchell Museum, Mount Vernon, Illinois

Page 184
171. *Between Rounds*, 1899
Oil on canvas, 50⅛ x 39⅞ in.
Philadelphia Museum of Art;
Given by Mrs. Thomas Eakins and
Miss Mary Adeline Williams

Page 185
172. *The Concert Singer*, 1890–92
Oil on canvas, 75⅛ x 54¼ in.
Philadelphia Museum of Art;
Given by Mrs. Thomas Eakins and
Miss Mary Adeline Williams

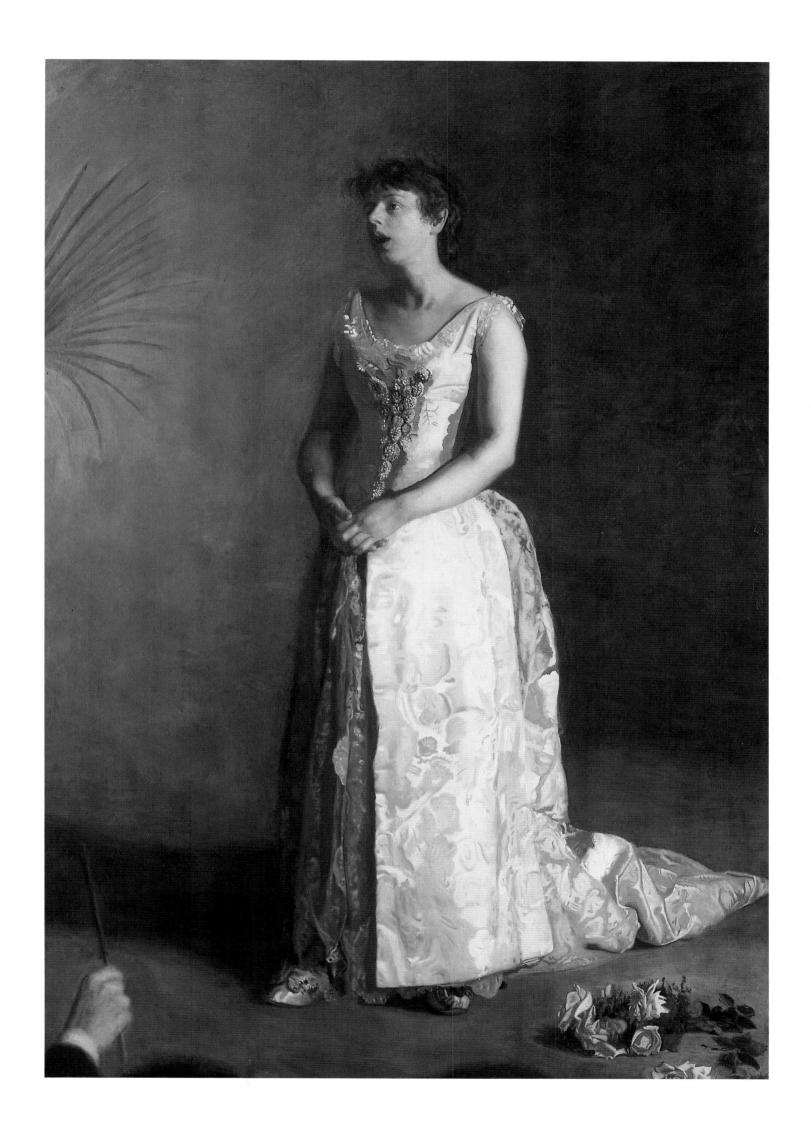

173. Photographer unknown
Eakins at about Sixty-five, with Samuel Murray in Front of Eakins's Fish House at Fairton, New Jersey, c. 1909
Silver/gelatin developing-out paper
Hirshhorn Museum and Sculpture Garden, Smithsonian Institution, Washington, D.C.; Archives

but more often to the "fish house" on the Cohansey River, where he had earlier painted the hunting pictures. Murray told her that Eakins, holding his own ankle, "could jump through the hoop formed by his arm and by his leg," in spite of his substantial weight (190 pounds). At the fish house Eakins could indulge his desire to swim in the nude (he was photographed this way more than once), and on hot nights he would open the doors and lie naked on a cocoa mat, without any concern that someone might be coming along on the nearby creek.[44]

At the Academy, Eakins's teaching duties were taken over for the remainder of the 1886–87 season by Thomas Anshutz and James P. Kelly. Both had written to the Committee on Instruction saying they would be willing to serve "temporarily."[45] As it turned out, Anshutz remained until 1916, and Kelly continued for seven years until his death in 1893. Others joined them in the fall of 1886: Thomas Hovenden, a popular New York genre and history painter, arrived to teach painting and drawing; and Bernhard Uhle, a former Academy student, offered instruction in portrait painting.

Although Eakins remained in Philadelphia, he never rejoined the faculty of the Academy. But the Eakins tradition remained strong there for at least a few years. Robert Henri, who entered the Academy in the fall of 1886, was intrigued by what he heard about the recently deposed master: "It was an excitement to hear his pupils tell of him. They believed in him as a great master, and there were stories of his power, his will in the pursuit of study, his unswerving adherence to his ideals, his great willingness to give, to help, and the pleasure he had in seeing the original and worthy crop out in a student's work."[46]

Some of Eakins's teachings, though considerably transformed, were communicated to Henri's generation through Anshutz, who sacrificed his full growth

as a painter to his teaching. A gifted and caring instructor, modest about his own abilities, he gave himself untiringly to his pupils and thereby earned their deep respect and admiration. He did not force them to accept any artistic formulas; rather, he was ready to accept all valid styles and encouraged his students to develop individual means of expression. One former pupil recalled: "His influence was stimulating; his effort, to develop the talent inherent in the student, not to impose his own methods in painting. He once said that he never approached his class with thought of what he would give them, but rather expectant of what he should find there of original discovery."[47] Although some of his students remember Anshutz as being rather aloof and distant, he was credited with an almost psychic sensitivity to their different moods. And in spirit he remained a student himself, often joining the class in drawing from the model and entering into student celebrations. Years later Henri remembered Anshutz as "a great influence, for he was a man of the finest quality, a great friend, gave excellent advice, and never stood against a student's development."[48]

After Eakins's departure the Academy seems to have returned to greater emphasis on drawing, though Anshutz continued to stress the larger relationships in the human figure. He gave his students advice that Eakins would have approved of: "Don't *copy* shades but put shades on your paper so as to make round things round. Every line and every shade on a drawing should *mean something*. The shade on one part of the body must be studied with relation not only to the shades next to it but all over the body."[49] Anshutz also continued the modeling classes that had meant so much to his predecessor. Again his words echoed those of Eakins: "Get the big things first, then the little ones."[50]

Dr. Keen's lectures on anatomy and the opportunities for dissection apparently continued without change, as did the lectures on perspective, now given by Anshutz. But in his teaching of the life class Hovenden departed from the traditions of the Academy. Unlike Eakins and Anshutz, he was a caustic critic of the students' work. Henri observed: "There is very little to learn from him I am beginning to think. My present opinion is that his criticisms are regulated by his liver. . . . Today he booms you, tomorrow he sends you down below."[51] Hovenden seems to have followed an instinctive approach to painting, unlike the pedagogical methods of Eakins. For example, Hovenden regarded Henri as a "theorist" and told him "don't think, just paint"—a clear echo of the popular French adage "Copy nature stupidly."[52]

Although Eakins no doubt sneered at what went on in the Academy after his departure, official and unofficial records suggest that radical changes were not made in the teaching program, at least in the first few years. Hovenden may have provided little enlightenment to the students (he remained only a year), but Anshutz commanded as much loyalty as Eakins and, in the long run, taught a greater number of students who became well-known, respected artists: Arthur B. Carles, Charles Demuth, William Glackens, Henri, George Luks, John Marin, and John Sloan.

Even though Anshutz had successfully seized Eakins's position at the Academy, it was a bittersweet victory since Eakins took many of the students with him. This was not initiated by Eakins: a group of former pupils asked him to

teach them. He readily agreed, and the result was the Art Students' League of Philadelphia—formed a little over a week after he had resigned from the Academy. The first classes were held February 22 in rented facilities on Market Street. H. T. Cresson, who had just left the Academy, took the initiative in organizing the league. A constitution was drawn up and officers were elected, Cresson being named president and George Reynolds, curator. As at the Art Students League of New York, management rested with the students, via an elected board of control. Eakins was the principal instructor and served without pay.

The league could not, of course, offer the outstanding physical facilities available at the Academy. But Eakins perpetuated the essential core of that institution's original teaching program: drawing and painting from the nude human figure, reinforced by modeling the figure in clay, and lectures delivered by him on perspective and anatomy. Dissecting facilities were found in the Pennsylvania

Above
174. Photographer unknown
Thomas Eakins with a Friend Blowing a Bugle, c. 1890–93
Silver print
The Bryn Mawr College Library, Bryn Mawr, Pennsylvania; The Adelman Collection

Right
175. *Franklin Louis Schenck* (also known as *The Bohemian*), c. 1890
Oil on canvas, 23⅞ x 19¾ in.
Philadelphia Museum of Art; Given by Mrs. Thomas Eakins and Miss Mary Adeline Williams

School of Anatomy and Surgery and the Philadelphia Dental School. Newspaper reports on the formation of the league indicate that the students wanted to study the entirety of the figure without any restrictions dictated "by prudishness and false modesty."[53] The league enrolled mainly male students, including several bohemian types, such as George Reynolds and Franklin Schenck, who must have been attracted by Eakins's free-thinking views on art and life. The few women were chiefly members of Eakins's family—his wife and his nieces Ella and Margaret Crowell—plus a handful of others whose names are unknown.[54]

The atmosphere at the Art Students' League must have been more relaxed than at the Academy. No group other than the league's own student board could control what Eakins taught, and the pupils surely reveled in their newfound freedom. Because the league's enrollment was relatively small, numbering from the mid-twenties to the high thirties, a clublike intimacy prevailed, with annual "riots," or student farces, given on or near Washington's birthday, the school's anniversary (see plate 174). Through the league Eakins made lasting friendships with many of his young disciples, especially the aspiring sculptor Samuel Murray; and the students forged close ties with one another. Eakins painted a number of portraits of his student-friends (plates 170, 175), and his pupils often painted each other. Quite a few photographs have survived from the days of the league—some taken as snapshots or mementos (plate 176), some as documentary studies of nude or draped figures (plate 177), occasionally in classical garb, as in the earlier Academy photographs. It is hard to determine who took these pictures, though Eakins must have played a significant role in at least some of them.

Above, left
176. Photographer unknown
Franklin Schenck at the Art Students' League, 1890–92
Hirshhorn Museum and Sculpture Garden, Smithsonian Institution, Washington, D.C.; Charles Bregler Archival Collection

Above, right
177. Thomas Eakins(?)
Charles Cox Painting in the Art Students' League, Chestnut Street, Philadelphia (with Ella Crowell[?], Charles Brinton Cox, and James M. Wright), c. 1886–93
Platinum print, 6¼ x 5½ in.
The Metropolitan Museum of Art, New York; David Hunter McAlpin Fund, 1943

A fascinating account of Eakins's lecturing technique was published in 1886 by an anonymous writer who attended his lectures at the Art Students League of New York; the writer praised him for his extensive knowledge of anatomy and his skill in making a complex subject easy to understand. Equipped with a skeleton, a supply of modeling clay, an anatomical cast, and a live human, Eakins would fashion a muscle in clay, then "fasten it upon the skeleton in its proper place." Turning to the plaster cast, the writer observed, Eakins "points out the location and appearance of the muscle as part of the whole form, and by the action of the living model he illustrates its general effect." Proceeding in this way, he treated the entire body, explaining "first not only what muscular development is, but how it is created, what it is created out of, what its service is, and what it looks like when it is performing its service."[55]

Moving from place to place in the city during its seven-year existence, the league never had permanent quarters, and that fact may have contributed to its eventual collapse in 1893. So must the ongoing changes in taste, as Eakins's method of teaching became increasingly remote from the aesthetic concerns of the early 1890s. At the Pennsylvania Academy, Anshutz and his fellow instructors were incorporating French Impressionism, Symbolism, and the decorative styles of the fin-de-siècle into their teaching. Eakins must have seemed an anachronism.

Eakins's teaching career did not end with the Art Students' League of Philadelphia. He was invited to lecture on anatomy at a number of institutions, including the Art Students' Guild of the Brooklyn Art Association (1881–85); the Art Students League of New York (1885–89); the National Academy of Design, New York (1888–95); the Women's Art School of the Cooper Union, New York (1891–98), the Art Students' Guild, Washington, D.C. (mid-1890s); and the Drexel Institute of Art, Science, and Industry, Philadelphia (1895).[56] There was, however, no known effort to recruit Eakins as an all-around teacher at either a New York or a Philadelphia institution.

A final episode at the Drexel Institute brought Eakins's teaching career in Philadelphia to a sad end. Asked to present fifteen public lectures on anatomy, Eakins explained in advance to the school's administration and his listeners that he would display a completely nude male, thereby offering any squeamish visitor the opportunity to step out. Or at least he thought he had made this clear. Apparently no one at Drexel seems to have understood that "nude" meant without the loincloth. In the third lecture, when Eakins removed all of the young model's clothing, Miss Lyndalls (an art instructor who was serving as chaperone) and some of the women students protested to the president of the institute. As a result, the remaining lectures were canceled. Eakins had indeed violated the school's rule that "nude models should not be exhibited to the young women."[57]

Dredging up memories of the Academy scandals nine years before, some writers on the Philadelphia newspapers made a sensation of the event. Others, such as Riter Fitzgerald of the *Philadelphia Evening Item*, tried to explain the situation, citing Eakins's own defense. Eakins pleaded ignorance of Drexel's rule about the nude, saying: "I would not have consented to deliver the lectures had such a

proposition been made. I never discovered that the Nude could be studied in any except the way I have adopted. All the muscles must be pointed out. To do this all drapery must be removed."[58] Once again Eakins's rigidly held principles had gotten him into trouble—and again in his native city. (There were no such limitations in the lectures he gave in New York.) Right or wrong, he was at the center of the battle, and his morality and his judgment were again under fire. He would never again teach in Philadelphia.

Had Eakins been successful as an instructor? We judge teachers by their products: the graduates who go on to establish their own reputations. Surveying the entire roster of those who attended the Art Students' League of Philadelphia, we find the names of only two artists who made anything of themselves artistically in later years: Samuel Murray, who became a highly competent, if conventional, creator of sculptured portraits and public monuments, and Susan Macdowell Eakins. At the Academy, he had taught hundreds of students, but a surprisingly small proportion of them became famous. We can count among them the sculptors Alexander Milne Calder, his son A. Stirling Calder, and Charles Grafly; Henry Ossawa Tanner, painter of religious subjects; John F. Peto, painter of still lifes; and Eva Watson-Schütze, Pictorial photographer. There were others, such as Frederick J. Waugh, seascape painter; Henry B. McCarter, painter and illustrator, who later joined the Academy's faculty; and, of course, Anshutz, an outstanding teacher and much underestimated as a painter. But of the many pupils who passed through Eakins's classes at the Academy, this is a small harvest. Perhaps he was too great a painter to be a great teacher.

Even though Eakins no longer felt any need to play politics or curry favor within the Philadelphia art establishment, he made a strong effort, in 1896, to organize a one-man show at Philadelphia's Earles' Galleries, his only such presentation. Twenty-nine works, almost half of which were portraits, were on view, along with reproductions of *The Gross Clinic* and *The Agnew Clinic* (plates 65, 224). Although no catalog has been discovered—there probably was none—newspaper accounts indicate that the show also included rowing pictures, paintings of shad fishing in Gloucester, *William Rush Carving His Allegorical Figure of the Schuylkill River* (plate 84), a painting of a zither player, and *Home Ranch* (Philadelphia Museum of Art). We have no record of any sales being made from this show. That might not have bothered Eakins if the display of portraits helped him win commissions, but no sudden increase in orders for his portraits is recorded at that time.

The major critical review of the show, by the *Philadelphia Evening Item*'s Riter Fitzgerald—who was usually quite friendly to Eakins—pointed out that the artist had gained a reputation for being "brutally frank" in his portraits, that his devotion to "Art" would not allow him "to idealize or etherealize his subjects."[59] These brief remarks tell us a great deal about why Eakins would not have been eagerly accepted by prospective clients. Judging from the portraits in the show, most of the work was indeed "brutally like his models,"[60] to quote the *Philadelphia Inquirer*. Mrs. Frank Hamilton Cushing (plate 178), though looking pensive in her fashionable puff-sleeved dress, is shown in a harsh light that

makes her unidealized head look as solid as a boulder and her arms like those of a stevedore. Only in *Miss Lucy Lewis* (plate 179) did Eakins temper his forthright honesty. Fitzgerald wrote of this work: "There is a partial idealization of a very pretty subject, which could have been carried very much further with profit."[61]

Despite periodic rejections of one kind or another, Eakins gradually began to develop a positive reputation in the 1890s as more and more critics recognized his merit. Now he no longer needed to count primarily on friends in the fraternity of Philadelphia critics—Fitzgerald, William J. Clark, and Francis J. Ziegler— for supportive reviews; others, especially those in New York who had no personal ties to him, began to laud his work simply because they saw value in it. No full-length article on Eakins was ever published during his lifetime, but he was mentioned favorably in several prominent books on American art. In 1905

178. *Mrs. Frank Hamilton Cushing*, 1895
Oil on canvas, 26¹³⁄₁₆ x 22 in.
Philadelphia Museum of Art;
Given by Mrs. Thomas Eakins and
Miss Mary Adeline Williams

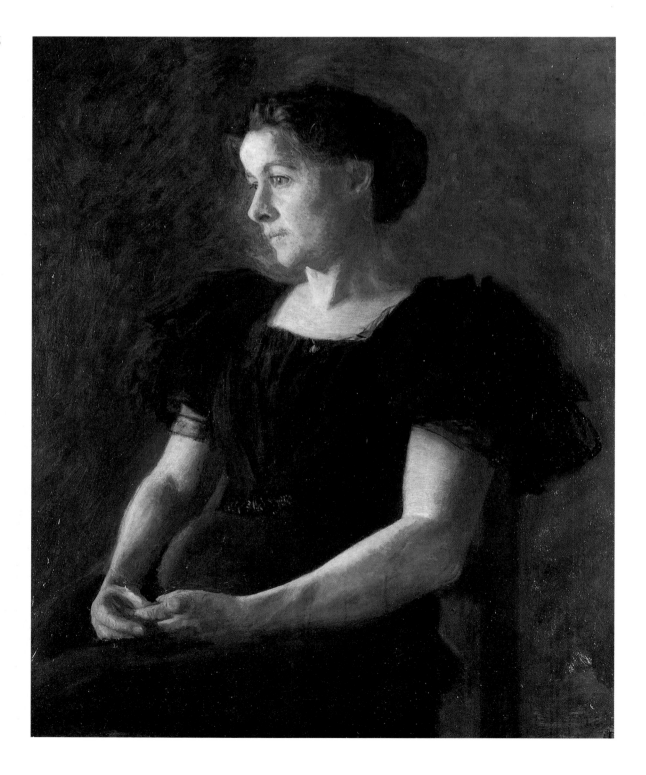

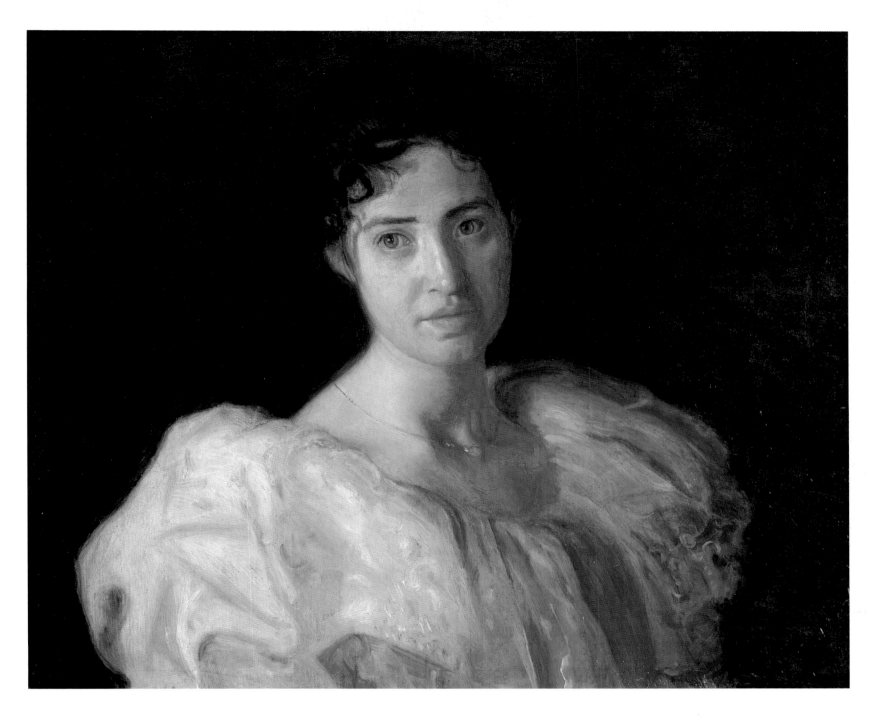

Sadakichi Hartmann praised Eakins in his *History of American Art*, taking note of his sculptural reliefs for the Trenton Battle Monument (plate 180), which he found "delightful in their naive and picturesque realism." Hartmann also listed Eakins among "our best men," who withdrew into seclusion or became hermits—among them Homer, William Morris Hunt, Homer Martin, Albert Pinkham Ryder, and Abbott Handerson Thayer.[62]

In the same year Samuel Isham wrote about Eakins at greater length and with more ambivalence in *The History of American Painting*. Whereas he praised Eakins's "grasp of the personality of his subjects, and an even greater enjoyment of the picturesqueness of their attitudes and apparel," he felt that the artist had neglected "the beauties and graces of painting," applying his pigment "inelegantly." "The eye," Isham wrote, "longs for beauty of surface, richness of impasto, or transparent depths of shadow." From the standpoint of paint handling, Isham thought J. Carroll Beckwith, Frederic Porter Vinton, and Joseph de Camp were superior to Eakins.[63]

180. *The Opening of the Fight*, 1893–94
Bronze, 54½ x 93½ in.
New Jersey State Museum
Collection, Trenton; Transferred
from Department of
Environmental Protection,
Historic Sites

Opposite
181. *The Cello Player*, 1896
Oil on canvas, 64½ x 48¼ in.
The Pennsylvania Academy of the
Fine Arts, Philadelphia; Joseph E.
Temple Fund

Juries responsible for making awards in the large national and international exhibitions registered their appreciation of Eakins between 1893 and 1897. His only previous prize, in 1878, had been a silver medal from the Massachusetts Charitable Mechanics Association, but in 1893 he won a bronze medal at the World's Columbian Exposition, Chicago, in 1900 an honorable mention at the Exposition Universelle, Paris, in 1901 a gold medal at the Pan-American Exposition (Buffalo); and in 1902 he was made an associate of the National Academy of Design. Two months later, he became a full academician.

The gradual rise in Eakins's reputation was accompanied by a partial healing of the breach between himself and the Pennsylvania Academy. Harrison S. Morris, managing director, took steps to cultivate the painter and win him back. As Morris wrote: "I felt his value to the Academy. A city with Eakins living in it detached from its Fine Arts Academy was a Hamlet-less farce. You might as well try to run a wagon on three wheels. Everybody would ask where the fourth was. The fourth, as essential as any of the rest, was Eakins."[64] Although Eakins never taught there again, in 1894 he began to submit work regularly to the Annuals, and three years later the Academy purchased *The Cello Player* (plate 181), his first painting to enter the collection.

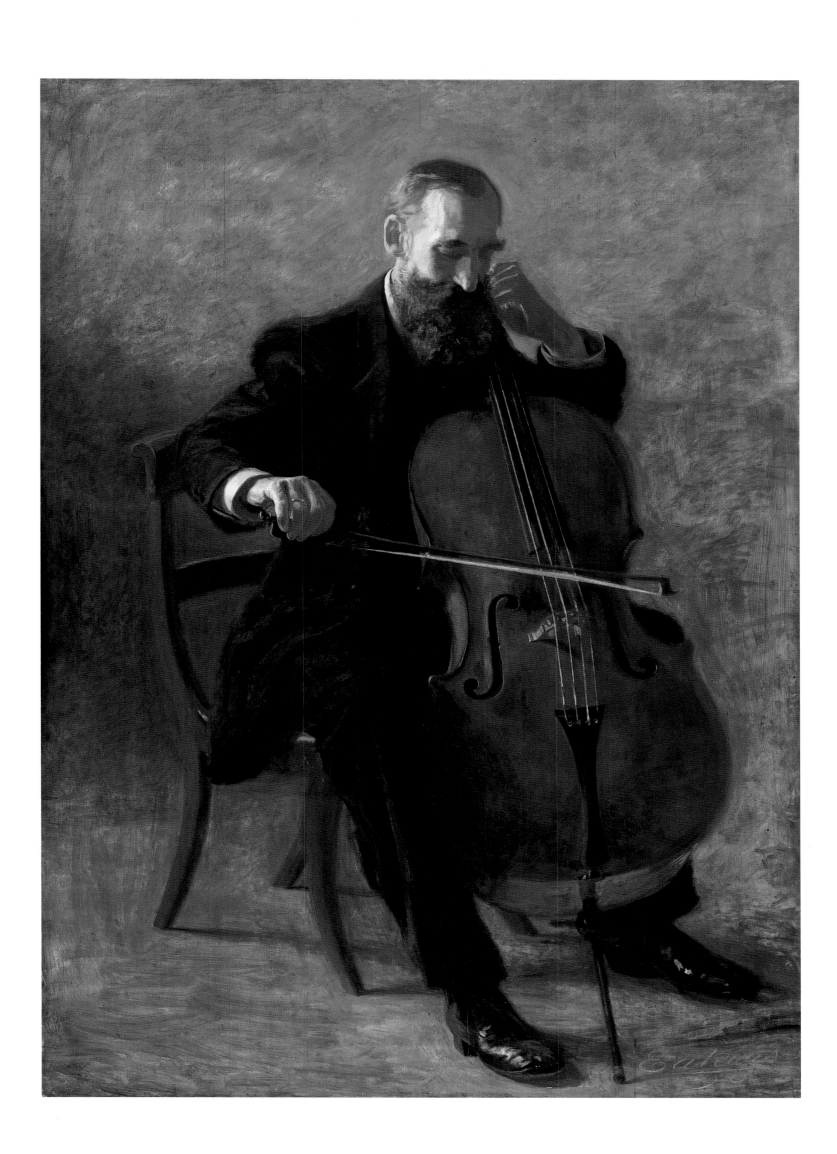

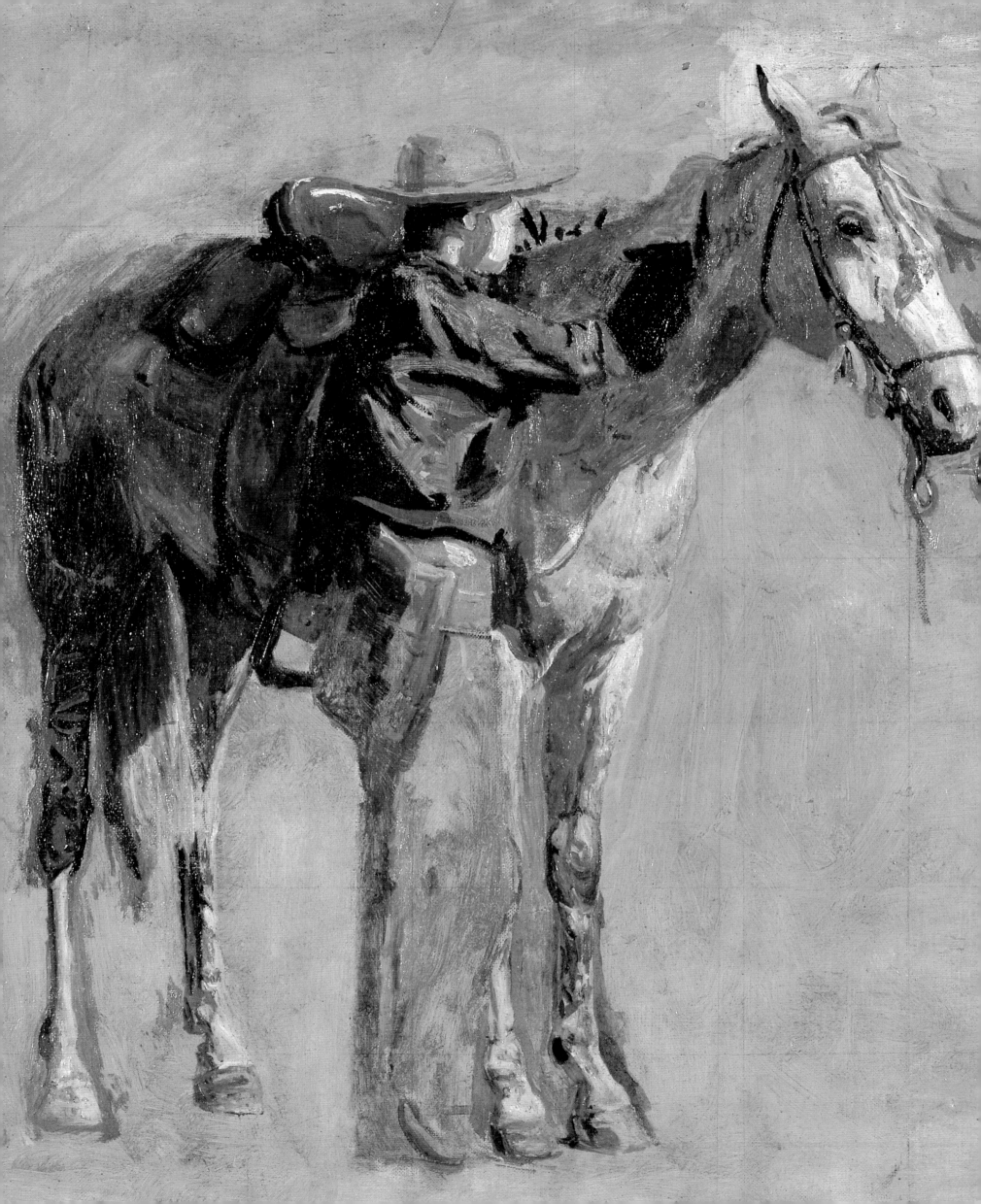

8.
The Cowboys and the Poet

Eakins painted little during the troubled year and a half after his resignation from the Academy. His creative renaissance did not begin until the summer of 1887, with his ten-week sojourn at a ranch in the Dakota Territory. The idea of taking a curative journey to the West may have been suggested by his friends Dr. S. Weir Mitchell and Dr. Horatio C Wood. The former was a neurologist who had pioneered the concept of the "rest cure" for the stresses of modern life; the latter, a physician and professor of nervous diseases at the University of Pennsylvania, sought practical applications of the "camp cure" idea. Dr. Wood thought city life was unhealthy and that body and mind would be restored by living in the wilder, more primitive areas of the country. In 1886 Wood had gone to the Dakota Territory on a hunting trip, and he came back with a financial stake in the B-T Ranch, some forty miles northwest of the town of Dickinson. In all likelihood it was Wood who invited Eakins to spend time at the ranch in the belief that out-door life among the cowboys would jolt him from his depression over the Academy scandal.

The B-T Ranch, managed by Albert Tripp, was located at the edge of the Badlands of the Little Missouri (now the southwestern part of North Dakota, but at that time still a territory). It was not far from the celebrated Elk Horn Ranch, which Theodore Roosevelt, then a member of the New York State Assembly, had purchased in 1883 and where he stayed off and on for three years. As pictured by Eakins in oil sketches and photographs (plate 183), the Dakota Territory was a vast, arid landscape filled with fantastic pinnacles, ridges, and ravines. Bleached by the harsh sun, the colors were mostly sandy tones, punctuated by pastels.

Eakins arrived in Dickinson on July 26, 1887. He was met at the train station by Tripp and by Dr. Wood's son George (his other son, James, had been a student of Eakins's in Philadelphia), and on the following day he rode with them to the ranch. Life there was rougher and more primitive than anything Eakins

182. Detail of *Cowboy (Study for "Cowboys in the Bad Lands")*, 1887–88. See plate 191.

197

183. *Badlands Landscape—Panoramic View*, 1887–88
Modern print from dry-plate negative, 4 x 5 in. plate
The Pennsylvania Academy of the Fine Arts, Philadelphia; Charles Bregler's Thomas Eakins Collection. Purchased with the partial support of the Pew Memorial Trust.

184. *Landscape (Sketch for "Cowboys in the Bad Lands")*, 1887
Oil on canvas, 10½ x 14½ in.
Philadelphia Museum of Art; Given by Mrs. Thomas Eakins and Miss Mary Adeline Williams

had ever experienced. In his letters to his wife, he described sleeping and eating out of doors, riding on the range, joining in the roundup. He also made it clear that he wanted to gather material for "cowboy pictures,"[1] which he hoped to be able to sell. His small oil studies of the landscape (plate 184) and of cowboys and their horses (plate 185) are informal and sketchy, seeming to have no immediate purpose. Similarly, his photographs of various western characters (plate 186), including many that recently surfaced in the Bregler Collection, seem to be random documents, perhaps made to be consulted later, back East, when he decided what exactly to paint.

That Eakins greatly enjoyed life on the range is clear from his letters to Susan:

198

185. *Cowboy Riding (Sketch)*, 1887
Oil on canvas on cardboard,
10½ x 14½ in.
Philadelphia Museum of Art;
Given by Mrs. Thomas
Eakins and Miss Mary
Adeline Williams

186. *Two Cowboys, with Horses, in
BT Ranch Yard, Dog in
Foreground*, 1887
Modern print from dry-plate
negative, 4 x 5 in. plate
The Pennsylvania Academy
of the Fine Arts,
Philadelphia; Charles
Bregler's Thomas Eakins
Collection. Purchased with
the partial support of the Pew
Memorial Trust.

An old indian fighter now a horse breeder came over to our ranch the day before to hunt some of his horses. We found them for him Sunday afternoon. He staid all night, & next morning Monday after breakfast we went to hunt his horses again which had strayed, & then we drove his horses & hunted our own. . . . The Indian fighter made a beautiful sight riding on his old indian war horse. It was as pretty riding as I ever saw. The old horse had a long regular swing up hill & down & over broken places & creeks & the man swung on him so easy & graceful he looked like a part of the horse.[2]

Eakins had become an experienced marksman from shooting rail on the New Jersey marshes, and he proved his skill in the Badlands with his .44 Winchester: "If we are out of deer meat," he wrote home, "I often shoot their heads off with my rifle."[3] Eventually he participated in something rather more threatening than deer hunting. Men from the B-T Ranch set out in pursuit of a dangerous horse thief and told Eakins to guard their camp, since the culprit might double back in search of food. He later recounted with relish the instructions he had been given: "If he should appear I am to hold him up, cover him with my Winchester make him dismount & then watch him till some one comes. If he makes the slightest attempt at resistance or disobedience I am not to hesitate and shoot him as he is known to be a cool & desperate villain."[4] Fortunately, the horse thief never showed up.

When the time came to leave the ranch early in October, Eakins took home his .44 rifle, a double-barreled shotgun, a .22-caliber rifle, a complete cowboy outfit, and two horses—Billy, a white bronco, and Baldy, a brown cow-pony. The latter was intended for his nieces and nephews to ride at the Crowell's Avondale farm, and the former was to replace their worn-out workhorse. Arriving in Philadelphia in the middle of the night, he rode the bronco, with Baldy in tow, up Mount Vernon Street to the family home.

187. Photographer unknown
Crowell Farmhouse, Avondale, Pennsylvania
Mr. and Mrs. Robert Trostle

188. Thomas Eakins(?)
*The W. J. Crowell Family in
Avondale, Pennsylvania*, 1890
Photograph
Nancy Crowell Reinbold,
Merrimack, New Hampshire

It was at the Avondale farm, owned by Frances and William Crowell, that Eakins could continue his recovery from the humiliation of his exit from the Academy. There he preserved a bit of the West, with his two horses, his firearms, and the other paraphernalia brought back from the Dakota Territory. The farm provided a rural retreat where he could dress up in his cowboy outfit and ride and shoot to his heart's content.

The Avondale farm was not new to Eakins, for he had been visiting there during summers and holidays since as early as 1877. That was the year that the farmhouse and 113-acre property were acquired by William Crowell, who at the age of thirty-four was diagnosed as having a heart condition. He left his job as an attorney and moved to Avondale with Frances and their large family, which eventually included ten children. The Crowell property, thirty-five miles southwest of Philadelphia, could be reached easily by rail, and Eakins would make the trip by night train or sometimes by bicycle.

William Crowell seemed never to have worked at the farm; his true interests were reading and other cultural pursuits. Neither William nor Frances had attended college, but both taught themselves several languages as well as the fine points of music and literature. At dinner or afterward William would often read to the family and guests from Thackeray, Dickens, James Fenimore Cooper, and other noted writers. "He subscribed to two newspapers," his son James recalled, and "read the news aloud after lunch each day while mother and the girls did up the dishes."[5] In addition to raising the family, Frances maintained a longstanding interest in music. After eight years at the farm she finally obtained a square grand piano and was able to pursue her avocation in earnest. Besides teaching

her daughters to play the piano, she went to Philadelphia once a week to take lessons herself.

Apparently the Crowells wished to make the farm a kind of Thoreauvian earthly paradise, a self-sufficient community, energized by cultural and intellectual pursuits and visited by notable figures in the world of art and music. Other visitors included mutual friends of the Crowells and Thomas Eakins: Weda Cook and her sister Maud (see plate 189), Max Schmitt, Emily Sartain, and some of Thomas's students, especially Samuel Murray, Franklin Schenck, and Edward Boulton. Family members were invited, too—Benjamin Eakins, Eliza Cowperthwait, and of course Eakins's wife, Susan, though it seems that he frequently visited the farm without her.

Having all these guests around must have been a great experience for the children, but no one did more for them than Eakins. He taught the three older ones—Eleanor (Ella), Margaret (Maggie), and Ben—how to paint, and he instructed all the nieces and nephews who were interested in the skills of riding and shooting. Swimming in White Clay Creek on the Crowell property was another of the children's summer pleasures in which Eakins enthusiastically participated. As Margaret McHenry has written, "Eakins was in his element, entering into everything with boyish vim and zest."[6]

Eakins went to the farm not only for pleasure but also to practice his art—painting, sculpture, and photography—along with "skinning and dissecting animals, treating the skins . . . making plaster casts of different hands."[7] A third-floor studio built for him by his brother-in-law in the back of the house remains intact to this day. Some family members recall that there was a skeleton in the room, with which he used to scare the children; others remember plaster casts of horses being there.[8] Several paintings and sculptures, some made as early as 1883, resulted from Eakins's Avondale experience. The oils *An Arcadian* and *Arcadia* (plates 94, 138), for example, were conceived and possibly executed at the farm. Evidence for this connection is found in a photograph that Eakins took there, which served as a study for the landscape in *An Arcadian;* his photograph of his nephew Ben holding panpipes (plate 136), also taken at the farm, was used in painting *Arcadia.* Although, as mentioned earlier, the Arcadian subjects may have been inspired by the death of Eakins's sister Margaret, they also relate directly to his experience at Avondale. The Crowell farm was a truly idyllic setting, self-sufficient and isolated from the turmoil of the city. In the Arcadia paintings, Eakins was paying homage to it as a harmonious environment in which he felt fulfilled and at peace.

At Avondale, vivid memories of his western sojourn, together with the opportunity to draw and paint the horses Billy and Baldy, led Eakins to produce one of his finest and most unusual works, *Cowboys in the Bad Lands* (plate 190). He made individual oil sketches at Avondale, more finished than the ones he had done in the West, for each figure and mount (plate 191), and thorough studies of details of the horses and the head of one of the riders, posed by his student Edward Boulton (plate 192). One of his own Dakota photographs (plate 186) helped Eakins establish the final figure grouping, but he did not copy it exactly. *Cowboys in the Bad Lands* is painted in much higher values than most of Eakins's

Above
190. *Cowboys in the Bad Lands*, 1888
Oil on canvas, 32½ x 45½ in.
Private collection

Right
191. *Cowboy (Study for "Cowboys in the Bad Lands")*, 1887–88
Oil on canvas, 20⅟₁₆ x 24⅟₁₆ in.
Philadelphia Museum of Art;
Given by Mrs. Thomas Eakins and
Miss Mary Adeline Williams

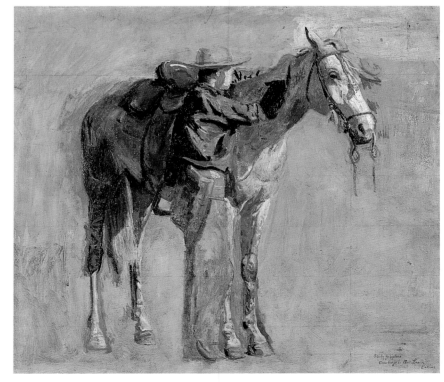

192. *Portrait Sketch of Edward Boulton*,
1887–88
Oil on canvas, 10¼ x 14¼ in.
Rebecca L. Soyer

landscapes, faithfully conveying the way the intense light of the sun bleaches the already pale colors of the terrain. As in so many of his pictures, the figures are reflective, quiescent. It is tempting to interpret the painting as an unconscious rendering of Eakins's own emotions: the cowboys are very likely his proxies, meditating on an alien and lonely expanse that may have symbolized the unknown future that lay ahead of him.

Billy and Baldy found their way into other works by Eakins, both painted and photographic. Billy, in particular, was a fine specimen and served as a model for the Soldiers' and Sailors' Memorial Arch at the entrance to Prospect Park, Brooklyn—a major sculptural commission showing President Lincoln and General Grant on horseback (plate 193), which Eakins executed in collaboration with the New York sculptor William O'Donovan. Eakins, who was responsible for the horses, turned to the live model: Billy served as Lincoln's mount, and Clinker, borrowed from Alexander J. Cassatt's farm in Berwyn, Pennsylvania, was used for Grant's. Eakins studied the movements of both animals at the farm by having O'Donovan and others ride them as he observed. Eakins rode Baldy around in the field for days, "studying one or the other of the horses, and working on a small wax model which he held in his hand."[9] A quarter-size version was made from the small models of each horse; and from these, the life-size sculptures were erected on large armatures in the field just to the east of the farmhouse.

The Avondale environment does not seem to have contributed anything special to the form or content of these sculptures; it was just a convenient place to model two full-size horses outdoors. The farm setting did, however, become an inspiration for a number of Eakins's photographs, and it was there that he took

205

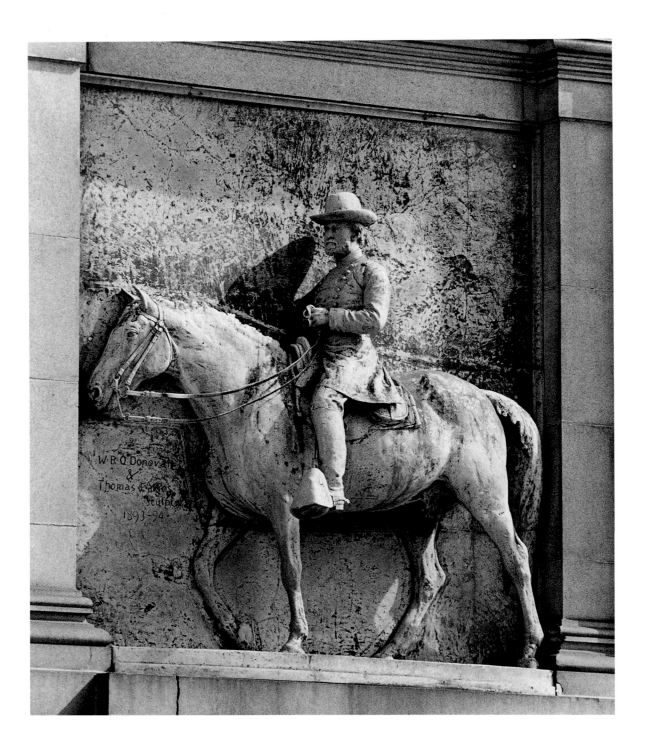

193. Thomas Eakins and William R.
 O'Donovan (1844–1920)
 Ulysses S. Grant, Soldiers' and
 Sailors' Memorial Arch, Brooklyn,
 1893–94
 Bronze

more of them than at any other location. Occasionally he would experiment with figures in motion, including images of himself riding a horse that were undoubtedly taken under his direction. But the subjects that held the greatest interest for him were his friends and family, particularly the children.

Eakins's motivation for taking these family photographs is unknown. Many of them were informal vignettes, almost snapshots (plate 194). Others are more than casual records, whose composition and posing reveal considerable forethought (plate 195). Possibly they represent Eakins's efforts to produce an "art photograph." Contemporary ideas about Pictorialism would have been known to him through his association with the Photographic Society of Philadelphia. Photography had been exhibited at the Academy while he was teaching there, and Susan was an expert photographer whose prints were exhibited in one of the later Academy shows.[10]

Eakins's photographs of family and friends at Avondale (plate 196) suggest

194. *Susan Macdowell Eakins with Ben, Will, and Artie Crowell in Avondale, Pennsylvania*, 1883
Photograph
Janet Lehr, Inc., New York

195. *Two of Eakins's Nephews at the Farm in Avondale*, 1885–90
Platinum print, 7¾ x 11¹⁵⁄₁₆ in.
The J. Paul Getty Museum, Malibu, California

a great deal about Whitman's aesthetic standards and expectations. He exclaimed that it was "a direct catch—no middleman." He went on to remark that the head was one of those "curious chances, out of a thousand, which hits a close mark . . . not to be schemed for—not to be purposed: only discovered, revealed, we might say."[30] Whitman liked the profile so much that he proposed to use it in his forthcoming book, *Good-bye My Fancy*, already in production, and a cropped version does indeed appear as the frontispiece in the final (1891) printing.[31]

Eakins, too, had photographed Walt Whitman, but not as often as has been thought, for some of the photographs usually attributed to him are not his at all.[32] He may have taken several photographs during the session just mentioned, possibly the ones later reproduced in an edition of *Leaves of Grass* published by the Boston firm of Small, Maynard in 1898 (plate 204). Eakins very likely had made these images to help O'Donovan and had hung them among the other photographs of Whitman on the wall of his studio.

Whitman told Traubel after one of the painter's calls: "Yes—that man Eakins is *sui generis*—himself—I like him—you will like him more and more."[33] Traubel did get to know Eakins better as a result of visiting his studio from time to time, often to check on the progress of O'Donovan's bust of Whitman. On one occasion he dropped in on the two artists, finding Eakins asleep. In Traubel's words, "After awhile [Eakins] came sauntering out & entered into our chat. Both of them interesting men—Eakins more the genius with art free & original—dry humor—sententious—disposed to look at you & make his quiet wise criticism & cease." Both Eakins and O'Donovan, Traubel reported, were "possessed with admiration of Whitman."[34] This same sentiment was echoed by Traubel on a visit to Eakins a couple of weeks later, when he spoke of the artist being "*sui generis*, a strong type—lounging, easy, not a useless word, full of admiration of W[hitman]."[35]

Traubel's accounts are invaluable because they establish Eakins's devotion to Whitman—something previously assumed but never actually stated at the time. Unfortunately, Traubel went into no more detail on this matter in the diaries, but his writings for the periodical the *Conservator* (which he also edited) record remarks made by Eakins on May 31, 1892—two months after he had served as a pallbearer at Whitman's funeral—at a gathering of admirers who were celebrating the poet's birthday. As Traubel reported:

> In direct and simple phrase [Eakins] dwelt upon Whitman's vast knowledge of form, as discovered by him, Eakins, at the period the now historic portrait was in process: a knowledge minute, irrefragable, astonishing—as of drapery and mechanics, of facial and bodily lines and masses; a possession the speaker [Eakins] never before had realized in anybody not specially given to that study [the study of art]. "And yet," concluded Eakins, "he [Whitman] probably had never seen a Van Dyck or a Rembrandt."[36]

With the help of several assistants Eakins had made a death mask (plate 205) and a cast of Whitman's hand. On the morning after the poet's death, Eakins arrived at Mickle Street with Murray and two assistants. They went

upstairs, where Whitman's body lay, and as Traubel reported: "Eakins threw back the shirt from the shoulders—. . . . They worked & worked—I watched & watched." Eakins both supervised and participated in this three-hour endeavor, with O'Donovan coming in "before it was finished."

"The head tonight seemed no way the worse," Traubel wrote. "The wavy float of the beard rather damaged—and a red line across the bridge of the nose, as if the plaster had at that point been stubborn." Then Traubel, confronting his deceased hero, waxed poetic, remarking on "Walt's serene face & folded hands & bared shoulders—as a god stretched out on god's own altar, dead."[37]

The Traubel diaries, published and unpublished, illuminate the community of spirit and aesthetic attitudes shared by these two giants in American culture—Whitman the poet and Eakins the painter. It can be assumed that each reinforced the beliefs of the other, and that both of these staunch individualists must have been strengthened in their courageous opposition to the genteel status quo.

Whitman's subjects were not just unconventional but shocking. With characteristic frankness, he openly addressed sexuality, the love of men for one another, and the naked body. Celebrating the joys of removing his clothes and sunbathing in the woods, Whitman wrote in *Specimen Days* (1882):

Sweet, sane still Nakedness in Nature!—ah if poor, sick, prurient humanity in cities might really know you once more! Is not nakedness then indecent? No, not inherently. It is your thought, your sophistication, your fear, your respectability, that is indecent. There come moods when these clothes of ours are not only too irksome to wear, but are themselves indecent. Perhaps indeed he or she to whom the free exhilarating ecstasy of nakedness in Nature has never been eligible (and how many thousands there are!) has not really known what purity is—nor what faith or art or health really is.[38]

Whitman disliked European manners and conventions, and he was passionately devoted to America and to a celebration of the democratic ideal. Throughout most of his career he was regarded as a maverick and an outcast by those in the literary mainstream. Yet he held firmly to his ideals, refusing ever to alter his views or his writing style to accommodate public taste. Whitman had hoped, in the early part of his life, to be accepted as a prophet, a national poet; but the publication of his first major book of poems, *Leaves of Grass*, in 1855 yielded mainly negative criticism and vilification. Continuing, undaunted, to write as he pleased, Whitman did finally taste some success toward the end of his life, especially winning accolades for his poetry in England.

The chief similarity between Eakins and Whitman was their self-sufficient confidence, which allowed them to disregard the conventions of their time. Eakins, like Whitman, insisted on making art in a way that seemed most appropriate and truthful, without giving in to popular or critical opinion. Again like Whitman, and unlike most of his Victorian contemporaries, he welcomed the healthy expression of physicality and an openness toward the nude body. Even the clothing they wore had a certain similarity, being loose,

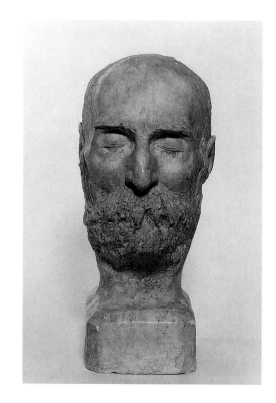

205. Thomas Eakins and assistants
Death Mask of Walt Whitman, 1892
Plaster, 15 in. high
Houghton Library, Harvard
University, Cambridge,
Massachusetts

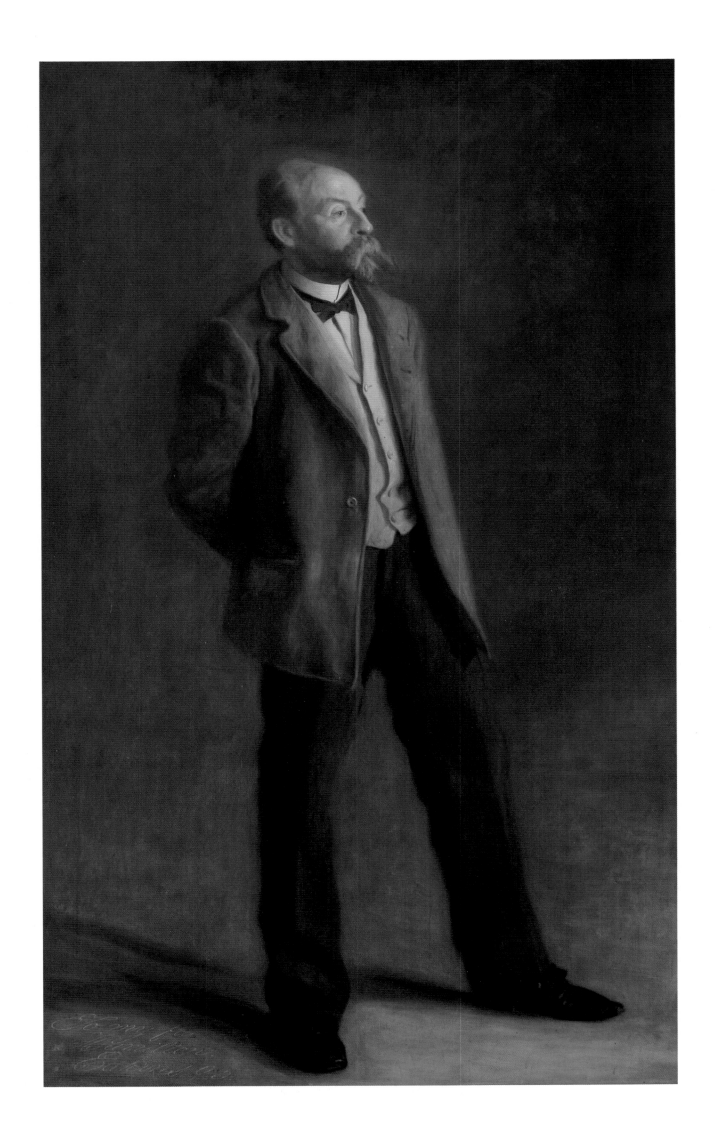

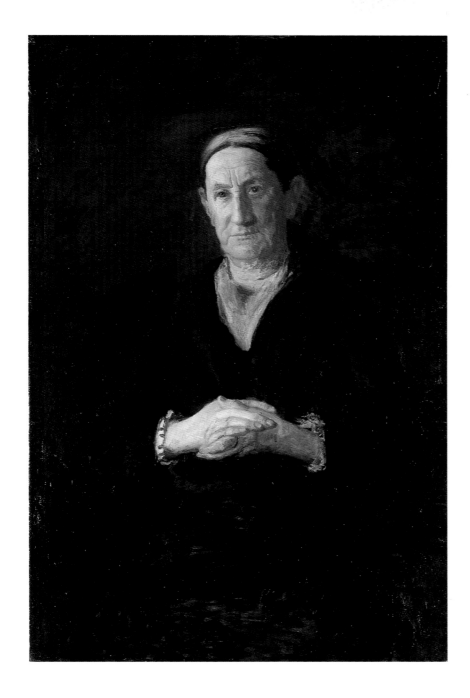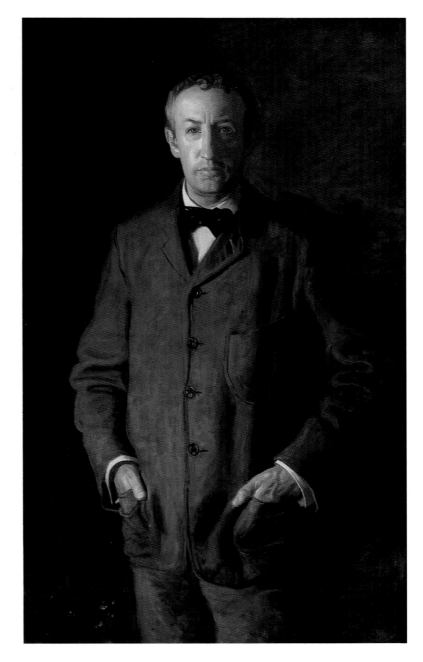

informal, and unconventional; Eakins seemed most comfortable in a sweater and baggy pants.

Eakins was more of an objective realist, and less of a romantic egoist, than Whitman. A positivist, Eakins only rarely incorporated romanticism or spirituality into his work. Having little interest in the cosmic or the mystical, he anchored his art in the phenomena of this world. Eakins seldom painted landscapes for their own sake, nor did he ever attempt a grand panorama of the American people or their environment, as Whitman did. Eakins concentrated on the individual; Whitman, on humanity and the cosmos.

The essence of the connection between the two men was captured by Harrison Morris, one of the few who knew both of them well. On Eakins's parallels to Whitman, Morris remarked, "Like Walt Whitman, whom he much resembled in reversion to primitive instincts tempered by nobility of thought, he could see in his disregard of prudish affectations only the return to truth."[39]

One other source for Eakins's thinking, related to Whitman, was the views of the Quakers (more correctly, the Society of Friends)—a dominant religious

Opposite
206. *John McLure Hamilton*, 1895
Oil on canvas, 80 x 50¼ in.
Wadsworth Atheneum, Hartford, Connecticut; The Ella Gallup Sumner and Mary Catlin Sumner Collection

Above, left
207. *Mrs. Elizabeth Duane Gillespie*, c. 1895
Oil on canvas, 44⅞ x 29⅜ in.
Philadelphia Museum of Art; Lent by the Associate Committee of Women

Above, right
208. *William B. Kurtz*, 1903
Oil on canvas, 52 x 32 in.
Mr. and Mrs. Daniel W. Dietrich II

219

and cultural influence in Pennsylvania and especially in Philadelphia.[40] This sect, founded in 1652 by George Fox, an English spiritual reformer, stressed the connection of each believer to God, without the intervention of religious rituals or clergy. The Quakers' appeal was to the spark of the Divine Essence in every person. The spirit of Christ was to be experienced directly by each individual, and it was the responsibility of every person to work out his or her own salvation.

In England and colonial America the Friends were vigorous antagonists of much that was decreed by the Crown and the Church of England. They were persecuted for failing to pay tithes, refusing to swear an oath, conducting marriages and burials without priests, testifying against fighting and wars, traveling on the Lord's Day, disturbing ministers, refusing to honor magistrates, and failing to attend the Church of England. Such contrariness was interpreted by the officials of church and state as impossibly audacious behavior.

During Philadelphia's first hundred years, the Friends played a critically important role not only in the city's religious life but also in its government. Gradually, however, they lost their position of power: some became wealthy and abandoned the faith, usually becoming Episcopalians; others took up arms at the time of the Revolutionary War and were expelled from the "meeting." In addition, other religious, national, and ethnic groups flocked to the colony, diluting the exclusiveness of Quaker power. At this point it is appropriate to introduce the concept of "secular Quakerism," a term I have coined to describe certain social and ethical beliefs that have survived from the original Quakers, though no longer having specific religious connections. This idea helps illuminate the ethos that prevailed in Philadelphia during Eakins's longtime residence there and that deeply influenced his thinking and his approach to his art.

Secular Quakerism stresses the independence of mind and thought required to answer the call of one's own conscience. In original Quaker doctrine, that call came from God; as Quaker beliefs became secularized, mysticism gave way to individualized independence. Secular Quakerism carried over from its religious origins an attitude of moral and ethical superiority, the believer quietly but persistently holding to his own correctness and criticizing (if not outwardly, at least inwardly) those who put on airs or sought social status. The simplicity of speech and dress, sobriety, self-discipline, and preference for silence that characterized the original Quakers were easily secularized, as was the belief in humanitarian causes, social justice, and the equality of the sexes.

Eakins could easily have absorbed such values from his family. His father taught in a Quaker school, and Benjamin's close friends and hunting partners, George Morris and William Hallowell, were from Quaker families. Benjamin's wife came from a Quaker background, and though she may not have adhered to the tenets of the Society of Friends, she certainly would have been exposed to their beliefs through her father, a member of the Society. Although Thomas Eakins was prone to criticizing Catholics and Protestants, there is no record of his ever having said anything negative about Quakers, and when he and Susan Macdowell were married, it was in a Quaker ceremony.

Eakins's simplicity of speech and dress, his stubborn adherence to his beliefs in the face of opposition, and his hatred of hypocrisy and pretension could

easily be related to Quaker values. Moreover, the emphasis on individual achievement that characterizes the typical Eakins portrait—such as *The Thinker* (page 2) and *Mrs. Elizabeth Duane Gillespie* (plate 207)—could be seen as mirroring Quaker doctrine. Although Eakins professed no religious beliefs, his paintings present unadorned humanity, individuality honestly expressed, souls responsible only to the light within. Shown almost always in plain, simple settings, his sitters think, meditate, reflect—the things that Quakers traditionally do so well. The sitter may belong to the aristocracy of achievement but is given none of the trappings of social aristocracy. In fact Eakins often asked his sitters, especially the men, to wear old, rumpled clothes and worn-out shoes. (In the case of the portrait of William B. Kurtz [plate 208], he asked the subject not to shave for twenty-four hours before posing.) For Quaker meetings, no one dresses up; casual garb is perfectly acceptable because one is judged not by man but by God.

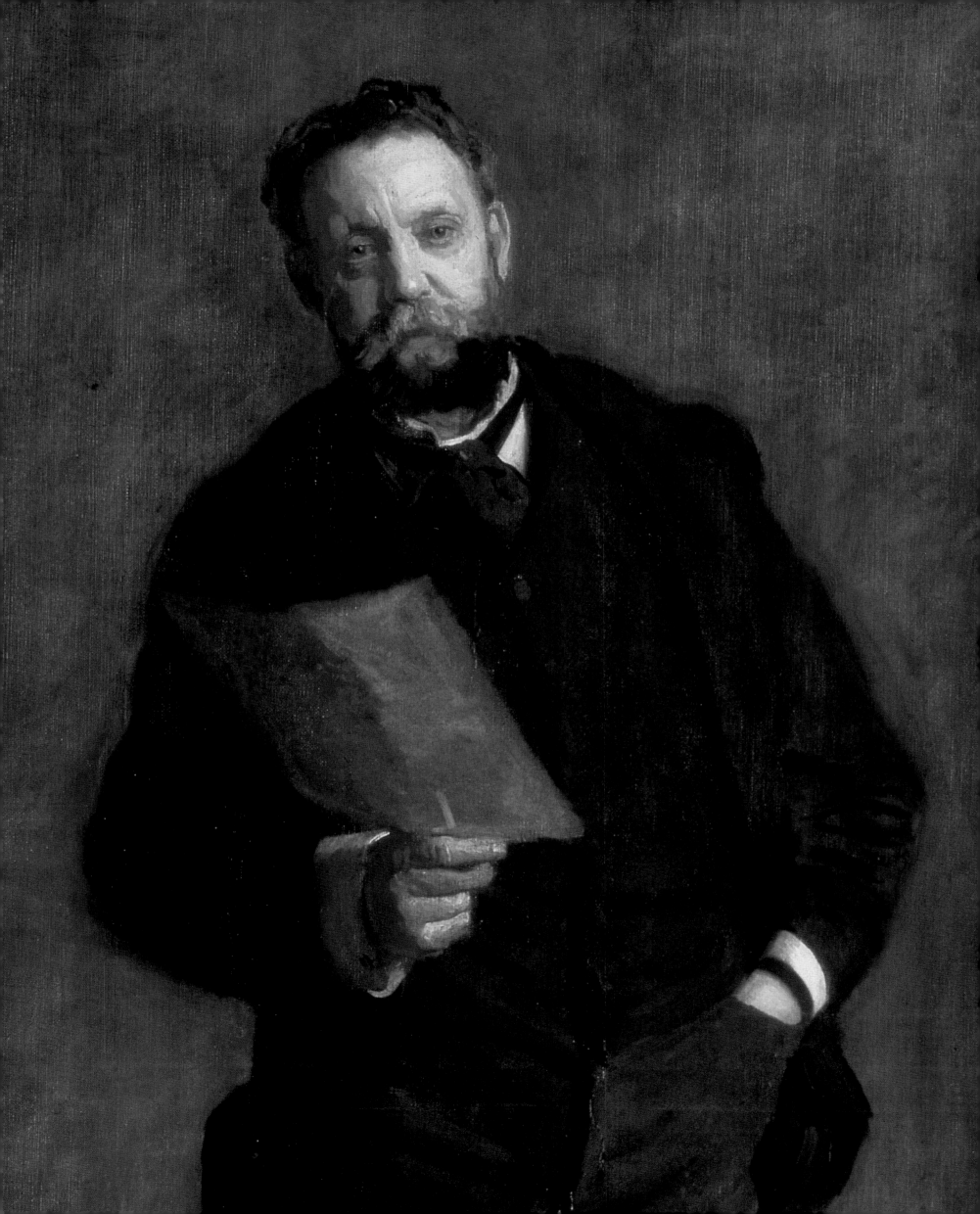

9.
Late Work and Belated Honors

During the years between Eakins's expulsion from the Academy in 1886 and 1913–14, when he stopped painting, he produced more portraits, by far, than any other type of subject. As always, the great majority of these were done at his own initiative, not as commissions. He had given up any hope that painting "sample" portraits would garner orders, so the prospect of financial reward can be eliminated as a motive. Why, then, was he so obsessively dedicated to the portrait? Among art historians, only Elizabeth Johns has come close to proposing a persuasive answer.[1] She views Eakins as influenced by the high value then placed on personal achievement in all walks of life. Both Eakins and, later, his widow made it clear that he wanted to produce a record for posterity of distinguished people, almost all of them Philadelphians—a tangible chronicle of those who had contributed to the scientific and cultural life of the city.[2] Typical examples are *The Oboe Player (Dr. Benjamin Sharp)* (plate 210) and *The Concert Singer* (plate 172). But not all of his sitters were heroes. Many of them, such as Kern Dodge (plate 211), were neither famous nor particularly distinguished: they were simply people—often his friends—who could do things well.

When Eakins represented individuals, he portrayed them and their accomplishments as self-made. He had immense faith in humanity, which he tried to articulate in pigment on canvas. He sought to re-create the essence of the person in a new form, but without adding any kind of editorial comment or institutional symbols of authority or power (except, perhaps, in his portraits of Catholic dignitaries). The unpretentious directness of his portraits is closely linked to their expressive content—communicating, in effect, that nothing has been added and that the individual exists in his or her own right, free from dependence on any external authority, system, or code of behavior.

In his late portraits, especially, Eakins sought the underlying structure and substance of the head and body and pulled no punches when it came to telling

209. Detail of *Professor Leslie W. Miller,* 1901. See plate 243.

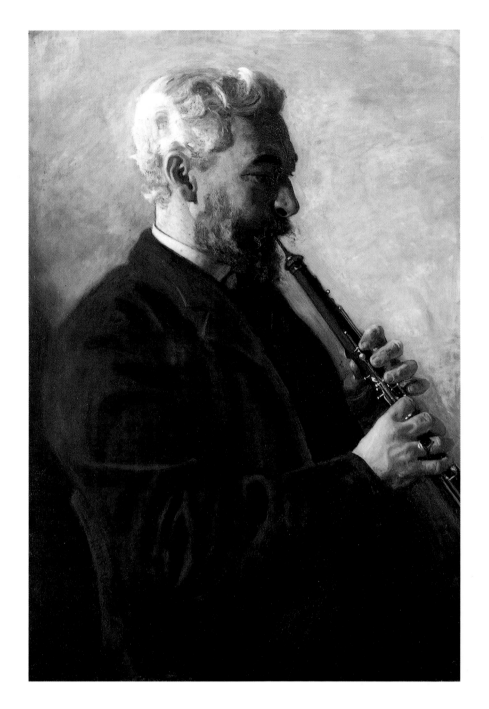

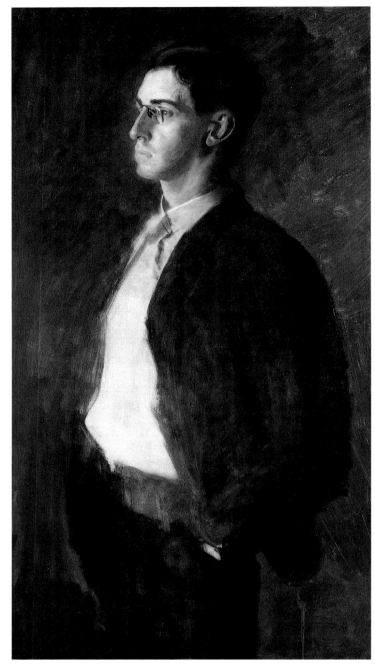

Above, left
210. *The Oboe Player (Dr. Benjamin Sharp)*, 1903
Oil on canvas, 36 x 24 in.
Philadelphia Museum of Art;
Given by Mrs. Benjamin Sharp

Above, right
211. *The Young Man (Kern Dodge)*,
c. 1898–1902
Oil on canvas, 45⅛ x 26½ in.
Philadelphia Museum of Art;
Given by Mrs. Thomas Eakins and
Miss Mary Adeline Williams

the truth about the individual who posed before him. In portraying male sitters, as in *William H. Macdowell* (plate 212), he usually captured their depth of character with ease, eschewing flattery. When he painted women, as in *Maud Cook* (plate 189), he applied the same standard of stark objectivity, going against the longstanding portrait tradition of removing imperfections and prettifying sitters. In some cases he made women appear less attractive and older than they really were, even "masculine" at times. Their heads are usually portrayed with the same direct, strong, revealing light that he used for his male portraits, and their bodies and clothing are presented as solid, massive forms.

There are exceptions, portraits of women for whom Eakins harbored deep affection or love, or whose warmth and radiance attracted him. For example, he gave much of himself emotionally in painting *Addie* (plate 169), the superb portrait of Mary Adeline Williams, who lived with the Eakinses and with whom he is said to have had an affair. This work is striking in the warm empathy Eakins has shown toward the sitter. It is one of the first portraits in which he opened

himself up to a particular woman rather than visualizing her according to his earlier intellectualized notion of a woman cast in a masculine mold. This painting marks the beginning of Eakins's ability to empathize with women in portraiture. He continued in this direction with *The Actress* (plate 1), *Miss Alice Kurtz* (1903; Fogg Art Museum), and *Mrs. Edith Mahon* (1904; Smith College Museum of Art).

A special place in Eakins's oeuvre is occupied by his portraits of the Catholic clergy. In the late 1890s, through his friend Samuel Murray, he became friendly with a group of distinguished churchmen associated with Saint Charles Borromeo Seminary in Overbrook, about six miles from Eakins's house. He often visited them with Murray, bicycling there on Sundays and staying for supper. Eakins may even have attended vespers—though he remained an unswerving agnostic. Given Eakins's antireligious sentiments, we must ask why he was

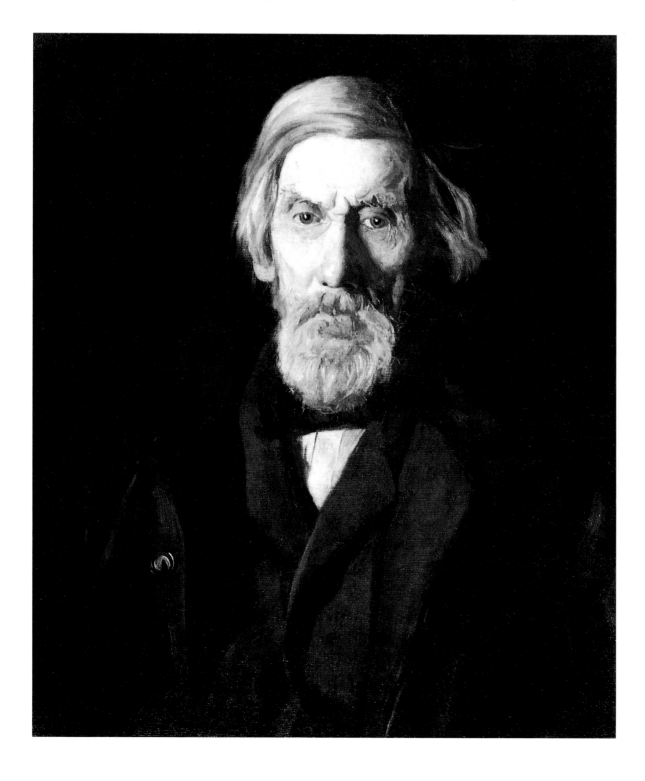

212. *William H. Macdowell*, c. 1904
Oil on canvas, 24 x 20 in.
Memorial Art Gallery of the
University of Rochester,
Rochester, New York; Marion
Stratton Gould Fund

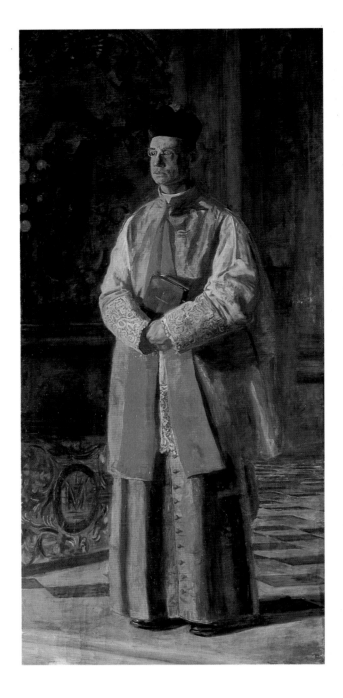

Above, left
213. *Monsignor James P. Turner*, c. 1906
Oil on canvas, 88 x 42 in.
The Nelson-Atkins Museum of
Art, Kansas City, Missouri; Gift of
the Enid and Crosby Kemper
Foundation

Above, right
214. *Archbishop Diomede Falconio*, 1905
Oil on canvas, 72⅛ x 54¼ in.
National Gallery of Art,
Washington, D.C.; Gift of
Stephen C. Clark

attracted to the Catholic clergy. For one thing, they were not Protestant ministers, the subject of his most vicious attacks in his later years. David Wilson Jordan said he thought that Eakins liked the priests because "they were human and told good stories, because they were intelligent, not too other-worldly like Protestants."[3] They were indeed learned men, disciplined and thoughtful, many of them of Irish or Italian descent and able to converse with him in French, Italian, and Latin. Rather than seeing their foreignness as a drawback, Eakins probably cherished the reminders of Old World culture that they provided; his youthful, self-conscious Americanism seems to have faded by this point.

Whatever his reasons for liking the clergy at Overbrook, Eakins found some of them, and other officials of the Catholic church, attractive as subjects for portraits. On an aesthetic level, the vestments of the church—especially those worn by dignitaries such as Monsignor James P. Turner (plate 213) and Archbishop Diomede Falconio (plate 214)—gave him a chance to indulge his marvelous sense of color, something he had held in check far too often. Turner's raspberry red and Falconio's sky blue and bluish gray garments delight the eye; in

fact, the raiments command more attention than the faces, which seem oddly expressionless. The sitters' minds seem to have wandered during the hours of posing, and Eakins, always faithful to appearances, captured their abstracted looks.

Being late works, the clerical portraits suffer some of the same problems that plagued Eakins's contemporaneous portrayals of secular sitters: the poses tend to be rigid and the figures lacking in animation. In *Sebastiano Cardinal Martinelli* (plate 215), Eakins placed his subject in a huge chair and surrounded him with a generous spatial envelope that was carefully defined, in advance, in three perspective drawings—surviving studies of this kind for his later portraits are rare. Although the likeness is undoubtedly excellent, Eakins's treatment of the face conveys little of the man's personality, and his handling of the figure does little to help: it is a rigid "snapshot" pose, in which Martinelli leans slightly backward, hands hanging limply from the arms of the chair, feet placed squarely on the floor. The painting is saved, however, by Eakins's handling of tone and color. Years of experience had taught him how to create a solid mass that convincingly inhabits the palpable atmosphere of an interior. From that point of view, the painting cannot be faulted.

Far more compelling as a character study is *Archbishop William Henry Elder* (plate 216). The eighty-four-year-old archbishop of Cincinnati, Elder was a colorful individual; since he could pose only for a week, Eakins was forced to deal

Below, left
215. *Sebastiano Cardinal Martinelli*, 1902
Oil on canvas on panel, 78⅜ x 60 in.
The Armand Hammer Museum of Art and Cultural Center, Los Angeles

Below, right
216. *Archbishop William Henry Elder*, 1903
Oil on canvas, 66¼ x 41⅛ in.
Cincinnati Art Museum; Gift of Louis Belmont Family, E. F. Hinkle Collection, and Bequests of Farny R. Wurlitzer and Frieda Hauck, by exchange

217. *Miss Amelia Van Buren,* c. 1891
Oil on canvas, 45 x 32 in.
The Phillips Collection,
Washington, D.C.

with essentials and not overwork his surfaces. Elder's massive form, seen almost straight on, dominates the picture, much in the manner of a Velázquez portrait. And like the Spanish master, Eakins was able to capture the character of his sitter with skill and insight, revealing the serious, thoughtful side of a man wise with experience.

In all, Eakins added fourteen distinguished Catholics, mostly from Philadelphia, to his roster of achievers. They imparted luster to the city's reputation and gave needed balance to his gallery of distinguished men and women. With the exception of a commissioned portrait of James A. Flaherty, a Catholic layman, the paintings were given away to the sitters, as was Eakins's custom. Over time, six of the canvases went to Saint Charles Borromeo Seminary and are enshrined in the beautifully appointed Eakins Room, where they may be enjoyed by all.

In spite of his maturity and skill as a portrait painter, Eakins had relatively few commissions between 1886 and 1900. Frank Waller, president of the Art Students League of New York, ordered a portrait (location unknown) of his aunt, Sophie Brooks, in 1886; four years later Eakins was commissioned to paint *Professor George W. Fetter* (plate 220) by the subject's students at the Girls' Normal School of Philadelphia. Four more commissions followed in the 1890s: one of the deceased Joshua Ballinger Lippincott (1892; Philadelphia Museum of Art), founder of the Philadelphia publishing firm that bears his name, ordered by his son and copied from a photograph; *Dr. Jacob Mendez da Costa* (plate 219), a physician and professor at Jefferson Medical College, requested by his friends; *Dr. Daniel Garrison Brinton* (c. 1899; American Philosophical Society, Philadelphia), a portrait of a physician and nephew of Dr. John Hill Brinton that, in Goodrich's opinion, was made from a photograph; and *Mrs. William H. Greene* (1899; Hirshhorn Museum and Sculpture Garden), wife of a noted physician associated with Jefferson, who ordered it to be painted from a photograph shortly after her death. The fact that three of these portraits were taken from photographs put Eakins almost in the role of a copyist.

Da Costa, swayed by friends whose views Eakins did not respect, was dissatisfied with Eakins's first effort: "I have known some of them," the painter wrote, "whom I esteem greatly to give the most injudicious art advice and to admire what was ignorant, ill constructed, vulgar and bad." Da Costa's temerity in suggesting that Eakins change the work inspired additional mocking words to the physician: "I presume my position is not second to your own in medicine, and I can hardly imagine myself writing to you a letter like this: Dear Doctor, The concurrent testimony of the newspapers and of friends is that your treatment of my case has not been one of your successes. I therefore suggest that you treat me a while with Mrs. Brown's Metaphysical Discovery."[4] No doubt in anger, Eakins cut the criticized canvas into pieces and embarked on a second one (plate 219), which the subject gave to the Pennsylvania Hospital in Philadelphia.

Eakins compiled a slightly better record of commissions in the early and mid-1900s. In 1902 he was invited to paint a portrait of John Seely Hart, principal from 1842 to 1858 of Central High School, where the portrait remains. The order, placed by an alumnus, required that he paint the deceased from a photo-

228

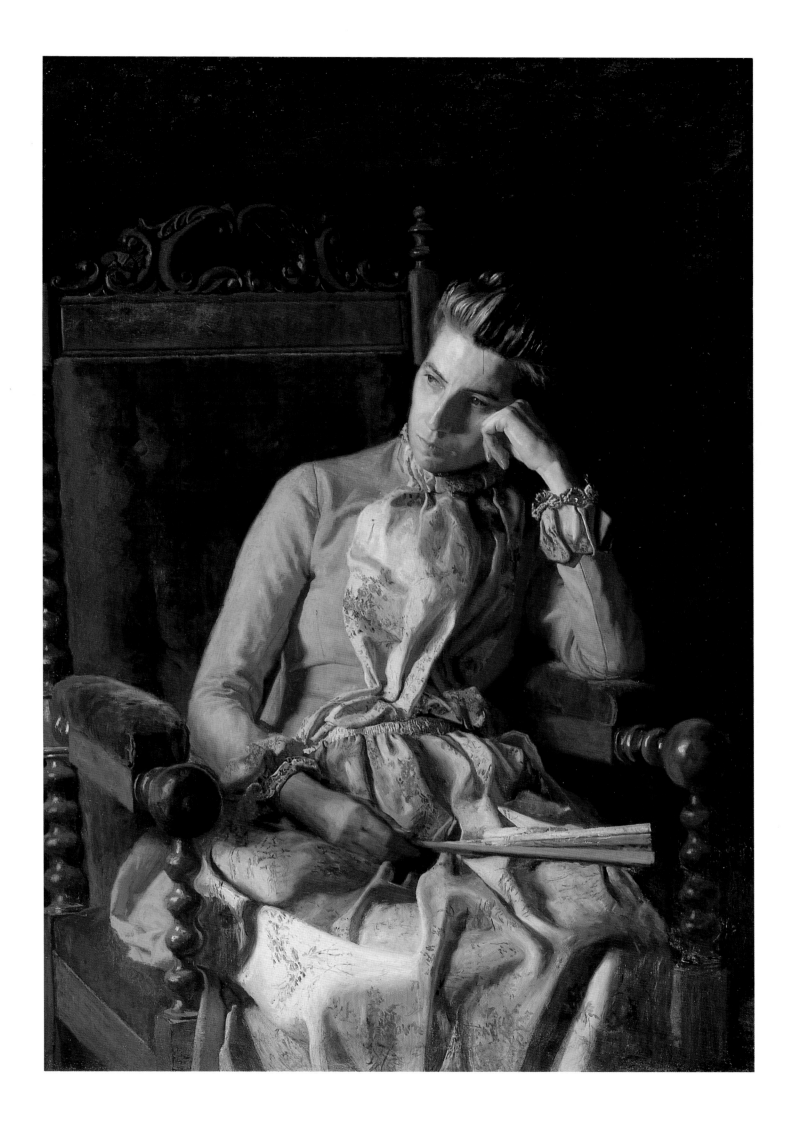

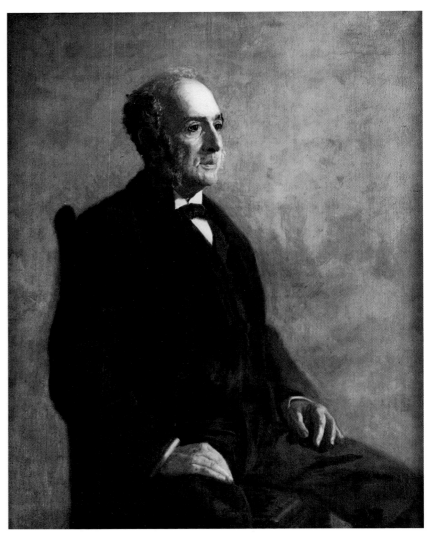

graph. Two years later, Eakins's former student Frank W. Tookes obtained a commission for him to portray the noted New York businessman Robert C. Ogden (1904; Hirshhorn Museum and Sculpture Garden)—a work the client did not like and promptly placed in storage. Other commissions included a portrait of Professor William Smith Forbes (1905) of Jefferson Medical College, presented by the Classes of 1905, 1906, 1907, and 1908 and still owned by the college; *John B. Gest* (1905; Museum of Fine Arts, Houston), ordered by the Fidelity Trust Company of Philadelphia, of which the subject had been president; *A. W. Lee,* a commission, but returned to Eakins by the subject; and *Richard Wood* (1906), commissioned by the sitter and kept.

Eakins's commissioned works are not his best—in fact, far from it. The Fetter portrait (plate 220), for example, is no more than an adequate record of the man and a corner of his office. Ogden is posed much like most of the Catholic clergymen Eakins painted: sitting stiffly in a chair, in the middle of the picture space, with a bored expression on his face. And the Gest and Lee portraits are among his least successful works, especially the latter. Both are wooden in their poses, and their faces have that detached, abstracted look that mars more than a few of Eakins's later portraits.

Eakins was much more comfortable painting people he knew. In the superb *Miss Amelia Van Buren* (plate 217), for example, he carved out the form of the sitter with a burst of direct light from the left. The quiet, yet dynamic

interaction of the volumes of Van Buren's head, arms, and torso brings the painting to life, without any hint of stiffness. Such a painting can hold its own against the best work of any of Eakins's contemporaries, no matter what their country of origin.

In 1889 Eakins was asked to do a portrait of Dr. D. Hayes Agnew, professor of surgery at the University of Pennsylvania School of Medicine and one of the greatest practitioners in the United States—almost as well known as Dr. Samuel D. Gross. The painting was to be a gift from three classes to the university in honor of Agnew's retirement. Eakins countered by volunteering to paint (for the original fee of $750) a comprehensive view of the surgeon in his clinic, which became the celebrated *Agnew Clinic* (plate 224). Eakins's biggest work, it was obviously a labor of love, reflecting his admiration for Agnew as a hero of American medicine. The carved inscription on the frame made by Eakins describes Agnew, in Latin, as "the most experienced surgeon, the dearest writer and teacher, and most venerated and beloved man."

A native of Christiana in Lancaster County, Pennsylvania, Agnew briefly attended Newark College (now the University of Delaware), then enrolled in the University of Pennsylvania medical school, which granted him an M.D. degree in 1838. He was the son of a doctor, with whom he conducted a country

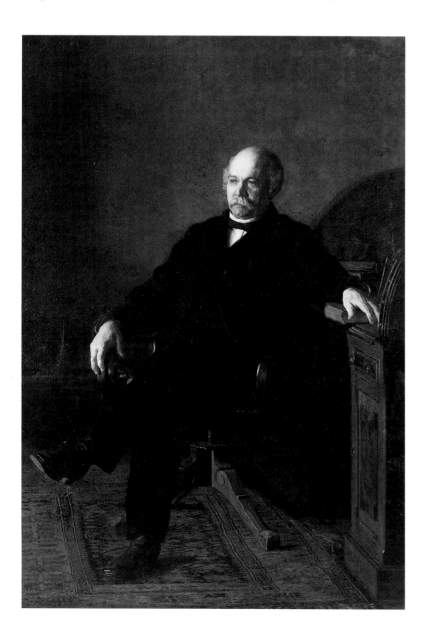

220. *Professor George W. Fetter*, 1890
Oil on canvas, 78 x 52 in.
Anonymous collection

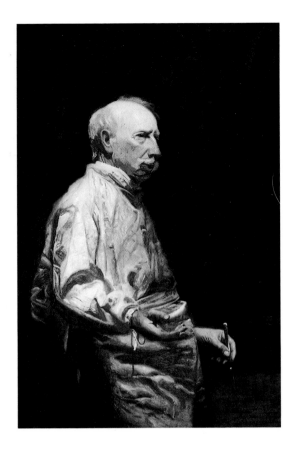

Above, left

221. *Sketch for "The Agnew Clinic,"* 1889
Oil on canvas on cardboard, 10¼ x 14¼ in.
Private collection

Above, right

222. *Dr. Agnew, A Study,* c. 1889
Oil on canvas, 49 x 31½ in.
Yale University Art Gallery, New Haven, Connecticut; Bequest of Stephen Carlton Clark

practice before going to Philadelphia in 1848 to teach at the Philadelphia School of Anatomy, operated by Dr. William W. Keen, who had been Eakins's colleague at the Academy. In 1871 Agnew joined the teaching staff of the University of Pennsylvania; seven years later he was the first faculty member to be appointed to the new John Rhea Barton Chair in Surgery. A highly respected and popular instructor, Agnew was praised by his students for his clear explanations of medical matters during his midday Wednesday lectures. Also an extremely able surgeon who conducted a clinic in the amphitheater of the University Hospital, Agnew had been drawn into the limelight as one of two physicians called in to attend President James Garfield after he had been mortally wounded by an assassin.

Eakins went to the hospital many times to observe Agnew. The small oil sketch (plate 221) that he did in preparation for *The Agnew Clinic,* which gives only the roughest tonal indications of the placement of his subjects, may have been made on site or from memory. Eakins also executed a more elaborate oil study of Agnew himself (plate 222) in his Chestnut Street studio. This masterpiece of portraiture incisively captures the distinguished surgeon's attentive yet reflective gaze as he pauses to explain the operation at hand. Although Agnew, when he arrived in the studio, would tell Eakins, "I can give you just one hour,"[5] he stayed much longer and returned fairly often.

The canvas for *The Agnew Clinic* was so large that Eakins had to sit on the floor of his studio, cross-legged, to paint the lower portion. In order to reproduce accurately the tiers of students seated in the background, he had benches built so that he could exactly reconstruct the visual effect of the University Hospital's amphitheater. Each student shown was real, and all have been identified. Similarly, the doctors performing the operation and the nurse were actual people,

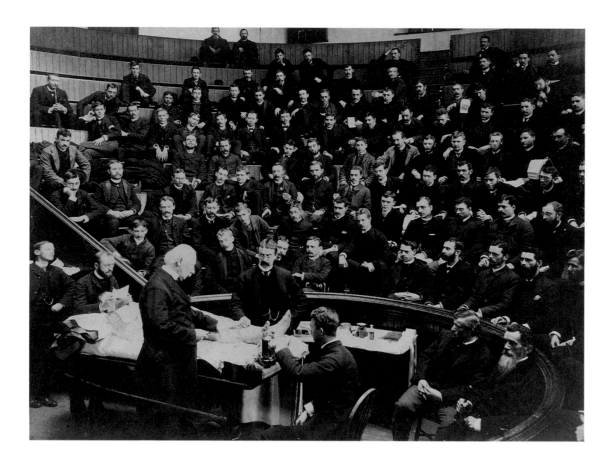

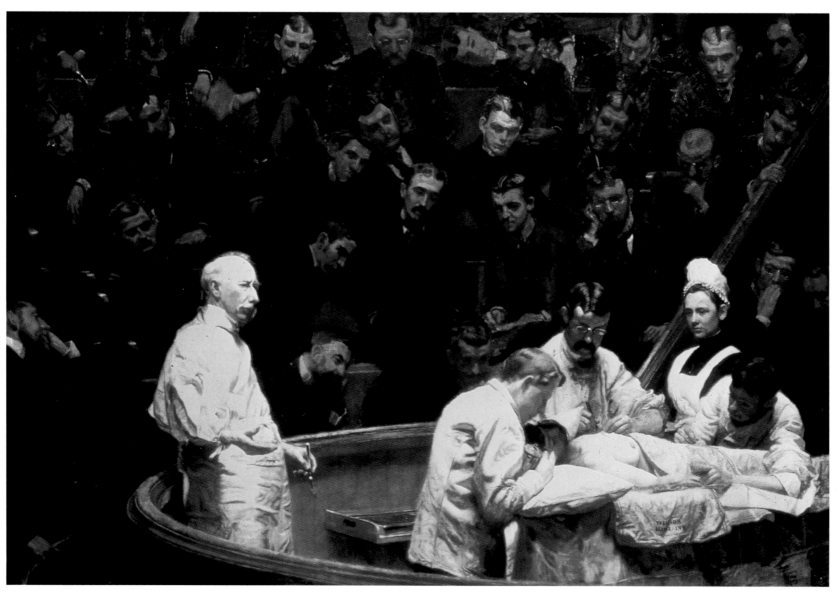

233

and these, too, have been identified. (No studies of these figures survive.) In a portrait said to have been painted by his wife, Eakins himself is shown at the far right, peering in through the entrance.

The Agnew Clinic, with its graphic depiction of an operation, immediately invites comparison with The Gross Clinic (plate 65), executed fourteen years before. Although Eakins's treatment of Agnew as an individual is no less effective than that of Gross, the composition of the later painting is far looser. Unlike The Gross Clinic, The Agnew Clinic reads horizontally, with the principal figures spread out almost like a sculptural relief. The lighting is more even and less dramatic than in the Gross painting, probably because each student in the amphitheater was a particular individual and could not be buried in shadow. The higher key and more uniform tonal values also reflect the relatively new practice of operating with the aid of artificial light (Gross's surgery had taken place under natural illumination from a skylight). The team activity of the surgeons is set apart as a separate unit, rather far from Agnew. And even within that group there is far less psychological unity than in the Gross painting; the nurse in The Agnew Clinic stands by impassively, without expression. Most troubling is the sea of students dominating the background. In his effort to include likenesses of everyone, Eakins created a secondary emphasis that is too strong for the rest of the painting. Had he been able to blot out much of the surrounding detail, he could have stressed much more effectively the central activity of Agnew and his colleagues. Still the picture was a heroic effort—all the more so because it was painted in just three months, a relatively short time for Eakins.

Medical practice had advanced rapidly in the years since The Gross Clinic was painted. Gross and his colleagues operate in their street clothes, anesthesia is administered on a gauze cloth, and there seems to be little or no effort to keep the environment free from bacteria. In The Agnew Clinic, the doctors wear white (though not rubber gloves or surgical masks), the surgical instruments are presumably sterile, and the ether is administered through a cone over the patient's face. (A photograph of Agnew in this same operating theater [plate 223], taken in 1886, shows him in his ordinary clothes; the adoption of white garments for the operation in The Agnew Clinic must therefore have been quite recent.) Eakins proudly portrayed the advances that had been made from one era of surgery to the other, and he surely showed Dr. Agnew's situation in 1889 with precise accuracy. The only concession he made, at Agnew's request, was to remove all but a little of the blood that would have been present.

Eakins's paintings of Agnew and Gross show these powerful surgeons at work in an almost exclusively male habitat. In The Gross Clinic the only woman present is the anonymous mother of the patient, who recoils in horror from the sight of the operation. In The Agnew Clinic, Eakins included a female who takes part in the operation, Nurse Mary Clymer. Her presence indicates an advance in the composition of the operating team from Gross's time, when the only counterpart of a nurse was the male orderly, Hughie O'Donnell, who stands in the entrance to the amphitheater. Unlike O'Donnell, Nurse Clymer was a professional, trained as a member of the second class in the nursing school at the University of Pennsylvania. From her class notes comes the following professorial

advice given to her and her fellow students: "We must always be dignified and grave, never forgetting that all we are trying to do is for the good of the patient. . . . We must be patient with Drs as well as patients. We must have moral and physical endurance and we must be self forgetting and self denying."[6] Clymer, who finished her studies the year the painting was completed, graduated at the top of her class, receiving the Nightingale Medal in recognition of her talents.

Dr. Agnew was all in favor of women entering the field of nursing, but adamantly opposed to their becoming medical students, and he resigned as surgeon at the Pennsylvania Hospital in 1871 rather than teach them. A strict Presbyterian, he said: "I did not believe the Lord ever intended they should study, much less practice [medicine]."[7] Although he accepted reappointment six years later and grudgingly tolerated women's presence in his classes, he never liked the idea of medical coeducation. As Margaret Supplee Smith has pointed out, he felt that women doctors might embarrass male patients, especially in examining and discussing genital maladies, and that entering the profession would also compromise the female physicians' womanly traits.[8]

There is one other woman in *The Agnew Clinic:* the anonymous female patient who lies on the operating table—one healthy breast exposed and a gaping wound where the other had just been removed. Recent research has shown that Agnew's practice of mastectomy for a cancer patient was palliative rather than permanently effective. Removing the diseased breast did not effect a cure, as Agnew himself admitted, but was justified, he thought, because it offered the patient "temporary relief from worry."[9]

Why did Eakins choose to show Agnew performing a mastectomy? Any number of operations could have been represented, and there is no evidence that Agnew was particularly renowned for breast surgery or that he or his students had asked Eakins to treat that subject in the painting. In all probability, it was Eakins's own selection, a decision that may reflect his belief in the hegemony of men over women at a time when he was still smarting from betrayal by female accusers in connection with the Academy affair. The patient is not only stretched out in a submissive pose, she falls under the complete control of Agnew and his team of surgeons, who ravage her—albeit in the name of science. One of the most prominent and vulnerable symbols of the patient's femininity has been cut away under the intense and curious gaze of males—an image that may reflect Eakins's unconscious desire to "punish" women, individually or as a group. Certainly his portrayal in no way ennobles women and could be seen as confirming the earlier accusations of his hostility toward them.

Eakins's candor in showing a mastectomy in graphic detail won many admirers in the field of medicine, but just as many detractors in the realm of art. In painting a work that might offend women or children, Eakins failed to observe the principle of decorum, a concept that originated in the Italian Renaissance and that was still very much alive in his own time, as the art historian Patricia Hills has pointed out.[10] Apparently the doctors and medical students at the University of Pennsylvania were not troubled by the scene, but some of the Pennsylvania Academy's directors privately avowed that the picture was "not cheerful for ladies to look at."[11] Perhaps this sentiment had something to do with

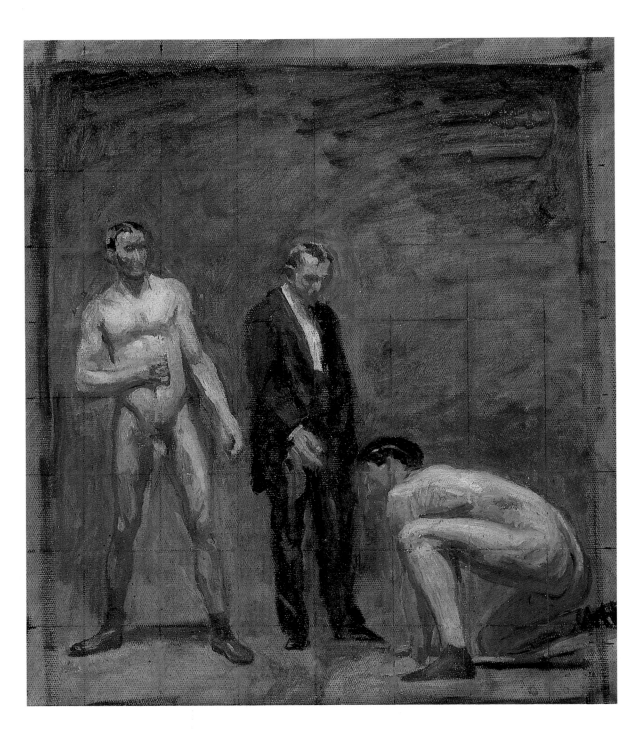

225. *Taking the Count,* 1898
Oil on canvas, 96¹⁵⁄₁₆ x 84⁵⁄₁₆ in.
Yale University Art Gallery, New
Haven, Connecticut; Whitney
Collections of Sporting Art, given
in memory of Harry Payne
Whitney and Payne Whitney by
Francis P. Garvan

the Academy's rejection of *The Agnew Clinic* from its 1891 Annual. The pretext
for the decision was that the painting was not eligible because it had already
been exhibited publicly at Haseltine's, which was true, but exceptions were often
made. Although the committee of artists in charge of the show had wanted to
show the painting, along with several other works by Eakins, the board's powerful
Committee on Exhibitions balked at accepting *The Agnew Clinic*. The artists'
committee expressed regret about this reversal, but nothing could be done.
Eakins's written plea to his old nemesis Edward H. Coates, president of the board,
was ignored.

Just when it seemed that Eakins had given himself over almost exclusively to
portraits, in 1898–99 he turned unexpectedly to the subjects of boxing and
wrestling. No motivation is known for his sudden burst of interest in sporting
pictures, other than his own fondness for these events. He is said to have attend-
ed boxing matches three or four nights a week at the Arena at Broad and Cherry

236

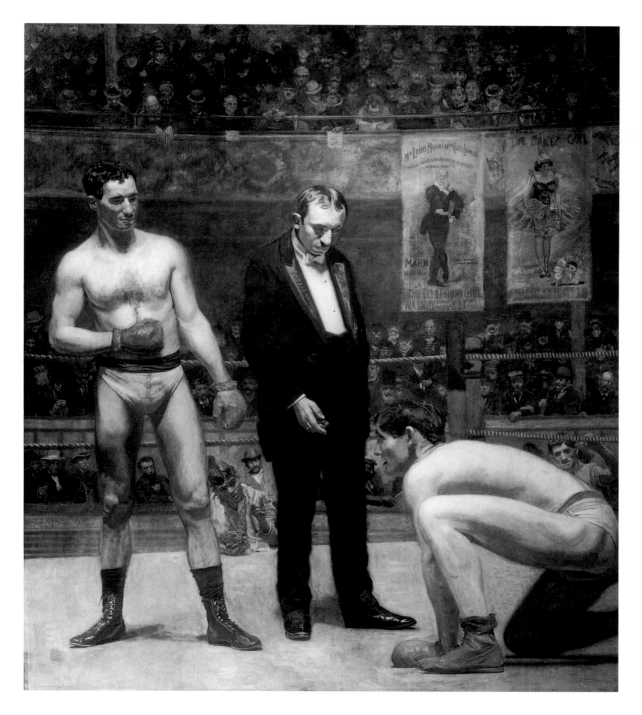

226. *Sketch for "Taking the Count,"* 1898
Oil on canvas, 18 x 16⅛ in.
Hirshhorn Museum and Sculpture
Garden, Smithsonian Institution,
Washington, D.C.; Gift of Joseph
H. Hirshhorn, 1966

streets, diagonally across from the Pennsylvania Academy. Clarence Cranmer—a newspaper reporter and friend of Eakins, who was portrayed as the timekeeper in *Between Rounds*—told Goodrich that the artist had seen "over 300 rounds of fighting, before he started this group of paintings."[12] Eakins seems to have genuinely enjoyed himself at these displays of a special kind of masculine skill. True, these men were not surgeons, scholars, or musicians, but they knew their trade and Eakins thought they were worth painting.

Eakins prepared for *Taking the Count* (plate 225) by painting an oil sketch (plate 226) of the three principal figures against a plain background: the two boxers, Charlie McKeever and Joe Mack, and the referee, Walter Schlichter. As is so often the case, the spontaneity of Eakins's sketch makes it more appealing than the finished work. In the sketch the figures are presented with the utmost simplicity, their heavy, muscular forms delineated in an almost classical manner. In the completed work the poses remain essentially the same, but the painting is cluttered with visual information, especially in the background, where once

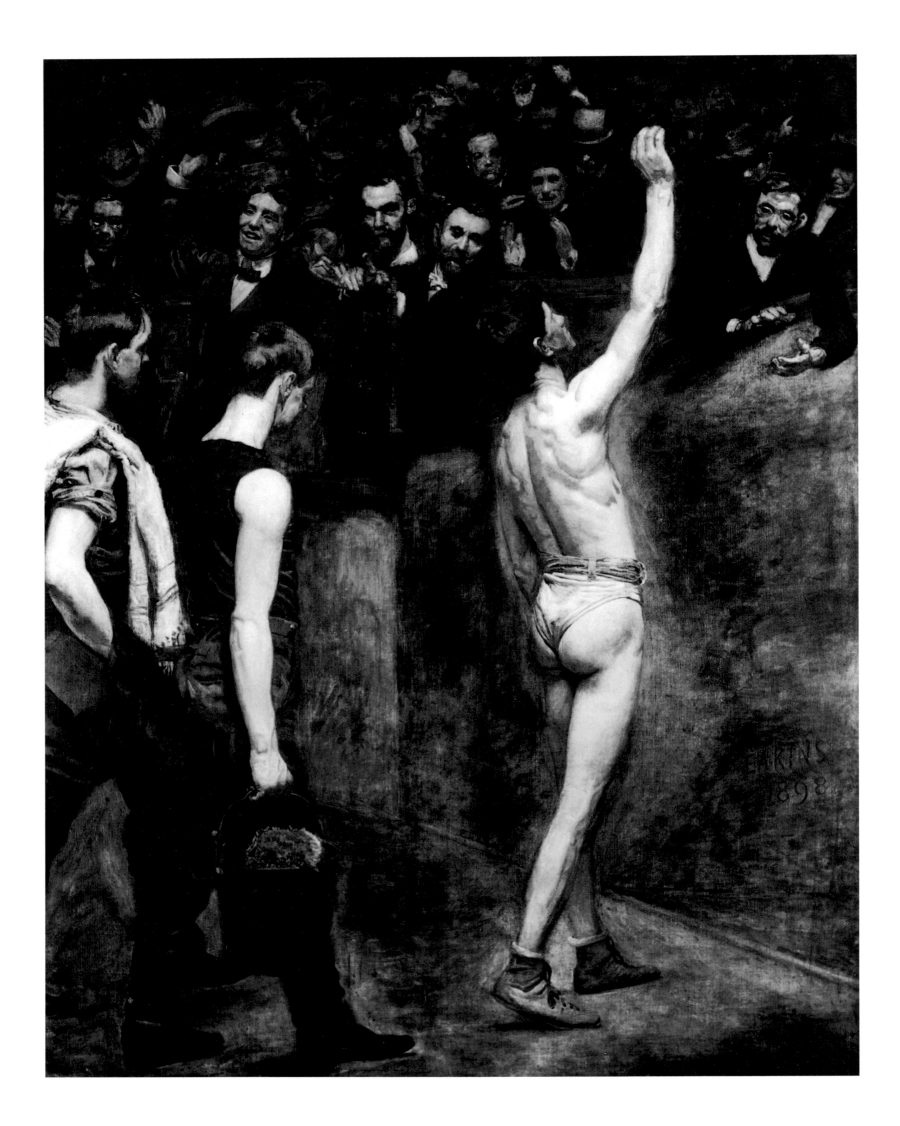

again Eakins apparently felt compelled to draw the spectators in full detail, as he did the two highly descriptive theater posters hanging from the balcony on the right. The heads of the boxers and referee, too, are quite specific, with much more emphasis on outline and harsh modeling than is usual for Eakins. It is as though he had begun to venture into the language of popular illustration to describe these subjects with mass appeal.

In a related painting, *Salutat* (plate 227), the narrative detail and the frozen poses of the members in the audience are almost photographic in treatment, though no camera studies for them have yet come to light. Two attendants walking in from the left are caught in almost cinematic freeze-frame, as are the clapping spectators. The pose of the boxer, Billy Smith, however, transcends the finite moment as he raises his right hand in a grand gesture of victory—like a triumphant gladiator in ancient Roman sculpture. Eakins reinforced this connection by carving a Latin inscription on the frame: DEXTRA VITRICE CONCLAMANTES SALUTAT (With his victorious right hand he salutes those acclaiming him). *Between Rounds* (plate 171) has even more literal, narrative detail than *Salutat*. There are highly legible signs in the gallery that read ROUND 2 and THE PRESS, and from the balcony hang the same pair of posters that appear in *Taking the Count*. Realistic, too, are snapshot poses of the boxer (Billy Smith again) and his handler, who fans him with a towel.

The photographic connection is also overt in both versions of Eakins's *Wrestlers* (plates 228, 230). A photograph (plate 229), probably taken by Eakins, of the two men tussling is the exact source for the pose: it would have been difficult for models to hold that position for any length of time, and so a photograph was the easiest solution. Not unexpectedly, the paintings have a slightly stilted quality—the usual result when a camera image is the principal source of data.

At a stage in life when Eakins had stopped trying to impress anyone, he painted these pictures to indulge his liking for popular sports, to express his interest in what he had seen so often and knew so well. No longer concerned about whether his works would sell, he painted as he wished, giving free rein to his descriptive and photographic tendencies. The pictures, accordingly, have very little formal structure. In fact, in a way, they look more like extremely competent, fully developed illustrations, in sharp contrast to the fashionably misty, flattened designs of those American artists influenced by Whistler and the French Symbolists. It is no wonder that Eakins's sporting scenes found no buyers and received a lukewarm or negative reception from critics and the public.

Eakins devoted a suite of late paintings to variations on another, far different theme: William Rush and his model. More than thirty years after treating this subject in *William Rush Carving His Allegorical Figure of the Schuylkill River* (plate 84), Eakins returned to it, infusing it with a new set of private messages and associations. In 1908 he painted two basic versions of the Rush theme (plates 234, 235); studies related to plate 235 suggest that he was gathering ideas for another variant, never made. There are more than a few oil studies as well—some quite close to the final two paintings, others dealing with separate units or exploring alternative compositions.

The 1908 version in Brooklyn (plate 234) invites comparison to the 1877

227. *Salutat*, 1898
Oil on canvas, 50⅛ x 40 in.
Addison Gallery of American Art,
Phillips Academy, Andover,
Massachusetts; Gift of anonymous
donor

239

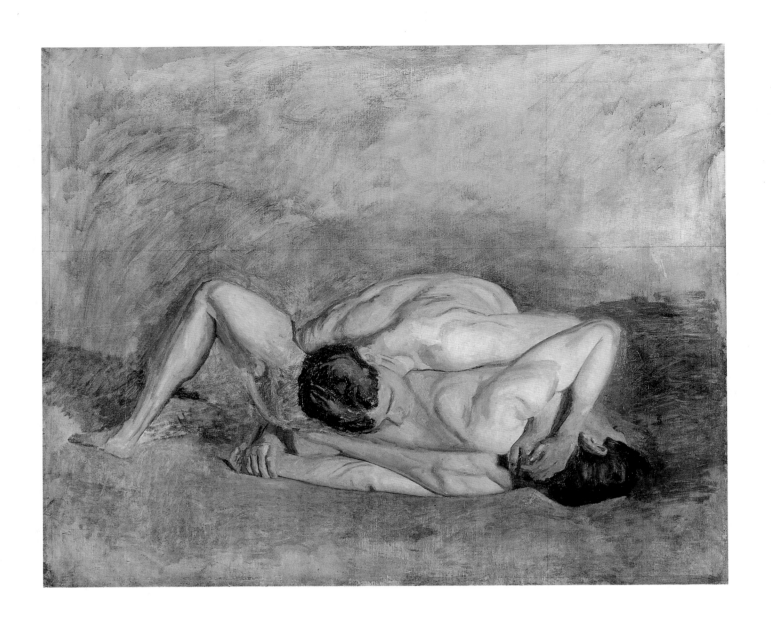

240

Left

233. *Study for "William Rush Carving His Allegorical Figure of the Schuylkill River,"* c. 1908
Oil on fiberboard, 8¾ x 10¼ in.
Hirshhorn Museum and Sculpture Garden, Smithsonian Institution, Washington, D.C.; Gift of Joseph H. Hirshhorn, 1966

Below

234. *William Rush Carving His Allegorical Figure of the Schuylkill River,* 1908
Oil on canvas, 36⁷⁄₁₆ x 48⁷⁄₁₆ in.
The Brooklyn Museum

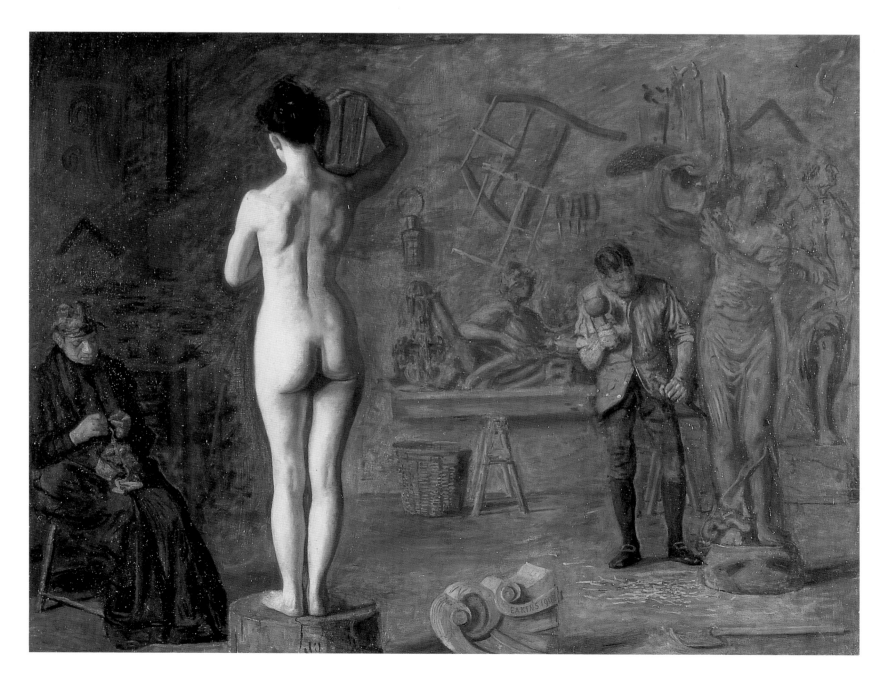

Eakins also made two small studies for the entire composition, one slightly larger than the other, in which he established the placement of the figures and accessories (plate 233). He seems to have had a clear idea about what he wanted in the general design because there is little experimenting or guesswork in either study. When it came to the final painting, he followed his original visual proposals almost exactly, though he opened up the spaces between the figures to avoid congestion.

The completed canvas has a curious additive quality about it, partly a result of having compressed the space so that the figures align along one plane, almost as in a sculptured relief. We read the painting from left to right, stopping to savor the fully modeled flesh of the nude, then moving on to the figure of Rush carving the nymph. In this picture, the wooden sculpture on which he works is larger and more prominent than in the 1876 and 1877 versions, thus gaining greater parity with the model.

The mellow Rembrandtesque tone of the Brooklyn painting is shared by *William Rush and His Model* (plate 235), but Eakins's strategy of posing that figure is boldly different: he turned the subject toward us, unabashedly revealing her

235. *William Rush and His Model,*
c. 1908
Oil on canvas, 35¼ x 47¼ in.
Honolulu Academy of Arts; Gift
of the Friends of the Academy,
1947

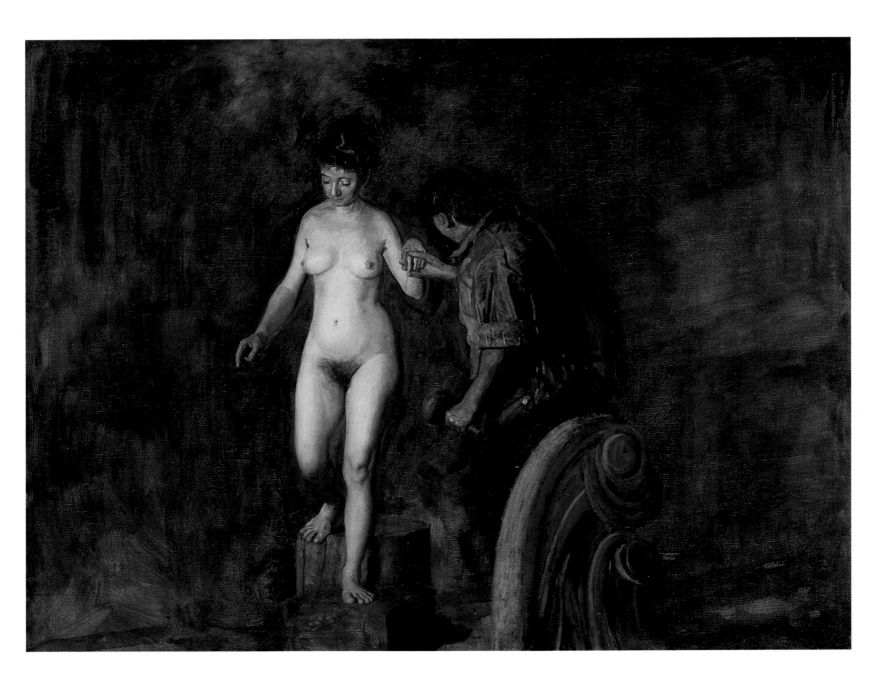

breasts and pubic hair. This was a radical departure for Eakins, who almost always showed his female models facing away from the viewer. But in this painting and the related studies for it and also for a possible variant, never executed (plates 236, 237), Eakins cast aside any lingering inhibitions. He was, after all, sixty-four years old, gradually growing in national stature, and financially secure. He could afford to paint to suit himself.

In *William Rush and His Model,* the amply proportioned but not particularly attractive female begins to descend from the stand on which she had been posing. The sculptor, mallet in his left hand, graciously extends his right hand to assist her. Although his face is not visible, his body language speaks eloquently of his solicitous attitude toward her. Here Eakins conveys the essence of the relationship of the artist to his model, wisely dispensing with the earlier distracting clutter of Rush's studio to focus only on the pair; the sole evidence of the historical setting is the pair of large carved scrolls that looms up in the foreground.

Eakins tells us, visually, that in painting as he envisions it the model is paramount. Nothing is concealed; no polite idealization detracts from the candid portrayal of what he regarded as nature's greatest creation, the female body. Rush (now looking like Eakins) is presented as a workman and in no way superior to

Above, left
236. *Sketch for "William Rush and His Model,"* c. 1908
Oil on cardboard, 14½ x 10½ in.
Philadelphia Museum of Art;
Given by Mrs. Thomas Eakins and Miss Mary Adeline Williams

Above, right
237. *The Model (Study),* c. 1908
Oil on canvas, 20 x 14 in.
Hirshhorn Museum and Sculpture Garden, Smithsonian Institution, Washington, D.C.

245

her; she receives the greater amount of light and, by virtue of her frontal pose, is identifiable as a specific person. The artist exists to reveal the truth of nature to the viewer, not to intercede and call undue attention to himself. In this painting Eakins summarizes his central belief about art and its making.

A fascinating pair of studies, one in the Philadelphia Museum of Art and the other in the Hirshhorn Museum, reveal Eakins's plans around this time for still another version of the Rush theme. In both works the nude model steps down from the stand, much as in *William Rush and His Model*, but in the Hirshhorn painting (plate 237) a woman standing at the left prepares to offer her a garment. Although the sculptor is absent from this work, he reappears in the Philadelphia sketch (plate 236) and again reaches out to help the model descend. In this study Eakins shows Rush (Eakins) as a younger man and reintroduces the attendant with the robe to the left. Behind and to the right we see two life-size carvings of the nymph, but there is no explanation for why they were duplicated; perhaps Eakins was experimenting with their placement in the painting and was planning to remove one. In any event, this is the most fully developed sketch for a work that was never executed. It and its companion piece testify to Eakins's abiding interest in the Rush subject—the basis for more of his paintings than any other theme.

The Rush pictures were Eakins's last attempts at history painting—or at any other subject besides portraits, and even his portraits became far fewer after 1908. Overall his portraits declined in quality, some of them intensifying the

Below, left
238. *Mrs. Nicholas Douty,* 1910
Oil on canvas, 24 x 18¾ in.
Cummer Gallery of Art,
Jacksonville, Florida

Below, right
239. *Mrs. Gilbert Lafayette Parker,* 1910
Oil on canvas, 24 x 20 in.
Museum of Fine Arts, Boston;
Charles Henry Hayden Fund

worst traits of those painted earlier in his career. In *Mrs. Nicholas Douty* (plate 238), for example, the face is masklike and set in expression—the uninspired result of Eakins's having followed a formula for painting. Even more troubling is *Mrs. Gilbert Lafayette Parker* (plate 239), in which the subject sits bolt upright, her glazed eyes contributing much to her generally bored and vacant facial expression. Eakins seems to have had little empathy with this sitter, and it is clear that he was just going through the motions.

After 1910, the year these two portraits were painted, he produced only two more. One, on which he received help from Susan Eakins, was a second portrait of President Rutherford B. Hayes, from a photograph, commissioned in 1912 or 1913. The other, painted in 1913 or 1914 and probably undertaken on his own initiative, was a full-length portrait of Dr. Edward Anthony Spitzka, a professor of anatomy at Jefferson Medical College, holding a cast of a human brain. With regard to the latter canvas, Mrs. Eakins told Goodrich that Eakins "couldn't get it to go right,"[13] and even with her assistance in painting the brain, the work never reached completion. A dealer cut the painting down to make it more salable, and all that remains is the head and shoulders roughly blocked in (plate 242). This was Eakins's last effort.

Despite having passed his prime as a painter, Eakins continued to exhibit new and older works at the Pennsylvania Academy Annuals and in various other important national shows. Though his reputation was beginning to grow, he still

Above, left
240. *Mrs. Thomas Eakins*, c. 1912
Platinum print, 6⅛ x 4⅜ in.
The Bryn Mawr College Library,
Bryn Mawr, Pennsylvania; The
Adelman Collection

Above, right
241. Susan Macdowell Eakins(?)
Eakins at about Seventy, c. 1914
Photograph
Hirshhorn Museum and Sculpture
Garden, Smithsonian Institution,
Washington, D.C.; Samuel Murray
Archival Collection

occasionally experienced rejections and he did not win any prizes or awards after 1908. He did receive personal tributes when he traveled with Samuel Murray to Lancaster, Pennsylvania, in 1912 to be present at the opening of an exhibition of portraiture that featured *The Agnew Clinic* (plate 224). Although he had been ill, he "had a grand good time."[14] The Agnew painting was given the place of honor because Agnew was from Lancaster County. The elaborate catalog honored this work by reproducing it as the frontispiece and referred to it as "one of his masterpieces and a remarkable example of distinctively American Art."[15] Eakins had fond memories of this event. When Henry McBride, art critic of the *New York Sun*, asked Mrs. Eakins what she thought had been the "most comforting experience" of the artist's career, she said it was the Lancaster reception: "They were very kind to him and he always spoke afterward of the pleasure they had given him."[16] After being neglected most of his life in Philadelphia, Eakins could lay

242. *Dr. Edward Anthony Spitzka,*
 c. 1913
 Oil on canvas, 30⅛ x 25⅛ in.
 Hirshhorn Museum and Sculpture
 Garden, Smithsonian Institution,
 Washington, D.C.; Gift of Joseph
 H. Hirshhorn, 1966

claim to a warm reception only in the provincial city of Lancaster—and not until he was sixty-nine years old.

Two years before his death Eakins finally enjoyed real success in his native city. His large three-quarter-length study of Agnew (plate 222) for *The Agnew Clinic* was shown at the Pennsylvania Academy's Annual of 1914, where it created a sensation. Helen Henderson, art critic of the *Philadelphia Inquirer*, referred to it as "certainly the most important canvas in the exhibition"; writing in the same newspaper two weeks later, she announced: "It will stand always with the great things of the world."[17] Rumors circulated by the newspapers said it was valued at twenty-five-thousand dollars, then fifty thousand. In fact, the price Eakins placed on the painting was four thousand dollars, far less than the rumored figures, but still more than double what he had asked for any other picture. He found a buyer, Dr. Albert C. Barnes, the wealthy developer of the antiseptic Argyrol and a collector of modern European and American art. Barnes tried to make Eakins reduce the price, but the painter held his ground and Barnes paid the full amount. Like Eakins, he was a Philadelphian and a controversial, rough-tongued enemy of convention, so it is fitting that he bought this work by an artist so often snubbed by Philadelphians.

The publicity surrounding Barnes's acquisition brought reporters to interview Eakins in his home. When asked by a reporter from the *Philadelphia Press* about the present and future of American art, Eakins made a plea for national values: "If America is to produce great painters and if young art students wish to assume a place in the history of the art of their country, their first desire should be to remain in America to peer deeper into the heart of American life, rather than spend their time abroad obtaining a superficial view of the art of the Old World." He admitted that when he himself was young, facilities for studying art in America were "meagre," and he was compelled to go abroad. But now the situation was different:

> It would be far better for American art students and painters to study their own country and portray its life and types. To do that they must remain free from any foreign superficialities. Of course, it is well to go abroad to see the works of the old masters, but Americans must branch out into their own fields as they are doing it. They must strike out of themselves and only by doing this will we create a great and distinctly American art.[18]

This statement, much in the spirit of Walt Whitman, is of unusual interest because it is so much like the words of Robert Henri and his circle of urban realists. Eakins had never before expressed himself so forcefully on the promise of American art, and one wonders if he had not caught some of the younger generation's revolutionary spirit.

Eakins came to the attention of the public again in 1916, when, on February 13, the *Philadelphia Press* published an illustrated piece on the aging artist and his friendships with Samuel Murray and with Harry Humphrey Moore—his deaf-mute art-school companion in Philadelphia and Paris, who had spent thirty-five years in the French capital. The reporter had gone to Eakins's

"quiet, dingy, old house" to interview the three men. Enumerating the achievements of each, he portrayed Eakins—seventy-one years old now, and ill—as an artist who had accomplished much; but each year had taken "the toll of life's fire and vigor, until now he is but an old, old man looking out upon a passing world." Most revealing were his remarks on Eakins's appearance and poor health. He was "enfeebled and yellowed by age and illness till his face is like a mask from which two dark eyes burn somberly—till his limbs will hardly bear him longer." Murray, he said, came to visit Eakins "almost daily," to watch "the gentle-faced wife of the ancient invalid tenderly caring for him."[19] The exact cause of Eakins's debilitating illness is not certain, but in all likelihood it had been triggered by formaldehyde poisoning from the huge amounts of milk he drank regularly. That chemical, later outlawed, was then used as a preservative, and Susan Eakins thought that her husband had been heavily affected by it during a 1911 visit to the Cohansey River "fish house" and had never been the same afterward. Eakins's health did deteriorate after that year. His friends reported that he would fall asleep at social gatherings, and his eyesight began to fail (he refused to wear glasses). He spent more and more time with Murray, who had acquired a studio on Lancaster Avenue, in West Philadelphia, where Eakins could spend his days watching him work. When the aging artist's legs had given out and he was confined to his house, Murray would carry him piggyback downstairs and take him to the sofa in the living room after the evening meal. Eakins welcomed his friend's constant companionship, saying, "Murray, come again tomorrow. I'm kinda lonesome."[20] When Eakins was dying in the spring of 1916, Murray stayed with him day and night for two weeks, holding his hand and talking with him until he dropped off to sleep. Eakins did not trust anyone but Murray to feed him, fearing that his wife and Addie Williams might give him patent medicine.

The end came shortly before one o'clock in the afternoon of Sunday, June 25, 1916—the result, it is said, of heart failure. Eakins had requested that there be no funeral or flowers and that his body be cremated. So it was. The ashes were kept in the family house until Susan Eakins's death in 1938, at which time her ashes and his were buried in the family plot at Woodlands Cemetery, just a stone's throw from the Schuylkill. There was no gravestone until recently, when a devotee of Thomas and Susan Eakins anonymously arranged for one to be placed on the site.[21]

Eakins's reputation as an artist grew rapidly just after his death. The most impressive tribute was a memorial show in 1917 at the Metropolitan Museum of Art, organized by the museum's curator of American art, Bryson Burroughs. At first Burroughs proposed just a small exhibition, but after visiting Susan Eakins in Philadelphia and seeing the paintings, he opted for a larger one. Sixty works were ultimately placed on view, accompanied by a fully illustrated catalog with a brief text by Burroughs. He praised Eakins as "the most consistent of American realists" and went on to say:

> His continual search was for character in all things. The purpose of his work seems at times akin to that of a scientist—of a natural historian who

sets down the salient traits of the subject he is studying—but in his case the scientific point of view was directed by a keen appreciation of the pictorial and frequently of the dramatic. The technical side of his painting partook also of the scientific with stress on the studies of anatomy and perspective, which, however, were kept in due subservience by his recognition of the higher elements of art. His pictures manifest always a contained and serious outlook; they are free from all vagueness in thought or form.[22]

Expecting viewers to have difficulty in coping with an art of this kind, Burroughs wrote apologetically: "Much of his work is indeed somewhat stern at first sight and his pictures demand an effort that all are not willing to give. But to those who take the trouble to enter into the artist's ideal, a wealth of rare observation and enthusiastic workmanship will be revealed; the austerities of the painting are seen as fitting to the themes."[23]

A comprehensive and highly complimentary two-part review by Henry McBride certified the importance of the Metropolitan show. He had gone to Philadelphia to interview Susan Eakins and Murray, and as a result his piece not only radiated enthusiastic approval of Eakins's work but also provided an informed biographical context for the artist. While admitting that Eakins's name was "unfamiliar to the present art public" and to prominent collectors, McBride asserted that he was "one of the three or four greatest artists this country has produced." *The Gross Clinic* (plate 65)—subject to so many attacks in earlier years— he lauded as "not only one of the greatest pictures to have been produced in America but one of the greatest pictures of modern times anywhere." Further, he said: "It is great from every point of view, impeccably composed, wonderfully drawn, vividly real and so intensely charged with Eakins's sense of the majesty of modern science as personified by Dr. Gross that the elevation of the artist's spirit is communicated to the beholder, and the ghastly blood stains—for Dr. Gross is shown in the clinic, pausing in the midst of an operation—are forgotten."[24] In view of the importance of works like this, McBride was astonished that Eakins had been neglected by collectors and museums. But, he observed, Eakins had not thrust himself forward like so many other successful artists of his time: "Ninety-nine-one-hundredths of the character of these men is made up of the quality known as 'push.' Thomas Eakins, on the contrary, was ninety-nine-one-hundredths artist, so Fame held aloof from him until after his death."[25]

McBride complained that museums had been shortsighted in failing to buy Eakins's paintings. He thought *William Rush Carving His Allegorical Figure of the Schuylkill River* (plate 84) was the "finest work" in an exhibition held at the Brooklyn Museum the previous year and urged that institution to buy it (they did not).[26] McBride's prime choice among all of Eakins's works for purchase by any museum was *The Thinker* (page 2), "the most restrained, most classic of all the Eakins canvases."[27] In this case a prominent museum—the Metropolitan—took the cue and bought it, along with *The Writing Master* (plate 108), in 1917. A small group of enlightened, open-minded individuals—for the most part critics, artists, and museum curators—finally recognized the real quality of the artist's oeuvre and

251

worked to gain recognition for him. In some cases, these committed advocates supported each other (McBride and Burroughs were friends), and in other instances they promoted Eakins simply out of their own deep belief in his work.

Robert Henri, vigorous champion of progressive causes in American art, was one of Eakins's most vocal spokesmen. Driven by sincere belief in the Philadelphia artist, he had written a tribute as early as 1915 for Horace Traubel's *Conservator,* and at the time of the Metropolitan memorial show Burroughs asked Henri to write to critics and others who might be able to promote the event. (Burroughs worried that the show might not pull in crowds without a publicity effort.) Henri himself wrote an eloquent and impassioned tribute to Eakins in the form of a letter to his pupils at the Art Students League of New York. He urged them to see the memorial show and to learn from it:

> Forget for the moment your school, forget the fashion. Do not look for the expected and the chances are you will find yourself, through the works, in close contact with the man who was a man, strong, profound and honest, and above all one who had attended the reality of beauty in nature as is. Who was in love with the great mysterious nature as manifested in man and things, had no need to falsify to make romantic, or to sentimentalize over to make beautiful.

He told his students to look at *The Gross Clinic* "for the real stupendous romance in real life" and at the "portrait of Miller" (presumably *Professor Leslie W. Miller* [plate 243]), though the catalog of the show does not list it) "for a man's feeling for a man. This is what I call a beautiful portrait. Not a pretty or a swagger portrait, but an honest, respectful, appreciative man to man portrait."[28]

It seems significant that Eakins's first real public recognition came from New York. Philadelphia reluctantly acknowledged his accomplishments by putting on an expanded version of the Metropolitan's show at the Pennsylvania Academy in 1917–18. The introduction to the Philadelphia catalog by Gilbert Sunderland Parker praised Eakins, but it was a belated tribute from the city that had largely ignored the work of one of its greatest artists.

243. *Professor Leslie W. Miller,* 1901
Oil on canvas, 88 x 44 in.
Philadelphia Museum of Art;
Given by Martha P. L. Seeler

253

Notes

Abbreviations for Frequently Cited Names and Sources

TE Thomas Eakins
BE Benjamin Eakins
CE Caroline Cowperthwait Eakins
FE Frances Eakins
SME Susan Macdowell Eakins
LG Lloyd Goodrich
ES Earl Shinn

AAA: Archives of American Art, Smithsonian Institution
DD: Mr. and Mrs. Daniel W. Dietrich II
FHL: Richard Tapper Cadbury Collection, Friends Historical Library, Swarthmore College, Swarthmore, Pennsylvania
HMSG: Charles Bregler Archival Collection, Collection Archive, Hirshhorn Museum and Sculpture Garden, Smithsonian Institution, Washington, D.C.
LG-SME: Lloyd Goodrich copy of original letter (now lost), lent to him by Susan Macdowell Eakins and now in the PMA-LEGA
PAFA: Pennsylvania Academy of the Fine Arts, Philadelphia, Archives
PAFA-CB: Pennsylvania Academy of the Fine Arts, Charles Bregler's Thomas Eakins Collection
PMA-LEGA: The Philadelphia Museum of Art, The Lloyd Goodrich and Edith Havens Goodrich, Whitney Museum of American Art, Record of Works by Thomas Eakins

Goodrich: Lloyd Goodrich, *Thomas Eakins*, 2 vols. (Cambridge, Mass.: Harvard University Press, 1982).
Hendricks: Gordon Hendricks, *The Life and Work of Thomas Eakins* (New York: Grossman, 1974).
McHenry: Margaret McHenry, *Thomas Eakins Who Painted* (Oreland, Pa.: Privately printed for the author, 1946).

Introduction (pages 7–12)

1. Eakins's interest in Rabelais's saying is documented in William Crowell to TE, April 10, 1890, PAFA-CB.

2. TE to an unnamed recipient, [1893]; in Bryson Burroughs, *Loan Exhibition of the Works of Thomas Eakins* (New York: Metropolitan Museum of Art, 1917), p. vii.

1. Beginnings (pages 13–21)

1. McHenry, pp. 51, 29. The main sources for Eakins family history are Susan Macdowell Eakins's undated letter to Lloyd Goodrich from the early 1930s, PMA-LEGA; and a family Bible that was passed down through the descendants of Thomas's sister Frances and brother-in-law William J. Crowell, now in a private collection.

2. TE to ES, January 30, [1875], FHL.

3. Solomon Solis-Cohen, "The Central High School as a Teacher of Science," address given October 29, 1888, at the Semi-Centennial Celebration of Central High School, Philadelphia; in Elizabeth Johns, "I, a Painter: Thomas Eakins at the Academy of Natural Sciences," *Frontiers* (annual of the Academy of Natural Sciences of Philadelphia) 3 (1981–82): 51.

4. Information on Eakins's course of study was secured by Goodrich from John L. Haney, president of Central High School. See Haney to LG, December 18, 1930; in Goodrich, 1:312.

5. Michael Fried, *Realism, Writing, Disfiguration* (Chicago and London: University of Chicago Press, 1987), p. 21. Fried's thesis is explained pp. 22–41 and *passim*.

6. *Philadelphia Inquirer*, July 12, 1861.

7. SME to Peggy Macdowell Walters, n.d.; in David Sellin, "Eakins and the Macdowells and the Academy," in *Thomas Eakins, Susan Macdowell Eakins, Elizabeth Macdowell Kenton* (Roanoke, Va.: North Cross School Living Gallery, 1977), p. 62.

8. Goodrich, 1:10.

9. E. V. Lucas, *Edwin Austin Abbey, Royal Academician*, 2 vols. (London: Methuen, Scribner's, 1921), 1:10–11.

10. Goodrich, 1:5.

11. Shaw, in McHenry, p. 29.

12. Goodrich, 1:7.

13. Max Schmitt to TE, May 1, 1866, HMSG.

14. Weda Cook, quoted by Alfred Frankenstein in a lecture on Eakins at the HMSG, August 8, 1977.

15. "Eakins Chats on Art in America," *Philadelphia Press*, February 22, 1914.

2. Paris and Spain (pages 23–49)

1. "Il tuo secondo viglietto [sic] ed italiano ricevuto ho e con piacere di molta pena miscolato letto; e addiviene il piacer d'un sentimento che m'assicura che andato via non sarò dimenticato e che una cara amica della mia partenza si dorrà. Ma qui nel animo mio surge grande tristizia, tristizia avendo Emilia; e credo che non passerà giammai. Nondimeno dacchè io abbia sovente udito dire un cotal proverbio, maggiore è la ventura stata divisa e diviene per compassione il dolore minore, e conciosiacosa che mi sia gran mestier di consolazione, ti prego, acciochè non m'uccida il mancar di questa, di compiangere del mio dolore. Io mi parto non che da un amico, ma da tutti. Mio buon padre e la dolce mamma mia lascio e vo in una contrada straniere, certo non Inghilterra, ma ancora straniere, assai, non essendovi o parente, o amico, o dei miei amici, amico; e vo solo." TE to Emily Sartain, September 18, 1866, PAFA. Translation from Goodrich, 1:15.

2. TE to CE, October 6, 1866, PAFA-CB.

3. Ibid.

4. TE to Emily Sartain, November 16, 1866, PAFA.

5. SME, interview with LG, n.d., PMA-LEGA.

6. His tale of gaining acceptance to the Ecole is told in his letters to BE, October 13 and 26, 1866, PAFA-CB. TE enclosed with those letters his own copies of letters to and from French officials, also on file, PAFA-CB.

7. Gordon Hendricks has suggested that Eakins, while still in Philadelphia, had

been enchanted by Gérôme's well-known and dramatic renditions of themes from antiquity and his meticulously detailed scenes from recent history. (Hendricks, p. 22.) Only one painting by Gérôme, *Egyptian Recruits Crossing the Desert*, had been on view at the Pennsylvania Academy, but numerous prints of his paintings were available.

8. TE to BE, October 26, 1866, PAFA-CB.

9. TE to BE, October 27, 1866, PAFA-CB.

10. Albert Boime, "The Teaching Reforms of 1863 and the Origins of Modernism in France," *Art Quarterly*, n.s. 1 (1977–78): 13.

11. *Règlements de l'Ecole Impériale et Spéciale des Beaux-Arts* (Paris, 1867), article 10.

12. George de Forest Brush, in "Open Letters," *Century Magazine* 37 (February 1889): 635.

13. Wyatt Eaton, ibid.

14. Will Low, ibid., p. 636.

15. [Earl Shinn], "Art Study . . . II. Gerome," *Nation* 8 (May 6, 1869): 352.

16. TE to BE, November 1, 1866, PAFA-CB.

17. Both quotes, TE to BE, November 11, 1866, LG-SME.

18. TE to BE, December 23, 1866, PAFA-CB.

19. TE to BE, January 16, 1867, PAFA-CB.

20. TE to BE, March 12, 1867, LG-SME.

21. I am grateful to Professor J. Stephens Crawford, University of Delaware, for his identification of the classical subjects of these paintings.

22. TE to BE, November 1, 1866, PAFA-CB.

23. TE to Emily Sartain, October 30, 1866, PAFA. Translated from Italian by Samuel Borton.

24. FE diary, July 10, 1868 (copy by Gordon Hendricks of the original, now lost), Gordon Hendricks research files on American artists, 1950–77, AAA.

25. TE to BE, October 26, 1866, PAFA-CB.

26. TE to CE, February 28, 1867, PAFA-CB.

27. TE to BE, May 21, 1867, LG-SME.

28. TE to BE, n.d. [c. August 15, 1867], PAFA-CB.

29. All quotes in this paragraph are from TE to BE, November 9, 1867, PAFA-CB.

30. TE to BE, November [1867], LG-SME.

31. TE to BE, in TE to CE and Eliza Cowperthwait, November 1867, PAFA-CB.

32. All quotes in this paragraph are from TE to BE, January 17, 1868, LG-SME.

33. All quotes in this paragraph and the next are from TE to BE, March 6, 1868, PAFA-CB.

34. All quotes in this paragraph are from TE to BE, May 9, 1868, DD.

35. Francis Henry Taylor, "Thomas Eakins—Positivist," *Parnassus* 2 (March 1930): 21.

36. These similarities were first noted by Elizabeth Milroy, in "Thomas Eakins' Artistic Training, 1860–1870" (Ph.D. diss., University of Pennsylvania, 1986), pp. 229–32.

37. Herbert Spencer, *Education: Intellectual, Moral, and Physical* (New York, 1860), pp. 39–40.

38. Hippolyte Taine, *Lectures on Art* (New York, 1875), p. 33.

39. Ibid., p. 59.

40. TE to BE, March 6, 1868, PAFA-CB.

41. TE to unknown recipient, April 1868, LG-SME. Unfortunately, none of his student sculptures have survived.

42. TE to unknown recipient, October 15, 1867, LG-SME.

43. TE to BE, October–November 1867, PAFA-CB.

44. FE diary, July 10, 1868.

45. FE diary, August 11, 19, 24, and 28, 1868.

46. TE to BE, September 8 [date probably copied incorrectly], 1868, LG-SME.

47. TE to BE, October 29, 1868, PAFA-CB.

48. TE to FE, October 29, 1868, AAA. Translated from French by Samuel Borton.

49. Emily Sartain to TE, July 8, 1868, PAFA-CB. TE to Emily Sartain, [July 1868], PAFA-CB.

50. TE to BE, October 29, 1868, PAFA-CB.

51. Both quotes, TE to FE, March 11, 1868, private collection.

52. TE to William Crowell, September 21, 1868, private collection.

53. TE to FE, March 26, 1869, AAA.

54. William Sartain, diary (an unpublished autobiography), Philadelphia Museum of Art Archives, n.p.

55. Edwin H. Blashfield, "Leon Bonnat," in *Modern French Masters*, ed. John C. Van Dyke (New York, 1896), p. 49.

56. TE to BE, September 8, 1869, LG-SME.

57. TE to BE, November 5, 1869, PAFA-CB.

58. William Sartain, diary, n.p.

59. All quotes in this paragraph are from TE to BE, December 2, 1869, PAFA-CB.

60. Ibid.

61. TE to unknown recipient, January 16, 1870, LG-SME.

62. TE to BE, January 26, 1870, LG-SME.

63. Both quotes, TE to BE, March 29, 1870, LG-SME.

64. Ibid.

65. William Sartain, diary, n.p.

66. William Sartain, diary, PAFA (a slightly different version from the one in the Philadelphia Museum of Art), p. 35.

67. Hendricks, p. 64.

68. Goodrich 1:59. The Spanish notebook, 1869–70, is in PAFA-CB. All quotes by TE to the end of this chapter are from this source. Translation from French by Samuel Borton.

69. Milroy, "Thomas Eakins," p. 311.

3. Philadelphia (pages 51–83)

1. For Eakins's activities at Fairton and his connection to the Williams family, see

Abigail Williams, "Thomas Eakins, American Artist, and Cumberland County," *Cumberland Patriot* (Spring 1981): 3.

2. TE to Kathrin Crowell, July 22, 1874, PAFA-CB.

3. Sallie Shaw, in McHenry, p. 29.

4. Both quotes, TE to Kathrin Crowell, August 19, 1874, PAFA-CB.

5. TE to Kathrin Crowell, August 22, 1874, PAFA-CB.

6. Shaw, in McHenry, p. 29.

7. TE to ES, April 12, 1874; January 30 [1875]; Good Friday [March 26], 1875; April 13, 1875; and an undated letter [c. 1875] ("The reason my oil picture. . . ."), FHL.

8. Hendricks, p. 71.

9. Elizabeth Johns, *Thomas Eakins: The Heroism of Modern Life* (Princeton, N.J.: Princeton University Press, 1983), p. 38.

10. Ibid., p. 19 n. 2.

11. TE to BE, March 6, 1868, PAFA-CB.

12. This point was made by SME in her unpublished biographical notes on TE, n.d., PAFA-CB.

13. Jean-Léon Gérôme to TE, May 10, 1873, LG-SME.

14. This work was sold at auction by Christie's, New York, May 23, 1990.

15. Gérôme to TE, September 18, 1874, LG-SME.

16. TE to ES, January 30 [1875], FHL.

17. John Wilmerding, *American Light: The Luminist Movement, 1850–1875: Paintings, Drawings, Photographs* (Princeton, N.J.: Princeton University Press; Washington, D.C.: National Gallery of Art, 1980), pp. 148, 150.

18. TE to Gérôme, [1874], PAFA-CB.

19. TE to ES, January 30 [1875], FHL.

20. Ibid. The phrase "Athletic boys, a Philadelphia club," indicates that these were members of the Philadelphia Athletics, a semiprofessional team. The setting is probably the stadium at Twenty-fifth and Jefferson streets (information courtesy of Professor Jerrold Casway).

21. Lloyd Goodrich, *Thomas Eakins: His Life and Work* (New York: Whitney Museum of American Art, 1933), p. 163.

22. Goodrich, unpublished catalog of Eakins's oeuvre, PMA-LEGA.

23. TE to ES, January 30, 1875, FHL.

24. TE to FE, September 24, 1867, PMA-LEGA. Xerox copy of lost original.

25. TE to ES, January 30, 1875, FHL.

26. Whitman, in Mark Van Doren, ed., *Walt Whitman* (New York: Viking, 1945), p. 452.

27. TE to ES, April 13, 1875, FHL.

28. Gross prepared himself for medical training by attending public school, then the Lawrenceville (N.J.) Academy, and eventually Jefferson Medical College, from which he graduated in 1828. He started a private practice in Philadelphia, but patients were so slow in coming that he spent much of his time translating medical treatises from French and German into English.

 Moving back to Easton, Gross developed a successful practice until 1833, when he was appointed to the faculty of the Medical College of Ohio at Cincinnati. He served there until he was called to the Louisville Medical Institute, in 1840. His great opportunity came in 1856 when his alma mater invited him to return and become professor of surgery. Before this appointment, Gross had written two books on anatomy (1830, 1831) plus treatises on intestinal wounds (1843), urology (1851), and foreign bodies in the air passages (1854). In Kentucky he had started to write his monumental *System of Surgery* (1859)—the definitive text on the subject in its time. Widely translated, this volume brought him an international audience of medical men. Several other pioneering works followed, including a *Manual of Military Surgery* (1861).

29. Samuel D. Gross, *A System of Surgery*, 2 vols. (Philadelphia, 1859), 1:488.

30. These are the words of David Wilson Jordan, a student and close friend of Eakins, as recalled by the painter Robert Henri in his diary of January 14, 1927, collection of Janet C. LeClair.

31. *Thoughts of A. Stirling Calder on Art and Life* (New York: Privately printed, 1947), p. 6.

32. The drawing was cited in Charles Bregler to George Barker, June 18, 1939, private collection.

33. John Sartain to Emily Sartain, August 1875 (no day indicated), Historical Society of Pennsylvania, Philadelphia, Sartain Papers.

34. William J. Clark, *Philadelphia Evening Telegraph*, June 16, 1876.

35. Clark, *Philadelphia Evening Telegraph*, April 28, 1876.

36. James D. McCabe, *The Illustrated History of the Centennial Exhibition* (Philadelphia, Chicago, and Saint Louis, 1876), p. 585.

37. David Sellin, *Charles H. Fromuth* (Washington, D.C.: Taggart and Jorgensen Gallery, 1988), n.p.

38. Jordan, as recalled by Henri in his January 14, 1927, diary.

39. Frederick B. Wagner, M.D., Thomas Jefferson University, interview with author, July 6, 1990.

40. William C. Brownell, "The Younger Painters of America," *Scribner's Monthly* 20 (May 1880): 13.

41. *New York Times*, March 8, 1879.

42. Susan N. Carter, "Exhibition of the Society of American Artists," *Art Journal* (American ed.), May 1879, p. 156.

43. *New York Tribune*, March 22, 1879.

44. *New York Times*, March 8, 1879; in Gordon Hendricks, "Thomas Eakins's *Gross Clinic*," *Art Bulletin* 51 (March 1969): 63.

45. *New York Daily Tribune*, March 22, 1879.

46. *New York Herald*, March 8, 1879.

47. Earl Shinn, "Exhibition of the Society of American Artists," *Nation* 28 (March 20, 1879): 207.

48. Brownell, "Younger Painters," pp. 12–13.

49. Ibid., p. 13.

4. In Search of Patrons and Independence (pages 85–127)

1. TE to George D. McCreary, June 13, 1877, PAFA-CB.

2. TE to Charles Henry Hart, September 13, 1912, AAA.

3. William J. Clark, *Philadelphia Telegraph*, December 10, 1877.

4. *Philadelphia Press*, February 7, 1878.

5. *Philadelphia Press*, June 15, 1878, quoting the *Delaware County Republican*.

6. Robert Torchia, "*The Chess Players* by Thomas Eakins," *Winterthur Portfolio*, forthcoming.

7. *New York Times*, March 28, 1878.

8. Washington Irving, *History of the Life and Voyages of Christopher Columbus*, 4 vols. (New York, 1828), 2:321.

9. Ibid.

10. On August 24, 1864, Thomas Eakins paid twenty-five dollars to the Bounty Fund of the Fifteenth Ward (Bounty Fund certificate, PAFA-CB). This fund was designed to free residents of the ward from military draft: a wealthy area could raise funds to pay bonuses to volunteers to enlist in their district, thus freeing eligible residents from the draft. (Information from Professor Raymond Callahan, University of Delaware.)

11. Goodrich, 1:190, based on Francis J. Ziegler, interview with LG, July 16 [no year indicated], PMA-LEGA.

12. John Lamb, Jr., "Eakins and the Arcadian Themes," in *Eakins at Avondale and Thomas Eakins: A Personal Collection*, ed. William Innes Homer (Chadds Ford, Pa.: Brandywine River Museum, 1980), p. 18.

13. Julie Schimmel, "Eakins in Arcadia," paper delivered at the Frick Collection–New York University Symposium on the History of Art, April 22, 1977.

14. On these matters, see TE to ES, Good Friday [March 26], 1875; April 13, 1875; and an undated letter [c. 1875] ("The reason my oil picture. . . ."), FHL.

15. Joseph Pennell, in Gordon Hendricks, "A May Morning in the Park," *Philadelphia Museum of Art Bulletin* 60 (Spring 1965): 59.

16. *Philadelphia Press*, November 25, 1880.

17. TE, journal, January 2, 1883–July 7, 1888, DD.

18. [J.R.?] Wilcraft to TE, March 15, 1895, PAFA-CB.

19. The prices are recorded in TE, "Record of Pictures Sold," PMA-LEGA; transcript by LG of original document lent to him by SME.

20. Walter G. Macdowell, in Susan P. Casteras, *Susan Macdowell Eakins, 1851–1938* (Philadelphia: Pennsylvania Academy of the Fine Arts, 1973), p. 15.

21. SME, interview with LG, in Goodrich, 1:222.

22. Ibid., 1:223.

23. Bregler, in McHenry, p. 59.

24. Goodrich, 1:223.

25. Ellwood C. Parry III, "The Thomas Eakins Portrait of Sue and Harry; or When Did the Artist Change His Mind?" *Arts Magazine* 53 (May 1979): 149.

5. Eakins as Theorist (pages 129–153)

1. Harrison S. Morris, *Confessions in Art* (New York: Sears Publishing Company, 1930), p. 32.

2. Mariana Griswold Van Rensselaer, *Henry Hobson Richardson and His Works* (Boston: Houghton, Mifflin, 1888), p. 22.

3. Davioud, in Sigfried Giedion, *Space, Time, and Architecture* (Cambridge, Mass.: Harvard University Press, 1949), p. 151.

4. TE to Edward R. Coates, February 15, 1886, PAFA-CB.

5. TE to BE, September 8 [date probably copied incorrectly], 1868, LG-SME.

6. TE, Spanish notebook, 1869–70, PAFA-CB.

7. Thomas Eakins, "The Differential Action of Certain Muscles Passing More Than One Joint," *Proceedings of the Academy of Natural Sciences of Philadelphia* 45 (1894): 172–80.

8. Eakins, in William C. Brownell, "The Art Schools of Philadelphia," *Scribner's Monthly* 18 (September 1879): 745.

9. Deaver, in Homer Saint-Gaudens, *The American Artist and His Times* (New York: Dodd, Mead, 1941), p. 179.

10. Charles Bregler, "Thomas Eakins as a Teacher, Second Article," *Arts* 18 (October 1931): 40.

11. TE, in Bregler, "Thomas Eakins as a Teacher," *Arts* 17 (March 1931): 383, 385.

12. In actuality, Leonardo did not follow this drawing in making the final picture, which also is in the Uffizi.

13. Theodor Siegl provided an analysis of the perspective method Eakins applied in this picture in *Philadelphia: Three Centuries of American Art* (Philadelphia: Philadelphia Museum of Art, 1976), pp. 391–92.

14. Ibid.

15. Ibid., p. 393.

16. McHenry, pp. 25–26.

17. Delaroche, in Helmut and Alison Gernsheim, *The History of Photography* (New York, Saint Louis, and San Francisco: McGraw-Hill, 1969), p. 70.

18. SME to Alfred Mitchell, October 1930, San Diego Museum of Art, San Diego, California.

19. *Philadelphia Photographer* 21 (January 1884): 15.

20. Fairman Rogers, "The Zoötrope," *Art Interchange* 3 (July 9, 1879): 2.

21. Eadweard Muybridge to TE, May 7, 1879, LG-SME.

22. Lloyd Goodrich, *Thomas Eakins: His Life and Work* (New York: Whitney Museum of American Art, 1933), p. 67.

23. Francis X. Dercum to George E. Nitzsche, May 10, 1929, University of Pennsylvania Archives, George E. Nitzsche Papers.

24. William Dennis Marks, *Animal Locomotion: The Muybridge Work at the*

University of Pennsylvania (Philadelphia, 1888), pp. 9–15.

25. Goodrich, *Eakins: His Life and Work*, p. 67.

26. McHenry, p. 79.

27. Marks, *Animal Locomotion*, pp. 14–15.

28. Ibid., p. 12.

6. Eakins as Teacher (pages 155–171)

1. TE to ES, April 2, 1874, FHL.

2. Earl Shinn, "A Philadelphia Art School," *Art Amateur* 10 (January 1884): 33.

3. TE to ES, April 13, 1875, FHL.

4. Goodrich, 1:11, indicates that these drawings date to Eakins's student years at the Pennsylvania Academy, but they are far too accomplished to be that early.

5. *Nation* 22 (May 4, 1876): 297.

6. The facilities of the school were described in William C. Brownell, "The Art Schools of Philadelphia," *Scribner's Monthly* 18 (September 1879): 739–40, and Fairman Rogers, "The Schools of the Pennsylvania Academy of the Fine Arts," *Penn Monthly* 12 (June 1881): 458, 462.

7. George Corliss to Christian Schussele, May 15, 1877; in TE to Board of Directors of the PAFA, [c. May 15, 1877], PAFA.

8. "Notes: Art Matters in Philadelphia," *Art Journal* (American ed.), April 1878, p. 127.

9. Susan H. Macdowell to Fairman Rogers, November 2, 1877, PAFA.

10. TE to Macdowell, September 9, 1879, HMSG.

11. Eakins, in Brownell, "Art Schools," p. 742.

12. Brownell, ibid., p. 740.

13. Eakins, ibid., pp. 740–41.

14. Rogers, "Schools," p. 459.

15. Brownell, "Art Schools," p. 747.

16. Eakins, ibid., p. 746.

17. Rogers, "Schools," p. 455.

18. Ibid., p. 453.

19. Ibid., p. 456.

20. Ibid., p. 458.

21. These ideas are recorded in Thomas Eakins, "Object of the School," an undated manuscript [1882], PAFA.

22. Maria Chamberlin-Hellman, "Thomas Eakins as a Teacher" (Ph.D. diss., Columbia University, 1981), p. 320.

23. SME, interview with LG, n.d., PMA-LEGA.

24. TE to J. Laurie Wallace, February 27, 1884, PAFA-CB.

25. Eakins, unpublished theoretical treatises, c. 1882–86, PMA.

26. This method is described in McHenry, pp. 25–26.

27. Homer Saint-Gaudens, *The American Artist and His Times* (New York: Dodd, Mead, 1941), pp. 175–76.

28. Eakins, in Charles Bregler, "Thomas Eakins as a Teacher," *Arts* 17 (March 1931): 383–84.

29. TE to Wallace, February 27, 1884, PAFA-CB.

30. Adam Emory Albright, "Memories of Thomas Eakins," *Harper's Bazaar* 81 (August 1947): 139.

31. Eakins, in Bregler, "Thomas Eakins," p. 384.

32. Albright, "Memories," p. 138.

33. Bregler, "Thomas Eakins as a Teacher, Second Article," *Arts* 18 (October 1931): 33.

34. Both quotes, Albright, "Memories," p. 138.

35. Bregler, "Teacher," p. 381.

36. TE to Amelia Van Buren (draft), July 9, 1887, PAFA-CB.

37. All quotes in this paragraph are from TE to Edward H. Coates, September 11, 1886, PAFA-CB.

38. Ibid.

39. Bregler, "Teacher," p. 380.

40. TE to Coates, September 12, 1886, PAFA-CB.

41. This information is based on TE, notes on drawings of standing nude photographs of himself, Jesse Godley, and J. Laurie Wallace, c. 1883, private collection.

42. Eakins, in Adam Emory Albright, *For Art's Sake* (Warrenville, Ill.: Privately printed, 1953), p. 61.

43. These slides are in the collection of the Franklin Institute, Philadelphia.

44. *Art Interchange* 3 (July 9, 1879): 6.

45. These slides are in the collection of the Franklin Institute.

7. Scandal (pages 173–195)

1. TE to Edward H. Coates, February 9, 1886, PAFA.

2. David Sellin, "Eakins and the Macdowells and the Academy," in *Thomas Eakins, Susan Macdowell Eakins, Elizabeth Macdowell Kenton* (Roanoke, Va.: North Cross School Living Gallery, 1977), pp. 32–41.

3. Thomas Anshutz to J. Laurie Wallace, August 7, 1884 [*sic*, read late spring 1884], Philadelphia Museum of Art; copy of original (now lost) in the possession of George Barker.

4. Ibid.

5. Information on the activities of the Sketch Club from Sidney C. Lomas, "History of the Philadelphia Sketch Club," vol. 1 (1860–1900), unpublished manuscript on file at the Philadelphia Sketch Club.

6. James P. Kelly et al. to the Board of Directors of the Pennsylvania Academy of the Fine Arts, March 12, 1886, PAFA.

7. TE to Coates, [early March 1886], PAFA-CB; William and Frances Crowell, affidavit addressed to John V. Sears (Chairman of the Philadelphia Sketch Club), June 5, 1886, PAFA-CB.

8. TE to Emily Sartain, March 25, 1886, PAFA.

9. These matters were alluded to in TE to Coates, February 15, 1886, PAFA-CB.

10. Ibid.

11. TE to Coates, [early March 1886], PAFA-CB.

12. Thomas P. Anshutz, G. F. [Frank] Stephens, and Charles H. Stephens to the president and members of the Philadelphia Sketch Club, March 6, 1886, Philadelphia Sketch Club.

13. TE to John V. Sears, March 13, 1886; March 26, 1886; April 17, 1886, Philadelphia Sketch Club.

14. TE to secretary of the Academy Art Club, [late March 1886], PAFA-CB.

15. TE to Coates, February 15, 1886, PAFA-CB.

16. TE to Coates, September 12, 1886, PAFA-CB.

17. William Crowell to TE, April 26, 1886, PAFA-CB.

18. Crowell, affidavit, June 5, 1886.

19. Frances Crowell to TE, April 4, 1890; William Crowell to TE, April 10, 1890, PAFA-CB.

20. TE to Frances Crowell, [April 1890], PAFA-CB.

21. Weda Cook (Addicks), interview with LG, May 30, 1931, PMA-LEGA.

22. Ibid. Maud Cook was Weda's sister.

23. Talcott Williams, Gentleman of the Fourth Estate (Brooklyn: R. E. Simpson and Son, 1936), pp. 215–16.

24. Mrs. James Mapes Dodge, interview with LG, May 20 [no year indicated], PMA-LEGA.

25. TE, quoted by James L. Wood, interview by LG, n.d., PMA-LEGA.

26. SME, notes on "Interview between Thomas Eakins, Charley Stephens, and Charley's father," May 9, 1887, PAFA-CB.

27. Crowell, affidavit, June 5, 1886.

28. Ibid.

29. TE to Coates, September 11, 1886, PAFA-CB.

30. Mrs. Harmstad [first name unknown], interview with LG, June 13 [no year indicated], PMA-LEGA.

31. Weda Cook, interview with LG, May 20, 1931, PMA-LEGA. Frank B. A. Linton, interview with LG, May 9 [no year indicated], PMA-LEGA.

32. Adolphe Borie, interview with LG, May 9 [no year indicated], PMA-LEGA. Francis Petrus Paulus to Bryson Burroughs, October 25, 1929, PMA-LEGA.

33. Catherine A. Janvier to SME, August 13, 1916, PMA-LEGA. Typed transcript by LG.

34. James L. Wood, interview with LG, n.d., PMA-LEGA.

35. Mrs. Nicholas Douty, interview with LG, June 10 [no year indicated], PMA-LEGA.

36. Wood, interview with LG, n.d., PMA-LEGA.

37. Weda Cook, interview with LG, May 21, 1931, PMA-LEGA.

38. Weda Cook, interview with LG, May 20, 1931, PMA-LEGA.

39. Lucy Langdon W. Wilson, interview with LG, n.d., PMA-LEGA.

40. Cook, interview with LG, May 20, 1931, PMA-LEGA.

41. TE to the Board of Directors of the Pennsylvania Academy of the Fine Arts, April 8, 1885, PAFA.

42. Murray, in McHenry, p. 124.

43. Ibid.

44. Ibid., p. 131.

45. Minutes, Committee on Instruction, Pennsylvania Academy of the Fine Arts, February 24, 1886, PAFA.

46. Robert Henri, The Art Spirit (Philadelphia: J. B. Lippincott, 1923), p. 87.

47. Helen W. Henderson, in One Hundred and Fiftieth Anniversary Exhibition (Philadelphia: Pennsylvania Academy of the Fine Arts, 1955), p. 106.

48. Robert Henri to George B. Zug, August 14, 1919, Yale Collection of American Art and Literature, Beinecke Rare Book and Manuscript Library, Yale University, New Haven, Connecticut.

49. Anshutz, in Robert Henri, diary, December 11, 1886, collection of Janet C. LeClair.

50. Ibid., February 3, 1887.

51. Henri, ibid., January 8, 1887.

52. Hovenden, ibid., April 9, 1887.

53. "Forming a Students' League," Philadelphia Press, February 19, 1886.

54. The constitution and records of the Art Students' League of Philadelphia are preserved in a private collection.

55. "An Object Lesson in Artistic Anatomy," Art Amateur 14 (January 1886): 33.

56. This list is from Goodrich, 1:303.

57. New York Sun, March 18, 1895.

58. Eakins, in Riter Fitzgerald, Philadelphia Item, March [n.d.] 1895.

59. Fitzgerald, in Evan H. Turner, "Thomas Eakins: The Earles' Galleries Exhibition of 1896," Arts Magazine 53 (May 1979): 105.

60. Ibid.

61. Ibid., p. 106.

62. Sadakichi Hartmann, A History of American Art, 2 vols. (Boston: L. C. Page, 1905), 1:36.

63. Samuel Isham, The History of American Painting (New York: Macmillan, 1905), pp. 525–26.

64. Harrison S. Morris, Confessions in Art (New York: Sears Publishing Co., 1930), p. 31.

8. The Cowboys and the Poet
(pages 197–221)

1. George Bacon Wood and Helen Foos Wood, "The Horatio C Wood Clan and Some of its Antics," unpublished manuscript; in Cheryl Leibold, "Thomas Eakins in the Badlands," Archives of American Art Journal 28 (1988): 3.

2. TE to SME, September 7, 1887, PAFA-CB.

3. TE to SME, September 30, 1887, PAFA-CB.

4. TE to SME, September 26 [1887], PAFA-CB.

5. James W. Crowell, "Recollections of Life on the Crowell Farm," in *Eakins at Avondale and Thomas Eakins: A Personal Collection,* ed. William Innes Homer (Chadds Ford, Pa.: Brandywine River Museum, 1980), p. 15.

6. McHenry, p. 91.

7. William J. Crowell, Jr., in McHenry, p. 92.

8. Mrs. Robert Trostle, interview with author, August 22, 1979; Eugene Crowell, interview with author, March 25, 1979.

9. LG, interview with Frances Crowell, early 1930s; in Lloyd Goodrich, *Thomas Eakins: His Life and Work* (New York: Whitney Museum of American Art, 1933), p. 108.

10. There can be little doubt that Eakins and his circle, including students and members of his family, were concerned with the issue of photography as an art. A loan exhibition from private collections at the Camera Club of New York, a stronghold of art photography under Alfred Stieglitz's influence, held between December 20, 1899, and January 5, 1900, featured works by this circle, including Eakins. (See *Camera Notes* 3 [April 1900]: 214–15.) Other Philadelphia participants were Susan Macdowell Eakins, Elizabeth Macdowell Kenton, Miss Crowell (probably Maggie), and Eakins's former students Eva L. Watson (later Watson-Schütze), Amelia C. Van Buren, Ellen Ahrens, and Samuel Murray.

11. Goodrich, 2:136.

12. Eugene Crowell, interview with author, March 25, 1979.

13. Frances Crowell, interview with Daniel W. Dietrich II, 1971.

14. Margaret Crowell, in SME to Frances Eakins Crowell, November 1, 1896, PAFA-CB.

15. Hendricks, p. 236.

16. Horace Traubel, *With Walt Whitman in Camden,* vol. 1 (Boston, 1906); vol. 2 (New York, 1908); vol. 3 (New York, 1914); vol. 4 (Philadelphia, 1953); vol. 5 (Carbondale, Ill., 1964); vol. 6 (Carbondale and Edwardsville, Ill., 1982). The unpublished diaries are at the Library of Congress, Washington, D.C.; they cover the period from July 6, 1890, to March 27, 1892.

17. Traubel, *Whitman,* 4:155.

18. See, for example, ibid., 1:153–54; 2:290, 295; 3:526–27; 4:155; 6:416.

19. Whitman, ibid., 2:290.

20. Ibid., 1:39.

21. Ibid., 1:284.

22. Traubel, unpublished diary, February 1, 1891.

23. Ibid., February 25, 1891.

24. Ibid., May 14, 1891.

25. Ibid., May 25, 1891.

26. Weda Cook (Addicks), interview with LG, n.d., PMA-LEGA.

27. Traubel, unpublished diary, May 1, 1891.

28. Ibid.

29. *Philadelphia Press,* May 2, 1891.

30. Traubel, unpublished diary, May 13, 1891.

31. Ibid., May 19, 1891.

32. William Innes Homer, "Attributing and Reattributing Thomas Eakins' Photography," paper, College Art Association of America, Philadelphia, February 13, 1983; and Homer, "Who Took Eakins' Photographs?" *Artnews* 82 (May 1983): 112–19.

33. Traubel, unpublished diary, May 14, 1891.

34. Ibid.

35. Traubel, unpublished diary, May 30, 1891.

36. Horace L. Traubel, "Walt Whitman's Birthday, May 31st," *Conservator* 3 (July 1892): 35.

37. Traubel, unpublished diary, March 27, 1892.

38. Whitman, in Mark Van Doren, ed., *Walt Whitman* (New York: Viking, 1945), pp. 619–20.

39. Morris, *Confessions,* p. 31.

40. The reader may have noticed several par-allels between Quakerism and Whitman's thinking; Whitman had, in fact, grown up under the influence of Quaker ideas. His mother was educated by Quakers, and his grandfather Whitman had been a friend of the fiery Quaker preacher Elias Hicks. As a youth Walt had thought of becoming a Quaker, possibly because he had been moved by a speech by Hicks that he and his parents had heard. Throughout his life he revered Hicks, founder of the more democratic and mystical branch of the sect, and thought that he was greater than the esteemed British author and social critic Thomas Carlyle. Shortly before his death, Whitman described himself as "perceptibly Quaker" (Whitman, in Henry Seidel Canby, *Walt Whitman* [Boston: Houghton, Mifflin, 1943], pp. 356–57 n. 5), and several literary critics have pointed to strong Quaker influences in *Leaves of Grass.*

9. Late Work and Belated Honors (pages 223–253)

1. Elizabeth Johns, *Thomas Eakins: The Heroism of Modern Life* (Princeton, N.J.: Princeton University Press, 1983).

2. Hugh J. Harley, "True Romance Revealed in Unique Bonds of Three Gifted Artists," *Philadelphia Press Magazine,* February 13, 1916, p. 14; SME to Clarence Cranmer, July 4, 1929, AAA.

3. David Wilson Jordan, interview with LG, May 2, 1930, PMA-LEGA.

4. TE to Jacob Mendez da Costa, January 9, 1893, LG-SME.

5. McHenry, p. 144.

6. Clymer, in Diana E. Long, "The Medical World of *The Agnew Clinic:* A World We Have Lost," *Prospects* 11 (1987): 194.

7. D. Hayes Agnew, autobiographical remarks included in letter to W. G. Whitely, n.d., in William D. Lewis Collection called *Delaware University Archives,* University Archives, University of Delaware, item 1834-6.

8. Margaret Supplee Smith, "*The Agnew Clinic:* 'Not Cheerful for Ladies to Look At,'" *Prospects* 11 (1987): 169.

9. Agnew, in John Deaver and Joseph McFarland, *The Breast: Its Anomalies, Its Diseases and Their Treatment* (Philadelphia:

Blakiston, 1917), p. 572.

10. Patricia Hills, "Thomas Eakins's *Agnew Clinic* and John S. Sargent's *Four Doctors: Sublimity, Decorum, and Professionalism*," *Prospects* 11 (1987): 217–18.

11. Ibid., p. 219.

12. Cranmer, interview with LG; in Goodrich, 2:144.

13. SME, interview with LG; in Goodrich, 2:262.

14. Eakins, in McHenry, p. 148.

15. *Loan Exhibition of Historical and Contemporary Portraits* (Lancaster, Pa.: Iris Club and the Lancaster Historical Society, 1912), p. 119.

16. SME, *New York Sun*, November 4, 1917; in *The Flow of Art: Essays and Criticisms of Henry McBride*, ed. Daniel Catton Rich (New York: Atheneum, 1975), p. 133.

17. Helen Henderson, *Philadelphia Inquirer*, February 8, 1914. Henderson, *Philadelphia Inquirer*, February 22, 1914.

18. "Eakins Chats on Art of America," *Philadelphia Press*, February 22, 1914.

19. Harley, "True Romance Revealed."

20. McHenry, p. 135.

21. Information from Frederick B. Wagner, Jr., M.D., Thomas Jefferson University. The anonymous donor of the gravestone was, in my view, the late Seymour Adelman, a longtime admirer of Thomas

Eakins and friend of Mrs. Eakins.

22. Bryson Burroughs, *Loan Exhibition of the Works of Thomas Eakins* (New York: Metropolitan Museum of Art, 1917), p. vi.

23. Ibid., p. vii.

24. McBride, *Flow of Art*, pp. 130–31.

25. Ibid., p. 132.

26. Ibid., p. 135.

27. Ibid., p. 137.

28. Robert Henri, "To the Students of the Art League," October 29, 1917, Yale Collection of American Literature, Beinecke Rare Book and Manuscript Library, Yale University, New Haven, Connecticut.

244. Photographer unknown
Thomas Eakins at Fifty to Fifty-five,
1894–99
Mr. and Mrs. Daniel W. Dietrich II

Chronology

1844
July 25—Thomas Cowperthwait Eakins is born at 4 Carrollton Square, Philadelphia. His father (born 1818) is Benjamin Eakins (originally spelled Akins); his mother is Caroline Cowperthwait Eakins (born 1820).

1848
Frances Eakins (sister) is born.

1853
After beginning his studies at home, Thomas enters Zane Street Grammar School. Margaret Eakins (sister) is born.

1857
The family moves to 1725 Washington Street (later 1729 Mount Vernon Street). Thomas graduates with high marks from Zane Street Grammar School. Accepted into Central High School, which is acclaimed for its high academic standards and emphasis on science. Excels in drawing courses and remains in the upper level of his class throughout four years of study.

1861
July 11—receives Bachelor of Arts degree from Central High School, graduating fifth out of fourteen in his class. Teaches penmanship with his father for several years.

1862
September—is denied position as professor of drawing, writing, and bookkeeping at Central High School. October—enrolls in antique classes and attends anatomy lectures at the Pennsylvania Academy of the Fine Arts.

1863
February—enrolls in life-drawing class and attends anatomy lectures at the Academy.

1864
Observes anatomy demonstrations by Dr. Joseph Pancoast at Jefferson Medical College.

1865
Caroline Eakins (sister) is born.

1866
September 22—sails from New York to Paris on the *Pereire*. October 1—docks at Le Havre, France. October 2—arrives in Paris. Takes a room in a hotel near the Louvre, then moves to 46, rue de Vaugirard. October 29—enters Jean-Léon Gérôme's atelier.

1867
March—begins painting at the Ecole des Beaux-Arts. July–August—travels in Switzerland with his high-school classmates William Sartain and William J. Crowell. They visit Christian Schussele in Strasbourg, France.

September—moves to a new studio, at 62–64, rue de l'Ouest, where he starts to paint independently.

1868
March—begins to study sculpture under Augustin-Alexandre Dumont at the Ecole. July—moves to 116, rue d'Assas. July–August—travels with his father and sister Frances in Italy, Germany, and Belgium. December—visits his family in Philadelphia.

1869
March—returns to Paris. August–September—studies painting under Léon Bonnat. December 1—arrives in Madrid. December 3—goes to the Fonda de Paris, a hotel in Seville. December 11—moves to a pension in Seville (until June 1870).

1870
January—Harry Humphrey Moore and William Sartain join Eakins in Seville. Eakins paints his first independent composition, *A Street Scene in Seville* (plate 42). Late May—visits Ronda, Spain. June—leaves Seville for a brief stay in Madrid. Goes to Paris before sailing for Philadelphia in mid-June. In Philadelphia, occupies a top-floor studio at 1729 Mount Vernon Street and begins painting contemporary scenes featuring his family and friends.

1871
April—displays *Max Schmitt in a Single Scull* (*The Champion Single Sculls*) (plate 48) and a portrait of M. H. Messchert, now lost, at the Union League of Philadelphia—the first recorded exhibition of his work.

1872
Caroline Cowperthwait Eakins (mother) dies.

1873
Takes anatomy courses from Dr. Joseph Pancoast and his son Dr. William Pancoast at Jefferson Medical College (until 1874).

1874
Exhibits *John Biglin, or The Sculler* (present location unknown), in the seventh annual exhibition of American Society of Painters in Water Colors and sells the painting (his first sale) for eighty dollars. April—teaches evening drawing classes at the Philadelphia Sketch Club. Becomes engaged to Kathrin Crowell. Paints first formal portrait, *Professor Benjamin Howard Rand* (plate 47).

1875
April—begins painting *The Gross Clinic* (plate 65) and continues working on it for the next six months. Exhibits two paintings at the Paris Salon and four at Goupil's in London. Sells

Whistling [for] Plover (plate 58) through Goupil's for sixty dollars.

1876
May—submits six works to the Centennial Exhibition, Philadelphia; all are accepted but *The Gross Clinic*, which ultimately is displayed at the United States Army Post Hospital at the Exhibition. Begins *William Rush Carving His Allegorical Figure of the Schuylkill River* (plate 84). Volunteers to assist Christian Schussele in teaching and to help Dr. William W. Keen as demonstrator of anatomy at the Pennsylvania Academy, all without pay.

1877
March—begins teaching, without pay, at the Art Students' Union, Philadelphia. May—stops assisting Schussele when the Academy tells Schussele not to delegate teaching responsibilities. Exhibits for the first time at the National Academy of Design. Executes his first portrait commission, a portrait of President Rutherford B. Hayes.

1878
March—exhibits at the first exhibition of the Society of American Artists. Returns to the Academy to assist Schussele. Fall—the Academy hires him as assistant professor of painting and chief demonstrator of anatomy. Receives his first award, a silver medal from the Massachusetts Charitable Mechanics Association, Boston, for two watercolors. Illustrates the first of several articles for *Scribner's Monthly*. *The Gross Clinic* is purchased by Jefferson Medical College for two hundred dollars. Becomes interested in Eadweard Muybridge's experiments in motion photography carried out at Palo Alto, California.

1879
August—Schussele dies. Shortly thereafter, Eakins is appointed professor of drawing and painting at the Academy. Begins to correspond with Muybridge. Kathrin Crowell dies.

1880
March—presents first lectures on perspective at the Academy. Elected to the Society of American Artists. Probably purchases first camera.

1881
Gives *The Chess Players* (plate 76) to the Metropolitan Museum of Art. Begins teaching anatomy at the Art Students' Guild, Brooklyn Art Association.

1882
Becomes director of the Pennsylvania Academy schools. Thomas Anshutz is named assistant professor of painting and drawing. Margaret Eakins dies.

1883

November—Fairman Rogers, his enthusiastic backer at the Academy, resigns as chairman of the Committee on Instruction. December—at Photographic Society of Philadelphia, Eakins demonstrates a camera with a shutter of his own design.

1884

January 19—marries Susan Hannah Macdowell, and they set up housekeeping in his studio at 1330 Chestnut Street. Appointed to Muybridge commission at the University of Pennsylvania and begins to experiment with motion photography.

1885

Devotes much time to motion photography. Begins teaching at the Art Students League, New York. His sister Caroline marries his student Frank Stephens. *The Swimming Hole* (plate 102) is rejected by Edward H. Coates, chairman of the Academy's Committee on Instruction, who had commissioned the work.

1886

February—at the recommendation of the Pennsylvania Academy board, resigns as director of the school. In protest, a group of students from the Academy form the Art Students' League of Philadelphia. With his wife moves back to 1729 Mount Vernon Street.

1887

July–October—visits the B-T Ranch in the Dakota Territory (North Dakota). First calls on Walt Whitman; continues to visit him intermittently until the poet's death in 1892.

1888

Begins lectures on anatomy at the National Academy of Design, New York. *Animal Locomotion: The Muybridge Work at the University of Pennsylvania*, which includes an account of Eakins's photographic studies, is published.

1889

Medical students at the University of Pennsylvania commission a portrait of Dr. D. Hayes Agnew; *The Agnew Clinic* (plate 224) is completed in three months. Caroline Eakins Stephens (sister) dies.

1891

Begins teaching at the Women's Art School of the Cooper Union, New York. Exhibits at the Pennsylvania Academy for the first time since 1885; one of his entries, *The Agnew Clinic*, is rejected on a technicality. (Does not submit work in 1892 or 1893.) Through William O'Donovan receives commission to sculpt horses for the Soldiers' and Sailors' Memorial Arch in Brooklyn.

1892

May—resigns from Society of American Artists after his works are rejected from the annual exhibition three years in a row. Receives commission to model two historical reliefs for the Trenton Battle Monument, Trenton, New Jersey. His pupil Samuel Murray begins to share his 1330 Chestnut Street studio.

1893

Exhibits eleven paintings at the World's Columbian Exposition in Chicago; receives a bronze medal.

1894

May—presents paper "The Differential Action of Certain Muscles Passing More Than One Joint" at the Academy of Natural Sciences, Philadelphia. Begins to send work again to Pennsylvania Academy Annuals and continues to do so throughout his life.

1895

February—lectures on anatomy at Drexel Institute, Philadelphia. March—is dismissed from Drexel for using a completely nude male model in a lecture to a mixed audience.

1896

His first and only one-man exhibition is held at Earles' Galleries, Philadelphia.

1897

February—Pennsylvania Academy purchases *The Cello Player* (plate 181). July—forbidden to visit the Crowell family at their farm in Avondale, Pennsylvania, as a result of the circumstances surrounding the suicide of his niece Ella.

1898

Returns to sporting subjects, primarily wrestling and boxing. Conclusion of his lectures at Cooper Union brings his teaching career to an end.

1899

Begins five years as a juror for the Carnegie Institute International Exhibition. His father and aunt Eliza Cowperthwait die.

1900

Mary Adeline (Addie) Williams, a family friend, comes to live at 1729 Mount Vernon Street with Eakins and his wife. October—vacates studio at 1330 Chestnut Street and occupies studio on top floor of 1729 Mount Vernon Street. Receives honorable mention at the Exposition Universelle, Paris.

1901

January—serves on jury for the Pennsylvania Academy Annual for first time since 1879. Receives gold medal at the Pan-American Exposition in Buffalo, New York.

1902

March—elected Associate of the National Academy of Design. May—elected Academician.

1904

Archbishop William Henry Elder (plate 216) is awarded Temple Gold Medal at the Academy. Exhibits seven paintings at the Saint Louis world's fair; *The Gross Clinic* is awarded gold medal.

1905

Awarded Thomas R. Proctor Prize at the National Academy of Design.

1906

Assists Samuel Murray with a statue of Commodore John Barry for Independence Square, Philadelphia.

1907

Awarded second-class medal at the Carnegie annual exhibition.

1908

Returns to the theme of William Rush and his model.

1909

Production decreases.

1910

In poor health and with eyesight failing, paints his last significant portraits.

1912

Receives ovation at the opening of a Lancaster County portraiture exhibition, Lancaster, Pennsylvania.

1914

Portrait of Dr. Agnew (plate 222) is shown at the Pennsylvania Academy Annual and is purchased for four thousand dollars by the collector Dr. Albert C. Barnes. Publicity about Eakins and his works increases.

1915

Exhibits six works at the Panama-Pacific International Exposition in San Francisco.

1916

Elected honorary member of Art Club of Philadelphia. Metropolitan Museum of Art purchases *Pushing for Rail* (plate 60) for $800. June 25—Thomas Eakins dies; he is cremated, and his ashes are buried, with his wife's, in 1939, in Woodlands Cemetery, Philadelphia.

1917

November—comprehensive memorial exhibition of Eakins's work opens at the Metropolitan Museum. December—the Pennsylvania Academy, succumbing to local pressure, also holds a memorial exhibition.

Selected Bibliography

BOOKS AND CATALOGS

Adelman, Seymour. "Thomas Eakins: Mount Vernon Street Memories." In *The Moving Pageant: A Selection of Essays.* Lititz, Pa.: Sutter House, 1977.

Buki, Zoltan, and Suzanne Corlette, eds. *The Trenton Battle Monument: Eakins Bronzes.* Trenton: New Jersey State Museum, 1973.

Burt, Nathaniel. *The Perennial Philadelphians.* Boston: Little, Brown, 1963.

Casteras, Susan P. *Susan Macdowell Eakins, 1851–1938.* Philadelphia: Pennsylvania Academy of the Fine Arts, 1973.

Cortissoz, Royal. "Thomas Eakins." In *American Artists.* New York: C. Scribner's Sons, 1923.

Craven, Wayne. "Images of a Nation in Wood, Marble and Bronze" and "Thomas Eakins." In *200 Years of American Sculpture.* New York: Whitney Museum of American Art, 1976.

Davis, Ann. "Seekers after Reality: Thomas Eakins and George Reid." In *A Distant Harmony.* Winnipeg, Canada: Winnipeg Art Gallery, 1982.

Eakins in Perspective: Works by Eakins and His Contemporaries, in Addition to Memorabilia. Philadelphia: Philadelphia Museum of Art, 1962.

Fink, Lois Marie. *American Art at the Nineteenth-Century Paris Salons.* Washington, D.C.: National Museum of American Art, Smithsonian Institution; Cambridge: Cambridge University Press, 1990.

Foster, Kathleen A. "Realism or Impressionism? The Landscapes of Thomas Eakins." In *American Art around 1900,* edited by Doreen Bolger and Nicolai Cikovsky, Jr. Washington, D.C.: National Gallery of Art; distributed by the University Press of New England, Hanover and London, 1990.

——— and Cheryl Leibold. *Writing about Eakins.* Philadelphia: University of Pennsylvania Press, 1989.

Fried, Michael. *Realism, Writing, Disfiguration.* Chicago and London: University of Chicago Press, 1987.

Gerdts, William H. *The Art of Healing: Medicine and Science in American Art.* Birmingham, Ala.: Birmingham Museum of Art, 1981.

Goodrich, Lloyd. "Thomas Eakins." In *Sixth Loan Exhibition: Winslow Homer, Albert P. Ryder, Thomas Eakins.* New York: Museum of Modern Art, 1930.

———. *Thomas Eakins: His Life and Work.* New York: Whitney Museum of American Art, 1933.

———. "Thomas Cowperthwait Eakins." In *The One Hundred and Fiftieth Anniversary Exhibition.* Foreword by Joseph T. Fraser, Jr. Philadelphia: Pennsylvania Academy of the Fine Arts, 1955.

———. *Thomas Eakins.* New York: Praeger, 1970. Hardcover edition of *Thomas Eakins Retrospective Exhibition.* New York: The Whitney Museum of American Art, 1970.

———. *Thomas Eakins.* 2 vols. Cambridge, Mass.: Harvard University Press, 1982.

Hendricks, Gordon. *Thomas Eakins: His Photographic Works.* Foreword by William B. Stevens, Jr. Philadelphia: Pennsylvania Academy of the Fine Arts, 1969.

———. *The Photographs of Thomas Eakins.* New York: Grossman, 1972.

———. *The Life and Work of Thomas Eakins.* New York: Grossman, 1974.

———. *A Family Album: Photographs by Thomas Eakins, 1880–1890.* New York: Coe Kerr Gallery, 1976.

Homer, William Innes, ed. *Eakins at Avondale and Thomas Eakins: A Personal Collection.* Foreword by James H. Duff. Chadds Ford, Pa.: Brandywine River Museum, 1980.

———. "New Light on Thomas Eakins and Walt Whitman in Camden." In *Walt Whitman and the Visual Arts,* edited by Geoffrey M. Sill and Roberta K. Tarbell. New Brunswick, N.J.: Rutgers University Press, 1992.

Hoopes, Donelson F. *Eakins Watercolors.* Foreword by Lloyd Goodrich. New York: Watson-Guptill, 1971.

Huber, Christine Jones. *The Pennsylvania Academy and Its Women, 1850–1920.* Philadelphia: Pennsylvania Academy of the Fine Arts, 1973.

In This Academy. Philadelphia: Pennsylvania Academy of the Fine Arts, 1976.

Johns, Elizabeth. *Thomas Eakins: The Heroism of Modern Life.* Princeton, N.J.: Princeton University Press, 1983.

Lifton, Norma. "Thomas Eakins and S. Weir Mitchell: Images and Cures in the Late Nineteenth Century." In *Psychoanalytic Perspectives in Art,* edited by Mary Mathews Gedo. Hillsdale, N.J.: Analytic Press, 1989, vol. 2, pp. 247ff.

Loan Exhibition of the Works of Thomas Eakins. Introduction by Bryson Burroughs. New York: Metropolitan Museum of Art, 1917.

Loan Exhibition of the Works of Thomas Eakins, Commemorating the Centennial of His Birth. Introduction by W. F. Davidson. New York: M. Knoedler, 1944.

McBride, Henry. *The Flow of Art: Essays and Criticisms of Henry McBride.* Edited by Daniel Catton Rich. New York: Athenaeum, 1975. Includes reprint of articles on Eakins.

McHenry, Margaret. *Thomas Eakins Who Painted.* Oreland, Pa.: Privately printed for the author, 1946.

McKinney, Roland. *Thomas Eakins.* New York: Crown, 1942.

Memorial Exhibition of the Works of the Late Thomas Eakins. Introduction by Gilbert Sunderland Parker. Philadelphia: Pennsylvania Academy of the Fine Arts, 1917–18.

Mumford, Lewis. *The Brown Decades: A Study of the Arts in America, 1865–1895.* New York: Harcourt, Brace, 1931.

———. "Eakins: Painter and Moralist." In *Interpretations and Forecasts, 1922–1972.* New York: Harcourt Brace Jovanovich, 1972.

Novak, Barbara. *American Painting of the Nineteenth Century: Realism, Idealism, and the American Experience.* New York: Harper and Row, 1979.

The Olympia Galleries Collection of Thomas Eakins Photographs. New York: Sotheby

Parke Bernet, 1977.

Onorato, Ronald J. *The Olympia Galleries Collection of Thomas Eakins Photographs*. Philadelphia: Olympia Galleries, 1976.

Panhorst, Michael. *Samuel Murray*. Washington, D.C.: Smithsonian Institution Press, 1982.

Photographer Thomas Eakins. Philadelphia: Olympia Galleries, 1981.

Porter, Fairfield. *Thomas Eakins*. New York: George Braziller, 1959.

Prown, Jules David. "Thomas Eakins' *Baby at Play*." In *Studies in the History of Art*. Washington, D.C.: National Gallery of Art, 1985, vol. 18, pp. 121–27.

Rosenzweig, Phyllis D. *The Thomas Eakins Collection of the Hirshhorn Museum and Sculpture Garden*. Washington, D.C.: Hirshhorn Museum and Sculpture Garden, Smithsonian Institution, 1977.

Sartain, John. *The Reminiscences of a Very Old Man, 1808–1897*. New York: D. Appleton, 1899.

Schendler, Sylvan. *Eakins*. Boston: Little, Brown, 1967.

The Sculpture of Thomas Eakins. Introduction by Moussa M. Domit. Washington, D.C.: Corcoran Gallery of Art, 1969.

Sellin, David. *The First Pose: 1876: Turning Point in American Art: Howard Roberts, Thomas Eakins, and a Century of Philadelphia Nudes*. New York: W. W. Norton, 1976.

———. "Eakins and the Macdowells and the Academy." In *Thomas Eakins, Susan Macdowell Eakins, Elizabeth Macdowell Kenton*. Introduction by Betty Tisinger. Roanoke, Va.: North Cross School Living Gallery, 1977.

Sewell, Darrel, et al. *Thomas Eakins: Artist of Philadelphia*. Philadelphia: Philadelphia Museum of Art, 1982.

Siegl, Theodor. *The Thomas Eakins Collection*. Introduction by Evan H. Turner. Philadelphia: Philadelphia Museum of Art, 1978.

Thomas Eakins: A Retrospective Exhibition. Washington, D.C.: National Gallery of Art, 1961.

Thomas Eakins: A Retrospective Exhibition of His Paintings. Preface by Clarence W.

Cranmer and foreword by R. J. McKinney. Baltimore: Baltimore Museum of Art, 1936.

Thomas Eakins: Image of the Surgeon. Texts by Elizabeth Johns, Jerome J. Bylebyl, and Gert H. Brieger. Baltimore: Walters Art Gallery, 1989.

Thomas Eakins Centennial Exhibition. Introduction by Lloyd Goodrich. Pittsburgh: Carnegie Institute, Department of Fine Arts, 1945.

Thomas Eakins: Twenty-one Photographs. Foreword by Joseph A. Seraphin and introduction by Seymour Adelman. Atlanta: Olympia Galleries, 1979.

Turner, Evan H. Untitled catalog for an exhibition of paintings by Eakins at Saint Charles Borromeo Seminary, Overbrook, Pennsylvania, 1970.

Weinberg, H. Barbara. *The Lure of Paris: Nineteenth-Century American Painters and Their French Teachers*. New York: Abbeville, 1991.

Wilmerding, John. "Peale, Quidor, and Eakins: Self-Portraiture as Genre Painting." In *Art Studies for an Editor: Twenty-five Essays in Memory of Milton S. Fox*. New York: Harry N. Abrams, 1975.

ARTICLES

Ackerman, Gerald M. "Thomas Eakins and His Parisian Masters Gérôme and Bonnat." *Gazette des Beaux-Arts* 73 (April 1969): 235–56.

Adams, Henry. "Thomas Eakins: The Troubled Life of an Artist Who Became an Outcast." *Smithsonian* 22 (November 1991): 52–66.

Albright, Adam Emory. "Memories of Thomas Eakins." *Harper's Bazaar* (August 1947): 138, 139, 184.

Aponte, Gonzalo E. "Thomas Eakins." *Jefferson Medical College Alumni Bulletin* 12 (December 1961): 2–9.

———. "Thomas Eakins (1844–1916): Painter, Sculptor, Teacher." *Transactions and Studies of the College of Physicians of Philadelphia* 32 (April 1965): 160–63.

———. "Some Associations of Thomas Eakins with Jefferson Medical College." *Philadelphia Medicine* 68 (June 2, 1972): 408–9.

Baldinger, Wallace S. "The Art of Eakins, Homer, and Ryder: A Social Revaluation." *Art Quarterly* 9 (Summer 1946): 212–33.

Benjamin, S.G.W. "Present Tendencies of American Art." *Harper's Weekly* 58 (March 1879): 495.

Boime, Albert. "American Culture and the Revival of the French Academic Tradition." *Arts Magazine* 56 (May 1982): 95–101.

Borowitz, Helen Osterman. "The Scalpel and the Brush: Anatomy and Art from Leonardo da Vinci to Thomas Eakins." *Cleveland Clinic Quarterly* (Spring 1986): 61–73.

Bowman, Ruth. "Nature, The Photograph and Thomas Eakins." *Art Journal* 33 (Fall 1973): 35, 38.

Bregler, Charles. "The Brooklyn Memorial Arch: A Note on Its Crowning Group of Sculpture." *Harper's Weekly* 4 (January 1896): 9, 15.

———. "Thomas Eakins as a Teacher." *Arts* 17 (March 1931): 378–86.

———. "Thomas Eakins as a Teacher, Second Article." *Arts* 18 (October 1931): 28–42.

———. "Photos by Eakins: How the Famous Painter Anticipated the Modern Movie Camera." *American Magazine of Art* 36 (January 1943): 28–29.

Brownell, William C. "The Art Schools of Philadelphia." *Scribner's Monthly* 18 (September 1879): 737–50.

———. "The Younger Painters of America. First Paper." *Scribner's Monthly* 20 (May 1880): 1–15.

Burroughs, Alan. "Thomas Eakins, the Man." *Arts* 4 (December 1923): 302–23.

———. "Catalog of Work by Thomas Eakins (1869–1916)." *Arts* 5 (June 1924): 328–33.

Burroughs, Bryson. "An Estimate of Thomas Eakins." *American Magazine of Art* 30 (July 1937): 402–9.

Caffin, Charles. "Some American Portrait Painters." *Critic* 44 (January 1904): 34.

Canaday, John. "Familiar Truths in Clear and Beautiful Language." *Horizon* 6 (Autumn 1964): 88–105.

Chamberlin-Hellman, Maria. "Samuel Murray,

Thomas Eakins, and the Witherspoon Prophets." *Arts Magazine* 53 (May 1979): 134–39.

"*The Chess Players* by Thomas Eakins." *Art World and Arts and Decoration* (August 1918): 196, 201.

Cikovsky, Nicolai, Jr. "Strength of Mind." *Art and Antiques* 7 (September 1984): 76–79.

Cranmer, Clarence W. "Eakins and the Passing Scene." *American Magazine of Art* 27 (June 1934): 350.

A.A.D. "The Photographs of Thomas Eakins." *Arts Magazine* 44 (February 1970): 55.

Dinnerstein, Lois. "Thomas Eakins' 'Crucifixion' as Perceived by Mariana Griswold Van Rensselaer." *Arts Magazine* 53 (May 1979): 140–45.

Donahue, Elinor. "Basketball, DaCosta and a Jefferson Tradition." *Jefferson Medical College Alumni Bulletin* 16 (Summer 1967): 13–20.

G.W.E. [George W. Edgell]. "Thomas Eakins." *Bulletin of the Worcester Art Museum* 20 (January 1930): 86–94.

Fosbergh, James. "Brooklyn's 'Home Scene' by Eakins." *Artnews* 53 (April 1954): 17–19, 60, 61.

———. "Music and Meaning: Eakins' Pro-gress." *Artnews* 56 (February 1958): 24–27, 50, 51.

Foster, Kathleen A. "An Important Eakins Collection." *Antiques* (December 1986): 1228–37.

Fried, Michael. "Realism, Writing, and Disfiguration in Thomas Eakins' *Gross Clinic.*" *Representations* 9 (Winter 1985): 33–104.

Gerdts, William H. "Thomas Eakins and the Episcopal Portrait: Archbishop William Henry Elder." *Arts Magazine* 53 (May 1979): 154–57.

Goodman, Helen. "Emily Sartain: Her Career." *Arts Magazine* 61 (1987): 61–65.

Goodrich, Lloyd. "Thomas Eakins, Realist." *Arts* 16 (October 1929): 72–83.

———. "Thomas Eakins Today." *American Magazine of Art* 36 (January 1944): 162–66.

———. "Realism and Romanticism in Homer, Eakins, and Ryder." *Art Quarterly* 12 (Winter 1949): 17–29.

———. " '. . . About a Man Who Did Not Care to Be Written About': Portraits in Friendship of Thomas Eakins." *Arts Magazine* 53 (May 1979): 96–99.

Goodyear, Frank H., Jr. "The Thomas Eakins Collection of the Philadelphia Museum of Art." *Arts Magazine* 53 (May 1979): 158–59.

Griffin, Randall C. "Thomas Anshutz's *The Ironworkers' Noontime.*" *Smithsonian Studies in American Art* 4 (Summer–Fall 1990): 129–43.

Hall, Diana Long. "Eakins' *Agnew Clinic:* The Medical World in Transition." *Transactions and Studies of the College of Physicians and Surgeons*, 5th series, vol. 7 (1985): 26–32.

Hartmann, Sadakichi. "Thomas Eakins." *Art News* 1 (April 1897).

Haughom, Synnove. "Thomas Eakins' Portrait of Mrs. William D. Frishmuth, Collector." *Antiques* 104 (November 1973): 836–39.

———. "Thomas Eakins' *The Concert Singer.*" *Antiques* 108 (December 1975): 1182–84.

Hendricks, Gordon. "A May Morning in the Park." *Philadelphia Museum of Art Bulletin* 60 (Spring 1965): 48–64.

———. "Ships and Sailboats on the Delaware." *Wadsworth Athenaeum Bulletin* 4 (Spring–Fall 1968): 39–48.

———. "Eakins' *William Rush Carving His Allegorical Statue of the Schuylkill.*" *Art Quarterly* 31 (Winter 1968): 382–404.

———. "Thomas Eakins's *Gross Clinic.*" *Art Bulletin* 51 (March 1969): 57–64.

———. "The Eakins Portrait of Rutherford B. Hayes." *American Art Journal* 1 (Spring 1969): 104–14.

———. "Eakins Slept Here." *Artnews* 72 (January 1973): 71.

Hills, Patricia. "Thomas Eakins's *Agnew Clinic* and John S. Sargent's *Four Doctors:* Sublimity, Decorum, and Professionalism." *Prospects* 11 (1987): 217–30.

Homer, William Innes. "Concerning Muybridge, Marey, and Seurat." *Burlington Magazine* 104 (September 1962): 391, 392.

———. "Thomas Eakins and the Avondale Experience." *Arts Magazine* 54 (February 1980): 150–53.

———. "Who Took Eakins' Photographs." *Artnews* 82 (May 1983): 112–19.

———. "New Documentation on Eakins and Walt Whitman in Camden." *Mickle Street Review* 12 (1990) (special issue on Whitman and the Visual Arts): 74–82.

——— and John Talbot. "Eakins, Muybridge, and the Motion Picture Process." *Art Quarterly* 26 (Summer 1963): 194–216.

Hyman, Neil. "Eakins' *Gross Clinic* Again." *Art Quarterly* 35 (Summer 1972): 158–64.

Johns, Elizabeth. "Thomas Eakins, A Case for Reassessment." *Arts Magazine* 53 (May 1979): 130–33.

———. "Drawing Instruction at Central High School and Its Impact on Thomas Eakins." *Winterthur Portfolio* 15 (Summer 1980): 139–49.

———. "I, a Painter: Thomas Eakins at the Academy of Natural Sciences." *Frontiers* (annual of the Academy of Natural Sciences of Philadelphia) 3 (1981–82): 43–51.

———. "The Heroism of Modern Life." *Wilson Quarterly* 11 (January 1987): 162–73.

Kaplan, Sidney. "The Negro in the Art of Homer and Eakins." *Massachusetts Review* 7 (Winter 1966): 105–20.

Kessler, Charles S. "The Realism of Thomas Eakins." *Arts Magazine* 36 (January 1962): 16–22.

Kirstein, Lincoln. "Walt Whitman and Thomas Eakins: A Poet's and a Painter's Camera-Eye." *Aperture* 16:3 (1971): n.p.

Leibold, Cheryl. "Thomas Eakins in the Badlands." *Archives of American Art Journal* 28 (1988): 2–15.

———. "The Many Faces of Thomas Eakins." *Pennsylvania Heritage* 17 (Spring 1991): 4–9.

Lifton, Norma. "Representing History: From Public Event to Private Meaning." *Art Journal* 14 (Winter 1984): 345–51.

Long, Diana E. "The Medical World of *The Agnew Clinic:* A World We Have Lost." *Prospects* 11 (1987): 185–98.

McCoy, Garnett. "Some Recently Discovered Thomas Eakins Photographs." *Journal of the Archives of American Art* 12, no. 4 (1972): 15–22.

McGaughey, Patrick. "Thomas Eakins and the Power of Seeing." *Artforum* 9 (December 1970): 56–61.

Meyer, Annie Nathan. "Two Portraits of Walt Whitman." *Putnam's Monthly and the Reader* 4 (September 1908): 707–10.

Milroy, Elizabeth. " 'Consummatum est . . .': A Reassessment of Thomas Eakins's *Crucifixion* of 1880." *Art Bulletin* 71 (June 1989): 270–84.

Moffett, Cleveland. "Grant and Lincoln in Bronze." *McClure's Magazine* 5 (October 1895): 419–32.

Montgomery, Thaddeus L. " 'The Gross Clinic': Its Future at Jefferson." *Jefferson Medical College Alumni Bulletin* 30 (Spring 1981): 11–13.

O'Connor, John, Jr. "Thomas Eakins, Consistent Realist." *Carnegie Magazine* 19 (May 1945): 35–39.

Onorato, Ronald J. "Photography and Teaching: Eakins at the Academy." *American Art Review* 3 (July–August 1976): 127–40.

———. "Thomas Eakins." *Arts Magazine* 53 (May 1979): 121–29.

Pach, Walter. "A Grand Provincial." *Freeman* 7 (April 11, 1923): 112–14. Reprinted in *The Freeman Book*. New York: B. W. Huebsch, 1924.

Parry, Ellwood C., III. "Thomas Eakins and the Gross Clinic." *Jefferson Medical College Alumni Bulletin* 16 (Summer 1967): 2–12.

———. "The *Gross Clinic* as Anatomy Lesson and Memorial Portrait." *Art Quarterly* 32 (Winter 1969): 373–91.

———. "Thomas Eakins and the Everpresence of Photography." *Arts Magazine* 51 (June 1977): 111–15.

———. "The Thomas Eakins Portrait of Sue and Harry; or, When Did the Artist Change His Mind?" *Arts Magazine* 53 (May 1979): 146–53.

———. "Thomas Eakins's 'Naked Series' Reconsidered: Another Look at the Standing Nude Photographs Made for the Use of Eakins's Students." *American Art Journal* 20 (1988): 53–77.

——— and Maria Chamberlin-Hellman. "Thomas Eakins as an Illustrator, 1878–1881." *American Art Journal* 5 (May 1973): 20–45.

Peck, Robert McCracken. "Thomas Eakins and Photography: The Means to an End." *Arts Magazine* 53 (May 1979): 113–17.

Rogers, Fairman. "The Schools of the Pennsylvania Academy of the Fine Arts." *Penn Monthly* 12 (June 1881): 453–62.

Rosenzweig, Phyllis. "Problems and Resources in Thomas Eakins Research: The Hirshhorn Museum's Thomas Eakins Collection." *Arts Magazine* 53 (May 1979): 118–20.

Rule, Henry B. "Whitman and Thomas Eakins: Variations on Some Common Themes." *Texas Quarterly* 17 (Winter 1974): 7–57.

Sartain, William. "Thomas Eakins." *Art World* 3 (January 1918): 291–93.

Scanlon, Lawrence E. "Eakins as Functionalist." *College Art Journal* 19 (Summer 1960): 322–29.

Simpson, Marc. "Thomas Eakins and His Arcadian Works." *Smithsonian Studies in American Art* 1 (Fall 1987): 71–95.

Smith, Carl S. "The Boxing Paintings of Thomas Eakins." *Prospects* 4 (1979): 403–19.

Smith, Margaret Supplee. "*The Agnew Clinic:* 'Not Cheerful for Ladies to Look At.' " *Prospects* 11 (1987): 161–83.

Steinberg, Leo. "Art/Work: Eakins and Gérôme." *Artnews* 70 (February 1972): 34–35.

Taylor, Francis Henry. "Thomas Eakins—Positivist." *Parnassus* 2 (March 1930): 20, 21, 43.

"Thomas Eakins: Another Neglected Master of American Art." *Current Opinion* 63 (December 1917): 411–13.

"Thomas Eakins Centennial Exhibition." *Philadelphia Museum Bulletin* 39 (May 1944): 119–35.

"Thomas Eakins, 1844–1916." *Pennsylvania Museum Bulletin* 25 (March 1930): 2–33.

Turner, Evan H. "Thomas Eakins in Overbrook." *Records of the American Catholic Historical Society of Philadelphia* 81 (December 1970): 195–98.

———. "Thomas Eakins: The Earles' Galleries Exhibition of 1896." *Arts Magazine* 53 (May 1979): 100–107.

Weinberg, Ephraim. "The Art School of the Pennsylvania Academy." *Antiques* 121 (March 1982): 690–93.

Weinberg, H. Barbara. "Nineteenth-Century American Painters at the Ecole des Beaux-Arts." *American Art Journal* 13 (Autumn 1981): 66–84.

Whelan, Richard. "Thomas Eakins: The Enigma of the Nude." *Christopher Street*, April 1979, pp. 15–18.

Williams, Tom C. "Thomas Eakins: Artist and Teacher for All Seasons." *American Artist* 39 (March 1975): 56–61, 65–67.

"William Sartain." *Art Journal* 6 (June 1880): 261.

Wilmerding, John. "Thomas Eakins' Late Portraits." *Arts Magazine* 53 (May 1979): 108–12.

Wilson, Bob. "Sculling to the Over-Soul: Louis Simpson, American Transcendentalism, and Thomas Eakins's *Max Schmitt in a Single Scull.*" *American Quarterly* 39 (Fall 1987): 410–30.

Zilczer, Judith. "Eakins Letter Provides More Evidence on the Portrait of Frank Hamilton Cushing." *American Art Journal* 14 (Winter 1982): 74–76.

Acknowledgments

I would like to thank the following individuals for their help during the course of my research: Gerald Ackerman, Seymour Adelman, Ruth Appelhof, George Barker, Samuel Borton, Ray Callahan, Jerrold Casway, Perry Chapman, Elizabeth G. Coates, Margaret Cook, Eugene Crowell, Christine Crowell, J. Stephens Crawford, Susan Danly, Dan and Jennie Dietrich, Beatrice Fenton, Kathy Foster, Zenos Frudakis, Jack Garrett, Gordon Hendricks, Jean Henry, Suzi Isaacs, Nina Kallmyer, Eileen Kearney, Ralph LaFrance, Janet LeClair, Cheryl Leibold, Garnett McCoy, Lily Milroy, Weston Naef, Sue Nutty, Ellwood Parry III, Nancy Reinbold, Marthe Reynolds, Donald J. Rosato, M.D., Phyllis Rosenzweig, Robert D. Schwarz, David Sellin, Joseph A. Seraphin, Darrell Sewell, Peggy Thomas, Jeanette Toohey, Gertrude Traubel, Frederick Wagner, M.D., Frolic Weymouth, Abigail Williams, Betsy Wyeth, Judith Zilczer, and the representatives of the numerous museums and galleries who so generously offered information about works by Eakins in their possession. My heartfelt thanks go to the collectors who opened their homes to me and provided information about the works they own.

Special acknowledgment must go to Lloyd Goodrich, who was the foremost Eakins scholar until his death in 1987. During our twenty-five-year friendship he was unfailingly helpful in matters relating to Eakins, and he generously opened his files to me.

My children were an important part of the support system I found at home and through long-distance telephone. Susan Christine Hyer, mother of my captivating granddaughter, Siana Sharp; Stace Innes Homer, Frederick L. Hyer III, and Nancy Elizabeth Hyer all provided encouragement and much-needed respite from the labors of writing. I am particularly grateful to Fred and Nancy and their friends Lauren Schlesinger and Robert Rose for their thoughtful discussion of some of the book's central issues, particularly Eakins's creativity and his attitude toward women.

During my four years of active research on this project I have benefited from the devoted assistance of Jack Becker, Sharon Clarke, Tracy Myers, Carol Nigro, Helen Raye, and Beth Venn. These individuals shared the unglamorous chores associated with preparing a manuscript, from photocopying articles to checking endnotes to alphabetizing the bibliography.

I wish to acknowledge the editorial expertise provided by Regina Ryan, who read the manuscript with great care and made valuable suggestions. Similar assistance was received from both Carol Nigro and Perry Ottenberg, M.D.; their comments on the manuscript were most helpful. Special thanks go to Nancy Grubb, senior editor at Abbeville Press, for her enthusiastic support of this project and her skilled and comprehensive editing of my text. Also at Abbeville, Anne Manning's cheerful efficiency in tracking down photographs, Nai Chang's excellent design, and Hope Koturo's careful supervision of the production process ensured a notably handsome volume.

I benefited greatly from research grants awarded to me by the John Sloan Memorial Foundation and Kennedy Galleries, Inc., and wish to thank Mrs. John Sloan and Lawrence Fleischman, respectively, for their interest and cooperation. For support of my research on Eakins, I am also indebted to the University of Delaware's College of Arts and Science grant-in-aid program.

Finally, I would like to express my deepest gratitude to my wife, Christine, who was not only supportive during the entire writing process but also read the manuscript, chapter by chapter, and made many valuable suggestions.

Index

271

Photography Credits

The photographers and the sources of photographic material other than those indicated in the captions are as follows:

Copyright © Addison Gallery of American Art, Phillips Academy, Andover, Mass., all rights reserved: plate 227; Copyright © 1991 The Art Institute of Chicago, all rights reserved: plates 83, 95; Will Brown: plate 179; Cathy Carver: plate 62; Copyright © 1951 The Dayton Art Institute, Dayton, Ohio/Rollyn Putterbaugh: plate 25; Delo Photo Craft, Mount Vernon, Ill./Louis C. Pavledes: plate 170; Tibor Franyo: plate 235; Edmund B. Gillon, Jr.: plate 193; Melvin L. Gurtizen: plate 36; Bob Halvey: plate 219; Barbara Hansen, New York: plate 190; Courtesy of Hirschl & Adler Galleries, Inc., New York: plate 192; Hirshhorn Museum and Sculpture Garden, Smithsonian Institution, Washington, D.C./Lee Stalsworth: plates 2, 8, 11, 33, 49, 64, 89, 103, 104, 133, 135, 136, 142, 156, 157, 168, 226, 229, 233, 242; William Innes Homer: plate 7; Courtesy of Kennedy Galleries, Inc.: plate 88; Copyright © Mauritshuis, The Hague: plate 69; Copyright © 1992 by The Metropolitan Museum of Art, New York: frontispiece, plates 41, 48, 60, 76, 78, 108, 111, 129, 131, 138, 160, 164, 177, 196; Elizabeth Milroy: plate 35; Eric Mitchell, 1985: plate 18; Copyright © Museo del Prado, Madrid, all rights reserved: plates 37, 38; Copyright © Museum of Fine Arts, Boston, all rights reserved: plates 52, 199; Copyright © 1985, all rights reserved, Museum of Fine Arts, Boston: plate 56; Copyright © 1991 Museum of Fine Arts, Boston, all rights reserved: plate 239; Courtesy of the National Gallery of Art, Washington, D.C.: plate 75; Wayne Newcomb, Roanoke, Va.: plate 112; Courtesy of Ellwood C. Parry III: plates 159, 161; Stephen Petegorsky, Northampton, Mass.: plate 86; Courtesy of the Philadelphia Museum of Art: plates 82, 224; Copyright © The Phillips Collection, Washington, D.C./Edward Owen: plate 217; Maureen Pratt: plate 59; Copyright © 1991 Trustees of Princeton University, N.J.: plate 85; Réunion des Musées Nationaux, Paris: plate 23; Joseph Szaszfai, Branford, Conn.: plate 144; University of Delaware Library, Newark, Del.: plate 106; Copyright © Wadsworth Atheneum, Hartford, Conn./Joseph Szaszfai: plate 206; Graydon Wood, 1991: plate 93; A.J. Wyatt: plates 80, 106, 123; Yale University Art Gallery, New Haven, Conn./Regina Monfort: plates 74, 81, 222.